Four Artists
of the
Stieglitz Circle

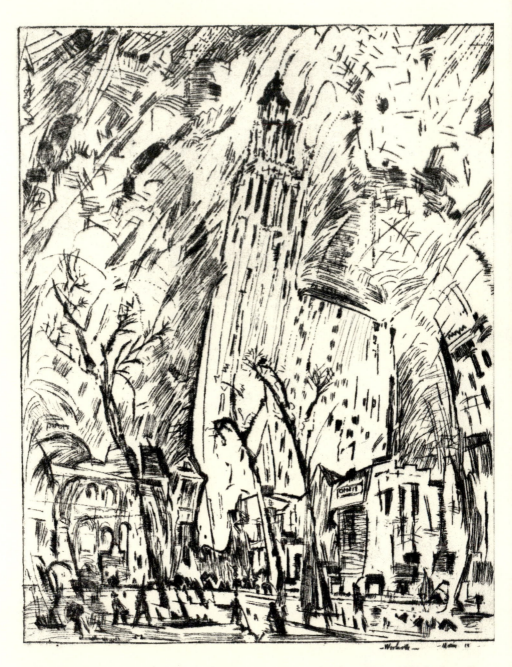

John Marin, *Woolworth Building (The Dance)*, 1913. Etching, 13 × 10½ inches. Courtesy Richard York Gallery, New York.

Four Artists
of the
Stieglitz Circle

A Sourcebook on
Arthur Dove, Marsden Hartley,
John Marin, and Max Weber

R. Scott Harnsberger

Art Reference Collection, Number 26
Russell T. Clement, Series Adviser

GREENWOOD PRESS
Westport, Connecticut • London

Library of Congress Cataloging-in-Publication Data

Harnsberger, R. Scott.
 Four artists of the Stieglitz Circle : a sourcebook on Arthur Dove, Marsden Hartley, John
Marin, and Max Weber / R. Scott Harnsberger.
 p. cm.—(Art reference collection, ISSN 0193–6867 ; no. 26)
 Includes bibliographical references and index.
 ISBN 0–313–31488–8 (alk. paper)
 1. Stieglitz Circle (Group of artists) 2. Stieglitz, Alfred, 1864–1946—Art
patronage. 3. Art, American—20th century. I. Title. II. Series.
759.13'09'041—dc21 2001054097

British Library Cataloguing in Publication Data is available.

Library of Congress Catalog Card Number: 2001054097
ISBN: 0–313–31488–8
ISSN: 0193–6867

First published in 2002

Greenwood Press, 88 Post Road West, Westport, CT 06881
An imprint of Greenwood Publishing Group, Inc.
www.greenwood.com

Printed in the United States of America

The paper used in this book complies with the
Permanent Paper Standard issued by the National
Information Standards Organization (Z39.48–1984).

10 9 8 7 6 5 4 3 2 1

For my son,
Michael Richard Woodruff

Contents

Acknowledgments

I would like to thank the following individuals, museums, galleries, libraries, and universities, which provided me with information and materials:

Ackland Art Museum

Albright-Knox Art Gallery

Amarillo Art Center

Amon Carter Museum of Western Art

Archives of American Art

Eileen Arsenault, Exhibitions Coordinator, Portland (Me.) Museum of Art

Babcock Galleries

Linda J. Bailey, Reference Librarian, Cincinnati Historical Society Library

Brooklyn Museum of Art

Butler Institute of American Art

Chrysler Museum

Julie Cobb, Reference Assistant, Special Collections, Newberry Library

Phyllis M. Cohen, Librarian, Museum of New Mexico, Museum of Fine Arts

Colby College Art Museum

Michael Culver, Curator, Ogunquit Museum of American Art

Delaware Art Museum

Terry Dintenfass Gallery

Peter Hastings Falk

Forum Gallery

Ronald J. Grele, Director, Oral History Research Office, Columbia University

Kevin Grogan, Director, Carl Van Vechten Gallery of Fine Arts, Fisk University

Brenda Hearing, Curator, Carnegie Corporation Archives, Rare Book and Manuscript Library, Butler Library, Columbia University

Hirschl and Adler Galleries

Jersey City Museum

Joslyn Art Museum, Abrahams Library

Mary Kalish-Johnson, Curatorial Assistant, Frederick R. Weisman Art Museum, University of Minnesota

Linda Karol, Faculty Secretary, Art Department, Hobart and William Smith Colleges

Kennedy Galleries

Kraushaar Galleries

Richard Leet, Director, Charles H. MacNider Museum

Mary Leonard, Reference Librarian, Mayer Library, Dallas Museum of Art

Judith McCulloch, Administrator, Cape Ann Historical Association

Genetta McLean, Director, Olin Arts Center, Bates College

Muscarelle Museum of Art, College of William and Mary

Marcy Neth, Librarian, Ryerson and Burnham Libraries, Art Institute of Chicago

New Jersey State Museum

Newark Museum

Owen Gallery

Owings-Dewey Fine Art

Philadelphia Museum of Art

Barbara Polowy, Hillyer Art Library, Smith College

Roswell (N.M.) Museum and Art Center

Salander-O'Reilly Galleries

Gail R. Scott, University of Maine at Presque Isle

Cathy G. Shaffer, Cincinnati Art Museum

Nancy M. Shawcross, Curator of Manuscripts, Special Collections Department, Van Pelt Library, University of Pennsylvania

Deborah Smedstad, Head Librarian, Balch Art Research Library, Los Angeles County Museum of Art

Southern Alleghenies Museum of Art

Wendy Thompson, Librarian, and Alene D. Oestreicher, Assistant Librarian, Miller Art Library, Baltimore Museum of Art

UCLA at the Armand Hammer Museum of Art and Cultural Center

Sean M. Ulmer, Herbert F. Johnson Museum of Art, Cornell University
Frederick O. Waage, Department of English, East Tennessee State University
Walker Art Center (Minneapolis)
Whitney Museum of American Art at Champion
Riva Yares Gallery
Richard York Gallery

Introduction

The Stieglitz Circle was a small group of artists and photographers who were supported and promoted by Alfred Stieglitz through his galleries and publications from 1905 to 1946. This annotated bibliography has been compiled to serve as a sourcebook for those conducting research on the Stieglitz Circle and four of its leading members: Arthur Dove, Marsden Hartley, John Marin, and Max Weber.

The first chapter opens with a biographical essay on Stieglitz, which is followed by subsections containing citations to books; exhibition catalogues; articles and essays; exhibition reviews; reference works; archival sources; and dissertations and theses that deal with the Stieglitz Circle generally (excluding photography) or that analyze, critique, discuss, or otherwise contain information on two or more of these artists.

The chapters on the four individual artists, which begin with biographical essays, are subdivided along the following lines:

I. Writings, Statements, and Correspondence. Separately published writings, statements, and correspondence of each artist are cited in this section. It is important that the reader consult the cross-references because material relevant to this section often appears in later sections (e.g., statements of the artists published in exhibition catalogues).

II. Books and Exhibition Catalogues. This section contains citations to books, exhibition catalogues of one-man shows, and selected catalogues of group and thematic exhibitions in which these artists' works are represented. I have used the generic term "catalogue" to designate any publication issued in conjunction with an exhibition from a pamphlet to a monograph. The annotations clarify the nature and scope of each entry. In the case of traveling exhibitions, only the originating site and inclusive dates are noted.

III. Articles and Essays. Periodical articles and essays from anthologies are cited in this section.

IV. Exhibition Reviews. The exhibition reviews are drawn chiefly, but not exclusively, from the major art history periodicals. Selected newspaper reviews are also listed if they have been reprinted in other sources. In most cases, the annotations note only the originating site and inclusive dates for traveling exhibitions, unless the review pertains to a different venue on the tour. The reviews are arranged chronologically by the date of the exhibition and then alphabetically by the name of the reviewer.

V. Reference Sources. This section cites reference sources such as biographical dictionaries and art history encyclopedias.

VI. Archival Sources. Sources for unpublished material for each artist are listed in this section, including the Archives of American Art and special collections in university libraries.

VII. Dissertations and Theses. Doctoral dissertations and master's theses appear in this section.

VIII. Annotated Reproductions. Annotated reproductions of each artist's works are arranged in this section by title. The majority of the source volumes contain critical annotations, brief essays, biographical notes, or bibliographic citations pertaining to the cited painting, drawing, print, or sculpture. Source volumes with briefer information (usually the title, date, medium, dimensions, and provenance) have been included in order to document the presence of an artist's work in a particular museum, gallery, exhibition, or private collection. Due to space limitations, listings from the catalogues of auction firms are selective, not comprehensive. With only a few exceptions, the source volumes are not referred to in other sections of this bibliography.

The format for the entries is as follows: title; date; keyword for source volume; black and white (b/w) or color (c) reproduction; and the page numbers on which the reproduction and annotations appear. In the case of unpaginated or partially paginated books, references to plate (Pl.) numbers are provided, sometimes in conjunction with page (pp.) numbers.

The book has the following four indexes:

Keyword Index to Source Volumes. This index decodes the keywords used for the source volumes in the Annotated Reproductions sections.

Author Index. This index lists personal authors, both for main entries and for authors of catalogue essays and exhibition reviews when they appear within the annotations.

Short-Title Index to Exhibition Catalogues. This index assists those who are unable to locate an exhibition catalogue by the main entry.

Subject Index. The subject index utilizes, so far as possible, Library of Congress subject headings since these are familiar to most researchers. Exhibition reviews are not included here because, being listed chronologically, they are easily accessible by date.

Note: The numbers in the indexes refer to entry numbers, not page numbers.

1

The Stieglitz Circle

Alfred Stieglitz was born on 1 January 1864 in Hoboken, New Jersey, and moved with his family to Manhattan when he was seven. After graduating from Townsend Harris High School in 1879, he enrolled at the City College of New York. In 1881 his father arranged for him to attend the Realgymnasium in Karlsruhe, Germany. By October 1882, Stieglitz had enrolled in Berlin's Technische Hochschule to study mechanical engineering. His passion for photography began in January 1883 after he purchased a camera that he had spotted on display in a shop window.

Shortly thereafter Stieglitz began attending a class in photochemistry taught by Professor Hermann Wilhelm Vogel at the Hochschule. Under Vogel's tutelage he became thoroughly acquainted with the technical aspects of photography. Stieglitz was eventually placed in charge of the campus photography laboratory, where he had the opportunity to carry out experiments with a variety of processes and materials. He published technical articles in Vogel's *Photographische Mittheilungen*, as well as in *Der Amateur-Photograph* and *Die Photographische Rundschau*. He also studied chemistry with August Wilhelm von Hofmann at Berlin University and dye chemistry with Karl Liebermann at the Charlottenburg Institute.

Stieglitz reluctantly returned to New York in September 1890 at his family's insistence. He accepted a position with the Heliochrome Company and assisted in the development of a process for color photographic reproductions. Within a year the firm went bankrupt, whereupon Stieglitz joined the Photochrome Engraving Company. In 1887 he entered his photograph *A Good Joke* in a London competition sponsored by the prestigious English journal *The Amateur Photographer*. He was awarded first prize and a silver medal by P.H. Emerson, the first of over 150 such awards that his photographs would garner during his lifetime. Stieglitz became a member of the Society of Amateur Photographers

in 1891 and regularly exhibited his photographs in juried competitions in the United States and Europe.

Stieglitz's crusade for photography's status as a fine art began with his article in the 1892 annual edition of *Photographic Mosaics*, "A Plea for Art Photography in America," where he outlined his aesthetic philosophy. He criticized the Impressionistic, manipulated, soft-focus images of British photographers, while extolling the virtues of sharp-focus, straightforward simplicity. Stieglitz was also writing for *The American Amateur Photographer*, which eventually led to his assuming the editorship in the spring of 1893.

The Camera Club of New York was founded in 1897 following the merger of the Society of Amateur Photographers and the New York Camera Club. Stieglitz was instrumental in editing the club's periodical *Camera Notes*. He recruited new contributors, including the art critics Charles Caffin and Sadakichi Hartmann and the photographers Clarence White and Edward Steichen. By 1900 Stieglitz was coming under attack by some club members for being egotistical, undemocratic, elitist, and even tyrannical. In response to this discord, Stieglitz founded the Photo-Secession on 17 February 1902, an organization dedicated to a common vision for photography. After accepting an invitation from the National Arts Club of New York to organize an exhibition of pictorial photographs, he solicited photographs from thirty-two individuals whose work he had encouraged and published, many of whom were not members of the Photo-Secession. The March 1902 exhibition *American Pictorial Photography* presented photography to the public as an independent and diverse art form. Shortly after staging this very successful exhibition, Stieglitz resigned from *Camera Notes* and launched a new quarterly periodical, *Camera Work*, in January 1903, which freed him from the constraints of formal clubs and established publications.

During its first two years *Camera Work* focused primarily on photography, although from 1907 onward this emphasis became less predominant, with more space being devoted to the other fine arts and general aesthetic issues. Stieglitz always insisted on the highest standards for content and presentation. Prominent contributors included George Bernard Shaw, Maurice Maeterlinck, H.G. Wells, Henri Bergson, and Gertrude Stein. However, the periodical proved too radical for its readers and ceased publication in 1917 after a total of fifty issues. With the financial backing of Agnes Meyer, Francis Picabia, and Marius de Zayas, Stieglitz began publishing a folio-size monthly in 1915 called *291*, which turned out to be even more controversial and lasted only twelve issues.

Steichen suggested that the studio that he had recently abandoned on the top floor of 291 Fifth Avenue, along with the two rooms behind it, be converted into a photographic gallery. With Stieglitz in agreement, the inaugural exhibition of the Photo-Secession Galleries took place on 25 November 1905. The site was commonly called the Little Galleries of the Photo-Secession; later it was simply known as 291.

During the early years the galleries exhibited only the work of American and

European pictorial photographers, but eventually both Stieglitz and Steichen recognized the need to also stage exhibitions featuring paintings, drawings, prints, and sculpture. In January 1907, drawings and watercolors by Pamela Colman Smith constituted the first such showing, followed in 1908 by exhibitions of works by Rodin and Matisse. Other European artists shown at 291 included Manet, Cézanne, Renoir, Toulouse-Lautrec, Rousseau, Picasso, Braque, Serverini, and Brancusi. The core artists and photographers of the Stieglitz Circle included Oscar Bluemner, Arthur B. Carles, Charles Demuth, Arthur Dove, Marsden Hartley, John Marin, Alfred Maurer, Georgia O'Keeffe (who married Stieglitz in 1924), Francis Picabia, Edward Steichen, Paul Strand, Abraham Walkowitz, Max Weber, and Marius de Zayas.

Although he professed to have no set aesthetic preconceptions or theories, Stieglitz felt that it was his mission to promote uniquely indigenous American art, and he looked not only for fine craftsmanship in the works that he exhibited but also for honesty, integrity, intense expression of subjective feelings, and a pioneering spirit. He likened 291 to a laboratory where new artistic endeavors could be openly weighed and examined by the viewers. The gallery achieved remarkable prominence given that it was never advertised outside the pages of *Camera Work*, and at the time Stieglitz was an adamant opponent of commercialism in the arts, which often made it difficult for patrons to purchase the works on display. To remedy this situation, several members of the Stieglitz Circle began to also exhibit their works at the more commercial Modern Gallery, which opened on 7 October 1915 under the directorship of de Zayas. Although Stieglitz initially supported the new gallery, he broke off his association a few months later in December.

Stieglitz's dogmatic and overbearing personality eventually started to alienate many of his associates, including Steichen and Weber. In April 1917, with his inner circle of supporters reduced to a few loyalists, Stieglitz held the final exhibition at 291, which was coincidentally O'Keeffe's first solo show. Stieglitz continued to work behind the scenes in the New York art world until he staged an exhibition, *Alfred Stieglitz Presents Seven Americans*, at the Anderson Galleries in March 1925. The success of the show prompted him to open the Intimate Gallery in Room 303 of the Anderson Galleries at 489 Park Avenue. Regular exhibitions of the work of Demuth, Dove, Hartley, Marin, O'Keeffe, and Strand were the mainstays of the new gallery. In contrast to his earlier noncommercial stance, Stieglitz began to successfully market his artists, even going as far as to report to the newspapers in 1927 that he sold Marin's watercolor, *Back of Bear Mountain*, to Duncan Phillips for the then-astounding sum of $6,000 (which was actually the sum that Phillips paid for a group of four of Marin's works).

With the closing of the Anderson Galleries in 1929, Stieglitz found himself in need of new quarters. The assistance of Paul and Rebecca Strand and Dorothy Norman enabled him to open his third gallery, An American Place, in Suite 1707 of a newly opened office building at 509 Madison Avenue. There he staged

annual exhibitions for Dove, Marin, and O'Keeffe—as well as several shows for Hartley and selected other artists and photographers—until he died of a stroke on 13 July 1946. In addition to his significant accomplishments in the field of photography, Stieglitz was a monumental figure in the evolution and promotion of modern American art.

I. BOOKS AND EXHIBITION CATALOGUES

001 *Advancing American Art.* Prague, Czechoslovakia: U.S. Information Service, 1947.

Catalogue of the European half of the exhibition *Advancing American Art*, which was sponsored by the U.S. Department of State. It includes one work each by Dove, Hartley, Marin, and Weber. Before departing for its European venues, the exhibition was shown at the Metropolitan Museum of Art, New York, 4–27 October 1946. Hugo Weisgall provides an introductory essay and notes on the paintings. For the complete story behind this ill-fated exhibition, see *Advancing American Art: Painting, Politics, and Cultural Confrontation at Mid-Century*, by Taylor D. Littleton and Maltby Sykes (Tuscaloosa: University of Alabama Press, 1989).

002 *America and Alfred Stieglitz: A Collective Portrait*, edited by Waldo Frank, Lewis Mumford, Dorothy Norman, Paul Rosenfeld, and Harold Rugg. New York: Literary Guild, 1934.

The essays in this book, which focus on Stieglitz's contributions to American cultural life, were authored by the five editors as well as William Carlos Williams, Herbert J. Seligmann, Elizabeth McCausland, and others. There are also appreciations of Stieglitz written by various individuals, which include Marin's "The Man and the Place" (pp. 233–235); Hartley's "291—And the Brass Bowl" (pp. 236–242); and Dove's "A Different One" (pp. 243–245).

003 Anderson Galleries. *Alfred Stieglitz Presents Seven Americans: 159 Paintings, Photographs and Things Recent and Never Before Publicly Shown by Arthur G. Dove, Marsden Hartley, John Marin, Charles Demuth, Paul Strand, Georgia O'Keeffe, Alfred Stieglitz.* New York: The Galleries, 1925.

Catalogue of an exhibition held at the Anderson Galleries, New York, 9–28 March 1925.

004 Andrew Crispo Gallery. *Pioneers of American Abstraction: Oscar Bleumner, Stuart Davis, Charles Demuth, Arthur Dove, John Marin, Georgia O'Keeffe, Charles Sheeler, Joseph Stella, Max Weber.* New York: The Gallery, 1973.

Catalogue of an exhibition held at the Andrew Crispo Gallery, New York, 17 October–17 November 1973, which includes twenty works each by Dove and Marin and fifteen by Weber.

005 _____. *Ten Americans: Avery, Burchfield, Demuth, Dove, Homer, Hopper, Marin, Prendergast, Sargent, Wyeth.* [Cover title: *Ten Americans: Masters of Watercolor.*] New York: The Gallery, 1974.

Catalogue of an exhibition held at the Andrew Crispo Gallery, New York, 16 May–30 June 1974. The exhibition included fifteen watercolors by Dove (all illustrated, six in color) and nineteen by Marin (eighteen are illustrated, six in color). Foreword by Andrew J. Crispo and catalogue essays by Larry Curry.

005A Antliff, Allan. *Anarchist Modernism: Art, Politics, and the First American Avant-Garde.* Chicago: University of Chicago Press, 2001.

Antliff discusses the anarchist aspects of the works of Dove (pp. 36–38) and Weber (pp. 111–117), both with reference to the critic Hutchins Hapgood.

006 Archives of American Art. *From Reliable Sources: An Exhibition of Letters, Photographs, and Other Documents from the Collections of the Archives of American Art, Smithsonian Institution, Commemorating the Twentieth Anniversary of the Founding of the Archives.* Washington, D.C.: The Archives, 1974.

This catalogue of an exhibition held at the Gallery of the Archives of American Art, Washington, D.C., contains sections devoted to Dove and Marin.

007 Baur, John I.H. *Revolution and Tradition in Modern American Art.* Cambridge: Harvard University Press, 1951.

In this important midcentury survey of American art, Baur offers critical assessments of Dove, Hartley, Marin, and Weber at various places throughout the book.

008 Berman, Avis. *Rebels on Eighth Street: Juliana Force and the Whitney Museum of American Art.* New York: Atheneum, 1990.

Juliana Force was the first director of the Whitney Museum of American Art and its predecessors, the Whitney Studio, the Whitney Studio Club, and the Whitney Studio Galleries. Berman recounts the "state of polite but many-stranded antagonism" that existed between Force and Stieglitz (pp. 222–229, 302–304). No artists of the core Stieglitz Circle—including Dove, Hartley, and Marin—were included in the collections of the predecessors of the Whitney Museum. Only later, beginning with the museum's first biennial exhibition of contemporary American painting in November 1932, were works by these artists added to the collection. Berman notes the acquisition of works by Hartley (pp. 397); Marin (pp. 303, 477); and Weber (p. 301). Although Dove exhibited at the Whitney Museum, his works were not acquired until 1951.

009 Birmingham Museum of Art. *The Expressionist Landscape: Northern American Modernist Painting, 1920–1947.* Birmingham, Ala.: The Museum; Seattle: Distributed by University of Washington Press, 1987.

Catalogue of an exhibition held at the Birmingham Museum of Art, Bir-

mingham, Alabama, 11 September–4 November 1987, which includes eleven works by Dove, eight each by Hartley and Marin, and one by Weber. In her essay "Transcendental Realism in the Stieglitz Circle: The Expressionist Landscapes of Arthur Dove, Marsden Hartley, John Marin, and Georgia O'Keeffe," Barbara Haskell explores the influence that German Expressionism—particularly that of Der Blaue Reiter—exerted on these artists. In his essay "Theory and Practice: Hartley, Bluemner, and the Expressionist Landscape," Jeffrey R. Hayes compares and contrasts the ways in which Hartley and Oscar Bluemner treated the landscape in terms of Expressionist theory. The catalogue contains a checklist of the exhibition and bibliographies for each artist.

010 Brandeis University. Poses Institute of Fine Arts. *American Modernism: The First Wave—Paintings from 1903–1933.* Waltham, Mass.: The Institute, 1963.

Catalogue of an exhibition held at the Poses Institute of Fine Arts, Brandeis University, Waltham, Massachusetts, 4 October–10 November 1963, which includes eight works by Dove, five by Hartley, and seven by Marin. The catalogue contains an essay by Sam Hunter and "A Statement" by Edith Gregor Halpert.

010A Brennan, Marcia. *Painting Gender, Constructing Theory: The Alfred Stieglitz Circle and American Formalist Aesthetics.* Cambridge: MIT Press, 2001.

Brennan discusses the historical and cultural context for Stieglitz's aesthetics starting in the 1920s, including its critical reception (with a focus on Paul Rosenfeld, Waldo Frank, and Clement Greenberg); Stieglitz's relationship with Dada artists living in New York; and issues relating to gender, masculinity, and sexuality in the works of the Stieglitz Circle artists, including Dove, Hartley, and Marin.

011 Broder, Patricia Janis. *The American West: The Modern Vision.* Boston: Little, Brown, 1984.

In Chapter 7, "Marsden Hartley: In Search of American Icons," Broder discusses the American Indian themes in Hartley's 1914 *Amerika* series painted in Berlin; his paintings executed in New Mexico during 1918 and 1919; and his *New Mexico Recollection* works painted in New York, Berlin, and Paris from 1919 to 1924. In Chapter 9, "John Marin: A Watercolor Legacy," she surveys Marin's New Mexico landscapes of 1929 and 1930.

012 Brooklyn Museum. *American Artists of the Alfred Stieglitz Circle.* Brooklyn, N.Y.: The Museum, 1990.

Catalogue of an exhibition held at the Brooklyn Museum, Brooklyn, New York, 9 February–18 June 1990, which includes two works by Dove, seven each by Hartley and Marin, and twenty-five by Weber. Essays by Linda Konheim Kramer and Barbara Dayer Gallati.

013 Brown, Milton W. *The Story of the Armory Show*. 2d ed. [Washington, D.C.]: Joseph H. Hirshhorn Foundation; New York: Abbeville Press, 1988.

Brown provides a listing of the works exhibited in the landmark Armory Show (*International Exhibition of Modern Art*), held at the Armory of the Sixty-ninth Regiment, New York, 17 February–15 March 1913, including those by Hartley (pp. 273–274) and Marin (pp. 290–291). Brown has revised and updated the original catalogue listings—in terms of titles, media, dates, lenders, prices listed, buyers and prices paid, present collections, works added, and supplementary notes—through utilizing documentary sources in the Kuhn Papers, the MacRae Papers, and the sales books of Walter Pach.

014 Cahill, Holger and Alfred Barr, Jr., eds. *Art in America in Modern Times*, 34–42. New York: Reynal and Hitchcock, 1934.

In Section I, Part V, "American Painting 1865–1934: The Impact of Modern Art," which formed the basis for a coast-to-coast NBC radio broadcast on 8 December 1934, Cahill discusses Marin's *Pertaining to Stonington Harbor* and Weber's *Beautification*.

015 *Camera Work: A Critical Anthology*, edited with an introduction by Jonathan Green. Millerton, N.Y.: Aperture, 1973.

An anthology of articles, exhibition reviews, and poetry from Stieglitz's publication *Camera Work* (see entry 016), arranged chronologically in four time periods. Green provides an introduction; biographies of the contributors; a bibliography; the table of contents for each issue; and indexes for names/subjects and plates. The anthology contains material by and about Dove, Hartley, Marin, and Weber.

016 *Camera Work: A Photographic Quarterly*. Nendeln, Liechtenstein: Kraus Reprint, 1969.

A facsimile reprint of the complete run of Stieglitz's quarterly periodical, from No. 1 (January 1903) to Nos. 49/50 (June 1917), bound in six volumes. Each issue contains critical and theoretical discussions of aesthetic issues in photography and modern art in general; exhibition reviews, chiefly focusing on exhibitions staged at the Photo-Secession Galleries; poetry; and photographic plates. To locate material by and about Dove, Hartley, Marin, and Weber, use the indexes provided by Jonathan Green in his anthology (see entry 015).

017 Carnegie Institute. Museum of Art. *Forerunners of American Abstraction: Painters; Charles Demuth, Arthur G. Dove, John Marin, Georgia O'Keeffe, Charles Sheeler, Joseph Stella; Sculptors; John B. Flannagan, John Storrs*. Pittsburgh: Museum of Art, Carnegie Institute, [1971].

Catalogue of an exhibition held at the Museum of Art, Carnegie Institute, Pittsburgh, 18 November 1971–9 January 1972, which includes twenty works by Dove and sixteen by Marin (each has five works illustrated).

018 Cassidy, Donna M. *Painting the Musical City: Jazz and Cultural Identity in American Art, 1910–1940.* Washington, D.C.: Smithsonian Institution Press, 1997.

In Chapter 1, "Dynamism, Motion, Speed: John Marin and the 'Great Music' of the City," Cassidy explores Marin's lifelong interest in music and the ways in which the abstract and emotive dynamism and rhythm of his New York etchings and watercolors are an expression of a musical language, or "great music," to use his phrase. Cassidy feels that music was an important way for Marin to find his cultural identity as an American artist because it allowed him to focus on indigenous art forms and subjects. In this chapter she also briefly touches on Weber's interest in the fourth dimension. In Chapter 3, "Jazz Paintings and National Identity: The Abstract Art of Arthur Dove and Stuart Davis," Cassidy discusses Dove's jazz paintings as an expression of cultural nationalism as well as an attempt by the artist to create abstract visual equivalents of music. She also discusses Dove's interest in phonograph, radio, and film music.

019 *Catalogue for a Loan Exhibition from the Edith Gregor Halpert Collection.* [S.l.: s.n., 1963.]

Catalogue of an exhibition held at the Santa Barbara Museum of Art, Santa Barbara, California, 6 August–15 September 1963. The exhibition featured works from the collection of Edith Gregor Halpert (founder of the Downtown Gallery), including four by Dove, three by Hartley, eight by Marin, and five by Weber. Introduction by James W. Foster, Jr.

020 Cincinnati Art Museum. *An American Show: The Cincinnati Art Museum Presents a Selection of Paintings by Six Living American Artists: Louis Bouché, Edward Hopper, Walt Kuhn, Yasuo Kuniyoshi, John Marin, Max Weber.* Cincinnati, Ohio: The Museum, 1948.

Catalogue of an exhibition held at the Cincinnati Art Museum, 11 October–30 November 1948, which includes twenty-two works by Marin and fifteen by Weber (each has two works illustrated in black and white). The catalogue contains a foreword by Philip Rhys Adams, an introduction by Robert Morris Coffin, and biographical notes on the artists.

021 Clark-Langager, Sarah A. *Order and Enigma: American Art between the Two Wars.* Utica, N.Y.: Museum of Art, Munson-Williams-Proctor Institute, 1984.

Catalogue of an exhibition held at the Museum of Art, Munson-Williams-Proctor Institute, Utica, New York, 13 October–2 December 1984, which includes one work each by Dove and Marin. Essay by Sarah A. Clark-Langager.

022 Coke, Van Deren. *Taos and Santa Fe: The Artist's Environment, 1882–1942.* [Albuquerque]: Published by the University of New Mexico Press for the

Amon Carter Museum of Western Art, Ft. Worth, Texas, and the Art Gallery, University of New Mexico, Albuquerque, [1963].

Catalogue of an exhibition sponsored by the Amon Carter Museum of Western Art and the Art Gallery of the University of New Mexico, which includes two works by Hartley and three by Marin. Coke reviews the artistic activities of Hartley (pp. 49–52) and Marin (pp. 86–89) in New Mexico. The book contains a checklist of the exhibition; a chronology; biographical notes on the artists; and a selected bibliography.

022A Connor, Celeste. *Democratic Vistas: Art and Theory of the Stieglitz Circle, 1924–1934*. Berkeley: University of California Press, 2001.

Connor closely examines a wide body of critical and theoretical literature in her analysis of the social and cultural context in which the Stieglitz Circle attempted to forge a truly democratic art, focusing in particular on the influence of Walt Whitman. She also provides discussions of contemporary critics, including Paul Rosenfeld and Waldo Frank. The final chapter takes a close look at the significance of New Mexico in the life and work of the Stieglitz Circle artists.

023 Corcoran Gallery of Art. *The Edith Gregor Halpert Collection*. [Washington, D.C.]: The Gallery, 1962.

Catalogue of an exhibition held at the Corcoran Gallery of Art, Washington, D.C., 28 September–11 November 1962. The exhibition featured works from the collection of Edith Gregor Halpert (founder of the Downtown Gallery), including six by Dove, four by Hartley, thirteen by Marin, and six by Weber. Foreword by George E. Hamilton, Jr.

024 Cork, Richard. *A Bitter Truth: Avant-Garde Art and the Great War*. New Haven, Conn.: Yale University Press, in association with the Barbican Art Gallery, London, England, 1994.

Cork discusses two of Hartley's paintings, *Painting No. 48, Berlin* of 1913 (pp. 22–23, 25) and *Portrait of a German Officer* of 1914 (pp. 91–92), and Weber's black-and-white lithograph *Der Krieg* of 1918 (pp. 192–193).

025 Craven, Thomas. *Modern Art: The Men, the Movements, the Meaning*. New York: Simon and Schuster, 1934.

In Chapter 16, "The New Gospel," Craven offers an assessment of Stieglitz's contribution to modern art; in Chapter 17, "Practising Americans," he briefly discusses Marin, whom he says "lacks the one essential quality of great genius—the power of self-discipline."

026 Crunden, Robert M. *American Salons: Encounters with European Modernism, 1885–1917*. New York: Oxford University Press, 1993.

In Book IV, "Paris: Where the Stein Families Provided Salons for Visiting Americans," Crunden provides details of the artistic and social activities of Hartley and Weber in Paris. In Book V, Chapter 1, "The Salons of New York: Alfred Stieglitz," he discusses Dove's early career.

027 Davidson, Abraham A. *Early American Modernist Painting, 1910–1935.* New York: Harper and Row, 1981.

In Chapter 1, "The Stieglitz Group," Davidson provides a brief history of Stieglitz's activities prior to 1917 and includes discussions of Dove, Hartley, Marin, and Weber.

028 Delaware Art Museum. *Avant-Garde Painting and Sculpture in America, 1910–1925.* Wilmington: The Museum, [1975].

Catalogue of an exhibition held at the Delaware Art Museum, Wilmington, 4 April–18 May 1975, which includes biographical essays on Dove by Susan E. Strickler (pp. 66–69); Hartley (pp. 80–83) and Marin (pp. 94–97) by Patrick L. Stewart, Jr.; and Weber by Priscilla Siegel (pp. 144–147).

029 Dijkstra, Bram. *The Hieroglyphics of a New Speech: Cubism, Stieglitz, and the Early Poetry of William Carlos Williams.* Princeton, N.J.: Princeton University Press, 1969.

In Chapter 3, "Stieglitz," Dijkstra discusses the relationship between William Carlos Williams and the Stieglitz Circle and points out the importance of concrete objects in the real world for both Stieglitz and Williams. In Chapter 4, "The Evangelists of the American Movement," he presents a lengthy discussion of Paul Rosenfeld's critical assessments of the Stieglitz Circle, focusing in particular on Hartley. In Chapter 6, "The Hieroglyphics of a New Speech," Dijkstra outlines what he sees as the common threads running through the work of Hartley (pp. 150–151), Dove (pp. 151–152), and Marin (pp. 157–159).

030 Dreier, Katherine. *Modern Art.* New York: Société Anonyme, 1926.

Dreier, a founder and president of Société Anonyme, provides brief biographical sketches of Stieglitz (pp. 89–90); Marin (p. 92); Dove (p. 93); Hartley (p. 94); and Weber (p. 95); each is accompanied by a photograph and a reproduction of one work.

031 *Eight American Masters of Watercolor: Winslow Homer, John Singer Sargent, Maurice B. Prendergast, John Marin, Arthur G. Dove, Charles Demuth, Charles E. Burchfield, Andrew Wyeth.* New York: Praeger, [1968].

Catalogue of an exhibition held at the Los Angeles County Museum of Art, Los Angeles, 23 April–16 June 1968, which includes twelve works by Dove and seventeen by Marin (both have eight works illustrated). Larry Curry provides brief discussions of their careers.

032 Eldredge, Charles C., Julie Schimmel, and William H. Truettner. *Art in New Mexico, 1900–1945: Paths to Taos and Santa Fe*. Washington, D.C.: National Museum of American Art, Smithsonian Institution; New York: Abbeville Press, [1986].

This book was published to coincide with an exhibition held at the National Museum of American Art, Smithsonian Institution, Washington, D.C., 7 March–15 June 1986. In her essay "The Hispanic Southwest," Schimmel briefly discusses Hartley's treatment of Hispanic religious artifacts (pp. 127–131). In his essay "The Faraway Nearby: New Mexico and the Modern Landscape," Eldredge explores the ways in which Hartley (pp. 153–156) and Marin (pp. 168–173) depicted the New Mexico landscape. The book contains brief biographies and a chronology.

033 Everett, Patricia C. *A History of Having a Great Many Times Not Continued to Be Friends: The Correspondence between Mabel Dodge and Gertrude Stein*. Albuquerque: University of New Mexico Press, 1996.

This collection of the complete and unedited correspondence between Mabel Dodge Luhan (née Mabel Dodge) and Gertrude Stein during the years 1911 to 1934 contains material pertaining to Hartley and, to a lesser extent, Weber.

033A *The Eye of Duncan Phillips: A Collection in the Making*, edited by Erika D. Passantino. Washington, D.C.: Phillips Collection, in association with Yale University Press, New Haven, Conn., 1999.

This massive history and illustrated catalogue of the Phillips Collection, Washington, D.C., contains sections on Stieglitz (pp. 378–379), Marin (pp. 380–388), and Weber (pp. 409–411), authored by Leigh Bullard Weisblat; and Dove (pp. 398–406) and Hartley (pp. 389–393), authored by Grayson Harris Lane.

034 *The Forum Exhibition of Modern American Painters*. New York: M. Kennerley, 1916.

Catalogue of an important early exhibition of American modernism that was sponsored by Willard Huntington Wright and held at the Anderson Galleries, New York, 13–25 March 1916. The exhibition included sixteen works by Dove, nine by Hartley, and fourteen by Marin. Each artist has one painting reproduced in black and white, accompanied by a statement of his aesthetic philosophy. The catalogue also contains Wright's essay "What Is Modern Painting?" in addition to six separate forewords authored by Christian Brinton, Robert Henri, W.H. de B. Nelson, Alfred Stieglitz, John Weichsel, and Wright.

035 Frank, Robin Jaffee. *Charles Demuth: Poster Portraits 1923–1929*. New Haven, Conn.: Yale University Art Gallery, 1994.

Catalogue of an exhibition held at the Yale University Art Gallery, New Haven, Connecticut, 17 September 1994–8 January 1995. Frank discusses De-

muth's poster portraits of Hartley (pp. 15–22); Dove (pp. 32–41); and Marin (pp. 48–53).

036 Geldzahler, Henry. *American Painting in the Twentieth Century*. New York: Metropolitan Museum of Art; Greenwich, Conn.: Distributed by New York Graphic Society, 1965.

In Chapter 2, "The First Wave of Modernism," Geldzahler discusses Dove (pp. 52–57); Hartley (pp. 57–62); and Marin (pp. 62–67), chiefly in terms of their works in the Alfred Stieglitz Collection of the Metropolitan Museum of Art.

036A Greenough, Sarah. *Modern Art and America: Alfred Stieglitz and His New York Galleries*. Washington, D.C.: National Gallery of Art; Boston: Bulfinch Press, 2000.

Catalogue of an exhibition held at the National Gallery of Art, Washington, D.C., 28 January–22 April 2001. Twenty-three extensively documented essays cover all aspects of Stieglitz's galleries and the artists whom he championed, with two essays on Hartley and one each on Dove and Marin. Three hundred sixty works are illustrated, many in color. The catalogue includes a checklist of the exhibition, a chronology of exhibitions presented by Stieglitz, and a bibliography.

037 Hirschl and Adler Galleries. *The Eye of Stieglitz*. New York: The Galleries, 1978.

Catalogue of an exhibition held at the Hirschl and Adler Galleries, New York, 7 October–2 November 1978, which includes eleven works by Dove, three by Hartley, eight by Marin, and two by Weber (all are illustrated). Essay by Richard T. York.

038 Homer, William Innes. *Alfred Stieglitz and the American Avant-Garde*. Boston: New York Graphic Society, 1977.

This was the first monograph on the Stieglitz Circle. Homer outlines the cultural and intellectual climate at the time that the Photo-Secession was founded in 1902; provides details on the operations and exhibitions of the Photo-Secession Galleries from 1905 to 1917; discusses the early life and work of the Stieglitz Circle artists and photographers; and offers a critical assessment of Stieglitz's contributions to modern art and photography in America. The book contains 135 black-and-white illustrations; a complete list of exhibitions held at the Photo-Secession Galleries; a chronology; and a bibliography.

039 Hough, Katherine Plake and Michael Zakian. *Transforming the Western Image in 20th Century American Art*. Palm Springs, Calif.: Palm Springs Desert Museum, 1992.

Catalogue of an exhibition held at the Palm Springs Desert Museum, Palm Springs, California, 21 February–26 April 1992, which includes two works by Hartley and three by Marin (all are illustrated in color).

040 Joslyn Art Museum. *The Thirties Decade: American Artists and Their European Contemporaries.* Omaha, Nebr.: The Museum, [1971].
Catalogue of an exhibition held at the Joslyn Art Museum, Omaha, Nebraska, 10 October–28 November 1971, which includes one work by Dove, four by Hartley, and two each by Marin and Weber. Essay by Allen Porter.

041 La Jolla Museum of Art. *Marsden Hartley, John Marin.* [La Jolla, Calif.: The Museum, 1966.]
Catalogue of an exhibition held at the La Jolla Museum of Art, La Jolla, California, 12 February–27 March 1966, which includes thirty-three works by Hartley and forty-two by Marin. Forty-one works are illustrated in black and white. Essays by Donald Brewer (on Hartley) and Sheldon Reich (on Marin).

042 Leavens, Ileana B. *From "291" to Zurich: The Birth of Dada.* Ann Arbor, Mich.: UMI Research Press, 1983.
Leavens contends that Dadaism in New York began at the Photo-Secession Galleries and subsequently had an influence on the movement comparable to that of the Cabaret Voltaire in Zurich. She presents a detailed analysis of the various European influences, both artistic and philosophical, on Stieglitz's aesthetics. She also discusses the ways in which the artistic milieu surrounding both the Photo-Secession Galleries and Stieglitz's publications *Camera Work* and *291* influenced Dadaism in Europe. Of particular interest are the chapter subsections on Hartley: "Marsden Hartley and Hugo Ball" (pp. 28–30); "Marsden Hartley and Jean Arp" (p. 31); and "Marsden Hartley and Germany" (pp. 110–111).

043 Levin, Gail and Marianne Lorenz. *Theme and Improvisation: Kandinsky and the American Avant-Garde, 1912–1950.* Boston: Bulfinch Press, 1992.
Catalogue of an exhibition organized by the Dayton Art Institute, Dayton, Ohio, and shown at four different venues between 19 September 1992 and 1 August 1993. The exhibition included three works by Dove and two by Hartley. Levin briefly discusses Wassily Kandinsky's influence on Dove in her essay "Kandinsky and the American Avant-Garde." In "Marsden Hartley, Albert Bloch, and Kandinsky in Europe," Levin recounts Hartley's interest in Kandinsky's *Der Blaue Reiter* almanac and his treatise *Über das Geistige in der Kunst*, as well as his meeting with the Russian artist in Germany. Although Kandinsky reinforced Hartley's interest in conveying his mystical inner life (or "spiritual enthusiasm," to use his words) through abstract compositions, he later attempted to downplay this influence and asserted that he "did not slide down the Kandinsky kaleidoscope."

044 Los Angeles County Museum of Art. *The Spiritual in Art: Abstract Painting, 1890–1985*. Los Angeles: The Museum; New York: Abbeville Press, 1986.

Catalogue of an exhibition held at the Los Angeles County Museum of Art, Los Angeles, 23 November 1986–8 March 1987. The exhibition included seven works by Dove and four by Hartley. In his essay "Nature Symbolized: American Painting from Ryder to Hartley," Charles Eldredge discusses the mystical and spiritual overtones of the abstractions of Dove and Hartley, as well as their distinctly American expressions of Symbolist ideals. In her essay "Mysticism, Romanticism, and the Fourth Dimension," Linda Dalrymple Henderson explores Weber's theory of the fourth dimension.

045 Lowe, Sue Davidson. *Alfred Stieglitz: A Memoir/Biography*. New York: Farrar, Straus, and Giroux, 1983.

Lowe, a grandniece of Stieglitz, provides valuable background on the founding and operation of Stieglitz's galleries. She also discusses his relationships—both personal and professional—with Dove, Hartley, Marin, and Weber. The book includes a bibliography; a chronology; a Stieglitz family tree; an index to *Camera Work*; and a list of exhibitions arranged by Stieglitz (1902–1946).

046 Mellquist, Jerome. *The Emergence of an American Art*. New York: Charles Scribner's Sons, 1942.

Mellquist discusses Stieglitz and 291 (pp. 184–212); Dove (pp. 362–366); Hartley (pp. 356–361); Marin (pp. 384–402); and Weber (pp. 254–262).

047 Milwaukee Art Center. *10 Americans: Davis, Demuth, Dove, Feininger, Graves, Marin, O'Keeffe, Shahn, Tobey, Weber*. Milwaukee: The Center, 1961.

Catalogue of an exhibition held at the Milwaukee Art Center, Milwaukee, 21 September–5 November 1961. Introduction by Edward H. Dwight.

048 Museum of Fine Arts, Boston. *Ten American Watercolor Painters*. Boston: The Museum, 1939.

Catalogue of an exhibition held at the Museum of Fine Arts, Boston, 15 April–7 May 1939, which includes eight works each by Dove and Marin (none are illustrated).

049 Nasgaard, Roald. *The Mystic North: Symbolist Landscape Painting in Northern Europe and North America, 1890–1940*. Toronto: University of Toronto Press, in association with the Art Gallery of Ontario, 1984.

This book was published to coincide with an exhibition held at the Art Gallery of Ontario, Toronto, Ontario, Canada, 13 January–11 March 1984. In Chapter 10, Nasgaard presents Dove and Hartley as two of the major proponents of the northern Symbolist landscape tradition, emphasizing their common belief in the immanence of subjective and spiritual truth in nature.

050 National Collection of Fine Arts (U.S.) *Roots of Abstract Art in America, 1910–1930*. Washington, D.C.: Published for the Collection by the Smithsonian Institution Press, 1965.

 Catalogue of an exhibition held at the National Collection of Fine Arts, Washington, D.C., 2 December 1965–9 January 1966, which includes twenty-six works by Dove, eleven by Hartley, and nineteen by Marin. Introduction by Adelyn D. Breeskin.

051 Newark Museum. *A Museum in Action: Presenting the Museum's Activities—Catalogue of an Exhibition of American Painting and Sculpture from the Museum's Collections with an Introduction by Holger Cahill*. Newark, N.J.: The Museum, 1944.

 Catalogue of an exhibition held at the Newark Museum, Newark, New Jersey, 31 October 1944–31 January 1945, which includes works by Hartley, Marin, and Weber. The catalogue contains statements by Hartley on *Mt. Ktaadn, First Snow No. 2* of 1939–1940; Marin on *Fir Tree, Deer Isle, Maine* of 1926; and Weber on *Landscape* of ca. 1928. Essay by Holger Cahill.

052 Niven, Penelope. *Steichen*. New York: Clarkson Potter, 1997.

 The photographer Edward Steichen was an early member of the Stieglitz Circle and a founder and council member of the Photo-Secession. Niven provides background on his relationships with Marin (pp. 262–264, 293–294) and Weber (pp. 338–341).

053 Norman, Dorothy. *Alfred Stieglitz: An American Seer*. New York: Random House, 1973.

 Norman provides several discussions of Stieglitz's relationships with Hartley and Marin; material relating to Dove and Weber is less extensive. The book also contains extracts from Norman's notebooks and Stieglitz's writings; a detailed chronology; an exhibition list; and a bibliography.

054 Olson, Arlene R. *Art Critics and the Avant-Garde: New York, 1900–1913*. Ann Arbor, Mich.: UMI Research Press, 1980.

 Olson focuses on three leading New York art critics: Royal Cortissoz of the *New York Tribune*; James Gibbons Huneker of the *New York Sun*; and Elizabeth Luther Cary of the *New York Times*. She includes excerpts from their reviews of early exhibitions of Dove (p. 67); Hartley (pp. 51, 66–67); Marin (pp. 33, 50–51, 56, 71); and Weber (pp. 50–51, 72–73).

055 Owen Gallery. *American Modern*. New York: The Gallery, 1996.

 Catalogue of an exhibition held at the Owen Gallery, New York, 1 May–15 June 1996. The exhibition featured works exhibited in Edith Gregor Halpert's Downtown Gallery, including two each by Hartley and Marin and one by Weber.

Two are illustrated in color: Weber's charcoal *Nudes* of 1911 and Hartley's *Still Life with Fruit* of 1929. The catalogue contains a foreword by Michael Owen; Alice Sinkoff's "Edith Gregor Halpert and the Downtown Gallery: A Remembrance"; and a checklist of the exhibition.

056 Pearson, Ralph M. *The Modern Renaissance in American Art: Presenting the Work and Philosophy of 54 Distinguished Artists.* New York: Harper and Brothers, 1954.
 Pearson presents critical assessments of Marin (pp. 51–56) and Weber (pp. 33–41).

057 Pennsylvania Academy of the Fine Arts. *In This Academy: The Pennsylvania Academy of the Fine Arts, 1805–1976—A Special Bicentennial Exhibition.* [Philadelphia]: The Academy, 1976.
 Catalogue of an exhibition held at the Pennsylvania Academy of the Fine Arts, Philadelphia, which includes two works each by Marin and Weber and one each by Dove and Hartley. These works are discussed by Carolyn Diskant in her essay "Modernism at the Pennsylvania Academy, 1910–1940" (pp. 205–228).

058 Philadelphia Museum of Art. *History of an American: Alfred Stieglitz, "291" and After; Selections from the Stieglitz Collection at the Philadelphia Museum of Art* [cover title]. [S.l.: s.n., 1944].
 Catalogue of an exhibition held at the Philadelphia Museum of Art, Philadelphia, 1 July–1 November 1944, which includes nineteen works by Dove, thirteen by Hartley, eighteen by Marin (plus sixty-one etchings), and two by Weber (none are illustrated). Foreword by Henry Clifford and Carl Zigrosser. A similar exhibition was held at the Taft Museum, Cincinnati, Ohio, 31 January–18 March 1951, under the title *History of an American: Alfred Stieglitz: "291" and After; Selections from the Artists Shown by Him from 1900 to 1925 on Exhibition at the Taft Museum, Cincinnati.*

059 Phillips, Marjorie. *Duncan Phillips and His Collection.* Rev. ed. New York: W.W. Norton, in association with the Phillips Collection, Washington, D.C., 1982.
 Duncan Phillips was the founder of the Phillips Memorial Gallery in 1918 (later renamed the Phillips Collection) and an important early patron of Dove. In Chapter 6, "Dove, Stieglitz, and Marin," Phillips' widow, Marjorie, recounts his acquisition of works by Dove and Marin from Stieglitz and reprints a number of items of correspondence between Phillips and the two artists. The appendix lists the principal acquisitions of the Phillips Collection between 1916 and 1972, including works by Dove, Hartley, Marin, and Weber.

060 Photo-Secession Galleries. *Younger American Painters: Brinley, Carles, Dove, Fellowes, Hartley, Marin, Maurer, Steichen, Weber.* New York: The Galleries, 1910.
 Catalogue of an exhibition held at the Photo-Secession Galleries, New York, 9–21 March 1910.

061 Pisano, Ronald G. *An American Place.* Southampton, N.Y.: Parrish Art Museum, 1981.
 Catalogue of an exhibition held at the Parrish Art Museum, Southampton, New York, 24 May–19 July 1981. The exhibition featured a representative group of paintings and photographs that were shown between 1929 and 1946 at An American Place, including seventeen works by Dove, nine by Hartley, and eight by Marin (each has three works illustrated). The catalogue contains a foreword by Dorothy Norman; an introduction and artist biographies by Ronald G. Pisano; a checklist of the exhibition; a bibliography; and an exhibition list for An American Place.

062 _____. *The Long Island Landscape 1914–1946: The Transitional Years.* Southampton, N.Y.: Parrish Art Museum, 1982.
 Catalogue of an exhibition held at the Parrish Art Museum, Southampton, New York, 13 June–1 August 1982, which includes twelve landscapes by Dove, two by Marin, and one by Weber. The catalogue contains an essay by Pisano and a chronology by Christine E. Bergman.

063 Platt, Susan Noyes. *Modernism in the 1920s: Interpretations of Modern Art in New York from Expressionism to Constructivism.* Ann Arbor, Mich.: UMI Research Press, 1985.
 Noyes' survey of modernism in New York during the 1920s, which focuses on its reception by critics, dealers, collectors, and artists of the period, contains the following chapter subsections: "Alfred Stieglitz" (pp. 12–16); "Stieglitz Circle Critics" (pp. 45–46); and "The Stieglitz Artists" (pp. 47–58).

064 Pomona College Galleries. *Stieglitz Circle: Demuth, Dove, Hartley, Marin, O'Keeffe, Weber.* Claremont, Calif.: The Galleries, 1958.
 Catalogue of an exhibition held at the Pomona College Galleries, Claremont, California, 11 October–15 November 1958. The exhibition included eleven works by Dove and nine each by Hartley, Marin, and Weber. The catalogue contains a foreword by Peter Selz; an essay by Frederick S. Wight; excerpts from a letter that Weber wrote to Selz (July 1958); and a chronology.

065 Queens County Art and Cultural Center. *The New Society of American Artists in Paris, 1908–1912.* Flushing, N.Y.: The Center, 1986.
 Catalogue of an exhibition held at the Queens Museum, Flushing, New York, 1 February–6 April 1986, which includes twelve works each by Marin and

Weber. The essays by D. Scott Atkinson and William Innes Homer examine the background and significance of the society.

066 Reeve, Kay Aiken. *Santa Fe and Taos, 1882–1942: An American Cultural Center*. (Southwestern Studies Monograph, No. 67.) El Paso: Texas Western Press, University of Texas at El Paso, 1982.

 Reeve discusses the development of the Taos–Santa Fe region as an artistic and cultural center during the first half of the twentieth century, including the influence of Pueblo and Hispanic cultures.

067 Robertson, Bruce. *Reckoning with Winslow Homer: His Late Paintings and Their Influence*. Cleveland, Ohio: Cleveland Museum of Art, in cooperation with the University of Indiana Press, Bloomington, 1990.

 In Chapter 7, "After the Armory Show: John Sloan, Newell Convers Wyeth, John Marin, and Marsden Hartley," Robertson concludes that Marin lacked Homer's gravity and somber realism and that Hartley's treatment of Homer's theme of crashing waves on the rocky shore was harder and more tragic.

068 Rudnick, Lois Palken. *Utopian Vistas: The Mabel Dodge Luhan House and the American Counterculture*. Albuquerque: University of New Mexico Press, 1996.

 In Chapter 2, "Visitors, 1918–1929," Rudnick discusses Hartley (pp. 80–86) and Marin (pp. 127–131) in terms of their artistic activities in Taos, New Mexico.

069 Rushing, William J. *Native American Art and the New York Avant-Garde, a History of Cultural Primitivism*. Austin: University of Texas Press, 1995.

 Rushing explores the influence of Native American culture on the works of Hartley (pp. 34–39, 55–58); Weber (pp. 43–49); and Marin (pp. 74–79).

070 Santa Fe Galleries. *Important American Painters: Charles Burchfield, Charles Demuth, Arthur Dove, Marsden Hartley, John Marin*. Santa Fe, N.M.: The Galleries, 1980.

 Catalogue of the inaugural exhibition of the Santa Fe East Galleries, Santa Fe, New Mexico, December 1980, which includes two works by Dove, four by Hartley, and seven by Marin.

071 Schleier, Merrill. *The Skyscraper in American Art, 1890–1931*. Ann Arbor, Mich.: UMI Research Press, 1986.

 In Chapter 3, "Alfred Stieglitz, Modernism in America, and a New View of the Skyscraper, 1890–1917," Schleier discusses Stieglitz's enthusiasm for the skyscrapers of New York City, in particular the Flatiron, Singer, and Woolworth Buildings. She also analyzes the skyscraper motif in the works of Marin (pp. 55–57) and Weber (pp. 57–61).

072 Seligmann, Herbert J. *Alfred Stieglitz: Notes on Some of His Conversations, 1925–1931, with a Foreword*. New Haven, Conn.: Yale University Library, 1966.

Seligmann's transcribed notes of his conversations with Stieglitz between 1925 and 1931 include numerous references to Dove, Marin, and, to a lesser extent, Hartley.

073 Société Anonyme. *Catalogue of an International Exhibition of Modern Art: Assembled by Société Anonyme*. [S.l.: s.n., 1926.]

Catalogue of an exhibition sponsored by Société Anonyme and held at the Brooklyn Museum, Brooklyn, New York, 19 November 1926–9 January 1927. The exhibition included three works each by Dove, Hartley, and Weber and four by Marin. More detailed information on this major international exhibition of modern art and the individual works that these artists exhibited can be found in Ruth L. Bohan's *The Société Anonyme's Brooklyn Exhibition: Katherine Dreier and Modernism in America* (Ann Arbor, Mich.: UMI Research Press, 1982), which contains a "Checklist of the Exhibition" as an appendix.

074 Southern Alleghenies Museum of Art. *American Masters of Watercolor: A 100 Year Survey*. Loretto, Pa.: The Museum, 1995.

Catalogue of an exhibition held at the Southern Alleghenies Museum of Art, Loretto, Pennsylvania, 17 June–10 September 1995, which includes one work by Weber, two by Marin, and three by Dove (none are illustrated). Introduction by Michael A. Tomor.

075 Städtische Kunsthalle Düsseldorf. *2 Jahrzehnte amerikanische Malerei 1920–1940*. Düsseldorf: Städtische Kunsthalle Düsseldorf, 1979.

Catalogue of an exhibition held at the Städtische Kunsthalle Düsseldorf, West Germany, 10 June–12 August 1979, which includes fourteen works by Marin and sixteen each by Dove and Hartley. Included are essays on Marin by Merrill Schleier and on Dove and Hartley by Peter Selz (text in German). Hartley and Marin each has five works illustrated, and Dove has eight.

076 Stavitsky, Gail. *Gertrude Stein: The American Connection*. New York: Sid Deutsch Gallery, 1990.

Catalogue of an exhibition held at the Sid Deutsch Gallery, New York, 3 November–8 December 1990, which includes two works by Hartley and four by Weber. Stavitsky's essay focuses on the American artists who frequented the legendary Paris salon of Gertrude and Leo Stein from 1904 to 1913 and includes discussions of Hartley and Weber. The catalogue contains the text of Stein's "Marsden Hartley," based on the original typescript in the Collection of American Literature, Beinecke Rare Book and Manuscript Library, Yale University; and Djuna Barnes' "Caricatures of Gertrude Stein and Marsden Hartley," reproduced from the 4 November 1923 issue of the *New York Tribune*.

077 Tashjian, Dickran. *Skyscraper Primitives: Dada and the American Avant-Garde, 1910–1925*. Middletown, Conn.: Wesleyan University Press, 1975.

Dada artists living in New York between 1910 and 1925, particularly Marcel Duchamp and Francis Picabia, exerted a wide-ranging influence on many avant-garde American poets, painters, and photographers. Tashjian's cultural history provides a detailed examination of these influences and interactions. In Chapter 3, "Marcel Duchamp and Man Ray," Tashjian points out the importance of Dada to Hartley's aesthetic development (pp. 60–62). Chapter 9, "The Art of Assemblage," contains a discussion of Dove's assemblages and portrait-collages (pp. 198–202).

078 _____. *William Carlos Williams and the American Scene, 1920–1940*. New York: Whitney Museum of American Art, in association with the University of California Press, Berkeley, 1978.

This book was published in conjunction with an exhibition held at the Whitney Museum of American Art, New York, 12 December 1978–4 February 1979. Tashjian chronicles Williams' association with various avant-garde American artists and photographers in addition to exploring the poet's aesthetic theories. Of particular relevance to the Stieglitz Circle are the chapters "Hartley and Contact with the West" (pp. 49–54) and "An American Place" (pp. 90–98).

079 Turner, Elizabeth Hutton. *In the American Grain: Arthur Dove, Marsden Hartley, John Marin, Georgia O'Keeffe, and Alfred Stieglitz—The Stieglitz Circle at the Phillips Collection*. Washington D.C.: Counterpoint, in association with the Phillips Collection, 1995.

Catalogue of an exhibition held at the Phillips Collection, Washington, D.C., 23 September–31 December 1995. The exhibition featured photographs by Stieglitz and works by four members of the Stieglitz Circle, including thirty-four by Dove, nine by Hartley, and twenty-three by Marin (all are illustrated). In her essay, Turner recounts Duncan Phillips' acquisition of many of these works from Stieglitz, with an extended discussion of his purchase of *Back of Bear Mountain*, the so-called $6,000 Marin. The book also includes sixty-two pages of selected correspondence between Phillips and Stieglitz, a chronology, and a checklist of the exhibition.

080 *291: No. 1–12: 1915–1916*. New York: Arno Press, 1972.

A reprint of the twelve issues of Stieglitz's periodical *291* (No. 1, March 1915 through No. 12, February 1916), with the illustrations reproduced in color (including Marin's cover for No. 4, June 1915). Introduction by Dorothy Norman.

081 Udall, Sharyn Rohlfsen. *Modernist Painting in New Mexico 1913–1935*. Albuquerque: University of New Mexico Press, 1984.

Udall presents extended discussions of the artistic activities of Hartley (Chapter 3) and Marin (Chapter 7) in New Mexico.

082 Underwood, Sandra Lee. *Charles H. Caffin: A Voice for Modernism, 1898–1918*. Ann Arbor, Mich.: UMI Research Press, 1983.

Charles H. Caffin was a leading American critic of early modernist art and photography. Underwood details Caffin's close relationship with Stieglitz in Chapter 6, "Associations with '291.' " Appendix V indexes Caffin's reviews for the *New York American*, which includes citations for exhibitions of Hartley, Marin, and Weber.

083 University of Connecticut. Museum of Art. *Edith Gregor Halpert and the Downtown Gallery*. [Storrs]: The Museum, 1968.

Catalogue of an exhibition staged as a tribute to Edith Gregor Halpert at the Museum of Art, University of Connecticut, Storrs, November 1968. The exhibition featured works of artists who exhibited at the Downtown Gallery, including three each by Dove, Hartley, Marin, and Weber. Biographical notes on the artists are provided. Essay by Marvin S. Sedik.

084 University of Iowa. Department of Art. New Gallery. *Vintage Moderns: American Pioneer Artists—1903–1932, Plus 4 Related Photographers*. Iowa City, Iowa: The Gallery, [1962].

Catalogue of an exhibition held at the New Gallery, Department of Art, University of Iowa, Iowa City, 24 May–2 August 1962. The exhibition focused primarily on artists and photographers of the Stieglitz Circle, including seven works by Dove, five by Hartley, eleven by Marin, and twelve by Weber. The catalogue contains an essay by Frank Seiberling and a checklist of the exhibition, accompanied by biographical sketches of the artists.

085 University of Maryland. Art Department and Art Gallery. *Retrospective for a Critic: Duncan Phillips; An Exhibition of Paintings, Sculpture and Watercolors from the Phillips Collection Relating to the Critical Writings of Duncan Phillips*. College Park: University of Maryland Art Department and Art Gallery, J. Millard Tawes Fine Arts Center, 1969.

Catalogue of an exhibition held at the Art Gallery, University of Maryland, College Park, 12 February–16 March 1969, which includes one work each by Dove, Hartley, and Marin. In her essay, Beth Holmes discusses Phillips' aesthetic philosophy and his contributions to art criticism and museology. The catalogue contains a "Bibliography of the Published Writings of Duncan Phillips"; a selected bibliography; a preface by George Levitine; an introduction by William Gerdts; and a foreword by Senator J.W. Fulbright.

086 University of Minnesota. University Art Museum. *Early Modernism in America: The Stieglitz Circle—Arthur Dove, Marsden Hartley, John Marin, Georgia O'Keeffe, Abraham Walkowitz, Max Weber*. Minneapolis: The Museum, 1983.

Catalogue of an exhibition held at the University Art Museum, University of Minnesota, Minneapolis, 18 July–21 August 1983. The exhibition included

seven works by Dove, four by Hartley, five by Marin, and six by Weber. The catalogue contains a foreword by Lyndel King; an essay and biographical sketches of the artists by Margaret Wolff; a checklist of the exhibition; and a selected bibliography.

087 University of Minnesota. University Gallery. *40 American Painters*. [Minneapolis: The Gallery, 1951.]
Catalogue of an exhibition held at the University Gallery, University of Minnesota, Minneapolis, 4 June–30 August 1951, which includes two works each by Marin and Weber. The catalogue contains statements by Marin (dated May 1951) and Weber (dated 1948).

088 _____. *5 Painters*. [Minneapolis: The Gallery, 1930.]
Catalogue of an exhibition held at the University Gallery, University of Minnesota, Minneapolis, which includes ten works each by Dove, Hartley, and Marin. Foreword and catalogue notes by Ruth Lawrence.

089 _____. *Hudson D. Walker: Patron and Friend, Collector of Twentieth-Century American Art*. Minneapolis: The Gallery, 1977.
Catalogue of an exhibition held at the University Gallery, University of Minnesota, Minneapolis, 9 October–6 December 1977. Hudson Dean Walker—dealer, museum curator, patron, and connoisseur of twentieth-century American art—donated his collection to the University of Minnesota. Walker's collection contained the largest private holding of Hartley's works, and twenty-nine examples were included in the exhibition (two are illustrated), along with one work by Dove and two by Weber. Foreword and catalogue notes by Percy North; preface by Lyndell King. See also entries 485, 511, and 512.

090 University of New Mexico. Art Museum. *Cubism: Its Impact in the USA, 1910–1930*. Albuquerque: The Museum, [1967].
Catalogue of a 1967 exhibition held at the Art Museum of the University of New Mexico, Albuquerque, which includes four works each by Hartley and Marin and three by Weber (whose *Conversation* of 1919 is featured as the color frontispiece). Essay by Clinton Adams.

091 Vassar College. Art Gallery. *The Stieglitz Circle: Bluemner, Dove, Hartley, Marin, Maurer, O'Keeffe, Weber*. Poughkeepsie, N.Y.: The Gallery, 1972.
Catalogue of an exhibition held at the Vassar College Art Gallery, Poughkeepsie, New York, 2–20 December 1972. The exhibition featured five works by Dove, three by Hartley, twenty by Marin, and two by Weber, all from the museum's collection. The catalogue contains an introduction, biographical essays on the artists, notes on the individual works, and a selected bibliography.

092 Washburn Gallery. *From the Intimate Gallery, Room 303, Anderson Galleries Building, 489 Park Avenue at Fifty-ninth Street, New York* [cover title]. New York: The Gallery, 1978.

Catalogue of an exhibition held at the Washburn Gallery, New York, 4–28 October 1978. All paintings and photographs in the exhibition were originally shown by Stieglitz at the Intimate Gallery between 1925 and 1929, including one each by Dove, Hartley, and Marin. Foreword by Dorothy Norman.

093 _____. *Seven Americans: Arthur G. Dove; Marsden Hartley; John Marin; Charles Demuth; Paul Strand; Georgia O'Keeffe; Alfred Stieglitz.* New York: The Gallery, 1974.

Catalogue of an exhibition held at the Washburn Gallery, New York, 6 February–2 March 1974. This show partially reconstructed the exhibition *Alfred Stieglitz Presents Seven Americans* (see entry 003).

094 _____. *"291."* New York: The Gallery, 1973.

Catalogue of an exhibition held at the Washburn Gallery, New York, 7 February–3 March 1973, which paid tribute to the Photo-Secession Galleries.

095 Watson, Stephen. *Strange Bedfellows: The First American Avant-Garde.* New York: Abbeville Press, 1991.

Watson details the artistic activities of Dove, Hartley, Marin, and Weber at various points throughout the book, although his most sustained discussion is in connection with the Photo-Secession Galleries (pp. 67–81). The book includes a chronology for the years 1900–1920 and a selected bibliography.

096 Wertheim, Arthur Frank. *The New York Little Renaissance: Iconoclasm, Modernism, and Nationalism in American Culture, 1908–1917.* New York: New York University Press, 1976.

In Chapter 8, "The Stieglitz Group," Wertheim discusses the aesthetic aims of Dove, Hartley, Marin, and Weber in the context of the Stieglitz Circle.

097 Whelan, Richard. *Alfred Stieglitz: A Biography.* Boston: Little, Brown, 1995.

Whelan covers the same ground as Sue Davidson Lowe's earlier biography/memoir of Stieglitz (see entry 045), although he provides more details on individual exhibitions of the works of Dove, Hartley, Marin, and Weber at Stieglitz's galleries.

098 Whitney Museum of American Art. *Juliana Force and American Art: A Memorial Exhibition.* New York: The Museum, 1949.

Catalogue of a exhibition held at the Whitney Museum of American Art, New York, 24 September–30 October 1949, in honor of the museum's first director. The exhibition included one work each by Dove, Hartley, Marin, and Weber.

Foreword by Flora Whitney Miller; essay by Herman Moore and Lloyd Good-rich; and tributes by John Sloan, Guy Pène du Bois, Alexander Brook, and Forbes Watson. The catalogue contains exhibition lists for the Whitney Studio, Whitney Studio Club, Whitney Studio Galleries, and Whitney Museum of American Art.

099 _____. *The Stieglitz Circle* [cover title]. New York: Whitney Museum of American Art, 1992.

Catalogue of an exhibition held at the Whitney Museum of American Art, Downtown at Federal Reserve, New York, 26 February–1 May 1992, and the Whitney Museum of American Art at Champion, Stamford, Connecticut, 26 June–26 August 1992. The exhibition included three works by Dove, two by Hartley, and four each by Marin and Weber. Essay by Amy Mizrahi Zorn.

100 _____. *The Whitney Studio Club and American Art, 1900–1932*. New York: The Museum, [1975].

Catalogue of an exhibition held at the Whitney Museum of American Art, New York, 23 May–3 September 1975. The exhibition featured works of artists who exhibited at the Whitney Studio Club, including two by Marin and one each by Dove, Hartley, and Weber. Essay by Lloyd Goodrich.

101 Wilmerding, John. *The Artist's Mount Desert: American Painters on the Maine Coast*. Princeton, N.J.: Princeton University Press, 1994.

Wilmerding discusses the landscapes of Marin (pp. 165–168) and Hartley (pp. 169–171) that feature locations in Maine such as Mount Desert Island, Schoodic Point, and Cape Split.

102 Yount, Sylvia and Elizabeth Johns. *To Be Modern: American Encounters with Cézanne and Company*. Philadelphia: Museum of American Art of the Pennsylvania Academy of the Fine Arts: Distributed by University of Pennsylvania Press, 1996.

Catalogue of an exhibition held at the Museum of American Art of the Pennsylvania Academy of the Fine Arts, Philadelphia, 15 June–29 September 1996. The exhibition partially reconstructed the academy's pioneering exhibition *Paintings and Drawings by American Artists Showing the Later Tendencies in Art*, staged in Philadelphia from 15 May to 16 June 1921. That exhibition featured 280 works and was significant insofar as it was the first comprehensive display of American modernist works in an American museum (a facsimile reproduction of the original catalogue is provided). This reconstructed exhibition included one work by Dove, four by Hartley, three by Marin, and four by Weber. Yount's essay discusses the original exhibition in the context of Philadelphia's artistic milieu of the time. Johns' essay deals with the popular and critical reception of the early American modernists.

103 Zabriskie Gallery. *Alfred Stieglitz and An American Place, 1929–1946* [cover title]. New York: The Gallery, [1978].

Catalogue of an exhibition held at the Zabriskie Gallery, New York, 2 May–3 June 1978. The exhibition featured sixty-six photographs and paintings (the majority of which were actually exhibited by members of the Stieglitz Circle at An American Place), including four works each by Dove, Hartley, and Marin. Essay by Doris Bry.

104 Zayas, Marius de. *How, When and Why Modern Art Came to New York.* Edited by Francis M. Naumann. Cambridge: MIT Press, 1996.

De Zayas, a Stieglitz Circle member and founder of the Modern Gallery, presents a survey of the early years of modern art in New York. Of particular interest are his sections "*291*—The Magazine" (pp. 72–77); "Stieglitz" (pp. 77–87); and "Marin" (pp. 87–90).

105 Zigrosser, Carl. *A World of Art and Museums.* Philadelphia: Art Alliance Press; Cranbury, N.J.: Associated University Presses, 1975.

In Chapter 14, "Alfred Stieglitz," Zigrosser, founder of the Weyhe Gallery and later curator of prints and drawings at the Philadelphia Museum of Art, offers a personal reminiscence of his friendship with Stieglitz. Zigrosser writes, "There seemed to be a touch of Svengali in him, a kind of urge to possess another's soul utterly. He could inspire enthusiasm and devotion to such a pitch that eventually the other person rebelled, and either went away or took up other pursuits. Whereupon he would complain sadly of betrayal."

II. ARTICLES AND ESSAYS

106 "Are These Men the Best Painters in America Today? *Look*'s 1948 Poll of Museum Directors and Art Critics." *Look* 12 (3 February 1948) 44–48.

This poll ranked Marin first and Weber second.

107 Baigell, Matthew. "American Landscape Painting and National Identity: The Stieglitz Circle and Emerson." *Art Criticism* 4:1 (1987) 27–47.

Baigell explores the influence that Walt Whitman and Ralph Waldo Emerson exerted on the Stieglitz Circle, with separate discussions devoted to Marin (who he feels was the closest adherent to the Emerson/Whitman tradition), Dove, and Hartley.

108 _____. "Walt Whitman and Twentieth-Century American Art." In *Walt Whitman and the Visual Arts*, edited by Geoffrey M. Sill and Roberta K. Tarbell, 121–141. New Brunswick, N.J.: Rutgers University Press, 1992.

Baigell explicates the Whitmanesque qualities in the works of Dove, Hartley, and Marin.

109 Baur, John I.H. "The Beginnings of Modernism, 1914–1940." In *Maine and Its Role in Modern Art*, edited by Gertrud A. Mellon and Elizabeth F. Wilder, 118–144. New York: Viking Press, under the auspices of Cobly College, Waterville, Maine, 1963.

Baur discusses Hartley and Marin in terms of their respective visions of Maine. He feels that they both produced a more intense distillation of the state than did the traditionalists or what he terms the "modernists-turned-traditionalists."

110 Berman, Avis. "Art: Modern American Seascapes—An Ancient Theme Rendered in a New Language." *Architectural Digest* 52 (July 1995) 114–119, 141.

Berman discusses Hartley's *Surf on Reef* of ca. 1937 and Marin's *Boat, Sea, and Shore, Small Point, Maine* of 1932 (both are illustrated in color).

111 Davidson, Abraham A. "Cubism and the Early American Modernist." *Art Journal* 26 (Winter 1966/1967) 122–129, 165.

Davidson explores Cubist and Futurist influences on the works of Hartley, Marin, and Weber.

112 Doty, Robert. "The Articulation of American Abstraction." *Arts Magazine* 48 (November 1973) 47–49.

Doty provides brief comments on the way in which a number of early American modernists approached abstraction, including Dove and Marin.

113 Halasz, Piri. "Figuration in the '40s: The Other Expressionism." *Art in America* 70 (December 1982) 110–119, 145, 147.

Halasz examines the work of the figurative Expressionists of the 1940s, including Weber (pp. 113–114) and Hartley (pp. 114–115). He feels that this style influenced a later generation of figure painters, now referred to as "neo-Expressionists."

114 Homer, William Innes. "Stieglitz and 291." *Art in America* 61 (July–August 1973) 50–57.

Homer comments on several exhibitions staged at the Photo-Secession Galleries, including *Watercolors by John Marin and Sketches in Oil by Alfred Maurer* (30 March–17 April 1909); *Exhibition of Paintings in Oil by Mr. Marsden Hartley of Maine* (8–18 May 1909); and *Younger American Painters* (12–21 March 1910), which included works by Dove, Hartley, Marin and Weber.

115 Keifer, Geraldine Wojno. "Alfred Stieglitz, *Camera Work*, and Cultural Radicalism." *Art Criticism* 7:2 (1992) 1–20.

Keifer examines Stieglitz's experiential aesthetics in light of the ways in which turn-of-the-century cultural radicalism was reflected in both his exhibition

policy and the writings and illustrations published in *Camera Work*. She argues that although Stieglitz was ostensibly committed to new and dynamic experiential ideas—particularly those originating in the European avant-garde literary milieu of Pater and Mallarmé—he was equally committed to the pragmatism of Dewey and James. This stance eventually led *Camera Work* away from its original radical and novel critical perspective.

116 Larkin, Oliver. "Alfred Stieglitz and '291.'" *Magazine of Art* 40 (May 1947) 178–183.

Larkin discusses Stieglitz's promotion of early American modernists, including Hartley, Weber, and Marin, focusing on their reception by art critics of the period.

117 Levin, Gail. "American Art." In *"Primitivism" in 20th Century Art: Affinity of the Tribal and the Modern*, edited by William Rubin, 452–469. New York: Museum of Modern Art; Boston: Distributed by New York Graphic Society Books, Little, Brown, 1984.

Levin provides details on the influence that primitive art exerted on members of the Stieglitz Circle, in particular, Weber's interest in African masks and sculpture and Hartley's fascination with the abstract character of American Indian motifs. She feels that American artists of the twentieth century were attracted to the directness and simplicity of primitive art because it embodied symbols of a less decadent age and thereby encompassed a more honest means of expression.

117A ———. "Die Musik in der frühen amerikanischen Abstraktion." In *Vom Klang der Bilder: Die Musik in der Kunst des 20. Jahrhunderts*, 368–373. Munich: Prestel, 1985.

Levin outlines the musical themes in the works of Dove, Hartley, and Weber (text in German).

118 Lewis, Stephen E. "The Modern Gallery and American Commodity Culture." *Modernism/Modernity* 4 (September 1997) 67–91.

Lewis discusses Marius de Zayas' Modern Gallery in the context of the declining influence of the Photo-Secession Galleries after the Armory Show. He contends that the ways in which American and European avant-garde artists adapted to the new commodity and machine age culture signified an important shift in the aesthetic and institutional framework of modern art in New York.

118A Minuit, Peter. "'291 Fifth Avenue.'" *The Seven Arts* 1 (November 1916) 61–65.

Paul Rosenfeld, writing under a pseudonym, attempts to capture the ambience of the Photo-Secession Galleries. He writes, "Stieglitz's ideas are not what makes him Stieglitz. It is rathermore his spirit, that splendid desire to give

himself to whosoever needs him—to America. It is his lofty conception of art, not as a *divertissement*, a refuge from the world, but as a bridge to a consciousness of self, to life, and through that, to new life and new creation again."

119 Ricciotti, Dominic. "City Railways/Modernist Visions." In *The Railway in American Art: Representations of Technological Change*, edited by Susan Danly and Leo Marx, 127–146. Cambridge: MIT Press, 1988.

Ricciotti explores the influence of Italian Futurism on Marin's *Lower Manhattan* of 1920 and on Weber's *New York* of 1913 and *Rush Hour, New York* of 1915.

120 Rodgers, Timothy Robert. "False Memories: Alfred Stieglitz and the Development of the Nationalist Aesthetic." In *Over Here: Modernism, the First Exile, 1914–1919*, 59–66. Providence, R.I.: David Winton Bell Gallery, Brown University, 1989.

Rodgers traces the development of Stieglitz's aesthetic theories from his early dialectical treatment of European modernism, to what he sees as Stieglitz's affected prophetic role with its vague spiritual overtones and lack of any consistent aesthetic principles, to the final collapse of the spirit of reconciliation and catholicism of artistic influence that accompanied Stieglitz's move to a vigorous promotion of a nationalist aesthetic as the grounding for American art after World War I.

121 Rosenfeld, Paul. "American Painting." *The Dial* 71 (December 1921) 649–670.

Rosenfeld offers critical assessments of Hartley (pp. 657–658); Weber (pp. 660–661); Marin (pp. 663–665); and Dove (pp. 665–666).

122 Tyrrell, Henry. "American Aquarallists—Homer to Marin." *The International Studio* 74 (August 1921) xxvii–xxxvi.

Tyrrell critiques the watercolors of Marin (pp. xxxi, xxxiii) and Weber (p. xxxiv).

123 Zilczer, Judith. "Alfred Stieglitz and John Quinn: Allies in the American Avant-Garde." *The American Art Journal* 17 (Summer 1985) 18–33.

Zilczer discusses art patron John Quinn's acquisition of modernist works from Stieglitz, including those of Hartley and Marin.

III. EXHIBITION REVIEWS

124 Huneker, James Gibbons. "Seen in the World of Art." In *Americans in the Arts, 1890–1920: Critiques by James Gibbons Huneker*, edited by Arnold T. Schwab, 563–564. New York: AMS Press, 1985.

Review of the exhibition *Younger American Painters: Brinley, Carles, Dove,*

Fellowes, Hartley, Marin, Maurer, Steichen, Weber, held at the Photo-Secession Galleries, New York, 21 March–15 April 1910 (reprinted from the *New York Sun*, 20 March 1910).

125 "The Younger American Painters and the Press." *Camera Work* no. 31 (July 1910) 43–51.
Reprinted reviews (see entry 124): B.P. Stephenson (*New York Evening Post*), Mr. Harrington (*New York Herald*), Elizabeth L. Cary (*New York Times*), Israel White (*Newark Evening News*), Guy Pène Du Bois (*New York American*), James B. Townsend (*American Art News*), and Sadakichi Hartman (for *Camera Work*).

126 Cortissoz, Royal. "291." In *Personalities in Art*, by Royal Cortissoz, 419–422. New York: Scribner's, 1925.
Review of the exhibition *Alfred Stieglitz Presents Seven Americans; 159 Paintings, Photographs and Things Recent and Never Before Publicly Shown by Arthur G. Dove, Marsden Hartley, John Marin, Charles Demuth, Paul Strand, Georgia O'Keeffe, Alfred Stieglitz*, held at the Anderson Galleries, New York, 9–28 March 1925 (reprinted, with modifications, from the *New York Herald Tribune*, 15 March 1925).

127 Comstock, Helen. "Stieglitz Group in Anniversary Show." *The Art News* 23 (14 March 1925) 5.
Review. See entry 126.

128 Fulton, Deogh. "Cabbages and Kings." *International Studio* 81 (May 1925) 144–147.
Review. See entry 126.

129 Read, Helen Appleton. "New York Exhibitions: Seven Americans." *The Arts* 7 (April 1925) 229, 231.
Review. See entry 126.

130 Mumford, Lewis. "The Art Galleries: Resurrection—And the Younger Generation." *The New Yorker* 9 (13 May 1933) 60.
Review of the exhibition *Selected Early Works: Dove, Marin, O'Keeffe*, held at An American Place, New York, May 1933.

131 Lowe, Jeanette. "New Exhibitions of the Week—Reunion of Marin, Dove, and O'Keeffe." *The Art News* 39 (30 November 1940) 11.
Review of the exhibition *Some Marins—Some O'Keeffes—Some Doves*, held at An American Place, New York, 17 October–11 December 1940.

132 Wolf, Ben. "Modern Americans at Rosenberg Gallery." *The Art Digest* 19 (1 July 1945) 21.

Review of the exhibition *Paintings by Avery, Hartley, Hélion, Rattner, Weber*, held at Paul Rosenberg and Co., New York, July 1945.

133 Seldis, Henry J. "Show Piece: The Stieglitz Circle Show at Pomona College." *Art in America* 46 (Winter 1958–1959) 62–65.
Review of the exhibition *The Stieglitz Circle: Demuth, Dove, Hartley, Marin, O'Keeffe, Weber*, held at the Pomona College Gallery, Pomona, California, 9 October–15 November 1958.

134 Coke, Van Deren. "Taos and Santa Fe." *Art in America* (October 1963) 44–47.
Review of the exhibition *Taos and Santa Fe: The Artist's Environment, 1882–1942*, sponsored by the Amon Carter Museum of Western Art, Fort Worth, Texas, which included works by Hartley and Marin.

135 Schwartz, Sanford. "New York Letter." *Art International* 17 (May 1973) 42–43.
Review of the exhibition *291* held at the Washburn Gallery, New York, 7 February–3 March 1973.

136 Corn, Alfred. "Reviews: New York—'American Modern.' " *Art News* 95 (October 1996) 141–142.
Review of the exhibition *American Modern*, held at the Owen Gallery, New York, 1 May–15 June 1996, which included works by Hartley, Marin, and Weber.

137 Phillips, Stephen Bennett. "The Symbiotic Alliance of Duncan Phillips and Alfred Stieglitz." *The Magazine Antiques* 147 (November 1995) 662–671.
Review of the exhibition *In the American Grain: Arthur Dove, Marsden Hartley, John Marin, Georgia O'Keeffe, and Alfred Stieglitz*, held at the Phillips Collection, Washington, D.C., 23 September–31 December 1995.

IV. REFERENCE SOURCES

138 *The Annual and Biennial Exhibition Record of the Whitney Museum of American Art*, edited by Peter Hastings Falk. Madison, Conn.: Sound View Press, 1991.
Contains entries for Dove, Hartley, Marin, and Weber.

139 *The Annual Exhibition Record of the Art Institute of Chicago, 1888–1950*. Edited by Peter Hastings Falk. Madison, Conn.: Sound View Press, 1990.
Contains entries for Dove, Hartley, Marin, and Weber.

140 *The Annual Exhibition Record of the Pennsylvania Academy of the Fine Arts.* Vol. 2, *1876–1913*, edited by Peter Hastings Falk. Madison, Conn.: Sound View Press, 1989.
Contains entries for Marin.

141 *The Annual Exhibition Record of the Pennsylvania Academy of the Fine Arts.* Vol. 3, *1914–1968*, edited by Peter Hastings Falk. Madison, Conn.: Sound View Press, 1989.
Contains entries for Dove, Hartley, Marin, and Weber.

142 Atkins, Robert. *Artspoke: A Guide to Modern Ideas, Movements, and Buzzwords, 1848–1944*, 208–210. New York: Abbeville Press, 1993. S.v. "291."

143 *Atlantic Brief Lives: A Biographical Companion to the Arts.* Edited by Louis Kronenberger. Boston: Little, Brown, 1971. S.v. "Stieglitz, Alfred," by Harold Clurman.

144 Baigell, Matthew. *Dictionary of American Art.* New York: Harper and Row, 1979. S.v. "Little Galleries of the Photo-Secession" and "Stieglitz, Alfred (1864–1946)."

145 *The Biennial Exhibition Record of the Corcoran Gallery of Art, 1907–1967.* Edited by Peter Hastings Falk. Madison, Conn.: Sound View Press, 1991.
Contains entries for Hartley, Marin, and Weber.

146 Castagno, John. *American Artists: Signatures and Monograms, 1800–1989.* Metuchen, N.J.: Scarecrow Press, 1990.
Contains entries for Dove, Hartley, Marin, and Weber.

147 Chilvers, Ian. *A Dictionary of Twentieth-Century Art.* Oxford and New York: Oxford University Press, 1998. S.v. "Stieglitz, Alfred (1864–1946)."

148 *The Dictionary of Art.* Edited by Jane Turner. New York: Grove's Dictionaries, 1996. S.v. "Stieglitz, Alfred," by Judith Zilczer; "291," by Roger J. Crum.

149 *Encyclopedia of American Art.* New York: E.P. Dutton, 1981. S.v. "Stieglitz, Alfred (1864–1946)," by Dennis Longwell.

150 Marlor, Clark S. *The Salons of America, 1922–1936.* Madison, Conn.: Sound View Press, 1991.
Contains entries for Dove, Hartley, Marin, and Weber for their exhibitions; Weber also has an additional entry for his directorship (p. 18).

151 _____. *The Society of Independent Artists: The Exhibition Record, 1917–1944*. Park Ridge, N.J.: Noyes Press, 1984.
Contains entries for Dove, Hartley, Marin, and Weber.

152 *McGraw-Hill Dictionary of Art*, edited by Bernard S. Myers. New York: McGraw-Hill, 1969. S.v. "Stieglitz, Alfred," by Joseph A. Baird, Jr.

153 Oppenheimer, Priscilla. "Stieglitz, Alfred." In *A Gertrude Stein Companion: Content with the Example*, edited by Bruce Kellner, 266–267. New York: Greenwood Press, 1988.

154 *The Oxford Dictionary of Art*, edited by Ian Chilvers and Harold Osborne, new ed. Oxford and New York: Oxford University Press, 1997. S.v. "Stieglitz, Alfred (1864–1946)."

155 *The Oxford Companion to Twentieth-Century Art*, edited by Harold Osborne. Oxford and New York: Oxford University Press, 1981. S.v. "Stieglitz, Alfred (1864–1946)."

156 *Petit Larousse de la Peinture*, sous la direction de Michel Laclotte. Paris: Larousse, 1979. S.v. "Stieglitz, (Alfred)," by Daniel Robbins.

157 *Praeger Encyclopedia of Art*. New York: Praeger, 1971. S.v. "Stieglitz, Alfred," by Emily Wasserman.

157A *Record of the Carnegie Institute's International Exhibitions, 1896–1996*, edited by Peter Hastings Falk. Madison, Conn.: Sound View Press, 1998.
Contains entries for Dove, Hartley, Marin, and Weber.

158 *The Thames and Hudson Dictionary of Art and Artists*, rev., expanded, and updated by Nikos Stangos; Herbert Read, consulting ed. New York: Thames and Hudson, 1994. S.v. "Stieglitz, Alfred (1864–1946)."

159 Williams, Lynn Barstis. *American Printmakers, 1880–1945: An Index to Reproductions and Biocritical Information*. Metuchen, N.J.: Scarecrow Press, 1993.
Contains entries for Hartley, Marin, and Weber.

160 Wilson, Raymond L. *Index of American Watercolor Exhibitions, 1900–1945*. Metuchen, N.J.: Scarecrow Press, 1994.
Contains entries for Marin and Weber.

V. ARCHIVAL SOURCES

161 Archives of American Art. *The Archives of American Art: Collection of Exhibition Catalogs*. Boston: G.K. Hall, 1979. S.v. "Stieglitz, Alfred."

162 Archives of American Art. *The Card Catalog of the Manuscript Collections of the Archives of American Art*. Wilmington, Del.: Scholarly Resources, 1980. S.v. "Stieglitz, Alfred."

163 Archives of American Art. *The Card Catalog of the Manuscript Collections of the Archives of American Art, Supplement 1981–1984*. Wilmington, Del.: Scholarly Resources, 1985. S.v. "Stieglitz, Alfred."
This circulating microfilm collection contains announcements and exhibition catalogues of the Photo-Secession Galleries, the Intimate Gallery, and An American Place, plus Stieglitz's correspondence with Dove, Marin, Weber, Edith Gregor Halpert, Duncan Phillips, Elizabeth McCausland, and others. The catalog is searchable through SIRIS (Smithsonian Institution Research Information System) via the Internet.

164 Bry, Doris. "The Stieglitz Archive at Yale University." *The Yale University Library Gazette* 25 (April 1951) 123–130.
An overview of the Alfred Stieglitz/Georgia O'Keeffe Archive in the Beinecke Rare Book and Manuscript Library, Yale University. One item of particular interest is Stieglitz's unpublished manuscript "The Story of Weber" (see entry 1324).

165 Markham, Sandra. "A Stieglitz Miscellany: The Stieglitz Archive." *History of Photography* 20 (Winter 1996) 340–341.
An overview of the Alfred Stieglitz/Georgia O'Keeffe Archive in the Beinecke Rare Book and Manuscript Library, Yale University.

166 The Phillips Collection, Washington, D.C.
The collection contains correspondence between Duncan Phillips and Stieglitz (1926–1946), which is available on microfilm from the Archives of American Art (see entries 162–163).

VI. DISSERTATIONS AND THESES

167 Birss, Ernst. " 'New York, at First, Did Not See . . . ': Modern Art, the Public, and the Stieglitz Circle, 1913–1916." M.A. thesis, University of Alberta, 1995.

168 Brennan, Marcia. "Abstract Passion: Images of Embodiment and Abstraction in the Art and Criticism of the Alfred Stieglitz Circle." Ph.D. diss., Brown University, 1997.

169 Carter, Nancy Corson. "The Inner Circle: Portraits in Alfred Stieglitz's *Camera Work*." Ph.D. diss., University of Iowa, 1972.

170 Cassidy, Donna M. "The Painted Music of America in the Works of Arthur G. Dove, John Marin, and Joseph Stella." Ph.D. diss., Boston University, 1988.

171 Chinery, Deborah Hannum. "The Avant-Garde in the Popular Culture of the 1930's: An Investigation into Alfred Stieglitz and the 'Seven Americans.' " M.A. thesis, University of West Florida, 1994.

172 Connor, Celeste. "Visions and Revisions of the American Landscape: Paintings and Photographs of the Stieglitz Circle, 1924–1934." Ph.D. diss., University of California at Berkeley, 1989.
 Contains discussions of Hartley and Marin.

173 Daniels, Marilyn Christine Johanne. " '291' and Cultural Criticism: To See through Closed Eyes." M.A. thesis, University of British Columbia, 1987.

174 Davidson, Abraham Aba. "Some Early American Cubists, Futurists and Surrealists: Their Paintings, Their Writings, and Their Critics." Ph.D. diss., Columbia University, 1965.
 Contains discussions of Dove, Hartley, Marin, and Weber.

175 Feinstein, Lea Vaughan. "Portraits and Word Portraits: Arthur Dove, John Marin, Georgia O'Keeffe, and Alfred Stieglitz." M.F.A. thesis, George Washington University, 1973.

176 Flood, Suzette Louise. "American Modernist Painters in France: The Decade before World War I." M.A. thesis, California State University, Fullerton, 1987.
 Contains discussions of Hartley and Weber.

177 Hull, Roger Platt. "*Camera Work*, an American Quarterly." Ph.D. diss., Northwestern University, 1970.

178 Kim, Yong-gwon. "Alfred Stieglitz and His Time: An Intellectual Portrait." Ph.D. diss., University of Minnesota, 1969.

179 Kotynek, Roy Anthony. "291: Alfred Stieglitz and the Introduction of Modern Art to America." Ph.D. diss., Northwestern University, 1970.

180 Kyle, Jill Anderson. "Cézanne and American Painting, 1900 to 1920." Ph.D. diss., University of Texas at Austin, 1995.
 Contains discussion of Hartley, Marin, and Weber.

181 Leavens, Ileana B. "Alfred Stieglitz and '291': Introduction of Modern Art Into America." M.A. thesis, University of Washington, 1972.

182 Mecklenburg, Virginia McCord. "American Aesthetic Theory, 1908–1917: Issues in Conservative and Avant-Garde Thought." Ph.D. diss., University of Maryland, 1983.
 Contains discussions of Marin and Weber.

183 Miller, Marie Celeste. " 'Seeking Similar Fundamentals': The Relationship between Painting and Poetry of American Early Moderns." Ph.D. diss., Emory University, 1983.
 Contains discussions of Dove and Marin.

184 Moak, Peter van der Huyden. "Cubism and the New World: The Influence of Cubism on American Painting 1910–1920." Ph.D. diss., University of Pennsylvania, 1970.
 Contains discussions of Hartley (pp. 173–181), Marin (pp. 181–184), and Weber (pp. 184–190).

185 Moffatt, Frederick Campbell. "The Maine Scene: John Marin and Marsden Hartley." M.A. thesis, Arizona State University, 1967.

186 Nathanson, Carol Arnold. "The American Response, in 1900–1913, to the French Modern Art Movements after Impressionism." Ph.D. diss., Johns Hopkins University, 1973.

187 Piron, Alice Marie O'Mara. "Urban Metaphor in American Art and Literature, 1910–1930." Ph.D. diss, Northwestern University, 1982.
 Contains discussions of Marin and Stieglitz.

188 Prebus, Cynthia H. "Transitions in American Art and Criticism: The Formative Years of Early American Modernism, 1895–1905." Ph.D. diss., Rutgers, the State University of New Jersey, 1994.
 Contains discussions of Dove, Marin, and Weber.

189 Ricciotti, Dominic. "The Urban Scene: Images of the City in American Painting, 1890–1930." Ph.D. diss., Indiana University, 1977.

Subsections of Chapter 6, "Manhattan Towers," contain discussions of the cityscapes of Marin (in "Marin and the Megalopolis," pp. 297–311) and Weber (in "Order in the City," pp. 311–313).

190 Scholl, Phoebe Kent. "A Study of the Styles and Techniques of Some Outstanding Recent American Watercolor Painters." Ed.D. diss., Columbia University, 1970.
 Contains discussions of Dove and Marin.

191 Szekely, Gillian M. Hill. "The Beginnings of Abstraction in America: Art and Theory in Alfred Stieglitz's New York Circle." Ph.D. diss., University of Edinburgh, 1971.

192 Taylor, Larry Hugh. "Alfred Stieglitz and the Search for American Equivalents." Ph.D. diss., University of Illinois, Urbana, 1973.

193 Udall, Sharyn Rohlfsen. "Modernist Painting in New Mexico 1913–1933." Ph.D. diss., University of New Mexico, 1981.
 Contains discussions of Hartley and Marin.

194 Wolanin, Barbara Boese. "Alfred Stieglitz' [*sic*] 291: America's First Glimpse of Modern Art." M.A. thesis, Oberlin College, 1969.

195 Zilczer, Judith. "The Aesthetic Struggle in America, 1913–1918: Abstract Art and Theory in the Stieglitz Circle." Ph.D. diss., University of Delaware, 1975.

2

Arthur Dove

Arthur Garfield Dove was born on 2 August 1880 in Canandaigua, New York. In 1882 his family moved to nearby Geneva, where a neighbor, who was an amateur painter, encouraged Dove's artistic interests. After graduating from high school in 1899, Dove enrolled at Hobart College and later transferred to Cornell University. Although it was Dove's original intention to study law, by the time he received his B.A. degree in 1903 he was firmly committed to a career in art. After moving to New York City, he began to prosper as a freelance illustrator for many popular magazines, including *McLure's, Century, Collier's, Illustrated Sporting News*, and *St. Nicholas*. During this time he became acquainted with Robert Henri, William Glackens, John Sloan, and other members of the Eight. He married Florence Dorsey on 21 July 1904.

In 1908 Dove and his wife embarked on a fourteen-month trip to Europe, spending most of their time in France, with short sojourns in Italy and Spain. Dove met several American painters in Paris, including Patrick Henry Bruce, Arthur Carles, Alfred Maurer, and Max Weber. He concentrated on painting the French countryside outside Paris and along the Mediterranean coast in a Post-impressionist style. His painting *The Lobster* was shown in the 1909 Salon d'Automne.

Dove returned to New York in July 1909. He arranged for a one-man show at Hobert College in October, which featured his European landscapes. His first meeting with Stieglitz was probably arranged by Maurer and took place in late 1909 or early 1910. Stieglitz included several of Dove's canvases in his *Younger American Painters* exhibition of March–April 1910. Later that year—after the birth of their son, William—the Doves moved to Westport, Connecticut, where they purchased a farm.

Dove produced two highly significant series during 1911 and 1912. The first was a group of small oils, *Abstractions Nos. 1 to 6*, executed in a Fauvist style. Although these paintings were based on landscape motifs, they had close par-

allels with Wassily Kandinsky's concurrent, yet completely independent, work
in abstraction. The second series was a set of abstract pastels known as *The Ten
Commandments*, which not only drew upon landscape elements but also featured
animals, boats, and urban architecture. These works were probably influenced
by contemporary modernist movements, particularly Analytical Cubism and Fu-
turism, which were being discussed at the time by Weber and other members
of the Stieglitz Circle. Dove was beginning to develop his own unique vocab-
ulary based on organic curvilinear and sawtooth shapes, as well as overlapping
and interpenetrating planes, which translated specific natural processes and
events into abstract forms. *The Ten Commandments* was featured in Dove's first
one-man show at Stieglitz's Photo-Secession Galleries during February–March
1912.

The sources of Dove's eclectic aesthetic theories included Henri Bergson,
Madame Blavatsky, P.D. Ouspensky, Claude Bragdon, Paul Klee, Wassily Kan-
dinsky, and the Dada and surrealist artists. He was also interested in scientific
theories of geometric properties of organic forms that were expounded in the
writings of D'Arcy Wentworth Thompson and Ernest Haeckel. Through his
acquaintance with the work of the Symbolists, Dove became interested in syn-
aesthesia, which is a phenomenon whereby two sensations are purportedly ex-
perienced simultaneously as the result of a single experience, for example, a
particular sound also experienced as a color. This tied into his attempt to tran-
scend reason and objective analysis to record his direct intuitive and unmediated
responses to the natural world. Dove also explored occult ideas such as "con-
ditions of light," the symbolism of geometric shapes, force fields and vibration,
and the fourth dimension.

Between 1917 and 1921 Dove's attention was focused primarily on his career
in commercial illustration, with his noncommercial work restricted principally
to charcoal drawings. After his father's death in 1921, Dove started spending
more time with fellow artist Helen Torr, also known as "Reds," who would
eventually become his second wife. By the autumn of 1921 the two were living
together on a houseboat moored on the Hudson River, off upper Manhattan.
They later purchased the *Mona*, a forty-two-foot yawl, and lived the nautical
life for several years as they cruised the harbors of Long Island Sound during
the summer. They moored at Halesite, near Huntington Harbor, during the win-
ters. In 1929, following the death of Florence, Dove and Torr married and
moved into quarters at the Ketewomoke Yacht Club in Halesite, where they
remained until 1933.

After Dove resumed painting during the 1920s, his works were mainly land-
scapes with mystical or symbolic overtones that combined representational and
abstract elements. Around mid-decade he began to use a compositional device
that he termed "force lines" or "growth lines" to animate the picture plane, which
sometimes took the form of pulsating concentric circles, as in *Fog Horns* of
1929. Dove enjoyed listening to popular music and executed several works
in 1927 based on the compositions of Irving Berlin and George Gershwin. Be-
tween 1924 and 1931 he produced a series of assemblages that consisted of

arrangements of found objects affixed to flat surfaces depicting individuals, often in a humorous or ironic manner, or the daily life he observed around Huntington Harbor, as in *Goin' Fishin'* of 1925.

Stieglitz staged Dove's second one-man show in 1926, which inaugurated a series of annual shows of the artist's paintings in his galleries that continued for the rest of Dove's career. That same year Duncan Phillips, art connoisseur and founder of the Phillips Memorial Gallery, purchased Dove's *Golden Storm* and *Waterfall* and subsequently became an important lifelong patron. By the end of the decade Dove's reputation as a major American artist had become firmly established, and his work in commercial illustration ended around 1931.

In 1933, after the death of his mother, Dove and his wife reluctantly moved back to his boyhood home in Geneva to manage the family farm. Although the following five years were full of financial hardships due to the Great Depression, Dove's art came into full maturity during this period. Each summer he painted a large body of watercolors that served as preparatory studies for oils painted later during the winter months. He also began a serious study of the technical aspects of pigments and other artistic materials, which resulted in experiments that combined oils with other media such as wax emulsion and tempera. Dove had a lifelong fascination with capturing natural light, and as a result his works of the 1930s often featured brilliant sunrises, cool moonlit nightscapes, or icy winter storms.

In the spring of 1938 Dove and his wife relocated to an abandoned shorefront post office in Centerpoint, New York, which they refurbished into a small home and studio. Early the following year Dove suffered a heart attack complicated by Bright's disease and other ailments. He spent long periods in a frail and semi-invalid condition for the remainder of his life.

Dove's late works continued the earlier nature themes, although his compositions became progressively more abstract and nonobjective, while at the same time increasingly harmonious and tranquil. He alternated between condensed and curvilinear biomorphic shapes, and flat, hard-edged geometric forms. Dove also began to experiment with new ideas in small works that he called "Sketches," which were executed in a variety of mixed media that included watercolor, gouache, tempera, ink, graphite, wax emulsion, and oil.

Dove's health deteriorated rapidly after learning of Stieglitz's death in July 1946, and he could paint only with his wife's assistance. He died four months later on November 22 in a hospital on Huntington, Long Island. Dove was one of the most lyrical painters of the early American modernists and an important pioneer in twentieth-century abstraction as well.

I. DOVE'S WRITINGS, STATEMENTS, AND CORRESPONDENCE

For a collection Dove's writings, published and unpublished (except correspondence), see entry 211; see also entries 002, 034, 059, 222, 417–418A, and 420–421.

196 *Dear Stieglitz, Dear Dove.* Edited by Ann Lee Morgan. Newark: University of Delaware Press, 1988.

Morgan transcribes and annotates approximately 650 items of correspondence between Dove and Stieglitz from 1914 to 1946, now housed in the Collection of American Literature, Beinecke Rare Book and Manuscript Library, Yale University. Despite the fact that Dove, unlike Stieglitz, rarely dated anything he wrote, Morgan has managed to supply dates to every letter through examining collateral material such as the diaries kept by Dove and his second wife, Helen Torr; additional collections of letters written by Dove, Stieglitz, and other correspondents; and published works. The letters are arranged chronologically in six time periods, each preceded by a brief introduction. The book also contains a preface; a general introduction; a glossary of names; a list of cited works by Dove, including present collection (if known); a bibliography; and numerous documentary photographs.

197 Dove, Arthur G. "An Idea." In *Arthur G. Dove Paintings*. New York: Intimate Gallery, 1927.

198 _____. "Notes by Arthur G. Dove." In *Dove Exhibition*. New York: Intimate Gallery, 1929.

Dove writes, "I have always felt it is much better to . . . paint things that exist in themselves and do not carry the mind back to some object upon which they depend for their existence."

199 _____. "291." *Camera Work* no. 47 (July 1914) 37.

Dove's response to Stieglitz's question "What is '291'?"

200 _____. "What Photography Means to Me." *MSS* (19 June 1922).

201 Eddy, Arthur Jerome. *Cubists and Post-Impressionism*, new and rev. ed., 48–49. Chicago: A.C. McClurg, 1919.

A statement by Dove, written at Eddy's invitation, on his *Based on Leaf Forms and Spaces* of 1911–1912.

II. BOOKS AND EXHIBITION CATALOGUES

202 Andrew Crispo Gallery. *Twelve American Masters of Collage: Bearden, Cornell, Courtright, Dole, Dove, Krasner, Motherwell, Rauschenberg, Reinhardt, Ryan, Stella, Wesselmann.* New York: The Gallery, 1977.

Catalogue of an exhibition held at the Andrew Crispo Gallery, New York, 17 November–30 December 1977. The exhibition included thirteen works by Dove (twelve are illustrated, six in color). Catalogue notes by Gene Baro.

203 Arthur G. Dove: "Mainly the Forties." [S.l.: s.n.], 1975. (Houston, Tex.: Graphic Concepts.)

Catalogue of an exhibition held at four different Texas venues between 4 September 1975 and 9 May 1976. The checklist includes thirty-five paintings and drawings, six of which are illustrated (four in color). The catalogue contains three brief essays by Barbara Haskell; Betty W. Hirsch; and Ann Robinson and Jim Harithas.

204 Balken, Debra Bricker. *Arthur Dove: A Retrospective.* Andover, Mass.: Addison Gallery of American Art, Phillips Academy; Cambridge: MIT Press, in association with the Phillips Collection, Washington, D.C., 1997.

Catalogue of an exhibition held at the Phillips Collection, Washington, D.C., 20 September 1997–4 January 1998. The exhibition included ninety-two oils, watercolors, pastels, drawings, and collages. The catalogue contains three essays: "Continuities and Digressions in the Work of Arthur Dove from 1907 to 1933," by Debra Bricker Balken; "Going Home: Geneva, 1933–1938," by Elizabeth Hutton Turner; and "New Directions: The Late Work, 1938–1946," by William C. Agee. A chronology and a checklist of the exhibition are provided.

205 Cohn, Sherrye. *Arthur Dove: Nature as Symbol.* Ann Arbor, Mich.: UMI Research Press. 1985.

Cohn presents a detailed account of Dove's aesthetic and intellectual development, with particular attention devoted to his influences, which included the Symbolists, Henri Bergson, Madame Helena Blavatsky, Claude Bragdon, P.D. Ouspensky, Wassily Kandinsky, Paul Klee, Dadaism, surrealism, and so forth. She analyzes many of Dove's works in terms of his interest in occult ideas such as "conditions of light"; the symbolism of geometric shapes; force fields and vibration; the fourth dimension; and synaesthesia. Cohn discusses his interest in scientific theories of geometric properties of organic forms found in the writings of D'Arcy Wentworth Thompson and Ernst Haeckel and notes how these theories were exemplified in his series *The Ten Commandments* of 1911–1912. It is her view that Dove's goal was "[to] find a pictorial language which could encompass his idealistic vision of life and be as well aesthetically convincing, humanly moving, and responsive to the artistic situation in which he worked." The book contains eighty-six black-and-white illustrations and a bibliography.

206 Cornell University. Andrew Dickson White Museum of Art. *Arthur G. Dove, 1880–1946: A Retrospective Exhibition.* Ithaca, N.Y.: Cornell University Press, 1954.

Catalogue of an exhibition held at the Andrew Dickson White Museum of Art, Cornell University, Ithaca, New York, 2–28 November 1954, which includes thirty-two paintings, three collages, and fifteen watercolors (twenty-eight are illustrated in black and white). The catalogue contains a foreword by Duncan Phillips; an essay by Alan R. Solomon; a chronology; a bibliography; and a checklist of the exhibition. The dates of this exhibition, which have been previously uncited in the literature, have been supplied courtesy of the Herbert F. Johnson Museum of Art, Cornell University.

207 DePietro, Anne Cohen. *Arthur G. Dove and Helen Torr: The Huntington Years*. Huntington, N.Y.: Heckscher Museum, 1989.

Catalogue of an exhibition held at the Heckscher Museum, Huntington, New York, 3 March–30 April 1989. Anne Lee Morgan's essay deals with Dove's early work. In her two essays, DiPietro covers Dove's late work and his relationship with his second wife, Helen Torr; she also transcribes her interview with the artist's son, William C. Dove. The catalogue contains a reminiscence by Torr's sister, Mary Torr Rehm. The exhibition checklist records seventy-five works by Dove and thirty-four by Torr. The selected bibliography includes archival sources.

208 Donald Morris Gallery. *Arthur G. Dove: Oils, Watercolors, Drawings, Collage*. Detroit: The Gallery, 1964.

Catalogue of an exhibition of thirty works held at the Donald Morris Gallery, Detroit, 3–23 May 1964.

209 Eldredge, Charles C. *Reflections on Nature: Small Paintings by Arthur Dove, 1942–1943*. New York: American Federation of Arts, 1997.

Catalogue of an exhibition held at the New Britain Museum of American Art, New Britain, Connecticut, 26 September–30 November 1997. The exhibition featured a group of twenty-eight mixed-media watercolor sketches that were presented to the Wichita Art Museum, Wichita, Kansas, by the artist's son, William C. Dove. The paintings are illustrated on color plates and discussed by Eldredge in his essay. These hard-edged abstractions, which utilized organic motifs, were outlets for Dove's imagination as well as testing grounds for new techniques and materials (e.g., wax emulsion).

210 Esther-Robles Gallery. *Watercolors: Dove*. Los Angeles: The Gallery, 1974.

Catalogue of an exhibition of thirty-six watercolors held at the Esther-Robles Gallery, Los Angeles, 3–26 October 1974.

211 Haskell, Barbara. *Arthur Dove*. San Francisco: San Francisco Museum of Art; Boston: Distributed by New York Graphic Society, 1974.

This book was published to accompany the exhibition *Arthur Dove*, held at the San Francisco Museum of Art, San Francisco, 21 November 1974–5 January 1975. In her thorough critical exposition of all phases of Dove's career, Haskell stresses that the artist's lifelong quest for continuity and wholeness was intimately tied to his profound identification with the forces and rhythms of the natural world. The book contains numerous reproductions of Dove's works (the majority in color); a chronology, including an exhibition history; a selected bibliography; and an appendix reprinting many of Dove's writings, both published and unpublished. No checklist of the exhibition is provided.

212 Heckscher Museum. *Arthur G. Dove of Long Island Sound.* Huntington, N.Y.: The Museum, 1967.

Catalogue of an exhibition held at the Heckscher Museum, Huntington, New York, 20 August–17 September 1967. The exhibition included twenty paintings and seventeen drawings and watercolors (ten works are illustrated in black and white). Foreword by Eva I. Gatling.

213 Hobart and William Smith Colleges. Houghton House Gallery. *Arthur Dove: Works from Geneva and Centerpoint, 1933–46.* Geneva, N.Y.: The Gallery, 1981.

Catalogue of an exhibition held at the Houghton House Gallery, Hobart and William Smith Colleges, Geneva, New York, 9–31 October 1981. The exhibition included thirty-three works; six are illustrated (one in color) and annotated by John Loftus and Edward Aiken. The catalogue contains an introduction by Loftus; a commentary by Aiken; a poem by S. Lewandowski; a chronology; and a checklist of the exhibition.

214 Kirschner, Melanie. *Arthur Dove: Watercolors and Pastels.* New York: George Braziller, 1998.

In her detailed discussions of Dove's watercolors and pastels, Kirschner emphasizes that both were essential to his work in oils, in addition to being important achievements in their own right. She discusses the watercolors in the context of the modernist watercolor movement in America during the 1910s and 1920s and also points out that this medium was closely tied to his practical working methods and his public presentation later in his career. She feels that pastels were crucial to Dove's development of abstract compositions, particularly in his series *The Ten Commandments* of 1911–1912, insofar as their light-absorbing texture gave him a viable alternative to working with oils. The book contains thirty-four color plates and a selected bibliography.

215 Montclair Art Museum. *Collage: American Masters.* Montclair, N.J.: The Museum, 1979.

Catalogue of an exhibition held at the Montclair Art Museum, Montclair, New Jersey, 25 March–24 June 1979, which includes three collages by Dove (one is illustrated). Introduction by Robert J. Koenig.

216 Morgan, Ann Lee. *Arthur Dove: Life and Work, with a Catalogue Raisonné.* Newark: University of Delaware Press, 1984.

Morgan's catalogue raisonné encompasses all of Dove's oil paintings, collages, and assemblages, in addition to most of his pastels, executed between 1907 and 1946. All known examples are included as well as all works known only through documentary evidence. Dove's watercolors and drawings are excluded. Each entry includes a catalogue number; title; date; medium and support; dimensions; signature; collection; provenance; remarks; and exhibitions. The

majority of works are illustrated, fifty-three in color. Morgan's text is divided into three parts: "The Life of Arthur Dove"; "The Art of Arthur Dove"; and "Context and Theory." In this last section she explores Dove's intellectual development, aesthetic theories, and influence on later artists. The book contains a foreword by Roxana Barry; an exhibition history; a bibliography; a subject index; and an index for titles of works. For a lengthy review of this book, see entry 232. In conjunction with the book's publication, three concurrent exhibitions were staged in New York, 3 November–29 December 1984: *Arthur G. Dove: Paintings, Drawings and Collages* (Terry Dintenfass); *Arthur G. Dove: Paintings and Watercolors* (Salander-O'Reilly Galleries); and *Arthur G. Dove: Paintings and Related Watercolors* (Barbara Mathes Gallery). An exhibition checklist for each venue is provided.

217 Phillips Collection. *Arthur Dove and Duncan Phillips: Artist and Patron.* Washington, D.C.: Phillips Collection; New York: George Braziller, 1981.

 Catalogue of an exhibition held at the Phillips Collection, Washington, D.C., 13 June–16 August 1981. Sasha M. Newman's essay traces the relationships that Dove established with both Alfred Stieglitz and Duncan Phillips; in addition, she analyzes Dove's stylistic development and aesthetic philosophy. Phillips' article on Dove, published in the *Magazine of Art*, is reprinted (see entry 256). The catalogue also contains a list of the original titles of Dove's works that were acquired by Phillips and subsequently retitled; a chronology of Dove's career; a selected bibliography and exhibition history; a list of catalogues and reviews; and a checklist of the seventy-nine works in the exhibition, all of which are illustrated (the majority in color).

218 Richard York Gallery. *Arthur Dove: Major Works.* New York: The Gallery, 1990.

 Catalogue of an exhibition of eight works held at the Richard York Gallery, New York, 5 October–17 November 1990. The catalogue contains a lengthy excerpt from Waldo Frank's "The Art of Arthur Dove" (see entry 266); a checklist of the exhibition, which is accompanied by bibliographic notes and reprinted quotations from various sources; and four color illustrations.

219 Syracuse University. Lubin House. *Arthur Dove Watercolors.* Syracuse, N.Y.: Syracuse University Press, 1972.

 Catalogue of an exhibition of twenty-four watercolors held at the Lubin House, Syracuse University, Syracuse, New York, 19 December 1972–19 January 1973. Essay by August L. Freunlich.

220 Terry Dintenfass Gallery. *Arthur G. Dove: Pastels/Charcoals/Watercolors.* New York: The Gallery, 1993.

 Catalogue of an exhibition held at the Terry Dintenfass Gallery, New York, 6 February–13 March 1993, which includes thirty-nine works (all are illustrated, as are four supplemental works not in the exhibition). The catalogue contains a

foreword by Terry Dintenfass, an essay by Deborah Bricker Balken, and a checklist of the exhibition.

221 Terry Dintenfass. *Arthur G. Dove: Collages*. New York: Terry Dintenfass, 1970.

Catalogue of an exhibition held at Terry Dintenfass, New York, 22 December 1970–23 January 1971, which includes thirteen collages (four are illustrated in black and white). The catalogue contains a checklist of the exhibition and a reprinted excerpt from an essay by Dorothy Rylander Johnson (see entry 228).

222 _____. *Arthur G. Dove: Exhibition of Paintings, 1917–1946*. New York: Terry Dintenfass, 1972.

Catalogue of an exhibition held at Terry Dintenfass, New York, 1–26 February 1972. The checklist records twenty-six works, five of which are illustrated in black and white. The catalogue contains a foreword by Thomas M. Messer and an excerpt from an item of Dove's correspondence (ca. 1929).

223 _____. *Arthur G. Dove: Exhibition of Watercolors and Drawings*. New York: Terry Dintenfass, 1970.

Catalogue of an exhibition held at Terry Dintenfass, New York, 31 March–25 April 1970.

224 _____. *Arthur G. Dove: The Abstract Work*. New York: Terry Dintenfass; Washington, D.C.: Phillips Collection, [1975].

Catalogue of an exhibition held at Terry Dintenfass, New York, 2–27 December 1975 and the Phillips Collection, Washington, D.C., 3 January–1 February 1976. Charles V.W. Brooks discusses Dove's abstract work in his foreword. The catalogue contains a checklist of the exhibition and a black-and-white illustration of each work.

225 _____. *Arthur G. Dove (1880–1946): Singular Works*. New York: Terry Dintenfass, 1980.

Catalogue of an exhibition held at Terry Dintenfass, New York, 8 January–15 February 1980. The checklist records twenty-six works, mainly oils (eighteen are illustrated in black and white). Foreword by Barbara Haskell.

226 _____. *Country Life: Arthur G. Dove*. New York: Terry Dintenfass, 1973.

Catalogue of an exhibition held at Terry Dintenfass, New York, 18 September–13 October 1973.

227 University of California, Los Angeles. Grunwald Center for the Graphic Arts. *The American Personality: The Artist-Illustrator of Life in the United States, 1860–1930*. Los Angeles: The Center, 1976.

Catalogue of an exhibition held at the Amon Carter Museum of Art, Fort

Worth, Texas, 8 July–22 August 1976. The exhibition included one of Dove's illustrations for the 17 May 1923 issue of *Life*, loaned from the Grunwald Center's collection (catalogue entry 64; not illustrated). A brief biographical sketch of Dove is provided (pp. 153–154).

228 University of Maryland. Art Gallery. *Arthur Dove: The Years of Collage; An Exhibition of the Collages of Arthur Dove, Together with a Selected Group of His Paintings; Collages by Joseph Stella, Alfred Maurer, Max Weber and Edward Plunkett; and American Folk Art and Victorian Constructions.* College Park: The Gallery, 1967.

Catalogue of an exhibition held at the University of Maryland Art Gallery, J. Millard Tawes Fine Arts Center, College Park, 13 March–19 April 1967. The Dove section of the exhibition featured twenty-five collages and ten other works (oils, watercolors, and a pastel), with twenty-one works illustrated in black and white. Foreword by William H. Gerdts and essay by Dorothy Rylander Johnson. Weber was represented in the exhibition by his collage *Sunday Tribune* of 1913, which is illustrated.

229 Wescher, Herta. *Collage*, 180–182. New York: H.N. Abrams, [1971].

A general discussion of Dove's collages accompanied by three illustrations: *Grandmother* of 1925 (Color Pl. 26); *The Critic* of 1925 (Pl. 141); and *Monkey Fur* of 1926 (Pl. 143).

230 Worcester Art Museum. *Paintings and Water Colors by Arthur G. Dove; Lent by the William H. Lane Foundation.* Worcester, Mass.: The Museum, 1961.

Catalogue of an exhibition held at the Worcester Art Museum, Worcester, Massachusetts, 27 July–17 September 1961. The exhibition featured forty-three works from the William H. Lane Foundation, Leominster, Massachusetts (eight are illustrated in black and white). The catalogue contains an essay by Daniel Catton Rich, a biographical note on the artist, and a checklist of the exhibition.

231 Wight, Frederick S. *Arthur G. Dove*. Berkeley and Los Angeles: Distributed for the Art Galleries of the University of California, Los Angeles, by the University of California Press, 1958.

Catalogue of an exhibition held at seven different venues between 1 October 1958 and 30 September 1959. The exhibition included 103 works (approximately one-half are illustrated, many in color). Wight's essay traces Dove's artistic development and critical reception, in addition to providing critical analyses of dozens of works. The catalogue contains a foreword by Duncan Phillips; a list of public collections owning the artist's paintings; an exhibition list; a selected bibliography; and a checklist of the exhibition.

III. ARTICLES AND ESSAYS

232 Agee, William C. "Book Reviews." *Archives of American Art Journal* 24: 4 (1984) 15–20.

A lengthy review of Ann Lee Morgan's *Arthur Dove: Life and Work with a Catalogue Raisonné* (see entry 216).

233 "Art News of America: Obituaries." *Art News* 45 (December 1946) 9.

234 "Arthur Dove Dies; Abstractionist, 66—Painter, Pioneer in Field Here, Protege of Stieglitz—Dealt with Natural Phenomena." *New York Times* (24 November 1946) 78.

235 "Arthur Dove, Modern." *The Art Digest* 21 (1 December 1946) 14.

An obituary.

235A Balken, Debra Bricker. "Arthur Dove's *Gas Ball and Roofs.*" *Kresge Art Museum Bulletin* 8 (1999) 20–23.

A discussion of Dove's pencil drawing *Gas Ball and Roofs* of 1932.

236 Baur, John I.H. "Arthur G. Dove." In *New Art in America*, edited by John I.H. Baur, 79–83. Greenwich, Conn.: New York Graphic Society, in cooperation with Praeger, New York, [1957].

An illustrated biographical sketch.

237 Berman, Avis. "The Quiet Man of American Modernism." *Smithsonian* 28 (November 1997) 122–128, 130, 132.

An illustrated biographical essay.

238 Cassidy, Donna M. "Arthur Dove's Music of the Jazz Age." *The American Art Journal* 20:1 (1988) 4–23.

Cassidy provides a detailed explication of the cultural background, compositional elements, and significance of Dove's series of jazz compositions of 1927. She also relates them to his earlier music paintings.

239 Cohn, Sherrye. "Arthur Dove and the Organic Analogy: A Rapprochement between Art and Nature." *Arts Magazine* 59 (June/Summer 1985) 85–89.

240 _____. "Arthur Dove and Theosophy: Visions of a Transcendental Reality." *Arts Magazine* 58 (September 1983) 86–91.

241 _____. "The Image and the Imagination of Space in the Art of Arthur Dove; Part I: Dove's 'Force Lines, Growth Lines' as Emblems of Energy." *Arts Magazine* 58 (December 1983) 90–93.

242 _____. "The Image and the Imagination of Space in the Art of Arthur Dove; Part II: Dove and 'The Fourth Dimension.' " *Arts Magazine* 58 (January 1984) 121–125.

These four articles were incorporated into Cohn's book *Arthur Dove: Nature as Symbol* (see entry 205).

243 Deak, Gloria-Gilda. "Arthur G. Dove." In *Kennedy Galleries Profiles of American Artists*, 2d ed., 78–79. New York: Kennedy Galleries, 1984.

A biographical essay.

244 Gallati, Barbara D. "Arthur G. Dove as Illustrator." *Archives of American Art Journal* 21:2 (1981) 13–22.

Gallati's overview of Dove's career as a commercial illustrator focuses on subject matter, style, and the parallels with his noncommercial art.

245 Goldwater, Robert. "Arthur Dove." *Perspectives USA* no. 2 (Winter 1953) 78–88.

Goldwater discusses Dove's art in the context of its mystical directness and its portrayal of the awesome spectacle of nature in symbolic terms.

246 Gustafson, Eleanor H. "Museum Accessions." *The Magazine Antiques* 145 (March 1994) 356.

A discussion of Dove's *Approaching Snow Storm* of 1934, acquired by the Wadsworth Atheneum, Hartford, Connecticut.

246A Harrison, Helen A. "Arthur Dove and the Origins of Abstract Expressionism." *American Art* 12 (Spring 1998) 66–83.

Harrison considers to what extent Dove can be considered a precursor of Abstract Expressionism, with attention devoted to the views of Robert Goldwater, Sheldon Cheney, Alfred H. Barr, Jr., William Seitz, and Sam Hunter. She concludes that Dove's work was less spontaneous than that of the mainstream Abstract Expressionists, insofar as it retained ties to the smaller-scale tradition of easel painting.

247 Haskell, Barbara. "Arthur G. Dove (1880–1946)." *American Art Review* 2 (January–February 1975) 130–143.

This article is excerpted from Haskell's essay in the exhibition catalogue *Arthur Dove* (see entry 211).

248 Homer, William Innes. "Identifying Arthur Dove's 'The Ten Commandments.' " *The American Art Journal* 12 (Summer 1980) 21–32.

Homer analyzes Dove's group of ten pastels *The Ten Commandments* of 1911–1912, which represents the earliest sustained series of abstract works by an American artist. Nine works are illustrated in black and white and accom-

panied by caption comments. Homer also discusses two other works that may
be part of the series and the newly discovered *Nature Symbolized No. 3*. He
points out that because the titles and dates of Dove's early works are quite
problematic, he relied on the artist's own card file of his works, which was later
expanded by Suzanne M. Smith (née Mullett) in a project sponsored by the
American Art Research Council of the Whitney Museum of American Art (see
entry 432).

249 McCausland, Elizabeth. "Dove: Man and Painter." *Parnassus* 9 (December 1937) 3–6.

McCausland explores the ways in which Dove's personal life provides subject
matter for his art. She warns that imputing esotericism to Dove or his works is
a mistake. She praises the artist's technical mastery, as well as the craftsmanship
that he bestows on his frames.

250 Morgan, Ann Lee. " 'A Modest Young Man with Theories': Arthur Dove
in Chicago." In *The Old Guard and the Avant-Garde: Modernism in Chicago,
1910–1940*, edited by Sue Ann Prince, 23–37. Chicago: University of Chicago
Press, 1990.

Morgan explores the contemporary critical reaction to the exhibition *Paintings
of Arthur Dove*, held at the W. Scott Thurber Galleries, Chicago, 14–30 March
1912, which was identical to the exhibition *Arthur G. Dove First Exhibition
Anywhere*, held at the Photo-Secession Galleries, New York, 27 February–12
March 1912.

251 _____. "An Encounter and Its Consequences: Arthur Dove and Alfred
Stieglitz, 1910–1925." *Biography: An Interdisciplinary Quarterly* 2:1 (1979)
35–59.

Morgan's biographical essay focuses on Dove's early career, with an emphasis on his personal and professional relationships with Stieglitz.

252 _____. "New Discoveries in American Art: Early Landscapes by Arthur
Dove Found in Paris," edited by Jayne A. Kuchna. *The American Art Journal*
20:4 (1988) 100–101.

Morgan discusses two recently discovered landscapes painted by Dove in an
Impressionist style during a 1908–1909 stay in France.

253 "Museum Buys Four Arthur Doves from Show." *The Art Digest* 9 (15
May 1935) 16.

Notice of Duncan Phillips' purchase of four Dove paintings for the Phillips
Memorial Gallery from the artist's April–May 1935 exhibition at An American
Place. Excerpts from two reviews of the exhibition are reprinted: Elizabeth
McCausland (*Springfield Sunday Union and Republican*) and Carlyle Burrows
(*New York Herald Tribune*).

254 Myers, Fred A. "Tree Forms: Arthur G. Dove (1880–1946)." *Carnegie Magazine* 41 (February 1967) 69.

A commentary on Dove's *Tree Forms* of ca. 1928, a gift of Mr. and Mrs. James H. Beal to the Carnegie Museum of Art, Pittsburgh.

255 Phillips, Duncan. "The Art of Arthur G. Dove." In *New Directions in Prose and Poetry*, no. 11, 509–512. New York: New Directions, 1947.

Phillips celebrates Dove as a pioneering and visionary American artist by writing, "In his spontaneously conceived and joyously executed designs—the aesthetic form, the poetic concept or caprice and the material substance or texture are all one. Each canvas has its own magic of color and surface, its own rightness in adapting exceptional means to unique ends." Six works are illustrated in black and white, accompanied by Phillips' comments.

256 _____. "Arthur G. Dove, 1880–1946." *Magazine of Art* 40 (May 1947) 192–197.

An important assessment of Dove's achievement by one of his leading patrons, who writes, "He was a visionary and a nature poet like Ryder but he was also a craftsman who loved a good job of painting for its own sake."

257 Rosenfeld, Paul. "Arthur G. Dove." In *Port of New York*, by Paul Rosenfeld, 167–174. New York: Harcourt, Brace, 1924.

Rosenfeld discusses what he sees as the strengths and shortcomings of Dove's work.

258 _____. "The World of Arthur G. Dove." *Creative Art* 10 (June 1932) 426–430.

Rosenfeld analyzes Dove's work with reference to his "strangely poetic images," "bold and still enigmatical designs," "mysterious" colors, and "religious, ecstatic, sibylline" rhythms. Rosenfeld feels that the power of Dove's canvases rests in his ability to articulate and objectify his private psychic states, which evoke a universal response in the viewer.

259 Roth, Evan. "Recent Acquisitions—Dove Painting and Studies: National Museum of American Art." *Museum News* 69 (May/June 1990) 48–49.

A brief notice of the acquisition of Dove's *Sun*, a wax emulsion on canvas of 1943 (along with two preparatory studies), by the National Museum of American Art, Washington, D.C.

260 Shackleford, George T.M. "Two Watercolors by Arthur Dove." *Yale University Art Gallery Bulletin* 37 (Spring 1980) 8–9.

Shackelford comments on two Dove watercolors in the collection of the Yale University Art Gallery, both gifts of George Hopper Fitch: *Steam Shovel—Port Washington* of 1931 and *Beach* of 1940.

261 Wimsatt, Justine S. "Wax Emulsion, Tempera or Oil? Arthur Dove's Materials, Techniques and Surface Effects." In *The American Institute for Conservation of Historic and Artistic Works: Preprints of Papers Presented at the Tenth Annual Meeting, Milwaukee, Wisconsin, 26–30 May, 1982*, 183–188. Washington, D.C.: The Institute, 1982.

Wimsatt discusses Dove's materials and techniques in the context of sixty works examined and treated by the Washington Conservation Studio of Kensington, Maryland. The works consisted of thirteen watercolors, two collages, one pastel, and forty-four paintings in oil, tempera, or wax emulsion (the majority owned by the Phillips Collection). Wimsatt utilizes Dove's correspondence, diaries, and marginalia to gain insight into his working methods.

262 Yeh, Susan Fillin. "Innovative Moderns: Arthur G. Dove and Georgia O'Keeffe." *Arts Magazine* 56 (June 1982) 68–72.

Yeh contends that both Dove and O'Keeffe were influenced by the Symbolist and the Arts and Crafts movements, as well as by Stieglitz's closely cropped cloud photographs. She focuses on a number of pairs of works by the two artists that she feels support her argument, including O'Keeffe's *From the Plains #1* of 1919 and Dove's *Team of Horses* of 1911. Yeh points out that these influences, in addition to the theoretical writings of Kandinsky, led Dove to construct nongeometrical abstract images by refining motifs found in nature.

263 Zilczer, Judith. "Synaesthesia and Popular Culture: Arthur Dove, George Gershwin, and the 'Rhapsody in Blue.'" *Art Journal* 44 (Winter 1984) 361–366.

Zilczer explores Dove's lifelong interest in both popular music, particularly jazz, and the notion of synaesthesia, or the subjective interactions of sensory perceptions. She focuses on two of Dove's works executed in 1927 that were inspired by his admiration for George Gershwin (the collage panel *Rhapsody in Blue, Part I—George Gershwin* and the painting *Rhapsody in Blue, Part II—George Gershwin*) and discusses their cultural context, compositional elements, jazz motifs, and critical reception.

IV. EXHIBITION REVIEWS

264 Haviland, Paul B. "Photo-Secession Notes: Exhibition of Pastels by Arthur G. Dove." *Camera Work* no. 38 (April 1912) 36, 44–45.

Review of *Arthur G. Dove First Exhibition Anywhere*, held at the Photo-Secession Galleries, New York, 27 February–12 March 1912. Also includes reprinted reviews by J. Edgar Chamberlin (*New York Evening Mail*) and Arthur Hoeber (*Globe and Commercial Advertiser*).

265 Merick, L. "Exhibitions Now On: Dove's Form and Color." *American Art News* 10 (2 March 1912) 2.
 Review. See entry 264.

266 Frank, Waldo. "The Art of Arthur Dove." *The New Republic* 45 (27 January 1926) 269–270.
 Review of the exhibition *Arthur G. Dove*, held at the Intimate Gallery, New York, 11 January–7 February 1926.

267 Pemberton, Murdock. "The Art Galleries." *The New Yorker* 2 (13 February 1926) 24.
 Review. See entry 266.

268 "Reviews of Current Exhibitions—Arthur Dove: Intimate Gallery." *The Art News* 24 (16 January 1926) 7.
 Review. See entry 266.

269 Watson, Forbes. "New York Exhibitions: Arthur Dove." *The Arts* 9 (February 1926) 100.
 Review. See entry 266.

270 "Exhibitions in New York—Arthur G. Dove: Intimate Gallery." *The Art News* 26 (24 December 1927) 9.
 Review of the exhibition *Arthur G. Dove Paintings*, held at the Intimate Gallery, New York, 12 December 1927–11 January 1928.

271 Mannes, Marya. "Gallery Notes." *Creative Art* (January 1928) xvii.
 Review. See entry 270.

272 Pemberton, Murdock. "The Art Galleries: Dove Comes to Terms—A Bursting Week of First-Class Things." *The New Yorker* 3 (24 December 1927) 57–58.
 Review. See entry 270.

273 "Exhibitions in New York—Arthur G. Dove: Intimate Gallery." *The Art News* 27 (20 April 1929) 10.
 Review of the *Dove Exhibition*, held at the Intimate Gallery, New York, 9–28 April 1929.

274 Moore, Dorothy Lefferts. "Exhibitions in New York." *The Arts* 15 (May 1929) 339–340.
 Review. See entry 273.

275 Pemberton, Murdock. "The Art Galleries." *The New Yorker* 5 (20 April 1929) 106–107.
Review. See entry 273.

276 "Exhibitions in New York—Arthur Dove: An American Place." *The Art News* 28 (5 April 1930) 12.
Review of the exhibition *Arthur G. Dove*, held at An American Place, New York, 22 March–22 April 1930.

277 Pemberton, Murdock. "The Art Galleries: With and without Labels—Some Primitives—Opportunity's Choice—Still Another Museum." *The New Yorker* 6 (5 April 1930) 85.
Review. See entry 276.

278 "Exhibitions in New York—Arthur Dove: An American Place." *The Art News* 29 (21 March 1931) 12.
Review of the exhibition *Arthur G. Dove, 27 New Paintings*, held at An American Place, New York, 9 March–4 April 1931.

279 Pemberton, Murdock. "The Art Galleries: New Doves." *The New Yorker* 7 (21 March 1931) 64–65.
Review. See entry 278.

280 Bennett, Rainey. "On View in the New York Galleries: Arthur Dove—An American Place." *Parnassus* 4 (April 1932) 16–17.
Review of the exhibition *Arthur G. Dove: New Paintings (1931–1932)*, held at An American Place, New York, 14 March–9 April 1932.

281 "Exhibitions in New York—Arthur Dove: An American Place." *The Art News* 30 (19 March 1932) 9.
Review. See entry 280.

282 Mumford, Lewis. "The Art Galleries: For the Elect—One of Daniel's Young Men—Children and Flowers." *The New Yorker* 8 (26 March 1932) 34.
Review. See entry 280.

283 Shelby, Melvin Geer. "Around the Galleries—An American Place." *Creative Art* 10 (May 1932) 395–396.
Review. See entry 280.

284 "Exhibitions in New York: Arthur Dove, Helen Torr—An American Place." *The Art News* 31 (25 March 1933) 5.
Review of the exhibition *Arthur G. Dove, Helen Tor, New Paintings and Watercolors*, held at An American Place, New York, 20 March–15 April 1933.

285 Mumford, Lewis. "The Art Galleries: Cabarets and Clouds." *The New Yorker* 9 (1 April 1933) 38–39.
 Review. See entry 284.

286 Mumford, Lewis. "The Art Galleries: Surprise Party—Wit and Water Colors." *The New Yorker* 10 (5 May 1934) 56.
 Review of the exhibition *Arthur G. Dove: New Things and Old*, held at An American Place, New York, 17 April–15 May 1934 (extended to 1 June 1934).

287 Mumford, Lewis. "The Art Galleries: A Group of Americans." *The New Yorker* 11 (4 May 1935) 31–32.
 Review of the exhibition *Arthur G. Dove: Exhibition of Paintings (1934–1935)*, held at An American Place, New York, 21 April–22 May 1935.

288 Mumford, Lewis. "The Art Galleries: The Independent Show." *The New Yorker* 12 (2 May 1936) 43–44.
 Review of the exhibition *New Paintings by Arthur G. Dove*, held at An American Place, New York, 20 April–20 May 1936.

289 Sayre, Ann H. "New Exhibitions of the Week—Arthur G. Dove Seeks Cosmic Rhythms." *The Art News* 34 (9 May 1936) 8.
 Review. See entry 288.

290 Lowe, Jeannette. "New Exhibitions of the Week—Abstractions of Nature by Arthur G. Dove." *The Art News* 35 (10 April 1937) 15–16.
 Review of the exhibition *Arthur G. Dove: New Oils and Water Colors*, held at An American Place, New York, 23 March–16 April 1937.

291 Mumford, Lewis. "The Art Galleries: Academicians and Others." *The New Yorker* 13 (10 April 1937) 50.
 Review. See entry 290.

292 Coates, Robert, M. "The Art Galleries: Outdoor Sculpture—The Venetians—Arthur Dove." *The New Yorker* 14 (23 April 1938) 45.
 Review of *Arthur G. Dove: Exhibition of Recent Paintings, 1938*, held at An American Place, New York, 29 March–10 May 1938.

293 Davidson, Martha. "New Exhibitions of the Week—Arthur G. Dove: The Fulfillment of a Long Career." *The Art News* 36 (7 May 1938) 16.
 Review. See entry 292.

294 Coates, Robert M. "The Art Galleries: Americans in Retrospective." *The New Yorker* 15 (29 April 1939) 87.

Review of *Arthur G. Dove: Exhibition of Oils and Temperas*, held at An American Place, New York, 10 April–17 May 1939.

295 Lowe, Jeannette. "New Exhibitions of the Week: Dove's Compositions in Oil and Montage." *The Art News* 37 (13 May 1939) 15.
 Review. See entry 294.

296 Coates, Robert M. "The Art Galleries: News from All Over." *The New Yorker* 16 (20 April 1940) 52.
 Review of *Arthur G. Dove: Exhibition of New Oils and Watercolors*, held at An American Place, New York, 30 March–14 May 1940.

297 Lowe, Jeannette. "New Exhibitions of the Week—A. Dove's Semi-Abstract Landscapes." *The Art News* 38 (13 April 1940) 13.
 Review. See entry 296.

298 McCausland, Elizabeth. "Exhibitions in New York—Arthur G. Dove: An American Place." *Parnassus* 12 (May 1940) 43.
 Review. See entry 296.

299 Rosenfeld, Paul. "Art—Dove and the Independents." *The Nation* 150 (27 April 1940) 549.
 Review. See entry 296.

300 Coates, Robert M. "The Art Galleries: The Impressionists." *The New Yorker* 65 (12 April 1941) 65.
 Review of the *Exhibition of New Arthur G. Dove Paintings*, held at An American Place, New York, 27 March–17 May 1941.

301 Lane, James W. "The Passing Shows: Arthur Dove." *Art News* 40 (1–14 May 1941) 28.
 Review. See entry 300.

302 Lane, James W. "The Passing Shows: Dove, Abstract Poet of Color." *Art News* 41 (15–31 May 1942) 21–22.
 Review of *Arthur G. Dove: Exhibition of Recent Paintings (1941–1942)*, held at An American Place, New York, 14 April–27 May 1942.

303 "The Passing Shows." *Art News* 42 (1–14 March 1943) 23.
 Review of the exhibition *Arthur G. Dove: Paintings—1942–43*, held at An American Place, New York, 11 February–17 March 1943 (extended to 25 March 1943).

304 Riley, Maude. "Arthur Dove at An American Place." *The Art Digest* 17 (1 March 1943) 9.
 Review. See entry 303.

305 Coates, Robert M. "The Art Galleries: Those Abstractionists Again." *The New Yorker* 20 (8 April 1944) 62, 64.
 Review of the exhibition *Arthur G. Dove Paintings—1944*, held at An American Place, New York, 21 March–21 May 1944.

306 "The Passing Shows." *Art News* 43 (1–14 May 1944) 19.
 Review. See entry 305.

307 "The Passing Shows." *Art News* 44 (15–31 May 1945) 7.
 Review of the exhibition *Arthur G. Dove Paintings—1922–1944*, held at An American Place, New York, 3 May–15 June 1945.

308 Riley, Maude. "Latest Doves Make Strong Impression." *The Art Digest* 19 (1 June 1945) 14.
 Review. See entry 307.

309 "Reviews and Previews." *Art News* 45 (June 1946) 50.
 Review of the exhibition *Recent Paintings (1946): Arthur G. Dove*, held at An American Place, New York, 4 May–4 June 1946.

310 Wolf, Ben. "Dove, Valid Modern." *The Art Digest* 20 (1 June 1946) 14.
 Review. See entry 309.

311 Coates, Robert M. "The Art Galleries: Arthur Dove, Walter Murch, Peter Blume." *The New Yorker* 22 (18 January 1947) 60.
 Review of the *Dove Retrospective Exhibition, Paintings: 1908 to 1946*, held at the Downtown Gallery, New York, 7–25 January 1947 (extended to 1 February 1947).

312 Hess, Thomas B. "Spotlight On: Dove." *Art News* 45 (January 1947) 23, 62.
 Review. See entry 311.

313 "Rising Moon Oil Painting by Arthur G. Dove." *American Artist* 11 (March 1947) 40.
 Review. See entry 311.

314 Wolf, Ben. "Retrospective Exhibition Given Arthur Dove." *The Art Digest* 21 (15 January 1947) 10.
 Review. See entry 311.

315 Breuning, Margaret. "Dove Makes Posthumous Watercolor Debut." *The Art Digest* 23 (15 May 1949) 13.
Review of *An Exhibition of Watercolors 1929–1946 by Arthur G. Dove*, held at the Downtown Gallery, New York, 3–21 May 1949.

316 Coates, Robert M. "The Art Galleries: Water Colors in Brooklyn." *The New Yorker* 25 (14 May 1949) 83.
Review. See entry 315.

317 LaFarge, Henry. "Reviews and Previews." *Art News* 48 (May 1949) 43.
Review. See entry 315.

318 Coates, Robert M. "The Art Galleries: Seventeen Men." *The New Yorker* 28 (3 May 1952) 86.
Review of the exhibition *Arthur G. Dove (1880–1946): Paintings*, held at the Downtown Gallery, New York, 22 April–10 May 1952.

319 Fitzsimmons, James. "Dove's Abstract Nature." *Art Digest* 26 (1 May 1952) 16.
Review. See entry 318.

320 Porter, Fairfield. "Reviews and Previews." *Art News* 51 (May 1952) 46.
Review. See entry 318.

321 Breuning, Margaret. "Fortnight in Review: Charles Demuth/Arthur Dove." *Art Digest* 28 (15 April 1954) 20.
Review of the *Dove/Demuth Watercolor Retrospective*, held at the Downtown Gallery, New York, 31 March–24 April 1954.

322 Guest, Barbara. "Reviews and Previews." *Art News* 53 (April 1954) 43.
Review. See entry 321.

323 "Art: The Alchemist." *Time* 64 (8 November 1954) 89.
Review of *Arthur G. Dove 1880–1946: A Retrospective Exhibition*, held at the Andrew Dickson White Museum of Art, Cornell University, Ithaca, New York, 2–28 November 1954.

324 George, LaVern. "Arthur Dove." *Arts Digest* 29 (15 December 1954) 11.
Review. See entry 323.

325 George, LaVern. "In the Galleries: Arthur Dove." *Arts* 30 (November 1955) 50.
Review of the exhibition *Collages: Dove*, held at the Downtown Gallery, New York, 1–26 November 1955.

326 O'Hara, Frank. "Reviews and Previews." *Art News* (November 1955) 52.
Review. See entry 325.

327 Coates, Robert M. "The Art Galleries: Five and One." *The New Yorker*
32 (10 March 1956) 120–121.
Review of the *Special Exhibition of Paintings by Dove*, held at the Downtown
Gallery, New York, 28 February–24 March 1956.

328 George, LaVern. "In the Galleries: Arthur Dove." *Arts* 30 (March 1956)
57.
Review. See entry 327.

329 Porter, Fairfield. "Reviews and Previews." *Art News* 55 (March 1956) 50.
Review. See entry 327.

330 Seckler, Dorothy Gees. "Gallery Notes: Five Decades of Renewal." *Art
in America* 44 (Spring 1956) 57.
Review. See entry 327.

331 Soby, James Thrall. "The Fine Arts: Arthur Dove and Morris Graves."
Saturday Review 39 (7 April 1956) 32–33.
Review. See entry 327.

332 Kramer, Hilton. "Month in Review." *Arts* 33 (October 1958) 49.
Review of the exhibition *Dove: First Public Presentation, Group of Water-
colors 1929–46*, held at the Downtown Gallery, New York, 30 September–11
October 1958.

333 "Art—Music of the Eye." *Time* 72 (20 October 1958) 84.
Review of the exhibition *Arthur G. Dove*, as staged at the Whitney Museum
of American Art, New York, 30 September–16 November 1958.

334 Hoffmann, Edith. "Current and Forthcoming Exhibitions: New York." *The
Burlington Magazine* 100 (November 1958) 406.
Review. See entry 333.

335 Ray, Martin W. "Arthur G. Dove, 'The Boldest . . . Pioneer.' " *Arts* 32
(September 1958) 34–41.
Review. See entry 333.

336 Campbell, Lawrence. "Dove: Delicate Innovator." *Art News* 57 (October
1958) 28–29, 57–58.
Reviews. See entries 332 and 333.

337 Coates, Robert. M. "The Art Galleries: Arthur G. Dove." *The New Yorker* 34 (11 October 1958) 181–184.
Reviews. See entries 332 and 333.

338 "Art—Painting the Coo." *Newsweek* 58 (14 August 1961) 52.
Review of the exhibition *Paintings and Water Colors by Arthur G. Dove Lent by the William H. Lane Foundation*, held at the Worcester Art Museum, Worcester, Massachusetts, 27 July–17 September 1961.

339 "Art—Pioneer Abstractionist." *Time* 78 (11 August 1961) 42–43, 45.
Review. See entry 338.

340 Kroll, Jack. "Reviews and Previews." *Art News* 60 (December 1961) 11.
Review of the exhibition *Arthur Dove: First Showing of Early Major Drawings and Color Studies in Form*, held at the Downtown Gallery, New York, 14 November–2 December 1961.

341 Preston, Stuart. "Current and Forthcoming Exhibitions: New York." *The Burlington Magazine* 194 (January 1962) 42.
Review. See entry 340.

342 Tillim, Sidney. "New York Exhibitions: In the Galleries—Arthur Dove." *Arts Magazine* 36 (January 1962) 43.
Review. See entry 340.

343 Johnson, Dorothy Rylander. "The Collages of Arthur Dove." *Artforum* 5 (May 1967) 40–41.
Review of the exhibition *Arthur Dove: The Years of Collage*, held at the University of Maryland Art Gallery, J. Millard Tawes Fine Arts Center, College Park, 13 March–19 April 1967.

344 Downes, Rackstraw. "Reviews and Previews." *Art News* 66 (May 1967) 12.
Review of the exhibition *Arthur G. Dove Paintings 1911–1946*, held at the Downtown Gallery, New York, 15 March–8 April 1967.

345 Kramer, Hilton. "The Loneliness of Arthur Dove." In *The Age of the Avant-Garde: An Art Chronicle of 1956–1972*, by Hilton Kramer, 278–281. New York: Fararr, Straus and Giroux, 1973.
Review (reprinted from the *New York Times*, 19 March 1967). See entry 344.

346 Ratcliff, Carter. "New York." *Art International* 14 (Summer 1970) 139.
Review of the exhibition *Arthur G. Dove: Watercolors and Drawings*, held at Terry Dintenfass, New York, 31 March–25 April 1970.

347 ———. "Reviews and Previews." *Art News* 69 (May 1970) 28.
Review. See entry 346.

348 Campbell, Lawrence. "Reviews and Previews: Arthur G. Dove." *Art News* 69 (January 1971) 18.
Review of the exhibition *Arthur G. Dove: Collages*, held at Terry Dintenfass, New York, 22 December 1970–23 January 1971.

349 Marandel, J. Patrice. "Lettre de New York." *Art International* 15 (20 March 1971) 54–55.
Review (text in French). See entry 348.

350 Pincus-Witten, Robert. "New York: Arthur Dove, Dintenfass Gallery." *Artforum* 9 (March 1971) 61.
Review. See entry 348.

351 Beckley, Bill. "Reviews and Previews." *Art News* 70 (February 1972) 14.
Review of *Arthur G. Dove: Exhibition of Paintings, 1917–1946*, held at Terry Dintenfass, New York, 1–26 February 1972.

352 Hancock, Marianne. "In the Galleries: Arthur Dove." *Arts Magazine* 46 (March 1972) 65.
Review. See entry 351.

353 Anderson, Alexandra. "New York Reviews: Arthur Dove." *Art News* 74 (February 1975) 103–104.
Review of the exhibition *Essences: Arthur G. Dove*, held at Terry Dintenfass, New York, 28 January–22 February 1975.

354 Bell, Jane. "Arthur Dove." *Arts Magazine* 49 (February 1975) 78.
Review. See entry 353.

355 Derfner, Phyllis. "New York Letter." *Art International* 19 (20 April 1975) 59–60.
Review. See entry 353.

356 Alloway, Lawrence. "Art." *The Nation* 222 (17 January 1976) 62.
Review of the exhibition *Arthur Dove*, held at the San Francisco Museum of Art, San Francisco, 21 November 1974–5 January 1975 (this review pertains to the exhibition as shown at the Whitney Museum of American Art, New York, 24 November 1975–18 January 1976).

357 Anderson, Alexandra C. "Arthur G. Dove: Abstracting Energy from Nature." *Art News* 75 (April 1976) 82–84.
Review. See entry 356.

358 "Art across North America—Outstanding Exhibitions: The Daring of Dove." *Apollo* 103 (May 1976) 440–441.
Review. See entry 356.

359 Bremer, Nina. "The Whitney Museum of American Art Exhibition: Retrospective Exhibition of Arthur Dove." *Pantheon* 34 (April–May–June 1976) 166.
Review. See entry 356.

360 Frankenstein, Alfred. "Arthur Dove: Abstraction at Will." *Art in America* 63 (March–April 1975) 58–61.
Review (as shown in San Francisco). See entry 356.

361 Hughes, Robert. "Art—Prophet and Poet of the Abstract." *Time* 105 (3 February 1975) 52–54.
Review (as shown in San Francisco). See entry 356.

362 Jordan, Jim M. "Arthur Dove and the Nature of the Image." *Arts Magazine* 50 (February 1976) 89–91.
Review. See entry 356.

363 Meador, Shirley. "Arthur G. Dove: Ahead of His Time." *American Artist* 39 (November 1975) 48–53, 93–95.
Review. See entry 356.

364 Schwartz, Sanford. "On Arthur Dove." *Artforum* 14 (February 1976) 28–33. Reprinted in *The Art Presence*, by Sanford Schwartz, 64–72. New York: Horizon Press, 1982.
Review. See entry 356.

365 Derfner, Phyllis. "New York Letter." *Art International* 20 (January/February 1976) 56.
Review of a Dove exhibition held at the Andrew Crispo Gallery, New York, November 1975.

366 Lorber, Richard. "Arts Reviews: Arthur Dove." *Arts Magazine* 50 (January 1976) 13.
Review. See entry 365.

367 Lubin, Mary Ann. "Arthur Dove." *Arts* 54 (April 1980) 12.
Review of the exhibition *Arthur G. Dove: Singular Works*, held at Terry Dintenfass, New York, 8 January–15 February 1980.

368 Klein, Ellen Lee. "Arts Reviews: Arthur Dove." *Arts Magazine* 59 (March 1985) 39.

Review of an exhibition staged concurrently at three New York venues, 3 November–29 December 1984: *Arthur G. Dove: Paintings, Drawings and Collages* (Terry Dintenfass); *Arthur G. Dove: Paintings and Watercolors* (Salander-O'Reilly Galleries); and *Arthur G. Dove: Paintings and Related Watercolors* (Barbara Mathes Gallery).

369 Stretch, Bonnie Barrett. "The Enigmatic Arthur Dove." *Art News* 84 (January 1985) 90–95.
 Review. See entry 368.

370 Westfall, Stephen. "Abstract Naturalism: Arthur Dove." *Art in America* 73 (May 1985) 124–133.
 Review. See entry 368.

371 Brock, Hovey. "Reviews—New York: Walter Anderson and Arthur Dove." *Art News* 91 (October 1992) 137.
 Review of the exhibition *The Nature of Nature: Walter Anderson/Arthur Dove*, held at the Luise Ross Gallery, New York, 5 March–30 April 1992.

372 Larson, Kay. "Art—Natural Man." *New York* 25 (20 April 1992) 96.
 Review. See entry 371.

373 Stein, Deidre. "Reviews—New York: Arthur Dove." *Art News* 92 (Summer 1993) 174.
 Review of the exhibition *Arthur G. Dove: Pastels, Charcoals, Watercolors*, held at the Terry Dintenfass Gallery, New York, 6 February–13 March 1993.

374 "Arthur Dove: A Retrospective." *American Art Review* 9 (November 1997) 182–187.
 Review of the exhibition *Arthur Dove: A Retrospective*, held at the Phillips Collection, Washington, D.C., 20 September 1997–4 January 1998.

375 Berman, Avis. "The Quiet Man of American Modernism." *Smithsonian* 28 (November 1997) 122–128, 130, 132.
 Review. See entry 374.

376 Hughes, Robert. "Art: Embedded in Nature." *Time* 150 (22 December 1997) 83, 86.
 Review. See entry 374.

377 Johnson, Mark M. "Arthur Dove: A Retrospective Exhibition." *Arts and Activities* 122 (December 1997) 16–19.
 Review. See entry 374.

378 Loughery, John. "Subject Matter in Modern Art." *The Hudson Review* 51 (Summer 1998) 389.

Review. See entry 374. This review pertains to the exhibition staged at the Whitney Museum of American Art, New York, 15 January–12 April 1998.

379 Naves, Mario. "Levelheaded Mysticism: Arthur Dove at the Whitney." *The New Criterion* 16 (March 1998) 50–52.

Review. See entry 378.

380 Plagens, Peter. "Arthur Dove: Whitney Museum of American Art." *Artforum* 36 (April 1998) 109.

Review. See entry 378.

380A Silberman, Robert. "Exhibition Reviews—New York and Minneapolis: Arthur Dove and Marsden Hartley." *The Burlington Magazine* 140 (July 1998) 506–507.

Review. See entry 378.

381 Stevens, Mark. "Art: The Quiet American." *New York* 31 (26 January 1998) 46–47.

Review. See entry 378.

382 Unger, Miles. "O Pioneer: The Art of Arthur Dove." *Art New England* 19 (April–May 1998) 21–23.

Review. See entry 374. This review pertains to the exhibition as staged at the Addison Gallery of American Art, Andover, Massachusetts, 25 April–12 July 1998.

383 Updike, John. "Pioneer—Arthur Dove: A Retrospective." *The New York Review of Books* 45 (5 March 1998) 14–16.

Review. See entry 378.

384 Wallis, Stephen. "In Review: The Natural." *Art and Antiques* 20 (October 1997) 117–121.

Review, as staged at the Phillips Collection. See entry 379.

385 Weil, Rex. "Reviews—National—Washington, D.C.: Arthur Dove—The Phillips Collection." *Art News* (December 1997) 167.

Review. See entry 374.

385A Moorman, Margaret. "Reviews—Up Now: Arthur Dove." *Art News* 97 (February 1998) 116.

Review of the exhibition *Arthur Dove: Works on Paper*, held at the Tibor de Nagy Gallery, New York, 8 January–7 February 1998.

V. REFERENCE SOURCES

386 *Allgemeines Lexikon der bildenden Künstler des XX. Jahrhunerts*, edited by Hans Vollmer. Leipzig: E.A. Seeman, 1953–1962. S.v. "Dove, Arthur."

387 *American National Biography*, edited by John A. Garraty and Mark C. Carnes. New York: Oxford University Press, 1998. S.v. "Dove, Arthur Garfield," by Catherine McNickle Chastain.

388 "Arthur G. Dove—Painter." In *The Index of Twentieth Century Artists, 1933–1937*, 512–513, 525. New York: Arno Press, 1970.

389 "Arthur Garfield Dove (1880–1946)." In *American Art Analog*, 807. New York: Chelsea House, in association with American Art Analog, 1986.

390 *Atlantic Brief Lives: A Biographical Companion to the Arts*, edited by Louis Kronenberger. Boston: Little, Brown, 1971. S.v. "Dove, Arthur Garfield."

391 Baigell, Matthew. *Dictionary of American Art*. New York: Harper and Row, 1979. S.v. "Dove, Arthur G. (1880–1946)."

392 Bénézit, E. *Dictionaire critique et documentaire des Peintres, Sculpteurs, Dessinateurs et Graveurs de tous les temps et de tous les pays*, nouvelle éd. Paris: Gründ, 1976. S.v. "Dove (Arthur Garfield)."

393 Castagno, John. *Artists as Illustrators: An International Directory with Signatures and Monograms, 1800–Present*. Metuchen, N.J.: Scarecrow, 1989. S.v. "Dove, Arthur Garfield."

394 *Chambers Biographical Dictionary*. 6th ed., edited by Melanie Parry. Edinburgh, Scotland, and New York: Chambers, 1997. S.v. "Dove, Arthur Garfield."

395 Chilvers, Ian. *A Dictionary of Twentieth-Century Art*. Oxford and New York: Oxford University Press, 1998. S.v. "Dove, Arthur (1880–1946)."

396 *Contemporary Artists*, edited by Colin Naylor and Genesis P-Orridge. New York: St. Martin's Press, 1977. S.v. "Dove, Arthur Garfield."

397 Cummings, Paul. *The Dictionary of Contemporary American Artists*, 6th ed. New York: St. Martin's Press, 1994. S.v. "Dove, Arthur G."

398 *The Dictionary of Art*, edited by Jane Turner. New York: Grove's Dictionaries, 1996. S.v. "Dove, Arthur (Garfield)," by Barbara Haskell.

399 *Dictionary of American Biography*. Suppl. Four, *1946–1950*, edited by John A. Garraty and Edward T. James. New York: Scribner's, 1974. S.v. "Dove, Arthur Garfield," by Frederick S. Wight.

400 *Dictionary of Literary Biography*. Vol. 188, *American Book and Magazine Illustrators to 1920*, edited by Steven E. Smith, Catherine A. Hastedt, and Donald H. Dyal. Detroit and Washington, D.C.: Gale Research, 1998. S.v. "Arthur G. Dove (1880–1946)," by Phyllis Peet.

401 *Dictionary of Modern Painting*. 3d ed., edited by Carlton Lake and Robert Maillard. New York: Tudor, 1964. S.v. "Dove, Arthur G.," by John Ashbery.

402 *Encyclopedia of American Art*. New York: E.P. Dutton, 1981. S.v. "Dove, Arthur G. (1880–1946)," by David W. Scott.

403 Fielding, Mantle. *Mantle Fielding's Dictionary of American Painters, Sculptors and Engravers*. New York: Apollo, 1986. S.v. "Dove, Arthur G."

404 Gowing, Lawrence. *A Biographical Dictionary of Artists*, rev. ed. New York: Facts on File, 1995. S.v. "Dove, Arthur, 1880–1946."

405 *McGraw-Hill Dictionary of Art*, edited by Bernard S. Myers. New York: McGraw-Hill, 1969. S.v. "Dove, Arthur Garfield," by Jerome Viola.

406 *The Oxford Companion to Art*, edited by Harold Osborne. London: Oxford University Press, 1970. S.v. "Dove, Arthur (1880–1946)."

407 *The Oxford Companion to Twentieth-Century Art*, edited by Harold Osborne. Oxford and New York: Oxford University Press, 1981. S.v. "Dove, Arthur Garfield (1880–1946)."

408 *The Oxford Dictionary of Art*, edited by Ian Chilvers and Harold Osborne. New ed. Oxford and New York: Oxford University Press, 1997. S.v. "Dove, Arthur (1880–1946)."

409 *Petit Larousse de la Peinture*, sous la direction de Michel Laclotte. Paris: Larousse, 1979. S.v. "Dove (Arthur Garfield)," by Daniel Robbins.

410 *Phaidon Dictionary of Twentieth-Century Art*. London and New York: Phaidon Press, 1973. S.v. "Dove, Arthur Garfield."

411 *Praeger Encyclopedia of Art*. New York: Praeger, 1971. S.v. "Dove, Arthur G.," by John Ashbery.

412 Seuphor, Michel. *Dictionary of Abstract Painting with a History of Abstract Painting*. New York: Tudor, 1957. S.v. "Dove, Arthur G."

413 *The Thames and Hudson Dictionary of Art and Artists*, rev., expanded, and updated by Nikos Stangos; Herbert Read, consulting ed. New York: Thames and Hudson, 1994. S.v. "Dove, Arthur G(arfield) (1880– 1946)."

414 *Who Was Who in American Art, 1564–1975: 400 Years of Artists in America*. Edited by Peter Hastings Falk. Madison, Conn.: Sound View Press, 1999. S.v. "Dove, Arthur G(arfield)."

415 *Who's Who in American Art*. Vol. 3, *For the Years 1940–41*. Washington, D.C.: American Federation of Arts, 1940. S.v. "Dove, Arthur G."

VI. ARCHIVAL SOURCES

416 Archives of American Art. *The Archives of American Art: Collection of Exhibition Catalogs*. Boston: G.K. Hall, 1979. S.v. "Dove, Arthur."

417 ———. *The Card Catalog of the Manuscript Collections of the Archives of American Art*. Wilmington, Del.: Scholarly Resources, 1980. S.v. "Dove, Arthur."

418 ———. *The Card Catalog of the Manuscript Collections of the Archives of American Art, Supplement 1981–1984*. Wilmington, Del.: Scholarly Resources, 1985. S.v. "Dove, Arthur."

This circulating microfilm collection contains extensive resources on Dove, including the Downtown Gallery Papers; the Elizabeth McCausland Papers; the Whitney Museum Papers; exhibition catalogues and announcements; photographs of artwork; collections of the artist's personal and professional correspondence (including material from the Phillips Collection), as well as his diaries; the Helen Dove (née Torr) Diaries; typescript of a revised M.A. thesis on Dove (1976) by Suzanne M. Smith (née Mullett), in addition to her provenance records of about 700 of Dove's paintings and sketches (1890–1943), which were compiled for the American Art Research Council (see entry 432). The catalog is searchable through SIRIS (Smithsonian Institution Research Information System) via the Internet.

418A Collection of American Literature. Beinecke Rare Book and Manuscript Library, Yale University, New Haven, Conn.

The Beinecke Library, which hosts an excellent Internet site, is the repository for a large collection of correspondence between Dove and Stieglitz (see entry 196).

419 Inventory of American Paintings. National Museum of American Art. Smithsonian Institution, Washington, D.C.

This database, which is searchable through SIRIS (see entries 416–418), contains ninety-five entries for Dove's paintings from public and private collections. Each entry provides the title of the work; date of execution; medium; dimensions; subject; present owner; references; illustration (bibliographic citation to source); file; and record ID.

420 The Phillips Collection, Washington, D.C.

The collection contains correspondence between Duncan Phillips and Dove dating from 1927 to 1943 and is available on microfilm from the Archives of American Art (see entries 417–418).

420A Sherwood Anderson Papers. Newberry Library, Chicago.

The papers contain eight items of correspondence from Dove to Anderson dating from ca. 1924 to 1942.

421 Van Wyck Brooks Papers. Van Pelt Library, University of Pennsylvania, Philadelphia.

The collection contains four undated items of correspondence from Dove to Brooks (one accompanied by an envelope bearing a 1935 postmark).

VII. DISSERTATIONS AND THESES

422 Cohn, Sherrye Baker. "The Dialectical Vision of Arthur Dove: The Impact of Science and Occultism on His American Art." Ph.D. diss., Washington University, 1982.

423 Edgar, Lucia Louise Clark. "Arthur Dove: A Study of the Relationship between Abstraction and Nature Imagery in Early 20th Century American Painting." M.A thesis, Vanderbilt University, 1979.

424 Fox, Kathleen Marie. "Echoes of Existence." M.F.A. thesis, University of Notre Dame, 1986.

Contains discussions of the influence of several artists, including Dove.

425 Green, Hope F. "The Problem of Abstraction and Arthur G. Dove." M.A. thesis, Pennsylvania State University, 1975.

426 Isaacs, Judith Susan. "Arthur Dove's Pastel Series 'The Ten Commandments.' " M.A. thesis, University of Delaware, 1985.

427 Johnson, Dorothy Rylander. "Arthur Dove: The Years of Collage." M.A. thesis, University of Maryland, 1967.

428 Klaric, Arlette. "Arthur G. Dove's Abstract Style of 1912: Dimensions of the Decorative and Bergsonian Realities." Ph.D. diss., University of Wisconsin—Madison, 1984.

429 Mann, Donna C. "Arthur G. Dove: The Formation of a Critical Image." M.A. thesis, University of Maryland, 1977.

430 Morgan, Ann Lee. "Toward the Definition of Early Modernism in America: A Study of Arthur Dove." Ph.D. diss., University of Iowa, 1973.

431 Muhlert, Jan Keene. "Arthur G. Dove, Early American Modernist." M.A. thesis, Oberlin College, 1967.

432 Mullett, Suzanne M. "Arthur Dove." M.A. thesis, American University, 1944.
 The first systematic attempt to catalog Dove's oeuvre based on the artist's own card files; a revised edition (1976) is in the Archives of American Art (see entries 417–418).

433 Reece-Hughes, Shirley Ellen. "Arthur G. Dove's Landscape Assemblages: A Unique Intersection of European Modernism, American Ideas, and Nature-Based Abstraction." M.A. thesis, University of North Texas, 1993.

434 Robinson, Joyce Henri. "Arthur Dove: An American Modern." M.A. thesis, University of Virginia, 1985.

435 Todd, Emily Leland. " 'Pieces of Experience Literally Seized': Arthur Dove's Symbolic Portraits in Collage, 1924–1925." M.A. thesis, Rice University, 1988.

436 Turner, Theodore. "Arthur G. Dove, 1880–1946." M.A. thesis, New York University, 1950.

437 Whelchel, Harriet A. "Arthur Dove's Assemblage Portraits and Their Relation to Stylistic and Theoretical Explorations by Other Artists of the Stieglitz Group." M.A. thesis, Emory University, 1985.

VIII. ANNOTATED REPRODUCTIONS

Abstract Landscape, n.d. WATERCOLOR/4 (b/w) 117.
Abstract Still Life, 1941. CHRISTIE/6772 (b/w) 217.
Abstraction, 1914. SYNCHROMISM (b/w) Pl. 150; p. 139.
Abstraction (Untitled), ca. 1917–1920. ARKANSAS/1 (b/w) 106–107.
Abstraction, Autumn Leaves, 1938. CHRISTIE/7508 (b/w) Pl. 218.

Abstractions: A gouche and a drawing, n.d. CHRISTIE/6772 (b/w) 217.
Abstraction No. 2, 1910. ELIOT (c) 183–184.
_____. WHITNEY/3 (b/w) Pl. 8; p. 109.
Abstraction No. 2, ca. 1911. DRAWING/13 (b/w) 36–37, 116.
_____. HASKELL (c) 110.
Abstraction No. 3, 1910–1911. ABSTRACTION/2 (c) 53, 56, 263.
Across the Harbor, 1930. CHRISTIE/7116 (b/w) Pl. 243.
After the Storm, 1922. NEW JERSEY (c) 30–31.
Alfie's Delight, 1929. CORNELL/2 (c) 183.
_____. WHITNEY/10 (b/w) 18, 20.
Anchorage, 1937. SOTHEBY/3749 (c) Pl. 122.
Approaching Snow Storm, 1934. WADSWORTH/3 (c) Pl. 51; pp. 304–306.
Autumn, 1935. ADDISON/1 (c) 292, 359.
_____. ADDISON/2 (c) 16, 86.
Barges, 1934. BAKER/PISANO (b/w) 45.
_____. WATERCOLOR/7 (c) 34–35, 63.
Barn IV, 1935. PHILLIPS/5 (b/w) 61.
Barn and Silo, 1935. HIRSCHL/3 (b/w) 33.
_____. KENNEDY/19 (c) Pl. 1 [sec. II].
A Barn Here and a Tree There, 1940. BEAL (b/w) 44–45, 47, 89–90.
Barn Interior, No. 1, ca. 1916. BOSTON/3 (b/w) 388–389.
Barn Interior #3, ca. 1917–1920. HIRSCHL/2 (b/w) 41.
_____. HIRSCHL/6 (b/w) 37.
Barn Next Door, 1934. PHILLIPS/5 (b/w) 62.
Barns, 1935. LONG ISLAND/1 (b/w) 26, 45.
Barns and Haystack, 1938. PHILLIPS/5 (b/w) 62.
Barnyard Fantasy (Fantasy), 1935. DREIER (b/w) 202–204.
_____. YALE/5 (b/w) 42–43.
Based on Leaf Forms and Spaces, 1911–1912. CUBIST/3 (c) 48–49.
Beach Umbrellas, 1931. CHRISTIE/7724 (c) Pl. 195.
Beyond Abstraction, 1946. CORNELL/1 (c) 68, 172.
Black and White, 1940. ROBY/1 (b/w) 50.
Blackbird, 1942. THYSSEN (c) 104–105, 390.
Brick Barge with Landscape, 1930. SOTHEBY/6373 (c) Pl. 181.
The Brothers #1, 1941. ABSTRACT/2 (b/w) 87–89.
_____. HONOLULU (c) 233.
The Brothers, 1942. MCNAY (b/w) 94–95.
Brown and Green Landscape, 1940. DELAWARE (b/w) 124–125.
Butterfly Landscape, 1940. LANDAU (c) Pl. 1.
Calf, ca. 1911–1912. YORK/2 (c) Pl. 21.
Canandaigua Outlet, Oaks Corner, 1937. BEAL (b/w) 44–45, 47, 89.
Car across the Street, n.d. ROBY/1 (c) 50–51.
Car in Garage, ca. 1934. HALPERT (b/w) Pl. 132.
Carnival, 1934. CHRISTIE/7508 (b/w) Pl. 217.

Carnival, 1935. MONTCLAIR (c) 96–97.

Cars in a Sleet Storm, 1938. ROCHESTER (b/w) 232.

Centerpoint, VI, ca. 1940. SOTHEBY/6927 (c) Pl. 180.

Centerpoint IX, 1941. PRINCETON/3 (b/w) 197.

Centerpoint Series #1, ca. 1941. HALPERT (b/w) Pl. 133.

Centerpoint Series #2, ca. 1941. SHELDON/2 (b/w) 245–246.

Centerpoint Series No. 20A, n.d. CHRISTIE/7230 (b/w) Pl. 228.

Chinese Music, 1923. PHILADELPHIA/3 (b/w) 349.

———. THEMES (b/w) 250–251.

City Moon, 1938. HIRSHHORN/1 (c) 64–65.

———. HIRSHHORN/2 (b/w) Pl. 421; p. 685.

———. LANDSCAPE/3 (c) 104–105, 162.

City Sunset, ca. 1938. SOTHEBY/4038 (b/w) Pl. 162.

Clouds, 1927. LANE (c) Pl. 12; p. 163.

Coal Carrier, ca. 1929–1930. PHILLIPS/5 (b/w) 62.

Colored Planes (Formation II), 1942. ABSTRACTION/1 (c) 9.

———. HIRSCHL/6 (c) 42–43.

Connecticut River, ca. 1912–1913. HALPERT (b/w) Pl. 61.

———. INDIANA (c) 128.

Continuity, n.d. SOTHEBY/3913 (b/w) Pl. 174.

Corn Crib, 1935. DES MOINES (c) 100–101.

Country Road, France, ca. 1908. SOTHEBY/3823 (b/w) Pl. 127.

Cow, ca. 1911. MET/1 (c) 110–113, 237.

Cow #1, 1935. RANDOLPH-MACON/1 (c) 78–79, 160–161.

———. RANDOLPH-MACON/2 (c) 29, 74.

Cow I and Cow: A Pair of Watercolors, 1935/1937. HALPERT (b/w) Pl. 135.

Cow at Play, 1941. IBM (c) 94–95.

Cows and Calves, ca. 1935. NEWARK/1 (b/w) 12, 15.

Cows in Pasture, 1935. PHILLIPS/1 (c) 164.

———. PHILLIPS/5 (b/w) 62.

———. PHILLIPS/6 (b/w) Pl. 188; p. 32.

———. STIEGLITZ/2 (c) 18–19, 110–111.

Crayon and Ink, 1945. CHRISTIE/7493 (b/w) Pl. 221.

———. CHRISTIE/7508 (b/w) Pl. 219.

The Critic, 1925. ASSEMBLAGE (b/w) 42–43, 157.

———. DADA (c) 175, 207, 288, 291.

———. DRAWING/13 (b/w) 36, 39, 116.

———. HASKELL (c) 126.

———. PARIS–NEW YORK (b/w) 360, 362.

———. WHITNEY/1 (c) 68, 209, 221.

———. WHITNEY/4 (c) 40–41, 225.

Dancing Willows, 1943–1944. LANE (c) Pl. 29; p. 165.

Study for *Dark Abstraction*, ca. 1920–1921. DRAWING/6 (b/w) 86.

———. FUTURISM (c) 364, 468.

_____. HIRSCHL/6 (c) 38–39.

Dawn III, 1932. BROOKLYN/1 (b/w) 29.

_____. MCNAY (b/w) 94–95.

_____. WATERCOLOR/2 (c) 202.

_____. WATERCOLOR/3 (c) 221.

_____. WATERCOLOR/7 (c) 35, 64.

Derrick. 1933. CHRISTIE/6890 (c) Pl. 330.

Distraction, 1929. KOOTZ/1 (b/w) Pl. 19; pp. 36–39.

_____. MOMA/11 (b/w) Pl. 28; p. 12.

The Dolphin, 1932. SHELDON/2 (b/w) 245.

Drawing for Sand Barge, 1930. PHILLIPS/5 (b/w) 65.

Electric Peach Orchard, 1935. PHILLIPS/5 (b/w) 62.

_____. PHILLIPS/6 (b/w) Pl. 186a; p. 32.

Evening Blue (Firmament), 1941. LANE (c) Pl. 25; p. 165.

Evolution of a Painting—Ten Studies for "The Brothers," 1939–1942. MCNAY
 (b/w) 94–95.

Face on a Bank, 1940. LANDAU (c) Pl. 2.

Falling Boathouse, 1938. HIRSCHL/3 (b/w) 34.

Falling Shed Roof, 1934. BEAL (b/w) 44–45, 47, 89.

Ferry Boat Wreck, Oyster Bay, 1931. HASKELL (c) 211.

_____. MARINE/2 (b/w) 136–137.

_____. STIEGLITZ/2 (c) 18–19, 106–107.

_____. WHITNEY/4 (c) 38–39, 225.

Field of Grain Seen from Train, 1931. DRAWING/13 (b/w) 36, 116.

Fields of Grain as Seen from Train [oil], 1931. ALBRIGHT-KNOX/2 (c) 136–
 137.

_____. HERITAGE (b/w) Pl. 41.

_____. STIEGLITZ/2 (c) 18–19, 108–109.

Fields of Grain as Seen from Train [watercolor], 1931. SOTHEBY/3617 (b/w)
 Pl. 41.

Fire in a Sauerkraut Factory, 1936. DRAWING/5 (c) 87, 131.

Fishboat, 1930. MET/8 (c) 62.

Flagpole, Apple Tree and Garden, 1943–1944. LANE (c) Pl. 28; p. 165.

Flight, 1943. PHILLIPS/5 (b/w) 62.

Flour Mill Abstraction, 1938. PHILLIPS/1 (c) 162–163.

_____. PHILLIPS/5 (b/w) 62.

_____. PHILLIPS/6 (b/w) Pl. 190; p. 32.

_____. SCENE/3 (c) 27, 84.

Flour Mill II, 1938. WADSWORTH/2 (c) 43, 76.

Fog Horns, 1929. HASKELL (c) 198.

_____. SCENE/1 (b/w) Pl. 5; p. 107.

_____. STIEGLITZ/2 (c) 18–19, 100–101.

Foot of Lake, 1938. YALE/5 (b/w) 42–43.

Forms against the Sun, ca. 1926. MURDOCK (b/w) 46–47.

Harbor, 1940. SOTHEBY/5335 (c) Pl. 236.
Haystack, 1931. HIRSHHORN/2 (b/w) Pl. 420; p. 685.
High Fidelity, 1941. CINQUANTE (b/w) 28–29, 230.
High Noon, 1944. LANDSCAPE/2 (c) Pl. 169; p. 177.
_____. LONG ISLAND/2 (c) 17–18, 20.
_____. MURDOCK (c) 48–49, 118.
_____. STIEGLITZ/2 (c) 18–19, 112–113.
_____. WICHITA (c) 129–131.
Holbrook's Bridge, 1935. EBSWORTH (c) 84–85, 202.
Holbrook's Bridge to the Northwest, 1938. MOMA/10 (b/w) 114, 176.
_____. NEUBERGER (c) 129–132.
Holsteins, 1935. SOTHEBY/3617 (b/w) Pl. 37.
Hound, 1934. SOTHEBY/6025 (c) Pl. 213.
House and Tree, 1940. SOTHEBY/3617 (b/w) Pl. 44.
Huntington Harbor, 1924. FLOWER/1 (c) 70–71.
_____. LONG ISLAND/2 (c) 18, 20–21.
Huntington Harbor I, 1926. PHILLIPS/5 (b/w) 63.
_____. PHILLIPS/6 (b/w) Pl. 184a; p. 32.
Huntington Harbor II, ca. 1926. BEAL (c) 44–45, 47, 52, 88.
Huntington, Wall Street, 1934. SUFFOLK (b/w) 14–15, 20.
Ice and Clouds, 1931. BUTLER (c) 236–237, 362.
Improvisation, 1927. GRAHAM (c) 26–27, 46.
In the Garden, 1935. SOTHEBY/4038 (b/w) Pl. 212.
Indian One, 1943. PHILLIPS/5 (b/w) 63.
Indian Spring, 1923. LANE (c) Pl. 10; p. 163.
Indian Summer, 1941. HECKSCHER/1 (b/w) 22–24.
The Inn, 1942. LOWENTHAL (c) 14.
_____. MET/7 (c) 77.
The Intellectual, 1925. GOODWIN (b/w) 8.
_____. MOMA/12 (b/w) 223, 537.
_____. SCULPTURE/1 (b/w) 69.
Italian Child Combing Her Hair, 1933. CHRISTIE/6890 (c) Pl. 328.
*"J. Harvey Smith had gazed upon the group for an instant, had turned pale,
 and then—pandemonium!"* 1907. ILLUSTRATION (b/w) 36, 129, 153.
Lake Afternoon, 1935. PHILLIPS/5 (b/w) 63.
Land and Seascape, 1942. VIEWS/1 (b/w) 14, 123.
Landscape in Five Flats, 1940. SOTHEBY/3617 (b/w) Pl. 35.
Landscape in Red, Yellow and Ultramarine, ca. 1909. SOTHEBY/3749 (b/w)
 Pl. 105.
Landscape II, 1941. BECK (c) 50–51, 125.
The Lantern, 1921. KOOTZ/1 (b/w) Pl. 16; pp. 36–39.
Last Train Going 'Round the Bend, ca. 1935. SOTHEBY/3823 (b/w) Pl. 136.
League of Nations, 1912. GEORGIA/1 (b/w) Pl. 12.
Lehigh Valley–New York Line and Lake, 1935. PHILLIPS/5 (b/w) 63.

Life Goes On, 1934. PHILLIPS/6 (b/w) Pl. 186b; p. 33.
Lighthouse, Lloyd's Harbor, 1932. LONG ISLAND/2 (c) 18, 20, 22–23.
Lloyd's Harbor, 1941. LANDAU (c) Pl. 3.
The Lobster, 1908. CARTER/1 (c) 82–83, 120.
———. PARIS–NEW YORK (b/w) 219.
Long Island, n.d. CHRISTIE/8790 (c) Pl. 98.
Long Island, 1925. BOSTON/2 (b/w) Pl. 567; pp. 97–98.
Mars Orange and Green, 1936. BECK (c) 50–51, 125.
———. WATERCOLOR/2 (b/w) 202.
Mars Yellow, Red and Green, 1943. RINGLING (b/w) 116.
Me and the Moon, 1937. PHILLIPS/4 (c) 72–73.
———. PHILLIPS/5 (b/w) 63.
The Mill Wheel, Huntington Harbor, 1930. SOTHEBY/5335 (c) Pl. 226.
Monkey Fur, 1928. CHICAGO/3 (c) 54, 158.
Moon, 1928. LEGACY (c) 130, 192–193.
Moon, 1935. EBSWORTH (c) 86–87, 202–204.
Moon and Sun, 1932. WHITNEY/13 (b/w) 10, 27.
Moonrise I, 1944. FITCH (b/w) 33.
Morning Sun, 1935. PHILLIPS/5 (b/w) 63.
Moth Dance, 1929. BEASTS (c) 14–15, 100.
Motor Boat, 1938. LANE (c) Pl. 20; p. 164.
Movement No. 1, ca. 1911. COLOR AND FORM (c) Pl. 17; p. 93.
———. COLUMBUS (c) 72–73, 191.
———. CROSSCURRENTS (b/w) 62.
———. HOWLAND (b/w) 40, 42–43.
———. STEBBINS (b/w) 302–304, 431, 446.
———. STIEGLITZ/2 (c) 18–19, 90–91.
———. SYMBOLIST (b/w) 120, 148.
Mowing Machine, 1922. FISK (b/w) 14, 40.
Nature Symbolized, ca. 1911. HEALTH (c) 11, 44.
———. STIEGLITZ/2 (c) 18–19, 92–93.
Nature Symbolized, ca. 1911–1914. MOMA/1 (c) 96–97.
———. MOMA/9 (b/w) 283.
Nature Symbolized, ca. 1917–1920. DRAWING/13 (b/w) 36, 38, 116.
Nature Symbolized #1, ca. 1911–1912. HIRSCHL/3 (c) 32.
Nature Symbolized, No. 2, ca. 1911. ABSTRACTION/2 (c) 53, 56, 263.
———. BAUR (b/w) [frontispiece], 63–64.
———. PARIS–NEW YORK (b/w) 252.
Nature Symbolized #3: Steeple and Trees, 1911–1912. ABSTRACTION/2 (c)
 263.
———. TERRA (c) 273.
Neighborly Attempt at Murder, 1941. LANE (c) Pl. 24; pp. 164–165.
1941, 1941. PHILLIPS/5 (b/w) 61.
Northport Harbor, 1940. SOTHEBY/3617 (b/w) Pl. 74.

No. 1, ca. 1915–1920. PHILADELPHIA/3 (b/w) 349.

No. 4 Creek, ca. 1914–1916. OVER HERE (b/w) 142.

Oil Tanker, ca. 1931–1932. HIRSCHL/6 (c) 40.

Orange Grove in California—Irving Berlin, 1927. THYSSEN (c) 98–100, 390.

Out over the Sound, 1941. LANDAU (c) Pl. 4.

Outboard Motor, 1927. LANE (c) Pl. 13; p. 163.

Over Seneca Lake, 1935. PHILLIPS/5 (b/w) 64.

Pagan Philosophy, ca. 1913. MET/1 (b/w) 189, 237.

_____. STIEGLITZ/1 (b/w) 389.

_____. WHITNEY/7 (b/w) 39, 72.

_____. WHITNEY/12 (b/w) Pl. 39; p. 21.

The Park, 1937. PHILLIPS/5 (b/w) 64.

Partly Cloudy, 1941. SOTHEBY/3617 (b/w) Pl. 40.

Phelps, New York, 1937. PHILLIPS/5 (b/w) 64.

_____. WATERCOLOR/3 (c) 221.

Pieces of Red, Green, and Blue, 1944. LANE (c) Pl. 31; p. 165.

Pine Tree, 1931. CLEVELAND/1 (b/w) 66.

_____. CLEVELAND/3 (b/w) 41–42, 66.

Plant Forms, ca. 1912. FLOWER/2 (c) 154.

_____. HASKELL (c) 110.

_____. PASTELS (c) 83, 132.

_____. STIEGLITZ/2 (c) 18–19, 94–95.

_____. WHITNEY/4 (c) 38–39, 225.

Portrait of Alfred Stieglitz, 1926. MOMA/9 (c) 152–153.

_____. MOMA/12 (b/w) 223, 538.

_____. PARIS–NEW YORK (b/w) 236.

Portrait of Ralph Dusenberry, 1924. MOMA/6 (b/w) 211, 250.

_____. MOORE (b/w) 100–103, 107, 114–115.

Pozzuoli Red, 1941. PHILLIPS/5 (b/w) 64.

_____. WASHINGTON/1 (c) 138–139.

Primitive Music, 1944. PHILLIPS/5 (b/w) 64.

Prize Fighter on Ropes, n.d. HECKSCHER/2 (b/w) 8–9.

R 25-A, 1942. PHILLIPS/5 (b/w) 64.

Rain or Snow, 1943. PHILLIPS/5 (b/w) 64.

_____. PHILLIPS/6 (b/w) Pl. 191; p. 33.

Red Barge, 1932. PHILLIPS/5 (b/w) 64.

The Red Crescent, 1930. CHRISTIE/7103 (b/w) Pl. 379.

Red Horse Climbing Hill, ca. 1926. CROSSCURRENTS (b/w) 100.

Red, Olive, and Yellow, 1941. BESTIARY (c) 180.

_____. PHILLIPS/5 (b/w) 65.

Red Sun, 1935. PHILLIPS/5 (b/w) 65.

Red, White and Green [two versions], 1940. PHILLIPS/5 (b/w) 65.

Reds, ca. 1924–1930. CORRESPONDENCES (b/w) Pl. 9b; [catalogue note].

Reflections, 1935. SBC (c) 104.

Reminiscence, 1937. PHILLIPS/5 (b/w) 65.
Rise of the Full Moon, 1937. PHILLIPS/6 (b/w) Pl. 189; p. 34.
Rising Moon, 1941. FITCH (b/w) 33.
Rising Tide, 1944. CANADA (b/w) Pl. 95.
————. MOMA/14 (b/w) 94, 150.
Roof Tops, 1943. ABSTRACT/1 (b/w) 102.
————. LANE (c) Pl. 27; p. 165.
Rope, Chiffon and Iron, ca. 1926. SOTHEBY/6373 (c) Pl. 133.
Rose and Locust Stump, 1944. PHILLIPS/5 (b/w) 65.
Running Dogs, 1930. KOOTZ/1 (b/w) Pl. 18; pp. 36–39.
Running River, ca. 1927. SALONS (c) 11, 16.
Runway, 1946. SOTHEBY/5584 (c) Pl. 301.
Sand and Sea, 1943. WASHINGTON/2 (c) 156–157, 200–201.
Sand Barge, 1930. HASKELL (c) 210.
————. MOMA/14 (b/w) 93, 150.
————. PHILLIPS/5 (b/w) 65.
————. STIEGLITZ/2 (c) 18–19, 104–105.
————. WIGHT (c) 29, 44–45.
Sand, Sail, and Sky, n.d. PHILLIPS/2 (b/w) Pl. CLX.
The Sea I, 1925. LANE (c) Pl. 11; p. 163.
Sea II, 1925. EBSWORTH (c) 88–89, 204.
————. HALPERT (c) Pl. 105.
Sea Gulls, 1938. HECKSCHER/1 (b/w) 22–25.
Sea Gulls on the Island, 1932. SPRINGFIELD/1 (b/w) 70–71.
The Seaside, ca. 1925. YORK/2 (c) Pl. 27.
Sentimental Music, 1917. MET/1 (c) 114–115, 237.
————. SCENE/3 (c) 26, 84.
Sewing Machine, 1927. JOACHIMIDES (c) Pl. 33; pp. 445–446.
Shapes, 1941. PHILLIPS/5 (b/w) 66.
Shore Front [two versions], 1938. PHILLIPS/5 (b/w) 66.
————. SEASHORE (b/w) Pl. 100.
Silver Ball No. 2, 1930. SAN FRANCISCO/2 (b/w) 35.
————. SAN FRANCISCO/3 (c) 126–127, 247–248.
Silver Chief, 1942. PHILLIPS/5 (b/w) 66.
Silver Storm, 1923. KOOTZ/1 (b/w) Pl. 20; pp. 36–39.
Silver Sun, 1932. CHICAGO/4 (c) 132.
Silver Tanks and Moon, 1929–1930. MACHINE (c) 215, 217–218.
————. PHILADELPHIA/3 (b/w) 349.
Six untitled works from *Sketchbook "E,"* ca. 1940–1946. ARKANSAS/2 (b/w)
 82–83.
Sky No. 5, 1935. CINQUANTE (b/w) 28–29, 230.
Slaughterhouse, n.d. HIRSCHL/3 (c) 35.
Snow and Ice, 1930. GUSSOW (c) 106–107.
Snow and Water, 1928. CURRIER (b/w) 98.

_____. WINTER (c) 108.

Snow on Ice, 1930. HALPERT (c) Pl. 56.

Snow Thaw, 1930. PHILLIPS/2 (b/w) Pl. CLXI.

_____. PHILLIPS/5 (b/w) 66.

_____. PHILLIPS/7 (b/w) 78.

Snowstorm, 1935. HALPERT (c) Pl. 52.

Something Brown, Carmine, and Blue, 1929. LEGACY (c) 192–193.

Spotted Yellow, 1943. HIRSCHL/1 (c) 105.

Square on the Pond, 1942. LANE (c) Pl. 26; p. 165.

Starry Heavens, 1924. MARONEY (c) 17–18, 58–59.

Still Life against Flowered Wallpaper, 1909. HIGH/2 (c) 84–85, 185, 193–194.

_____. SOTHEBY/3823 (b/w) Pl. 125.

Stone House, Halsite, 1941. HIRSCHL/3 (b/w) 34.

Stovepipe, ca. 1914–1917. OVER HERE (b/w) 143–144.

_____. HIRSCHL/6 (c) 36.

Summer, 1935. LANE (c) Pl. 17; p. 164.

Summer Orchard, 1937. MUNSON/1 (c) 154–155, 226.

Sun Drawing Water, 1933. PHILLIPS/5 (b/w) 66.

Sun and Moon, 1937. PREVIN (b/w) Pl. 13.

Sun on Lake, 1938. SOTHEBY/3617 (b/w) Pl. 76.

Sun on the Lake, 1938. LANE (c) Pl. 22; p. 164.

Sun on Water, 1917–1920. PRINCETON/3 (b/w) 196–197.

Sun through Tree 2, 1934. SAN DIEGO (b/w) [unpaginated].

Sunrise, 1937. WADSWORTH/2 (c) 42, 76.

Sunrise, 1941. BAKER/PISANO (b/w) 46–47.

Sunrise I, 1937. BAUR (c) 38, 63–64.

_____. CROSSCURRENTS (b/w) 122.

_____. LANE (c) Pl. 18; p. 164.

Sunrise II, 1913. ADDISON/1 (c) 358–359.

_____. ADDISON/2 (b/w) 76, 85.

_____. DRAWING/7 (b/w) 13, 131.

Sunrise III (Sunset, No. 3), 1936–1937. DREIER (b/w) 202–205.

_____. MOMA/10 (b/w) 36, 176.

_____. YALE/5 (b/w) 42–43.

_____. YALE/7 (b/w) Pl. 90.

Sunrise IV, 1937. HIRSHHORN/2 (c) Pl. 491; p. 685.

Sunrise in Northport Harbor, 1929. LONG ISLAND/2 (c) 18–20.

_____. WICHITA (c) 128–129.

Sunset, 1934. FLEISCHMAN/2 (b/w) 37.

_____. KENNEDY/6 (b/w) Pl. 27; [catalogue note].

Swans, 1940. PHILLIPS/5 (b/w) 66.

Swinging in the Park (there were colored people there), 1930. BLUES (c) 28,
 46, 101.

_____. LEGACY (c) 127, 192–193.

Tanks, 1938. LANE (c) Pl. 19; p. 164.

Tar Barrels, Huntington Harbor (Oil Drums), 1930. CARNEGIE/2 (b/w) 170–172.

———. STIEGLITZ/2 (c) 18–19, 102–103.

Team of Horses, ca. 1911–1912. CARTER/1 (c) 84–85, 120.

———. WHITNEY/7 (b/w) 38, 72.

Telegraph Pole, 1929. CHICAGO/2 (c) 129–130, 380.

———. SPIRIT (b/w) 15, 54–55.

Ten Cent Store, 1924. SHELDON/1 (c) 38, 70.

———. SHELDON/2 (c) 50–51, 245.

———. STILL LIFE/1 (b/w) 250–252.

That Red One, 1944. LANE (c) Pl. 30; p. 165.

———. WHITNEY/6 (c) 21, 86.

Thunder Shower, ca. 1939–1940. CARTER/2 (b/w) 26–27.

———. FORT WORTH/2 (b/w) [unpaginated]; [catalogue note].

Thunderstorm, 1917–1920. IOWA (c) 32–33.

Thunderstorm, 1921. COLUMBUS (c) 74–75, 191–192.

———. HOWLAND (b/w) 40, 43, 45.

———. STIEGLITZ/2 (c) 18–19, 96–97.

Traveling, 1942. LANE (c) Pl. 23; p. 164.

Tree, 1934. COMMERCE (b/w) [unpaginated].

———. CORPORATE (c) 120–121.

Tree, 1934. NELSON-ATKINS/2 (b/w) 170–171.

———. SOTHEBY/4038 (b/w) Pl. 161.

Tree (41), 1935. MET/2 (c) 185.

———. STEBBINS (c) 302–304, 431, 446.

Tree Forms, ca. 1928. BEAL (c) 23, 44–45, 47, 88–89.

———. CARNEGIE/2 (c) 21, 170–172.

Tree Forms, 1932. ACKLAND/1 (b/w) Pl. 145.

———. ACKLAND/2 (b/w) 24–25.

Tree Forms II, 1935. PHILLIPS/5 (b/w) 66.

———. SCALE (c) 34, 63.

Tree Forms and Water, ca. 1928. MET/1 (c) 116–117, 237.

Tree Study, ca. 1925. MINNESOTA/4 (b/w) 93–95.

Tree Trunk, ca. 1929. LANE (c) Pl. 15; pp. 163–164.

Tree Trunks, 1934. PHILLIPS/5 (b/w) 67.

Trees, n.d. SOTHEBY/6736 (b/w) Pl. 221.

Two Bank Robbers, n.d. HECKSCHER/2 (b/w) 8–9.

Two Forms, 1931. LONG ISLAND/3 (c) 42, 63.

———. OWEN/2 (c) [unpaginated].

Untitled, ca. 1912. DRAWING/3 (b/w) 45–46.

Untitled, ca. 1924. AGEE (b/w) 13, 22.

———. CARTER/2 (b/w) 26–27.

Untitled, ca. 1938. WATERCOLOR/1 (c) 156, 158–159.

Untitled, ca. 1941–1946. PENNSYLVANIA/1 (c) 53, 94.

Untitled [three versions], 1942–1944. WATERCOLOR/8 (c) 251–253.

Untitled, 1943. WATERCOLOR/8 (c) 251–253.

Untitled No. 10, ca. 1938–1943. HIRSCHL/8 (c) 73.

Untitled Centerpoint #2, 1941. HECKSCHER/1 (b/w) 22–25.

Up the Alley, 1918. DALLAS (b/w) 142–143.

U.S., 1940. THYSSEN (c) 102–103, 390.

U.S.A., 1944. CORCORAN/3 (b/w) 105–106.

Violet and Green, 1931. NEW YORK/1 (c) 36–37.

A Walk—Poplars, 1920. HALPERT (c) Pl. 48.

_____. TERRA (c) 274.

Waterfall, 1925. PHILLIPS/2 (b/w) Pl. CLVIII.

_____. PHILLIPS/5 (b/w) 67.

_____. STIEGLITZ/2 (c) 18–19, 98–99.

The Wave, 1924. KOOTZ/1 (b/w) Pl. 17; pp. 36–39.

Wednesday—Snow, 1931. LANE (c) Pl. 16; p. 164.

What Harbor, 1939. LANE (c) Pl. 21; p. 164.

White Channel, 1942. SBC (c) 105.

Willow, 1938. FLEISCHMAN/2 (b/w) 33.

Willows, 1940. KENNEDY/20 (b/w) Pl. 23.

_____. MOMA/10 (b/w) 109, 176.

_____. MOMA/12 (b/w) 223, 538.

_____. PHILLIPS/5 (b/w) 67.

Wooded Pond, 1935. PHILLIPS/5 (b/w) 67.

Woodpecker, 1941. PHILLIPS/6 (b/w) Pl. 193b; p. 34.

Yachting, ca. 1911. LANE (c) Pl. 9; p. 163.

Yellow, Blue, and Violet, 1928. LEGACY (c) 192–193.

Yellow, Blue-Green and Brown, 1941. PHILLIPS/5 (b/w) 67.

A Yellow Form, ca. 1942. SOTHEBY/3913 (c) Pl. 198.

Young Old Master, 1946. PHILLIPS/5 (b/w) 67.

3

Marsden Hartley

Hartley was born on 4 January 1877 in Lewiston, Maine (in 1906 he dropped his given name Edmund and adopted his stepmother's maiden name, Marsden). His early artistic education took place between 1898 and 1900 at the Cleveland School of Art, the New York School of Art, and the National Academy of Design. Between 1906 and 1909, while living in Boston and North Lovell, Maine, Hartley produced his first mature works—autumn and winter landscapes—in a Post-impressionist style using bright, elongated dabs of pure color, the so-called Segantini stitch, named after the Italian artist Giovanni Segantini (1858–1899). After he showed these works to Maurice and Charles Prendergast, they wrote him a letter of introduction to William Glackens. Glackens arranged for a small showing of Hartley's work in his New York studio in the spring of 1909, where they were viewed by several other members of the Eight and received an especially favorable reaction from Arthur B. Davies.

Hartley's strong interest in literature and religion began to develop around this time. He read the works of many writers, including Emerson, Whitman, Whittier, Santayana, William James, Bergson, Pater, and Ruskin. He also studied classics of Christian mysticism and Eastern religions, which provided him not only a framework to intuitively render the transcendental aspects of the physical world but also a vocabulary of mystical and occult symbols that he incorporated into works like *Musical Theme (Oriental Symphony)* of 1912–1913.

In the spring of 1909 Hartley was introduced to Stieglitz, who arranged for a one-man exhibition in May. During the exhibition Hartley met gallery owner N.E. Montross, who provided him with a small stipend for living expenses and showed him one of Albert Pinkham Ryder's seascapes. Hartley was so impressed with its evocation of romanticism and mysticism that he paid several visits to the then-aging artist in his New York tenement studio for conversation and to view his paintings. As he later recalled, "Ryder's spirit lived in me intensely." Hartley was also able to see a selection of European art during a May 1910

exhibition at the Photo-Secession Galleries that included works by Monet, Renoir, Cézanne, Toulouse-Lautrec, Rousseau, Rodin (drawings), and Matisse.

Hartley divided his time between New York City and Maine until he embarked on a European trip in April 1912, with his expenses paid through the sale of his paintings and financial gifts from Stieglitz and other generous benefactors. His first stop was Paris, where he rented a studio in Montparnasse. In addition to spending time with American artists, including Arthur Carles, Charles Demuth, and Alfred Maurer, he visited the salon of Gertrude and Leo Stein, where he had an opportunity to discuss literature and to view works by Renoir, Matisse, Cézanne, and Picasso. Hartley found Paris generally disappointing, although he formed important friendships there with the German artist Arnold Rönnebeck and his cousin, Lieutenant Karl von Freyberg. They both helped him read the German text of Wassily Kandinsky's book *On the Spiritual in Art* and the almanac *Der Blaue Reiter*, edited by Kandinsky and Franz Marc. Hartley embarked for Germany in April 1913 and found Berlin much more to his liking, particularly the military atmosphere and the thriving homosexual subculture. His friendship with Rönnebeck and von Freyberg evolved into what he called a "beautiful triangle." He also enjoyed the company of several German artists in Berlin and Munich, including Kandinsky, Marc, and Gabriel Münter.

Hartley began a series of abstractions that featured German military motifs and hidden symbolism. In November 1913 he returned to New York, where Stieglitz staged a one-man exhibition of his Paris and Berlin works in January 1914. Back in Berlin by April, he continued with his military abstractions (including *Berlin Ante-War, Berlin Abstraction*, and *Portrait of a German Officer*) and executed his "Amerika" series on Native American themes. That autumn he not only learned that his father had died in August but also had to cope with the terrible news that his close friend von Freyburg had been killed in action. He began to find himself short of money due to the lack of sales of his work, and by December 1915 the German food shortages finally forced his return to New York. Although his German military canvases had been well received in Berlin, their reception in the United States, when shown by Stieglitz in April 1916, was less favorable given the prevailing anti-German sentiment. He soon began rendering his compositions in a more decorative Synthetic Cubist vein, as in *Compote with Fruit, Handsome Drinks*, and *Trixie*, all from 1916.

Between 1917 and 1919 Hartley spent time in Provincetown with members of Mabel Dodge's salon; in Bermuda with Charles Demuth; in Ogunquit, Maine, where he executed a series of still lifes on glass; and in New Mexico, where he was especially taken by the Native American dances and the Mexican American altarpieces known as *santos*. It was here that he began to move away from the abstract representation of his subjective inner emotional life and instead attempted to base his art more on an objective and dispassionate foundation. He worked mainly in pastels in New Mexico and later rendered twenty-five landscapes in oil from memory (the New Mexico Recollections series) after his return to New York in November 1919.

Hartley spent some time in Gloucester, Massachusetts, where he adopted a looser, more painterly style. He found himself, however, becoming increasing depressed and isolated. He longed to return to Europe, which he finally managed in July 1921 after a very successful auction of his paintings. While in Berlin he worked on still lifes (oils and lithographs) and continued his series of New Mexico Recollections. In 1925 the financial resources gained from the publication of his first book of poetry allowed him to embark on an Italian sojourn, which was followed by a brief return to New York. Eventually, he found himself back in Paris by the summer of 1924. In August 1925 he moved to Vence in the south of France after he wrote Stieglitz that he wanted to recapture "the French purity of feeling." After a year he moved on to Aix-en-Provence, where he painted a series of Cézannesque landscapes, which were not well received when shown by Stieglitz at the Intimate Gallery in January 1929.

After his return to the United States in March 1930, Hartley was anxious to counter the ongoing view of critics and colleagues that his art lacked genuine American roots. He painted the Franconia Range of the White Mountains in New Hampshire before moving on to the solitary area near Gloucester, Massachusetts, known as Dogtown Common. He rendered the massive granite boulders of the region in a series of stark and severe compositions, while also finding the time to write dozens of poems. In Dogtown Hartley began to experience a personal and artistic revival, with a return to the more emotive and subjective approach that he had embraced earlier in his career.

Hartley traveled to Mexico in 1932 after receiving a Guggenheim Foundation fellowship. Several of his Mexican canvases were charged with a strong affinity for the religious aspects of Aztec and Toltec cultures, while others paid tribute to three mystics whom he admired: Paracelsus (Yliaster), Jakob Böhme, and Richard Rolle. These paintings were arranged to form the panels of what he called an "Arcane Library" and exhibited at the Galeria de la Escuela Central de Artes Plasticas in Mexico City during February 1933.

In April 1933 Hartley departed for what was to be his final trip to Germany. By September he had settled in Garmisch-Partenkirchen, where he focused on painting and drawing the Bavarian Alps. The following year, after his return to the United States, he went to Gloucester to resume his Dogtown series. He also painted seashells, marine life, and floral still lifes. Because his paintings were not selling well—and Stieglitz refused to continue paying for their storage—Hartley was forced to destroy 100 canvases and drawings on 4 January 1935, which was his fifty-eighth birthday.

Finding himself emotionally drained, Hartley took a brief trip to Bermuda before sailing to Nova Scotia in September 1935. He eventually moved in with the Francis and Martha Mason family of Eastern Points. Hartley wrote a fictionalized story based on the family entitled "Cleophas and His Own: A North Atlantic Tragedy," giving them French Canadian names to protect their anonymity. The story centered on the tragic drownings at sea of the Mason sons Alty and Donny and their cousin, Allen. Several years later he painted a series

of figurative works as a memorial to the family that included *Fishermen's Last Supper* (two versions, 1938 and 1940–1941) and *Adelard the Drowned, Master of the "Phantom"* and *Cleophas, Master of the "Gilda Gray,"* both of 1938–1939.

Hartley's last show with Stieglitz, which took place at An American Place during April–May 1937, featured his Dogtown and Nova Scotia canvases. He was represented thereafter by Hudson D. Walker, then briefly by William Macbeth, and finally by Paul Rosenberg. Starting in 1937, Hartley spent much of his time painting various locales in Maine, including Georgetown and Vinalhaven, while living with friends or in rented quarters. This was in part a calculated career move to capitalize on the current popularity of regionalism and establish himself as "the painter of Maine," although he was fully aware of Marin's own claim to this sobriquet. He painted several powerful and stormy seascapes in addition to eighteen views of Mt. Katahdin in Baxter State Park. Hartley also turned his attention to the human figure, both in individual and group portraits, as in *Madawaska—Acadian Light-Heavy* of 1940 and *Lobster Fishermen* of 1940–1941 and in religious scenes such as *Christ Held by Half-Naked Men* of 1940–1941.

Hartley spent his final summers as a guest in the home of Forrest and Katie Young in the small fishing village of Corea, Maine. He found time to complete two books of poetry, *Androscoggin* and *Sea Burial*, and to visit New York occasionally to see friends and attend his exhibitions. In 1941 he was diagnosed with hypertension, which increasingly took a toll on his artistic activities. Eventually, he became seriously ill and was hospitalized in Ellsworth, Maine, where he died of a heart attack on 2 September 1943.

Hartley's paintings reflect the inner struggle of his lifelong spiritual quest, with a depth and intensity seldom matched in early American modernism. He also influenced several postwar artists, including Robert Indiana and Jasper Johns.

I. HARTLEY'S WRITINGS, STATEMENTS, AND CORRESPONDENCE

Hartley was a prolific poet and essayist. In addition to his autobiography (see entry 455), his major writings can be found gathered in three collected works (see entries 439, 446, and 450). A few of his more significant individual essays are listed in the following entries. See also entries 002, 034, 469, 489, 501, 558, 593, 597, 606, 774–775, 777–778, 780, 860, and 906.

438 Gallup, Donald, ed. *The Flowers of Friendship: Letters Written to Gertrude Stein*. New York: Knopf, 1953.

The book contains six letters from Hartley to Stein: Paris, fall 1912 (pp. 64–65); Berlin, October 1913 (pp. 84–86); New York, 10(?) December 1913

(pp. 89–90); New York, 16 January 1914 (p. 90); Vence, 27 December 1925 (p. 183); and Paris 29 January(?) 1930 (p. 242).

439 Hartley, Marsden. *Adventures in the Arts: Informal Chapters on Painters, Vaudeville and Poets.* Introduction by Waldo Frank. New York: Boni and Liveright, 1921.
Twenty-eight essays on art, literature, photography, and theater.

440 ———. "America as Landscape." *El Palacio* 5 (21 December 1918) 340–342.
Hartley exhorts artists to forsake their conventional approaches and explore the aesthetic possibilities inherent in the American landscape in order to create a truly native art.

441 ———. *Androscoggin.* Portland, Maine: Falmouth Publishing House, 1940.
Hartley's second published book of poetry.

442 ———. "A.P. Ryder: 'The Light That Never Was.' " In *Albert Pinkham Ryder: Painter of Dreams*, by William Innes Homer and Lloyd Goodrich, 227–229. New York: H.N. Abrams, 1989.
This appreciation of Albert Pinkham Ryder, which Hartley intersperses with some personal reminiscences, was written around 1929.

443 ———. "Art—And the Personal Life." *Creative Art* 2 (June 1928) xxx–xxxiv.
A statement of Hartley's aesthetic philosophy.

444 ———. "The Business of Poetry." *Poetry: A Magazine of Verse* 15 (December 1919) 152–158.
Hartley outlines what he believes to be the essential elements of good poetry, which include the precision of simplicity, conscious structure, spaciousness, charming humor, and dissonant modern themes.

445 ———. *Cleophas and His Own: A North Atlantic Tragedy.* Halifax, N.S.: Press Publication, 1982.
This book contains a facsimile reproduction of the typed manuscript of Hartley's story, along with accompanying poems, from the Marsden Hartley Memorial Collection, Bates College, Lewiston, Maine. Preface by Gerald Ferguson.

446 ———. *The Collected Poems of Marsden Hartley, 1904–1983*, edited by Gail R. Scott. Santa Rosa, Calif.: Black Sparrow Press, 1987.
Gail R. Scott has compiled and edited an extensive collection of Hartley's

poetry, with representative examples from all phases of his career, both published and unpublished, arranged in twenty-one sections. The endnotes provide details concerning textual sources, publication, probable dating, pertinent biographical background, and related paintings or prose essays. The book includes a preface by Scott; a foreword by Robert Creeley; a reprint of Hartley's essay "The Business of Poetry" (see entry 444); and a title/first line index.

447 _____. *Eight Poems and One Essay by Marsden Hartley (1877–1943) in the Marsden Hartley Memorial Collection.* Lewiston, Maine: Treat Gallery, Bates College, 1976.

This book features eight previously unpublished poems, seven of which were given by Hartley to his niece, Norma Gertrude Berger, and one that was dedicated to the poet Seumus O'Sheel and signed by Hartley using his pseudonym Benio Horbia. Also included is "The New Paintings of Carl Sprinchorn of the Maine Woods," a previously unpublished review of the exhibition *Paintings by Carl Sprinchorn*, held at the Macbeth Gallery, New York, 4–23 January 1943. The book contains an introduction by Synnove Haughom and a brief bibliography.

448 _____. "Epitaph for Alfred Stieglitz." *Camera Work* no. 48 (October 1916) 70.

Reprinted excerpt from a letter to Stieglitz, dated 10 August 1916.

449 _____. "New England on the Trapeze." *Creative Art* 8 (February 1931) suppl.-57–58.

Hartley criticizes the commercialism of New England.

450 _____. *On Art*, edited by Gail R. Scott. New York: Horizon Press, 1982.

Scott has compiled an indispensable collection of Hartley's writings on art and aesthetics, many of which are from archival sources or otherwise difficult to locate. Included are forewords, statements, and essays from various exhibition catalogues; periodical articles; lectures; contributions to books; and unpublished essays from the Collection of American Literature, Beinecke Rare Book and Manuscript Library, Yale University. Scott provides a lengthy introduction; textual and source notes; a complete checklist of Hartley's published writings; and an index.

451 _____. "The Paintings of Florine Stettheimer." *Creative Art* 9 (July 1931) 18–23.

This critical evaluation focuses on the portraits. For comments on Hartley's assessment, see Barbara J. Bloemink, *The Life and Art of Florine Stettheimer*, 174–175, 177 (New Haven, Conn.: Yale University Press, 1995).

452 _____. "Red Man Ceremonials: An American Plea for American Es-
thetics." *Art and Archeology* 9 (January 1920) 7–14.
 Hartley praises the Native American as "the one truly indigenous regionalist
and esthete of America." He discusses Native American dances and extolls their
sense of time, symbolic significance, notion of the theatric, embodiment of spir-
itual drama, fine perception of nuance, knowledge of color relations, and inven-
tive rhythms.

453 _____. *Sea Burial.* Portland, Maine: Leon Tebbetts Editions, 1941.
 Hartley's third and final published book of poetry.

454 _____. *Selected Poems*, edited and introduced by Henry W. Wells. New
York: Viking Press, 1945.
 A posthumously published collection.

455 _____. *Somehow a Past: The Autobiography of Marsden Hartley*, edited
by Susan Elizabeth Ryan. Cambridge: MIT Press, 1997.
 This is the first appearance in print of Hartley's autobiography. The hand-
written version that Ryan has transcribed is from the Collection of American
Literature, Beinecke Rare Book and Manuscript Library, Yale University. It
bears the subtitle *Prologue to Imaginative Living* and was written during No-
vember and December 1933 while Hartley was in Bavaria. In addition to her
introduction, Ryan provides documentary and annotative endnotes. Two later
versions of *Somehow a Past*, which Hartley worked on intermittently from the
late 1930s to the early 1940s, bear the subtitles *A Sequence of Memories Not
to Be Called an Autobiography* and *A Journal of Recollection.* These versions
are more fragmentary and less comprehensive (selected excerpts from both ap-
pear as appendixes). The book also contains several letters written by Hartley
to Gertrude Stein and Norma Berger; two versions of Hartley's poem "Somehow
a Past"; forty-five illustrations; a chronology; and an index.

456 _____. "Tribal Aesthetics." *The Dial* 65 (16 November 1918) 399–401.
 Hartley laments the lack of appreciation for southwestern Native American
dance: "It is a life of anciently splendid ritual, and we of this time have lost the
gift of ritual. We are without the power to celebrate the simple experience. We
have no ceremony for our vision."

457 _____. *Twenty-five Poems.* Paris: Contact Editions, 1923.
 Hartley's first published book of poetry.

458 _____. "What Is 291?" *Camera Work* no. 47 (July 1914) 35–36.
 Hartley's response to Stieglitz's question "What is 291?"

459 *Heart's Gate: Letters between Marsden Hartley and Horace Traubel, 1906–1915*. Highlands, N.C.: Jargon Society, 1982.

These letters between Hartley and his friend and mentor Horace Traubel are edited and introduced by William Innes Homer.

460 "Letters from Germany, 1933–1938." *Archives of American Art Journal* 25:1/2 (1985) 3–28.

This selection of letters written by American artists in Germany during the 1930s includes nine from Hartley to Adelaide Kuntz and one to Edith Gregor Halpert. The letters are accompanied by uncredited introductory comments, footnotes, and captions to the illustrations.

461 "Marsden Hartley's Letters to Franz Marc and Wassily Kandinsky 1913–1914." *Archives of American Art Journal* 29:1/2 (1989) 35–44.

A selection of fourteen items of correspondence written by Hartley to Gabriele Münter, Franz Marc, and Wassily Kandinsky during 1913 and 1914, introduced and annotated by Patricia McDonnell.

461A McCoy, Garnett. "South of the Border with Marsden Hartley: Letters to Edith Halpert, 1931–1933." *Archives of American Art Journal* 37:1/2 (1997) 11–19.

Four letters written by Hartley to Edith Gregor Halpert, founder of the Downtown Gallery and Hartley's dealer at the time, dated from 5 November 1931 to 12 January 1933. They deal with his stay in Mexico and financial matters relating to the sale of his work.

II. BOOKS AND EXHIBITION CATALOGUES

462 Anderson Galleries. *Seventy-five Pictures by James N. Rosenberg and 117 Pictures by Marsden Hartley: To Be Sold by Auction by Order of Mr. Rosenberg and Mr. Hartley*. New York: The Galleries, 1921.

Catalogue of an exhibition and auction held at the Anderson Galleries, New York, 10–17 May 1921. Catalogue text by Alfred Stieglitz and James N. Rosenberg.

463 Ames, (Polly) Scribner. *Marsden Hartley in Maine (through the Eyes of Katie Young of Corea, Maine)*, edited by Richard S. Sprague. [Maine Studies, 94.] Orono: University of Maine Press, 1972.

Hartley spent the last four summers of his life in Corea, Maine, at the home of Forrest and Katie Young. This reminiscence of Hartley's final years was recorded by his friend and fellow painter (Polly) Scribner Ames. The original manuscript and the accompanying drawings, which date from 2 September 1943, are housed in the Archives of American Art, Smithsonian Institution, Washington, D.C. The book contains a foreword by Elizabeth McCausland and an afterword by Carl Sprinchorn.

464 Babcock Galleries. *Marsden Hartley 1877–1943: Paintings from 1910 to 1942 and a Bavarian Sketchbook of Silverpoint Drawings, 1933.* New York: The Galleries, 1980.

Catalogue of an exhibition held at the Babcock Galleries, New York, March 1980. The exhibition included twenty oils and a sketchbook of silverpoint drawings executed in the Bavarian Alps in 1933. The catalogue contains an essay by James R. Mellow, two illustrations, and a checklist of the exhibition.

465 Barridoff Galleries. *Marsden Hartley in New England.* Portland, Maine: The Galleries, 1980.

Catalogue of an exhibition held at the Barridoff Galleries, Portland, Maine, 12 July–3 September 1980.

466 Bernard Danenberg Galleries. *Marsden Hartley: A Retrospective Exhibition.* New York: The Galleries, 1969.

Catalogue of an exhibition held at the Bernard Danenberg Galleries, New York, 16 September–4 October 1969, which includes thirty-six oils (all illustrated, one in color) and an unspecified selection of watercolors, pastels, drawings, and lithographs. The catalogue contains a checklist of the exhibition; a chronology; a list of one-man exhibitions and works in public collections; a reprint of Frederick S. Wight's essay from *New Art in America* (see entry 600); and a reprint of Hartley's essay from *Creative Art* (see entry 443).

467 Broun, Elizabeth. *Albert Pinkham Ryder,* 134–136, 170–174. Washington, D.C.: Published for the National Museum of American Art by Smithsonian Institution Press, 1989.

Broun singles out six of Hartley's works and discusses the influence of Ryder on their format and symbolic language.

468 Cape Ann Historical Association. *Marsden Hartley: Soliloquy in Dogtown.* Gloucester, Mass.: The Association, 1985.

Catalogue of an exhibition held at the Cape Ann Historical Association, Gloucester, Massachusetts, 26 July–21 September 1985. The exhibition featured an unspecified number of paintings and drawings that Hartley executed during the 1930s in an uninhabited area of Massachusetts' Cape Ann known as Dogtown Common. The catalogue contains three essays: "Introduction/The Challenge of Dogtown," by Martha Oaks; "Marsden Hartley: 'The' Painter of Dogtown," by James F. O'Gorman; and "Marsden Hartley: The Painter as Poet," by Peter Anastas. Several documentary photographs of the region are included.

469 Cincinnati Modern Art Society. *Marsden Hartley/Stuart Davis.* Cincinnati, Ohio: The Society, 1941.

Catalogue of a dual exhibition featuring twenty-one works by Hartley held at the Cincinnati Modern Art Society, Cincinnati, Ohio, 24 October–24 November 1941. Foreword by Peggy Frank. The section on Hartley is preceded by his

introduction, "Pictures," and followed by a checklist, a biographical sketch, and a bibliography.

470 Cooper, Emanuel. *The Sexual Perspective: Homosexuality and Art in the Last 100 Years in the West.* 2d ed. London and New York: Routledge, 1994.
In Chapter 6, "The Sexual Code," Cooper discusses Hartley's homosexuality both in terms of the artist's social isolation and personal loneliness and in the context of his quest for spiritual fulfillment.

471 Everson Museum of Art. *Provincetown Painters, 1890's–1970's.* Syracuse, N.Y.: The Museum 1977.
Catalogue of an exhibition held at the Everson Museum of Art, Syracuse, New York, 1 April–26 June 1977, which includes Hartley's *Trixie* of 1916. In her essay "History of the Provincetown Art Colony," Dorothy Gees Seckler discusses Hartley in terms of his artistic activities in Provincetown (pp. 33, 35).

472 Gropper Art Gallery. *Marsden Hartley and Carl Sprinchorn: Paintings, Drawings, Pastels, Graphic Work.* Cambridge, Mass.: The Gallery, 1967.
Catalogue of an exhibition that included twenty-eight works by Hartley held at the Gropper Art Gallery, Cambridge, Massachusetts, 7–30 June 1967.

472A Hackett-Freedman Gallery. *Marsden Hartley: Observation and Intuition.* San Francisco: The Gallery, 2001.
Catalogue of an exhibition held at the Hackett-Freedman Gallery, San Francisco, 1 February–31 March 2001. Essay by Peter Selz.

473 Haskell, Barbara. *Marsden Hartley.* New York: Whitney Museum of American Art, in association with New York University Press, 1980.
Catalogue of a retrospective exhibition held at the Whitney Museum of American Art, New York, 4 March–25 May 1980. The exhibition featured 115 works, all of which are illustrated (40 on color plates). Haskell's lengthy essay provides biographical details on all phases of Hartley's career along with a critical appraisal of his aesthetic influences; choice of subject matter; compositional structure and color schemes; and motifs and symbolism. The work is accompanied by documentary photographs; a bibliography and exhibition history; and a checklist of the exhibition.

474 Heckscher Museum. *The Students of William Merritt Chase.* Huntington, N.Y.: The Museum, [1973].
Catalogue of an exhibition held at the Heckscher Museum, Huntington, New York, with the "Major Artists" portion shown 18 November–20 December 1973. The second half of the catalogue, devoted to Chase's modernist students, is introduced by Ronald G. Pisano's essay "Chase and the Modern Movement in American Art." Each artist is represented by an early work executed under

Chase's tutelage and a later work. The catalogue includes Hartley's *Still Life* (now lost) and his *Garmisch Parten Kirchen Number 1* of 1933–1934.

475 Hokin, Jeanne. *Pinnacles and Pyramids: The Art of Marsden Hartley*. Albuquerque: University of New Mexico Press, 1993.

Hokin provides a detailed explication of the mountain motif in Hartley's work and devotes separate chapters to New Mexico, France, Germany, and Maine. She draws extensively on the artist's writings to illuminate his aesthetic viewpoint and attitude toward nature. The book contains numerous black-and-white illustrations and thirty-four color plates, plus an extensive bibliography.

475A Hollis Taggart Galleries. *Concerning Expressionism: American Modernism and the German Avant-Garde*. New York: The Galleries, 1998.

Catalogue of an exhibition held at the Hollis Taggart Galleries, New York, 20 May–31 July 1998, which includes six works by Hartley. Essay by Patricia McDonnell.

476 Knoedler Galleries. *Marsden Hartley: A Selection of His Paintings and Drawings of the Twenties and Thirties*. New York: The Galleries, 1968.

Catalogue of an exhibition held at the Knoedler Galleries, New York, 9–27 January 1968, which includes thirty paintings and nine drawings. The catalogue contains a checklist of the exhibition and a chronology.

476A Kraushaar Galleries. *Marsden Hartley: Drawings*. New York: The Galleries, 2000.

Catalogue of an exhibition of twenty drawings held at Kraushaar Galleries, New York, 11 February–11 March 2000. The catalogue contains an essay by Bruce Robertson, nine illustrations, and a checklist of the exhibition.

477 La Farge, Oliver. *Santa Fe: The Autobiography of a Southwestern Town*, 262–263. Norman: University of Oklahoma Press, 1959.

A reprinted item from the 4 May 1920 issue of the *New Mexican* newspaper titled "New Mexico Verse," which discusses Hartley's poem "The Festival of the Corn," from his *Sunlight Persuasions* series.

478 Levin, Gail. *Marsden Hartley in Bavaria*. Clinton, N.Y.: Emerson Gallery, Hamilton College; Hanover, N.H.: Distributed by the University Press of New England, 1989.

Catalogue of an exhibition held at the Emerson Gallery of Hamilton College, Clinton, New York, 23 September–5 November 1989. Levin's catalogue essay deals with Hartley's Bavarian sojourns of 1913 and 1933–1934. The exhibition featured fifteen paintings, two pastels, nineteen charcoal and crayon works, four lithographs, seventeen pencil drawings, five ink drawings, and twenty-one sil-

verpoints. The catalogue contains numerous illustrations and documentary photographs.

479 Long Island University. C.W. Post Art Gallery. *Marsden Hartley, 1877–1943*. Greenvale, N.Y.: The Gallery, 1977.

Catalogue of an exhibition of forty-seven works held at the C.W. Post Art Gallery, Long Island University, Greenvale, New York, 6 November–14 December 1977. The catalogue contains an essay by H. Harvard Arnason and a bibliography.

480 Ludington, Townsend. *Marsden Hartley: The Biography of an American Artist*. Boston: Little, Brown, 1992.

Ludington's exhaustive research into archival sources as well as his extensive discussions with other Hartley scholars have provided him with valuable psychological insights into the artist's aesthetic aims, intellectual development, and mystical predilections; also, his felicitous style makes the book an enjoyable read for its own sake.

481 ———. *Seeking the Spiritual: The Paintings of Marsden Hartley*. Ithaca, N.Y.: Cornell University Press; published in association with the Ackland Art Museum, University of North Carolina at Chapel Hill, and Babcock Galleries, New York, 1998.

This book was published to coincide with the exhibition *Seeking the Spiritual: The Paintings of Marsden Hartley* held at the Ackland Art Museum, University of North Carolina at Chapel Hill, 25 January–29 March 1998. Following an introductory essay, which focuses on the ties between Hartley's poetry and his paintings, Ludington annotates twenty-seven works from ca. 1906 to ca. 1941–1943 (all illustrated on color plates).

482 MacGowan, Christopher J. *William Carlos Williams's Early Poetry: The Visual Arts Background*. Ann Arbor, Mich.: UMI Research Press, 1984.

MacGowan discusses Williams' relationship with Hartley in a number of contexts throughout the book, including their common interest in Wassily Kandinsky (pp. 44–48); "contact" theory (pp. 86–88); and Dadaism (pp. 89–93).

483 Marling, William. *William Carlos Williams and the Painters, 1909–1923*. Athens: Ohio University Press, 1982.

In Part II of Chapter 5, "Three Painters of the 67th St. Salon," Marling provides a detailed account of Hartley's friendship with Williams.

484 McCausland, Elizabeth. *Marsden Hartley*. Minneapolis: University of Minnesota Press, 1952.

McCausland's monograph, despite some shortcomings, remains one of the

more perspicacious critical expositions of Hartley's career. A checklist of Hartley's works, a chronology, and a bibliography are included.

485 McDonnell, Patricia. *Marsden Hartley: American Modern. The Ione and Hudson D. Walker Collection.* Minneapolis: Frederick R. Weisman Art Museum, University of Minnesota; Seattle: Distributed by University of Washington Press, 1997.

Catalogue of an exhibition held at the Frederick R. Weisman Art Museum, University of Minnesota, Minneapolis, 4 June–31 August 1997. The exhibition included thirty-seven oils and sixteen works on paper, plus three related works, all from the Ione and Hudson D. Walker Collection. McDonnell's essay "Changes of Heart: Marsden Hartley's Ideas and Art" focuses on the artist's aesthetic and intellectual development. The catalogue contains a foreword by Lyndel King; a chronology; a selected bibliography; a checklist of the exhibition; and numerous color illustrations and documentary photographs.

486 *Marsden Hartley, Ausstellung.* [S.l.: s.n.], 1961.

Catalogue of an exhibition held at three German venues during 1961: Amerika Haus, Berlin, 15 March–6 April; Städtische Galerie, München, 14 April–5 May; and Kunstmuseum der Stadt, Düsseldorf, 10 May–1 June.

487 Mitchell, William J. *Ninety-nine Drawings by Marsden Hartley [1877–1943] from Its Marsden Hartley Memorial Collection, Treat Gallery.* Lewiston, Maine: Art Department, Bates College, 1970.

This book reproduces all ninety-nine of Hartley's drawings in the Marsden Hartley Memorial Collection, Bates College, Lewiston, Maine, accompanied by an introduction, catalogue notes, and a bibliography by William J. Mitchell.

488 Moore, Marianne. *The Selected Letters of Marianne Moore*, edited by Bonnie Costello, 408. New York: Alfred A. Knopf, 1997.

Letter from Moore to Hartley, dated 2 January 1941, concerning the latter's *Androscoggin* (see entry 441).

489 Mount Saint Vincent University. Art Gallery. *Marsden Hartley and Nova Scotia*, edited by Gerald Ferguson. Halifax, N.S.: The Gallery, in association with the Press of the Nova Scotia College of Art and the Art Gallery of Ontario, [Toronto], 1987.

This book, which focuses on Hartley's artistic and literary output during his stays in Nova Scotia during 1935 and 1936, was published to accompany the exhibition held at the Mount Saint Vincent University Art Gallery, Halifax, Nova Scotia, 22 October–23 November 1987 and the Art Gallery of Ontario, Toronto, 6 January–13 March 1988. A selection of Hartley's writings is featured, including letters written to Adelaide Kuntz; journal entries and poems relating

to Nova Scotia; and the complete text of his unpublished manuscript "Cleophas and His Own: A North Atlantic Tragedy" (see entry 445), which is discussed by Gail R. Scott in her essay. The book also contains forewords by Mary Sparling and Roald Nasgaard; an introduction by Gerald Ferguson; an essay by Ronald Paulson on Hartley's artistic odyssey; a chronology; a selected bibliography; and numerous illustrations, photographs, and maps.

490 Museum of Modern Art (New York). *Lyonel Feininger/Marsden Hartley*. New York: The Museum, 1944.

The second half of this catalogue is devoted to the memorial exhibition *Marsden Hartley*, held at the Museum of Modern Art, New York, 24 October 1944– 14 January 1945. The exhibition featured eighty-seven paintings and nineteen drawings, prints, and pastels (thirty-eight works are illustrated, one in color). The catalogue contains a foreword by Monroe Wheeler; reprints of some of Hartley's essays, notes, and letters; a checklist of the exhibition; a chronology; lists of Hartley's lithographs, one-man exhibitions, and American museums owning his works; and a selected bibliography.

491 Museum of New Mexico. Art Gallery. *Marsden Hartley*. Santa Fe: The Museum, 1958.

Catalogue of a loan exhibition (from the Ione and Hudson D. Walker collection of the University of Minnesota, arranged in cooperation with Roswell Museum) held at the Museum of New Mexico Art Gallery, Santa Fe, February 1958. The catalogue contains a checklist of the twenty-one works in the exhibition, an essay by Frederick Black, a chronology, and six illustrations.

492 Oles, James. *South of the Border: Mexico and the American Imagination, 1914–1947*. Washington, D.C.: Smithsonian Institution Press, 1993.

Catalogue of an exhibition held at the Yale University Art Gallery, New Haven, Connecticut, 10 September–21 November 1993. The exhibition included three works by Hartley: *Popocatepetl, Spirited Morning—Mexico* of 1932, *Carnelian Country* of 1932, and *Tollan—Aztec Legend* of 1933. In his essay "South of the Border: American Artists in Mexico, 1914–1947," Oles discusses Hartley's interest in the Mexican landscape and pre-Columbian cultures (pp. 151– 159).

493 Robertson, Bruce. *Marsden Hartley*. New York: H.N. Abrams, in association with the National Museum of American Art, Smithsonian Institution, Washington, D.C., 1995.

Although Robertson's monograph presents a solid general narrative of Hartley's career, few in-depth discussions of individual works are included. The book contains a brief selected bibliography and over 100 illustrations (52 in color).

494 Salander-O'Reilly Galleries. *Marsden Hartley (1877–1943): Paintings and Drawings*. New York: The Galleries, 1985.

Catalogue of an exhibition held at the Salander-O'Reilly Galleries, New York, 6 March–27 April 1985. The exhibition featured sixty-six paintings (all are illustrated, forty-two in color) and nineteen drawings (all are illustrated in black and white). Essay by Karen Wilken.

495 _____. *Marsden Hartley (1873–1943): Paintings and Drawings*. New York: The Galleries, 1987.

Catalogue of an exhibition held at the Salander-O'Reilly Galleries, New York, 8 January–27 February 1987. The exhibition featured thirty-five paintings (thirty-two are illustrated in color) and fifteen drawings (ten are illustrated in black and white). Essay by Lawrence B. Salander.

496 _____. *Marsden Hartley: Six Berlin Paintings, 1913–1915*. New York: The Galleries, 1992.

Catalogue of an exhibition held at the Salander-O'Reilly Galleries, New York, 3–23 September 1992. The six Berlin paintings in the exhibition were *Raptus* of ca. 1913; *The Warriors* of 1913; *Painting No. 3* of 1914; *Paris Days . . . Pre War* of 1914; *Berlin Series No. 2* of 1914; and *Himmel* of 1915 (all are illustrated in color). Essay by Gail Levin.

497 _____. *Marsden Hartley: The Late Figure Works*. New York: The Galleries, 1990.

Catalogue of an exhibition held at the Salander-O'Reilly Galleries, New York, 4–30 June 1990. The focus of the exhibition was Hartley's figure works executed between 1938 and 1943, including twenty-six paintings (all are illustrated in color) and fifty-seven drawings from the Marsden Hartley Memorial Collection, Museum of Art, Olin Arts Center, Bates College, Lewiston, Maine (all are illustrated in black and white). Foreword by Lawrence B. Salander.

498 Scott, Gail R. *Marsden Hartley*. New York: Abbeville Press, 1988.

Scott, a leading Hartley scholar, discusses all aspects of Hartley's career, including his aesthetic, intellectual, and spiritual influences and development. She critically analyzes dozens of works in terms of their compositional elements, subject matter, symbolism, and significance. The book contains a chronology; an exhibition history; a list of public collections owning the artist's work; a selected bibliography; and 154 illustrations, many in color.

499 Sid Deutsch Gallery. *Inaugural Exhibition Celebrating Our Move to Expanded Premises: Late Nineteenth and Twentieth Century American Masters, and a Show of Sixteen Marsden Hartley Silverpoints*. New York: The Gallery, 1989.

Catalogue of an exhibition, which includes sixteen of Hartley's silverpoint drawings, held at the Sid Deutsch Gallery, New York, 3–25 October 1989.

500 Stedelijk Museum. *Marsden Hartley*. Amsterdam: The Museum, 1960.
Catalogue of an exhibition held at seven different venues in the United States and Europe between 1 December 1960 and 31 January 1962. The exhibition featured fifty-two paintings, fourteen gouaches and watercolors, and seven lithographs (thirty-three works are illustrated in black and white and two in color). The catalogue contains an essay by Elizabeth McCausland and a checklist of the exhibition.

501 Tebbetts, Leon H. *Marsden . . . As I Knew Him: My Friendship with Marsden Hartley* [cover title]. Hallowell, Maine: Valley Publishers, 1995.
A reminiscence by Leon H. Tebbetts, who published two books of Hartley's poetry, *Androscoggin* and *Sea Burial* (see entries 441 and 453). Tebbetts quotes from his correspondence with both Hartley and Hartley's friend, the German sculptor Arnold Rönnebeck. The book concludes with five of Hartley's poems, all previously unpublished.

502 _____. *Selected Stories and Essays*. Hallowell, Maine: Valley Publishers, 1994.
Tebbetts' collection contains an essay on Hartley.

503 Tom Veilleaux Gallery. *An Exhibition and Sale of Over Fifty Paintings from the Estate of Carl Sprinchorn (1887–1971)*. Farmington, Maine: The Gallery, 1994.
Gail R. Scott's catalogue essay provides details of Hartley's friendship with the Swedish-born American artist Carl Sprinchorn, based on information contained in the Carl Sprinchorn Papers housed in the Special Collections Department, Raymond H. Folger Library, University of Maine.

504 Turner, Elizabeth Hutton. *American Artists in Paris, 1919–1929*, 174–178. Ann Arbor, Mich.: UMI Research Press, 1988.
Turner discusses Hartley's years in France from 1925 to 1928 and reprints extracts from Hartley's correspondence with Adelaide Kuntz, Mathilde Reice, Alfred Stieglitz, and John Storrs.

505 Udall, Sharyn R. *Contested Terrain: Myth and Meaning in Southwest Art*. Albuquerque: University of New Mexico Press, 1996.
In Chapter 4, "Southwest Phoenix: Marsden Hartley's Search for Self in New Mexico," Udall discusses the ways in which Hartley's artistic, literary, and spiritual pursuits were interwoven during his New Mexico visits of 1918 and 1919. She notes that his *Indian Fantasy* of 1914, which is a painting from the *Amerika*

series, "is a complex product of Hartley's love for colorful, abstract patterning, cosmic mystical references, and a distant dream of the beauty and harmony of primitive Indian life."

506 *The University Galleries of the University of Southern California and the University Art Museum of the University of Texas at Austin Present a Selection of Representative Works by Marsden Hartley, Painter/Poet, 1877–1943*. [S.l.: s.n., 1968.]

Catalogue of a retrospective exhibition held at the University Galleries, University of Southern California, Los Angeles, 20 November–20 December 1968; the Tucson Art Center, Tucson, Arizona, 10 January–16 February 1969; and the University Art Museum, University of Texas at Austin, 10 March–27 April 1969. The exhibition featured 105 oils, pastels, lithographs, and drawings. The catalogue contains statements by Donald B. Goodhall, Edward S. Peck, and Alfredo Valente; forty-three black-and-white and five color illustrations; a chronology; and a checklist of the exhibition.

507 University of Kansas. Museum of Art. *Marsden Hartley: Lithographs and Related Works*. Lawrence: The Museum, [1972].

Catalogue of an exhibition held at the Museum of Art, University of Kansas, Lawrence, 19 March–16 April 1972. The exhibition featured seventeen lithographs (all are illustrated) and sixteen related works. The catalogue contains an essay by Charles C. Eldredge and a checklist of the exhibition.

508 University of Maine at Presque Isle. *Marsden Hartley: Visionary of Maine*. Presque Isle, Maine: The University, 1982.

Catalogue of an exhibition held at Library of the University of Maine at Presque Isle, 19 September–21 October 1982. The exhibition included thirteen paintings (three are illustrated) and twelve drawings (one is illustrated). The catalogue contains an essay by Gail R. Scott and a checklist of the exhibition.

509 University of Minnesota. Frederick R. Weisman Art Museum. *Dictated by Life: Marsden Hartley's German Paintings and Robert Indiana's Hartley Elegies*. Minneapolis: The Museum; New York: Distributed by Distributed Art Publishers, 1994.

Catalogue of an exhibition held at the Frederick R. Weisman Art Museum, University of Minnesota, Minneapolis, 14 April–18 June 1995. The exhibition featured Robert Indiana's series of fifteen elegies to Hartley executed between 1989 and 1994 and fourteen of Hartley's military abstractions painted in Berlin between 1913 and 1915 (all works are illustrated on color plates). The catalogue contains a foreword by Lyndel King; an introduction and an essay, "El Dorado: Marsden Hartley in Imperial Berlin," by Patricia McDonnell; and an essay by Michael Plante, "Truth, Friendship, and Love: Sexuality and Tradition in Robert

Indiana's Hartley Elegies." The catalogue also includes many documentary il-
lustrations and photographs; a checklist of the exhibition; and a selected bibli-
ography.

510 University of Minnesota. University Art Museum. *At the Crossroads of
Modernism: Marsden Hartley and Alfred Maurer from the University Art Mu-
seum's Permanent Collection.* Minneapolis: The Museum, 1990.

 Catalogue of an exhibition held at the University Art Museum, University of
Minnesota, Minneapolis, 10 January–15 March 1990, which includes twenty
works each by Hartley and Maurer. The catalogue contains an essay by Judith
Shendar, a checklist of the exhibition, and illustrations of five works (three by
Hartley).

511 _____. *Marsden Hartley 1908–1942: The Ione and Hudson D. Walker
Collection.* Minneapolis: The Museum, [1984].

 Catalogue of an exhibition held at eleven different venues between 20 January
1984 and 22 November 1985. The exhibition included forty-four paintings,
drawings, and lithographs from the collection of the University Art Museum,
University of Minnesota, Minneapolis, a 1977 gift of Hudson D. Walker (see
entry 089). Each entry is accompanied by Percy North's annotations. Thirty-
four works are illustrated (seven in color). The catalogue contains an essay by
Lyndel King, a chronology, and a selected bibliography.

512 _____. *Marsden Hartley Pastels: The Ione and Hudson D. Walker Col-
lection.* Minneapolis: The Museum, 1986. ·

 Catalogue of an exhibition held at the University Art Museum, University of
Minnesota, Minneapolis, 31 March–1 June 1986. The exhibition included all
but one of the eighteen Hartley pastels in the Hudson D. Walker collection (see
entry 089), many of which had never been exhibited before due to their fragile
condition. The catalogue contains a foreword by Lyndel King; an essay by
Robert L. Gambone; a checklist of the exhibition; a chronology; a selected
bibliography; and five color reproductions.

513 University of Minnesota. University Gallery. *The Mountains of Marsden
Hartley.* Minneapolis: The Gallery, 1979.

 Catalogue of an exhibition of nineteen works held at the University Gallery
of the University of Minnesota, Minneapolis, 26 March–29 April 1979. The
catalogue contains an essay by Carol Rice and a selected bibliography.

514 Weinberg, Jonathan. *Speaking for Vice: Homosexuality in the Art of
Charles Demuth, Marsden Hartley, and the First American Avant-Garde.* New
Haven, Conn.: Yale University Press, 1993.

 Weinberg utilizes Hartley's writings in his effort to explicate the homosexual
allusions, motifs, and symbols in the artist's work. He also delves into discus-

sions of Hartley's paintings in terms of their reversals and confusions of gender, as well as their spiritual versus sexual themes, both in the general context of the pre–World War II cultural milieu and in light of Hartley's own personal relationships.

515 Williams, William Carlos. *The Autobiography of William Carlos Williams.* New York: Random House, 1951.

Chapter 29, "New Faces," contains the poet's reminiscences of his friendship with Hartley. Williams writes, "He was one of the most frustrated men I knew. Marsden was happiest toward the end of his life among the Down East fishermen of the Maine coast. A tragic figure. I really loved the man, but we didn't always get along together, except at a distance."

III. ARTICLES AND ESSAYS

516 "Art—Maine Man." *Time* 44 (20 November 1944) 50.

A brief biographical sketch.

517 "Art News of America—Obituaries." *Art News* 42 (1–14 October 1943) 6.

An obituary.

518 Barnett, Vivian Endicott. "Marsden Hartley's Return to Maine." *Arts Magazine* 54 (October 1979) 172–176.

Barnett's article focuses on a number of the Hartley seascapes that were included in the exhibition *Marsden Hartley: Recent Paintings of Maine*, held at the Hudson D. Walker Gallery, New York, 28 February–2 April 1938.

519 Barry, Roxanne. "The Age of Blood and Iron: Marsden Hartley in Berlin." *Arts Magazine* 54 (October 1979) 166–171.

Barry examines Hartley's Berlin period abstractions on military and Native American themes.

520 Burlingame, Robert. "Marsden Hartley's *Androscoggin*: Return to Place." *The New England Quarterly* 31 (December 1958) 447–462.

Burlingame explicates several poems in *Androscoggin* (see entry 441).

521 Cassidy, Donna M. " 'On the Subject of Nativeness:' Marsden Hartley and New England Regionalism." *Winterthur Portfolio* 29 (Winter 1994) 227–245.

Cassidy presents an extended critical analysis of Hartley's repatriation and nativist rebirth in the 1930s. She discusses his utilization of the popular media; his establishing aesthetic links with Albert Pinkham Ryder and Winslow Homer; his exploitation of the contemporary longing for a sense of place in American

culture; his choice of regional subject matter; and his use of his own writings to reestablish himself as a nationalist and a New England regionalist.

522 Casteras, Susan P. "Marsden Hartley, *Peaches and Lemons.*" *Yale University Art Gallery Bulletin* 37 (Spring 1980) 28–29.
Casteras comments on Hartley's watercolor *Peaches and Lemons* of 1927–1928.

523 Cohen, George Michael. "The Bird Paintings of Morris Graves." *College Art Journal* 18 (Fall 1958) 2–19.
Cohen compares Hartley and Graves in terms of their artistic treatment of dying seabirds (pp. 11–13). Hartley's *Black Duck* of 1940–1941 is illustrated, and his poem "This Portrait of a Sea Dove, Dead" is reprinted from *Selected Poems* (see entry 454).

524 Deak, Gloria-Gilda. "Marsden Hartley." In *Kennedy Galleries Profiles of American Artists*, 2d ed., 110–111. New York: Kennedy Galleries, 1984.
A biographical essay.

525 Debrol, M. "Marsden Hartley—Painter of Mountains." *Creative Art* 2 (June 1928) xxxv–xxxvi.
An analysis of the spiritual aspects of the mountain motif in Hartley's work.

526 Dennis, James M. *Renegade Regionalists: The Modern Independence of Grant Wood, Thomas Hart Benton, and John Stuart Curry*. Madison: University of Wisconsin Press, 1998.
In Chapter 11, "Marsden Hartley's Return as a Nativist," Dennis discusses Hartley's Maine paintings of the 1930s and early 1940s in terms of the artist's attempt to capture a sense of place, and he also explores parallels in Grant Wood's regionalism.

527 Driscoll, John Paul. "New Discoveries in American Art [edited by Jayne A. Kuchna]: A Marsden Hartley of 1908." *The American Art Journal* 12 (Winter 1980) 85–86.
A discussion of Hartley's *Landscape* of 1908, which is perhaps the earliest known dated work to bear the artist's signature.

528 "Edmund Marsden Hartley, 1877–1943." In *American Paintings and Sculpture in the University Art Museum Collection*, 138–193, 531–533. Minneapolis: University Art Museum, University of Minnesota, 1986.
Following a biographical essay on Hartley by Lyndel King and Percy North, the latter annotates a majority of the sixty-one Hartley oils in the collection of the University Art Museum (now the Frederick R. Weisman Art Museum), University of Minnesota, Minneapolis, which were a bequest of Hudson D. Walker. All works are illustrated (eight in color).

529 Eldredge, Charles C. "Marsden Hartley, Lithographer." *The American Art Journal* 5 (May 1973) 46–53.

Eldredge examines Hartley's lithographs in terms of what they reveal about the directions that he was to pursue in his later paintings and drawings.

530 Foster, James W., Jr. "Two New Purchases." *The Baltimore Museum of Art News* 11 (December 1947) 4–6.

Foster discusses the acquisition of Hartley's *Still Life* by the Baltimore Museum of Art. Foster feels that this painting represents both Hartley's "feeling for color" and "his sensitive union of emotion and intellect, utilizing vigor of brush stroke with delicacy of scratched line."

531 Gallup, Donald. "The Weaving of a Pattern: Marsden Hartley and Gertrude Stein." *Magazine of Art* 41 (November 1948) 256–261.

Gallup explores Hartley's friendship with Gertrude Stein through an analysis of twenty-six letters that the artist wrote to her between 1912 and 1934 (see entry 438).

532 Gaehtgens, Thomas W. "Paris—München—Berlin: Marsden Hartley und die europäische Avantgarde." In *Kunst um 1800 und die Folgen: Werner Hofmann zu Ehren*, edited by Christian Beutler, Peter-Klaus Schuster, and Martin Warnke, 367–382. Munich: Prestel-Verlag, 1988.

An analysis of the contemporary European influences on Hartley between 1912 and 1915, with separate sections devoted to his work in Paris, Berlin, and Munich. Text in German.

533 George, Douglas. "Three Way Stations in the Career of Marsden Hartley: Berlin, Ogunquit, and Aix-en-Provence." *Bulletin. The University of New Mexico, University Art Museum* no. 8 (1974) 18–20.

George discusses three of Hartley's works in the collection of the Museum of Art, University of New Mexico, Albuquerque: *Berlin Series, No. 1* of 1915–1916, *Flowers in Vase* of 1917, and *Pears and Peaches #2* of 1927.

534 Gerdts, William H. "The Square Format and Proto-Modernism in American Painting." *Arts Magazine* 50 (June 1976) 70–75.

Gerdts traces the history of the square format canvas in American art back to around 1880. He discusses some of Hartley's early works that utilize this format and notes their debt to Ryder and Twachtman.

535 Goldwater, Robert. "Evening Storm, Schoodick [*sic*] Maine." *The Kenyon Review* 9 (Spring 1947) [165–166].

An analysis of Hartley's *Evening Storm, Schoodic, Maine* of 1942.

536 Harithas, James. "Marsden Hartley's German Period Abstractions." *The Corcoran Gallery of Art Bulletin* 16 (November 1967) 22–26.

A brief article on the deeper symbolic significance of Hartley's abstractions painted in Berlin, focusing in particular on *Berlin Abstraction* of 1914–1915 and the drawing *Berlin Symbols #6* of 1913.

537 "Hartley Hurricane Acquired." *The Art Digest* 17 (February 1943) 23.
Notice of the acquisition of Hartley's *Hurricane Island, Vinalhaven, Maine* of 1942 by the Philadelphia Museum of Art.

538 Hartmann, Sadakichi. "Unphotographic Paint—The Texture of Impressionism." *Camera Work* no. 28 (October 1909) 20–23.
The opening paragraphs contain comments on Hartley's use of the Segantini "stitch" technique.

539 Hartt, Frederick. "A Marsden Hartley." *Smith College Museum of Art Bulletin* nos. 25–28 (June 1947) 41.
Hartt discusses Hartley's *Sea Window—Tinker Mackerel* of 1942. He notes, "The extraordinary effect of the picture is due not only to the forceful breadth of the technique, but to the richly suggestive grouping of the represented elements."

540 Haskell, Barbara. "Marsden Hartley: Two New Additions to the Permanent Collection." *Whitney Review* (1976/1977) 20–23.
Haskell discusses Hartley's *Landscape, New Mexico* of 1919–1920 and *Painting, Number 5* of 1914–1915 (both are illustrated in color).

541 Hass, Irvin. "The Print Collector: Marsden Hartley." *Art News* 51 (October 1952) 13, 66.
A brief overview of Hartley's work in lithography.

542 Hopkins, Henry T. "Marsden Hartley's 'The Lost Felice.' " *Bulletin. Los Angeles County Museum of Art* 16, no. 3 (1964) 3–11.
Hopkins discusses the compositional devices and symbolism in Hartley's *The Lost Felice* of 1939, which he considers to be "undoubtedly one of a half-dozen of Hartley's finest works."

543 Jaffe, Irma B. "Cubist Elements in the Painting of Marsden Hartley: A Phenomenological View." *Art International* 14 (April 1970) 33–38.
Jaffe explores Hartley's appropriation of Cubist devices in his works during the decade between 1910 and 1920. She feels that Hartley's strong inclination toward experimentation led him to an eclectic, albeit limited, use of the Cubist vocabulary that would remain a lasting influence.

544 Kramer, Hilton. "Critic's Notebook: Another Country." *Arts and Antiques* 9 (December 1992) 74–75.
A brief overview of Hartley's Berlin period abstractions.

545 _____. "Hartley's Lonely Vigil." *Art Digest* 28 (1 June 1954) 8, 23, 27.

Kramer attempts to pinpoint the reasons for Hartley's waning influence and reputation in the postwar era. He concludes that Hartley's gradual conversion from an emotional to an intellectual approach is not something that contemporary artists—for whom "imagination" reigns supreme—find relevant to their artistic concerns.

546 Levin, Gail. "Hidden Symbolism in Marsden Hartley's Military Pictures." *Arts Magazine* 54 (October 1979) 154–158.

Levin provides an explication of the martial and numerological symbolism in Hartley's military canvases painted in Berlin between 1913 and 1915.

547 _____. "Marsden Hartley and Mysticism." *Arts Magazine* 60 (November 1985) 16–21.

Hartley's interest in mysticism and occult philosophy is the focus of Levin's article. She discusses a number of the artist's works in this context, including the esoteric symbolism in several Berlin period abstractions and Mexican landscapes.

548 _____. "Marsden Hartley and the European Avant-Garde." *Arts Magazine* 54 (September 1979) 158–163.

Levin traces Hartley's association with a number of European modernists, including Picasso, Kandinsky, Marc, Delaunay, Epstein, and Kupka. She also comments on Hartley's paintings on glass and his interest in ethnographic and folk art.

549 _____. "Marsden Hartley, Kandinsky, and Der Blaue Reiter." *Arts Magazine* 52 (November 1977) 156–160.

Levin explores the aesthetic and spiritual influences that the German artists of Der Blaue Reiter, including Wassily Kandinsky and Franz Marc, exerted on Hartley's military and Native American abstractions painted in Berlin.

549A _____. "Marsden Hartley's 'Amerika': Between Native American and German Folk Art." *American Art Review* 5 (Winter 1993) 120–125, 170–171.

Levin discusses two of Hartley's lesser-known oils from his "Amerika" series—*Schiff* and *Leuchtterm*—both painted in Berlin during 1915 and now in the collection of the Staatliche Galerie Moritzburg, Halle, Germany. She points out that Der Blaue Reiter introduced Hartley to German folk art (he was particularly impressed with Bavarian glass paintings) and also kindled his interest in Native American art. The two paintings contain decorative designs and motifs drawn from both traditions.

550 _____. "Photography's 'Appeal' to Marsden Hartley." *Yale University Library Gazette* 68 (October 1993) 12–42.

Levin traces the previously undocumented role that photography played in Hartley's aesthetic philosophy and creative endeavors. She makes extensive use of the artist's writings, including his correspondence housed in the American Literature Collection, Beinecke Rare Book and Manuscript Library, Yale University. The article features reproductions of many of Hartley's photographs and related paintings.

551 MacGowan, Christopher J. "William Carlos Williams' 'The Great Figure' and Marsden Hartley." *American Literature* 53 (May 1981) 302–305.
"The Great Figure" was published in Williams' collection *Sour Grapes* (1921). MacGowen analyzes the poem in terms of the common numeric symbolism, spontaneity of composition, and sense of artistic isolation that it shares with Hartley's military abstractions painted in Berlin.

552 Madoff, Steven Henry. "Looking at Art—Marsden Hartley: Painter in Motion." *Art News* 88 (November 1989) 81–82.
Madoff's discussion centers around Hartley's *Last of New England—The Beginning of New Mexico* of ca. 1920.

553 Marling, William. "Marsden Hartley and William Carlos Williams: The Figure of a Friendship." *Arts Magazine* 55 (June 1981) 103–107.
In recounting the often strained friendship between Hartley and Williams, Marling compares and contrasts their poetry, noting that they both employed similar techniques and shared a common interest in themes and subject matter.

554 "Marsden Hartley." *Journal of the Archives of American Art* 8 (January 1968) 9–21.
A transcript of Hudson D. Walker's tape-recorded recollections of Hartley in an interview conducted by Elizabeth McCausland and Mary Bartlett Cowdrey.

555 "Marsden Hartley, Biographical Note." *Creative Art* 2 (June 1928) xxviii.
An uncredited biographical sketch.

556 "Marsden Hartley: Fame Finally Catches Up to Poet-Painter of Maine." *Life* 32 (16 June 1952) 84–89.
A brief overview of Hartley's career accompanied by seven color illustrations.

557 "Marsden Hartley, Noted Artist, Dies—Internationally Known for His Landscapes and Marines—Stricken in Maine at 66." *New York Times* (3 September 1943) 19.

557A "Marsden Hartley: *Raptus.*" *Bulletin. The Currier Gallery of Art* (May–June 1967) [unpaginated].
Notice of the acquisition of Hartley's *Raptus* of ca. 1913.

558 McBride, Henry. "Modern Art." *The Dial* 70 (January 1921) 113–114.

McBride reprints extracts from Hartley's lecture at the Société Anonyme, 30 November 1920, and recounts some of the question-and-answer session that followed.

559 McCausland, Elizabeth. "The Lithographs of Marsden Hartley." *Artist's Proof* 2 (Spring 1962) 30–32.

In her discussion of Hartley's lithographs, McCausland notes that while they are important to the artist's oeuvre, the actual works themselves suffer from being printed on poor-quality paper.

560 _____. "Return of the Native: Marsden Hartley." *Art in America* 40 (Spring 1952) 55–79.

This article is based on McCausland's address given at the University of Minnesota, 6 May 1952, on the occasion of the publication of her monograph, which provides a more extended critical study of the artist (see entry 484).

561 _____. "Tradition and Marsden Hartley." *Texas Quarterly* 5 (Winter 1962) 193–199.

McCausland traces Hartley's artistic development and concludes that it reached its apex when he became a "consummate poet of nature" through transforming the American landscape into an object of universal appeal. She warns against focusing too much on Hartley's youthful experiments with European styles and idioms.

562 McDonnell, Patricia. " 'Dictated by Life': Spirituality in the Art of Marsden Hartley and Wassily Kandinsky, 1910–1915." *Archives of American Art Journal* 29:1–2 (1989) 27–34.

McDonnell explores the influence that Wassily Kandinsky exerted on Hartley's aesthetic development, particularly the ways in which the Russian artist affected his attitudes toward abstraction. She contends that Hartley, sometimes labeled a "spiritualist" or "mystic," was in reality more concerned with recording the intuitive subjective impressions of his direct perceptual experiences of the external world. This places him solidly in the traditions of American transcendentalism and the empiricism of William James.

563 _____. " 'Essentially Masculine': Marsden Hartley, Gay Identity, and the Wilhelmine German Military." *Art Journal* 56 (Summer 1997) 62–68.

Hartley lived in Berlin from April 1913 to December 1915. McDonnell analyzes his military paintings of this period in the context of the city's homosexual subculture, including a discussion of the so-called Eulenberg Affair. She argues that these paintings contain veiled symbolism that not only reflects the masculinity celebrated in the Wilhelmine German culture but also alludes spe-

cifically to Hartley and his German companions, such as Lieutenant Karl von Freyberg.

564 _____. "*Indian Fantasy*: Marsden Hartley's Myth of *Amerika* in Expressionist Berlin." *North Carolina Museum of Art Bulletin* 16 (1993) 50–64.

McDonnell provides a detailed, critical explication of Hartley's *Indian Fantasy* of 1914, including its cultural and intellectual background, both German and American, and its stylistic influences and motifs.

565 _____. "Representation in Early American Abstraction: Paradox in the Painting of Marsden Hartley, Stanton McDonald-Wright and Morgan Russell." In *Over Here: Modernism, the First Exile, 1914–1919*, 67–77. Providence, R.I.: David Winton Bell Gallery, Brown University, 1989.

McDonnell explores the influence that Paul Cézanne and Gertrude Stein exerted on some of Hartley's early artistic precepts, such as his belief that intuitive, not rational, faculties nurtured creativity and his contention that art must be based first and foremost on experience and direct observation of the natural world.

566 Mellquist, Jerome. "Marsden Hartley." *Perspectives USA* no. 4 (Summer 1953) 62–77.

Mellquist offers an overview of the various phases of Hartley's career: Postimpressionism, Fauvism, Cubism, Symbolism, and Expressionism. He also discusses a number of Hartley's poems in the context of his aesthetic development.

567 _____. "Marsden Hartley: Visionary Painter." *The Commonweal* 34 (31 December 1943) 276–278.

An obituary.

568 Merideth, Robert. "A 'Maine-Iac' in Search of Tradition." *Colby Library Quarterly* 7 (March 1965) 27–29.

Merideth writes that it was Hartley's "sense of identification, not only with Maine as a place, but with Maine as a part of a cultural tradition, a heritage of values and perceptions, that made him successful in his later years."

569 Millard, Charles W. "Marsden Hartley." *The Hudson Review* 33 (Autumn 1980) 415–420.

Millard sums up his critical assessment of Hartley's achievement by writing, "Looking back over Hartley's career from the vantage point of his death in September 1943, one is struck by how irregular it was qualitatively and stylistically and how little it seems to have resulted from the expression of a strong, unwavering, internal vision."

570 Milman, Estera. "Dada New York: An Historiographic Analysis." In *Dada/Dimensions*, edited by Stephen C. Foster, 165–186. Ann Arbor, Mich.: UMI Research Press, 1985.

Milman discusses Hartley's views on Dada as presented in "The Importance of Being Dada," the afterword to *Adventures in the Arts* (see entry 439).

571 Munson, Gorham. "Homage to Marsden Hartley: The Painter from Maine." *Arts* 35 (February 1961) 32–41.

This lengthy, critical assessment of Hartley's achievement focuses on the artist's subject matter, compositional devices, and palette.

572 Musick, J.B.M. "*Smelt Brook Falls* by Marsden Hartley." *Bulletin of the City Art Museum of St. Louis* 24 (April 1939) 21–22.

Musick analyzes Hartley's *Smelt Brook Falls* of 1937.

573 North, Michael. "The Sign of Five: Williams' 'The Great Figure' and Its Background." *Criticism* 30 (Summer 1988) 325–348.

North discusses William Carlos Williams' poem "The Great Figure" in light of the Cubist-inspired alphanumeric symbols in both Hartley's *Portrait of Berlin* of 1913 and Charles Demuth's *I Saw the Figure 5 in Gold* of 1928. North argues that "the poem presents in dramatic form the essential semiotic exchange of Hartley's painting, in which numerals acquire representational qualities while images of people become conventional and abstract."

574 "Notes and Footnotes—Marsden Hartley (1877–1943)." *American Artist* 7 (October 1943) 3.

An obituary.

575 O'Connor, John, Jr. "Two New Paintings: Patrons Art Fund Purchases Added to Permanent Collection." *Carnegie Magazine* 17 (January 1944) 245–248.

O'Connor comments on the purchase of Hartley's *Young Hunter Hearing the Call to Arms* of 1939 by the Museum of Art, Carnegie Institute, Pittsburgh.

576 Pardee, Hearne. "A Reading of Marsden Hartley." *Arts Magazine* 58 (September 1983) 104–106.

In his analysis of the relationship between Hartley's poetry and painting, Pardee notes that in both Hartley often attempts to isolate a single concrete object or event in order to confer on it a symbolic aura that transcends local or regional concerns, thereby creating a tension between the literal and the transcendental.

577 Phillips, Duncan. "Marsden Hartley." *Magazine of Art* 37 (March 1944) 82–87.

Phillips reprints and discusses various passages from Hartley's *Adventures in the Arts* (see entry 439), focusing on what he believes they reveal about Hartley's influences.

578 Pincus-Witten, Robert. "On Target: Symbolist Roots of American Abstraction." *Arts Magazine* 50 (April 1976) 84–91. Reprinted in *Eye to Eye: Twenty Years of Art Criticism*, by Robert Pincus-Witten, 27–42. Ann Arbor, Mich.: UMI Research Press, 1984.

Pincus-Witten sets forth the thesis that the target images in modern art were an outgrowth of the Symbolist preoccupation with literary and intellectual themes and their use of the severed head motif. He discusses Hartley's military abstractions in this context.

579 Riley, Maude. "Death Takes Hartley." *The Art Digest* 18 (1 October 1943) 9, 29.

An obituary.

580 Robinson, William H. "Marsden Hartley's *Military*." *The Bulletin of the Cleveland Museum of Art* 76 (January 1989) 1–26.

Robinson presents a detailed explication of the background, iconography, and stylistic elements of Hartley's *Military* of 1914–1915.

581 Rosenfeld, Paul. "Books and the Arts: Marsden Hartley." *The Nation* 157 (18 September 1943) 326.

An obituary.

582 _____. "Marsden Hartley." In *Men Seen: Twenty-Four Modern Authors*, by Paul Rosenfeld, 177–188. New York: L. MacVeagh, Dial Press, 1925.

Rosenfeld analyzes Hartley's prose writing in *Adventures in the Arts* (see entry 439); he also critiques the artist's poetry, which he calls "coldly splendid."

583 _____. "Marsden Hartley." In *Port of New York*, by Paul Rosenfeld, 83–101. New York: Harcourt, Brace, 1924.

Rosenfeld discusses what he feels are the strengths and shortcomings of Hartley's art.

584 _____. "Marsden Hartley: Characteristics of the Work of One of the Very Greatest Talents among Present Day American Artists." *Vanity Fair* 18 (August 1922) 47, 84, 94, 96.

In this critical assessment, Rosenfeld praises Hartley's "extraordinary thematic invention" and "fastidious originality of expression," yet he finds that the artist's compositions often lack balance and harmony.

585 Ryan, Susan Elizabeth. "Elegy for an Exile." *Art and Antiques* 9 (March 1992) 84–89, 106, 109.
A discussion of Robert Indiana's series of elegies to Hartley.

586 Schwartz, Sanford. "The Northern Seascape." *Art in America* 64 (January–February 1976) 72–76. Reprinted in *The Art Presence*, by Sanford Schwartz, 53–63. New York: Horizon Press, 1982.
Schwartz examines Hartley's landscapes with an eye to the artist's psychological and intellectual motivations and the influence of Albert Pinkham Ryder.

587 _____. "When New York Went to New Mexico." *Art in America* 64 (July–August 1976) 92–97.
Toward the end of his article, Schwartz discusses Hartley's love-hate relationship with New Mexico.

588 Scott, Gail R. "Marsden Hartley at Dogtown Common." *Arts Magazine* 54 (October 1979) 159–165.
Hartley spent the summer of 1931 at Dogtown Common, near Gloucester, Massachusetts. Scott discusses the ways in which Hartley's experiences that summer resulted in an artistic and spiritual revitalization, which subsequently led him to a newly discovered sense of place on a universal level. She draws on Hartley's poems, letters, and autobiographical notes in an attempt to interpret his paintings, drawings, and pastels that feature this rocky and isolated terrain.

589 Seligmann, Herbert J. "Hartley Discovers American Civilization." *Manuscripts* no. 1 (February 1922) 14–15.

590 Silver, Kenneth E. "Modes of Disclosure: The Construction of Gay Identity and the Rise of Pop Art." In *Hand-Painted Pop: American Art in Transition, 1955–62*, 178–203. Los Angeles: Museum of Contemporary Art; New York: Rizzoli International, 1992.
Silver discusses the ways in which several of Hartley's works influenced Jasper Johns, including *Portrait of a German Officer* of 1914; *Eight Bells Folly: Memorial to Hart Crane* of 1933; and *Sustained Comedy (Portrait of an Object)* of 1939.

591 Tashjian, Dickran. "Marsden Hartley and the Southwest: A Ceremony for Our Vision, a Fiction for the Eye." *Arts Magazine* 54 (April 1980) 127–131.
Tashjian draws heavily on Hartley's writings to make the case that the insights that he gained through his contact with Native American religion and culture in the Southwest proved to be critical in the formation of his aesthetic outlook. Hartley attempted to create a uniquely American art through focusing on spontaneous and immediate personal experiences at the local level and then trying to capture them on canvas.

592 Tselos, Dimitri. "Bibliography." *Gazette des Beaux-Arts* 32 [VI Series] (November–December 1947) 190–191.
Review of the exhibition catalogue *Lyonel Feininger/Marsden Hartley* (see entry 490).

593 Udall, Sharyn R. "Marsden Hartley's Self Portrait." *El Palacio: Magazine of the Museum of New Mexico* 98 (Spring 1993) 26–33, 61–62.
Udall reprints and analyzes Hartley's poem "Portrait Effigy. L'Oiseau de feu-Feuervogel 'Sioux,' " a literary self-portrait, written in Santa Fe on 22 September 1919 at the request of arts patron Eva S. Fenyes.

594 Valentiner, W.R. "Log Jam, by Marsden Hartley." *Bulletin of the Detroit Institute of Arts of the City of Detroit* 23 (January 1944) 33.
Notice of the acquisition of Hartley's *Log Jam, Penobscot Bay* of 1940–1941 by the Detroit Institute of Arts.

595 Waage, Frederick O. "Fierce Passion and Frozen Light: Pattern and Inner Life in Marsden Hartley's Poetry." In *Design, Pattern, Style: Hallmarks of a Developing American Culture* [Southeastern American Studies Association, 83], edited by Don Harkness, 53–55. Tampa, Fla.: American Studies Press, 1983.
Waage examines the patterns and symmetry in Hartley's poetry, as well as the critical viewpoints expressed in his essays, for clues to explain his turbulent inner struggle between objective representation and subjective imagination.

596 Walker, Hudson D. "Marsden Hartley." *The Kenyon Review* 9 (Spring 1947) 248–259.
An assessment of Hartley's work by Hudson D. Walker, one of the artist's most important patrons later in his career.

597 Watson, Ernest W. "Two Painters: A Study in Contrasts." *American Artist* 9 (May 1945) 12–18, 35.
Watson compares and contrasts the careers of Hartley and Roy Brown, concluding with a quote from a letter sent by Hartley to Carl Sprinchorn, dated 3 September 1931.

598 Wells, Henry W. "The Pictures and Poems of Marsden Hartley." *Magazine of Art* 38 (January 1945) 26–30, 32.
Wells outlines the parallels between Hartley's paintings and poetry, emphasizing the artist's visual imagination, humanity, and democratic spirit.

599 _____. "The Poetry of Marsden Hartley." *Quarterly Review of Literature* 1 (Winter 1944) 100–106.
Wells summarizes Hartley's poetic achievement by writing, "On the one hand

his idealism, his warmth, his tendency towards retrospection and his faith in man and nature suggest kinship with the century in which he was born. On the other hand, his artistic audacity, his eclecticism, his succinctness and complete freedom from sentimentality imply literary ideals of recent years."

600 Wight, Frederick S. "Marsden Hartley." In *New Art in America: Fifty Painters of the Twentieth Century*, edited by John I.H. Baur, 73–78. Greenwich, Conn.: New York Graphic Society, in cooperation with Praeger, New York, [1957].
 A biographical sketch accompanied by six illustrations.

601 Williams, William Carlos. "Beginnings: Marsden Hartley 1948." In *A Recognizable Image: William Carlos Williams on Art and Artists*, edited with an introduction and notes by Bram Dijkstra, 151–154. New York: New Directions, 1978. An abridged version was published as Part 1 of "Two Pieces," *Black Mountain Review* 7 (Autumn 1957) 164–168.
 In this extended reminiscence of his friendship with Hartley, Williams writes, "He wrote his poems, and he was at times a very perceiving and detailed observer and had a poetic gift—not as significant as his wonderful gifts with the brush, but a vision which, when taken with his paintings as a part of the man, we cannot ignore. Some of his poems are unequalled."

602 _____. "Marsden Hartley: 1956." In *A Recognizable Image: William Carlos Williams on Art and Artists*, edited with an introduction and notes by Bram Dijkstra, 155–156. New York: New Directions, 1978.
 A brief reminiscence.

603 Winter, Peter. "Der Maler aus Maine und Preussens Militaria." *Kunst und Antiquitäten* pt. 9 (1993) 6–7.
 An overview of the military themes in Hartley's war motif works painted in Berlin. Text in German.

IV. EXHIBITION REVIEWS

604 "Photo-Secession Notes." *Camera Work* no. 28 (October 1909) 51.
 Review of the exhibition *Exhibition of Paintings in Oil by Mr. Marsden Hartley, of Maine*, held at the Photo-Secession Galleries, New York, 8–18 May 1909.

605 "Photo-Secession Notes: Exhibition of Paintings by Marsden Hartley." *Camera Work* no. 38 (April 1912) 36, 42–44.
 Review of the exhibition *Recent Paintings and Drawings by Marsden Hartley*, held at the Photo-Secession Galleries, New York, 7–26 February 1912, and

reprinted reviews of David Lloyd (*Evening Post*), Joseph Edgar Chamberlin (*Evening Mail*), James Huneker (*New York Sun*), Elizabeth L. Cary (*New York Times*), and Hutchins Hapgood (*Globe and Commercial Advertiser*).

606 "Exhibitions at '291.' " *Camera Work* no. 45 (June 1914) 16–23.
Review of the exhibition *Paintings by Marsden Hartley* held at the Photo-Secession Galleries, New York, 12 January–12 February 1914, plus reprinted reviews of Henry McBride (*New York Sun*), J. Edgar Chamberlin (*Evening Mail*), Charles H. Caffin (*New York American*), and Adolph Wolff (*International*). The forewords to the exhibition catalogue (by Hartley, Mabel Dodge, and Gertrude Stein) are reprinted.

607 Du Bois, Guy Pène. "Exhibitions in the Galleries: Marsden Hartley, A Modernist Who Looks Backwards." *Arts and Decoration* 5 (March 1915) 192–193.
Review of the exhibition *Paintings by Marsden Hartley: "The Mountain Series,"* held at the Daniel Gallery, New York, January–February 1915.

608 "The Martial Spirit of Hartley." *American Art News* 14 (8 April 1916) 9.
Review of the exhibition *Paintings by Marsden Hartley*, held at the Photo-Secession Galleries, New York, 4–22 April 1916.

609 " '291' Exhibitions: 1914–1916—Hartley Exhibition." *Camera Work* no. 48 (October 1916) 12, 58–60.
Review. See entry 608. Also reprinted reviews by Henry McBride (*New York Sun*), Charles H. Caffin (*New York American*), Willard Huntington Wright (*Forum*, revised), and Robert J. Cole (*Evening Sun*).

610 Seligmann, Herbert J. "The Elegance of Marsden Hartley—Craftsman." *The International Studio* 74 (October 1921) l–lIII.
Review of the exhibition *Seventy-Five Pictures by James N. Rosenberg and 117 Pictures by Marsden Hartley*, held at the Anderson Galleries, New York, 10–17 May 1921.

611 "Exhibitions in the New York Galleries: Marsden Hartley—Intimate Gallery." *The Art News* 27 (12 January 1929) 7.
Review of the *Hartley Exhibition*, held at the Intimate Gallery, New York, January 1929.

612 Moore, Dorothy Lefferts. "Exhibitions Coming and Going." *The Arts* 15 (February 1929) 121–122.
Review. See entry 611.

613 Pemberton, Murdock. "Soul Exposures." *Creative Art* 4 (January 1929) xlvii–xlviii.
Review. See entry 611.

614 "Exhibitions in New York: Marsden Hartley—An American Place." *The Art News* 29 (20 December 1930) 56.
Review of the exhibition *Marsden Hartley—New Paintings*, held at An American Place, New York, 15 December 1930–18 January 1931.

615 "New York Season." *The Art Digest* 5 (1 January 1931) 14.
Review. See entry 614.

616 Pemberton, Murdock. "The Art Galleries: Old Stories Retold." *The New Yorker* 6 (27 December 1930) 49.
Review. See entry 614.

617 Schnakenberg, H.E. "Exhibitions: Marsden Hartley." *The Arts* 17 (January 1931) 274.
Review. See entry 614.

618 "Exhibitions in New York: Marsden Hartley—Downtown Gallery." *The Art News* 30 (23 April 1932) 9.
Review of the exhibition *Pictures of New England by a New Englander; Exhibition of Recent Paintings of Dogtown, Cape Ann, Massachusetts*, held at the Downtown Gallery, New York, 26 April–15 May 1932.

619 "Hartley, Artist-Poet, Interprets New England." *The Art Digest* 6 (1 May 1932) 15.
Review. See entry 618. Excerpts from a review by Edward Alden Jewell (*New York Times*) are also included.

620 Shelby, Melvin Geer. "Around the Galleries—Downtown Gallery." *Creative Art* 10 (June 1932) 474–475.
Review. See entry 618.

621 Benson, E.M. "Exhibition Reviews: Marsden Hartley." *The American Magazine of Art* 29 (May 1936) 331–332.
Review of the exhibition *Marsden Hartley*, held at An American Place, New York, 22 March–14 April 1936.

622 Mumford, Lewis. "The Art Galleries: Tourist in Italy—Hartl and Hartley—Spring Miscellany." *The New Yorker* 12 (4 April 1936) 50.
Review. See entry 621.

623 "New York Criticism." *The Art Digest* 10 (15 April 1936) 16.
Reprinted excerpts from reviews by Henry McBride (*New York Sun*) and Lewis Mumford (*The New Yorker*). See entry 621.

624 Sayre, Ann H. "New Exhibitions of the Week: Sea—Gulls, Roses, Ikons, a Letter Never Sent." *The Art News* 34 (28 March 1936) 8.
Review. See entry 621.

625 Breuning, Margaret. "Seeing the Shows: Marsden Hartley." *Magazine of Art* 30 (June 1937) 386, 388.
Review of the exhibition *Marsden Hartley: Exhibition of Recent Paintings, 1936*, held at An American Place, New York, 20 April–17 May 1937.

626 Davidson, Martha. "New Exhibitions of the Week—Marsden Hartley: Paintings of the North." *The Art News* 35 (8 May 1937) 16–17.
Review. See entry 625.

627 Coates, Robert M. "The Art Galleries: A Whitney Annual—French Impressionists—Some Americans." *The New Yorker* 14 (19 March 1938) 39.
Review of the exhibition *Marsden Hartley: Recent Paintings of Maine*, held at the Hudson D. Walker Gallery, New York, 28 February–2 April 1938.

628 Davidson, Martha. "New Exhibitions of the Week: The Climax of Hartley's Painting in Powerful Coastal Scenes." *The Art News* 36 (26 March 1938) 21.
Review. See entry 627.

629 "Not to 'Dilate over the Wrong Emotion.' " *The Art Digest* 12 (15 March 1938) 9.
Review. See entry 627. An excerpt from a review by Melville Upton (*New York Sun*) is also included.

630 "Art: Hartley's Figures." *Time* 33 (20 March 1939) 24, 26.
Review of the exhibition *Marsden Hartley: 25th One Man Show*, held at the Hudson D. Walker Gallery, New York, 6 March–8 April 1939.

631 Breuning, Margaret. "Exhibition Reviews: Marsden Hartley." *Magazine of Art* 32 (April 1939) 252.
Review. See entry 630.

632 Brian, Doris. "New Exhibitions of the Week: Forceful Painting in a Twenty-Fifth Show by Marsden Hartley." *The Art News* 37 (25 March 1939) 14.
Review. See entry 630.

633 Coates, Robert M. "The Art Galleries: Abstractionists, and What about Them?" *The New Yorker* 15 (18 March 1939) 58.
Review. See entry 630.

634 "Marsden Hartley Holds His 25th Solo Show." *The Art Digest* 13 (15 March 1939) 52.
Review. See entry 630.

635 Devree, Howard. "Exhibition Reviews: Around New York—Marsden Hartley." *Magazine of Art* 33 (April 1940) 233.
Review of the exhibition *Recent Paintings of Maine, Marsden Hartley*, held at the Hudson D. Walker Gallery, New York, 11–30 March 1940.

636 Lane, James W. "New Exhibitions of the Week: The Virile Paintings by Marsden Hartley." *The Art News* 38 (16 March 1940) 15.
Review. See entry 635.

637 "The 'New' Hartley Emerges from Down East." *The Art Digest* 14 (15 March 1940) 8.
Review. See entry 635.

638 Williams, William Carlos. "Marsden Hartley: 1940." In *A Recognizable Image: William Carlos Williams on Art and Artists*, edited with an introduction and notes by Bram Dijkstra, 149–150. New York: New Directions, 1978.
Review. See entry 635.

639 Brian, Doris. "The Passing Shows: Hartley." *Art News* 41 (15–31 March 1942).
Review of the exhibition *Marsden Hartley*, held at the Macbeth Gallery, New York, 9–28 March 1942.

640 "Marsden Hartley in Successful Show." *The Art Digest* 16 (15 March 1942) 15.
Review. See entry 639.

641 "Early Hartley Drawings on View." *The Art Digest* 17 (15 October 1942) 11.
Review of the exhibition *Early Drawings by Marsden Hartley*, held at the Knoedler Galleries, New York, 12–31 October 1942.

642 "The Passing Shows." *Art News* 41 (15–31 October 1942) 27.
Review. See entry 641.

643 Boswell, Helen. "Marsden Hartley Shows Rugged Paintings." *The Art Digest* 17 (15 February 1943) 8.
Review of the exhibition *Recent Paintings by Marsden Hartley*, held at Paul Rosenberg and Co., New York, 2–27 February 1943.

644 Coates, Robert M. "The Art Galleries: Davis, Hartley, and the River Seine." *The New Yorker* 18 (13 February 1943) 58–59.
Review. See entry 643.

645 "The Passing Shows." *Art News* 42 (15–28 February 1943) 24.
Review. See entry 643.

646 Adams, Philip R. "Marsden Hartley Memorial." *Columbus Gallery of Fine Arts Monthly Bulletin* 14 (January 1944) 1–2.
Review of the *Marsden Hartley Memorial Exhibition*, held at the Columbus Gallery of Fine Arts, Columbus, Ohio, 8 January–7 February 1944.

647 "Hartley Memorial." *Art News* 42 (1–14 February 1944) 7.
Review. See entry 646.

648 Greenberg, Clement. "Art." *The Nation* 159 (30 December 1944) 810–811. Reprinted in *Clement Greenberg: The Collected Essays and Criticism*. Vol. 1, *Perceptions and Judgments, 1939–1944*, edited by John O'Brian, 246–248. Chicago: University of Chicago Press, 1986.
Reviews of the exhibition *Marsden Hartley*, held at the Museum of Modern Art, New York, 24 October 1944–14 January 1945 and the dual exhibition *Drawings and Paintings by Marsden Hartley (1877–1943)*, held at M. Knoedler and Co. (drawings) and Paul Rosenberg and Co. (paintings), New York, 11–30 December 1944.

649 "The Passing Shows." *Art News* 43 (15–31 December 1944) 19–20.
Reviews. See entry 648.

650 "Art: The Recluse and the Refugee." *Newsweek* 24 (13 November 1944) 107–108.
Review of the exhibition *Marsden Hartley*, held at the Museum of Modern Art, New York, 24 October 1944–14 January 1945.

651 Coates, Robert M. "The Art Galleries: Two Pairs." *The New Yorker* 20 (4 November 1944) 50–51.
Review. See entry 650.

652 Louchheim, Aline B. "Expressionist and Cubist: America's Version—Hartley and Feininger Dual Retrospective." *Art News* 43 (1–14 November 1944) 18–19, 32.
Review. See entry 650.

653 Riley, Maude. "The Modern Shows Hartley and Feininger." *The Art Digest* 19 (1 November 1944) 6–7.
Review. See entry 650.

654 Breuning, Margaret. "The Rugged Intensity of Marsden Hartley." *The Art Digest* 20 (1 December 1945) 17.
Review of the exhibition *Marsden Hartley, Paintings and Drawings*, held at the Macbeth Gallery, New York, 26 November–15 December 1945.

655 "The Passing Shows." *Art News* 44 (1–14 December 1945) 25.
Review. See entry 654.

656 Arb, Renne. "Spotlight On: Hartley." *Art News* 47 (April 1948) 33.
Review of the *Exhibition of Paintings by Marsden Hartley before 1932*, held at the Bertha Schaefer Gallery, New York, 5–17 April 1948.

657 Wolf, Ben. "The Early Hartley." *The Art Digest* 22 (15 April 1948) 29.
Review. See entry 656.

658 Breuning, Margaret. "Marsden Hartley Seen in Late, Great Works." *The Art Digest* 23 (15 October 1948) 12.
Review of the exhibition *Paintings by Marsden Hartley*, held at the Rosenberg Galleries, New York, 18 November–12 October 1948.

659 Coates, Robert M. "The Art Galleries: Marsden Hartley's Maine." *The New Yorker* 24 (30 October 1948) 85–86.
Review. See entry 658.

660 "Reviews and Previews." *Art News* 47 (November 1948) 44.
Review. See entry 658.

661 Breuning, Margaret. "The Hard Core of Hartley's Native Genius." *The Art Digest* 24 (15 January 1950) 9.
Review of the exhibition *Paintings by Marsden Hartley*, held at the Rosenberg Galleries, New York, 9–28 January 1950.

662 La Farge, Henry A. "Reviews and Previews." *Art News* 48 (January 1950) 45.
Review. See entry 661.

663 Breuning, Margaret. "Moderns Vis-a-Vis." *The Art Digest* 25 (15 November 1950) 19.
Review of the exhibition *Hartley/Maurer*, held at the Bertha Schaefer Gallery, New York, 13 November–2 December 1950.

664 Goodnough, Robert. "Reviews and Previews." *Art News* 49 (November 1950) 4.
Review. See entry 663.

665 Cole, Mary. "Fifty-Seventh Street in Review: Gleizes, Adler, Hartley." *The Art Digest* 25 (15 April 1951) 18.
Review of a group exhibition featuring Albert Gleizes, Jankel Adler, and Hartley held at the Passedoit Gallery, New York, 2–30 April 1951.

666 Campbell, Lawrence. "Reviews and Previews." *Art News* 50 (May 1951) 42.
Review of the exhibition *Paintings by Marsden Hartley*, held at the Rosenberg Galleries, New York, 16 April–12 May 1951.

667 Cole, Mary. "Marsden Hartley's Poetry of Paint." *The Art Digest* 25 (1 May 1951) 17.
Review. See entry 666.

668 Seckler, Dorothy Gees. "Reviews and Previews." *Art News* 52 (March 1953) 37.
Review of the exhibition *Drawings by Hartley/Watercolors by Rattner*, held at Paul Rosenberg and Co., New York, 23 February–14 March 1953.

669 Campbell, Lawrence. "Reviews and Previews." *Art News* 53 (March 1954) 53.
Review of the exhibition *Marsden Hartley–A.H. Maurer: Landscapes 1907–1931*, held at the Bertha Schaefer Gallery, New York, 15 February–13 March 1954.

670 Feinstein, Sam. "57th Street: Hartley—Maurer." *Art Digest* 28 (15 February 1954) 19.
Review. See entry 669.

671 Kramer, Hilton. "Abstract Interlude: An Exhibition of Paintings and Drawings by Marsden Hartley." *Arts Digest* 29 (1 January 1955) 9.
Review of the exhibition *Marsden Hartley: The Berlin Period, 1913–1915: Abstract Oils and Drawings*, held at the Martha Jackson Gallery, New York, 3–29 January 1955.

672	Parker, Tyler. "Reviews and Previews." *Art News* 53 (January 1955) 48.
Review. See entry 671.

673	Campbell, Lawrence. "Reviews and Previews." *Art News* 54 (May 1955) 48.
Review of the exhibition *Paintings by Marsden Hartley*, held at Paul Rosenberg and Co., New York, 4–30 April 1955.

674	Coates, Robert M. "The Art Galleries: Sea and Sand." *The New Yorker* 31 (16 April 1955) 109–111.
Review. See entry 673.

675	Seuphor, Michel. "Fortnight in Review." *Arts Digest* 29 (15 April 1955) 21.
Review. See entry 673.

676	Breuning, Margaret. "Margaret Breuning Writes." *Arts* 30 (April 1956) 47.
Review of the exhibition *Marsden Hartley–A.H. Maurer: American Pioneers, 1868–1943*, held at the Bertha Schaefer Gallery, New York, 16 April–5 May 1956.

677	Parker, Tyler. "Reviews and Previews." *Art News* 55 (April 1956) 84–85.
Review. See entry 676.

678	Porter, Fairfield. "Reviews and Previews." *Art News* 56 (Summer 1957) 70.
Review of the exhibition *Hartley: Landscape and Still-Life in Oil*, held at the Martha Jackson Gallery, New York, 14 May–14 June 1957.

679	Young, Vernon. "In the Galleries: Marsden Hartley." *Arts* 31 (June 1957) 48.
Reviews of the exhibitions *Hartley: Landscape and Still-Life in Oil* (see entry 678) and *Marsden Hartley*, held at the Babcock Galleries, New York, 2 April–4 May 1957.

680	Breuning, Margaret. "Marsden Hartley as Antaeus." *Arts* 33 (December 1958) 50.
Review of the exhibition *Marsden Hartley, 1877–1943*, held at the Babcock Galleries, New York, 8 December 1958–3 January 1959.

681	Campbell, Lawrence. "Reviews and Previews." *Art News* 57 (December 1958) 13.
Review. See entry 680.

682 Coates, Robert M. "The Art Galleries: Hartley and Maurer." *The New Yorker* 34 (20 December 1958) 84–85.
Review. See entry 680.

683 Campbell, Lawrence. "Reviews and Previews." *Art News* 57 (January 1959) 10–11.
Review of the exhibition *Marsden Hartley: Drawings and Lithographs*, held at the Babcock Galleries, New York, 5–24 January 1959.

684 Clark, Eliot. "New York Commentary." *The Studio* 157 (June 1959) 187.
Review. See entry 683.

685 Mellow, James R. "In the Galleries: Marsden Hartley." *Arts* 33 (January 1959) 58.
Review. See entry 683.

686 Breuning, Margaret. "... from the Hartley Estate ..." *Arts* 34 (January 1960) 46.
Review of the *Hartley, 1877–1943: Exhibition of Paintings*, held at the Babcock Galleries, New York, 4–30 January 1960.

687 Coates, Robert M. "In the Galleries: Marsden Hartley." *The New Yorker* 35 (30 January 1960) 69–70, 72.
Review. See entry 686.

688 Crehan, Hubert. "Reviews and Previews." *Art News* 58 (January 1960) 15.
Review. See entry 686.

689 Tillim, Sidney. "In the Galleries." *Arts* 34 (April 1960) 61–62.
Review of the exhibition *Drawings by Marsden Hartley*, held at Paul Rosenberg and Co., New York, 16 February–12 March 1960.

690 Sandler, Irving H. "Reviews and Previews: Marsden Hartley." *Art News* 59 (November 1960) 13–14.
Review of the exhibition *Marsden Hartley*, held at the Alfredo Valente Gallery, New York, 28 September–5 November 1960.

691 Tillim, Sidney. "In the Galleries: Marsden Hartley." *Arts* 35 (November 1960) 56–57.
Review. See entry 690.

692 "Art—American Master." *Newsweek* 58 (25 September 1961) 108–109.
Review of the exhibition *Marsden Hartley*, held at eleven different venues in the United States and Europe between 6 December 1960 and 8 April 1962.

693 Coates, Robert M. "The Art Galleries: Hartley and de Kooning." *The New Yorker* 38 (24 March 1962) 131–132.
Review. See entry 692.

694 Kramer, Hilton. "Homage to Marsden Hartley: Hartley and Modern Painting." *Arts* 35 (February 1961) 42–45.
Review. See entry 692.

695 Lynes, Russell. "After Hours: Down-Eastener Off to Europe." *Harper's Magazine* 222 (January 1961) 26, 28.
Review. See entry 692.

696 Raynor, Vivien. "New York Exhibitions: In the Galleries—Marsden Hartley." *Arts Magazine* 36 (May–June 1962) 92–93.
Review. See entry 692.

697 Reichardt, Jasia. "Modern Art in London: Marsden Hartley." *Apollo* 75 (July 1961) 23.
Review. See entry 692.

698 Peterson, Valerie. "Reviews and Previews." *Art News* 60 (April 1961) 12.
Review of the exhibition *Marsden Hartley: Drawings and Pastels*, held at the Babcock Galleries, New York, 18 April–6 May 1961.

699 Raynor, Vivien. "In the Galleries: Marsden Hartley." *Arts* 35 (April 1961) 50–51.
Review. See entry 698.

700 Sandler, Irving H. "Reviews and Previews." *Art News* 60 (Summer 1961) 54.
Review of the exhibition *Marsden Hartley: Paintings and Drawings*, held at the David Anderson Gallery, New York, 22 April–20 May 1961.

701 LaFarge, Henry. "Reviews and Previews: Marsden Hartley." *Art News* 61 (May 1962) 12.
Review of the exhibition *Marsden Hartley*, held at the Babcock Galleries, New York, 27 March–14 April 1962.

702 Raynor, Vivien. "New York Exhibitions: In the Galleries—Marsden Hartley." *Arts Magazine* 36 (May–June 1962) 92–93.
Review. See entry 701.

703 Faunce, Sarah. "Reviews and Previews: Marsden Hartley and Alfred Maurer." *Art News* 62 (January 1964) 12.
Review of the exhibition *Hartley-Maurer—Still Life*, held at the Babcock Galleries, New York, 7 January–15 February 1964.

704 Neumann, Thomas. "Reviews and Previews: Marsden Hartley." *Art News* 63 (April 1964) 16.
Review of the exhibition *Marsden Hartley: Oils, Drawings, Pastels, 1909–1964* [*sic*], held at the Alfredo Valente Gallery, New York, 24 March–30 April 1964.

705 Levin, Kim. "Reviews and Previews: Marsden Hartley." *Art News* 65 (April 1966) 16.
Review of the exhibition *Marsden Hartley*, held at the Alfredo Valente Gallery, New York, March–April 1966.

706 Edgar, Natalie. "Reviews and Previews: Marsden Hartley." *Art News* 66 (December 1967) 15.
Review of the exhibition *Marsden Hartley: Still Life Compositions, Lithographs, 1923–24*, held at the Martha Jackson Gallery, New York, 28 October–18 November 1967.

707 Ashton, Dore. "New York." *Studio International* 175 (March 1968) 145.
Review of the exhibition *Marsden Hartley: A Selection of His Paintings and Drawings of the Twenties and Thirties*, held at the Knoedler Galleries, New York, 9–27 January 1968.

708 Levin, Kim. "Reviews and Previews: Marsden Hartley." *Art News* 66 (January 1968) 14.
Review. See entry 707.

709 Simon, Rita. "In the Galleries: Marsden Hartley." *Arts Magazine* 42 (February 1968) 66.
Review. See entry 707.

710 Benedikt, Michael. "Reviews and Previews: Marsden Hartley and Hugo Robus." *Art News* 67 (January 1969) 20–21.
Review of the exhibition *Hartley/Robus*, held at the Forum Gallery, New York, 15–30 November 1968.

711 Brumer, Miriam. "In the Galleries: Marsden Hartley and Hugo Robus."
Arts Magazine 43 (December 1968–January 1969) 60.
 Review. See entry 710.

712 Plagens, Peter. "Marsden Hartley Revisited: Or, Were We Really Ever
There?" *Artforum* 7 (May 1969) 40–43.
 Review of the exhibition *Marsden Hartley: Painter/Poet, 1877–1943*, held at
the University Galleries, University of Southern California, Los Angeles, 20
November–20 December 1968. This review pertains to the exhibition as shown
at the University Art Museum, University of Texas at Austin, 10 March–27
April 1969.

713 Allen, William D. "In the Galleries: Marsden Hartley." *Arts Magazine* 44
(September–October 1969) 64.
 Review of the exhibition *Marsden Hartley: A Retrospective Exhibition*, held
at the Bernard Danenberg Galleries, New York, 16 September–4 October 1969.

714 Kline, Katherine. "Reviews and Previews: Marsden Hartley." *Art News*
68 (November 1969) 19C.
 Review. See entry 713.

715 Kramer, Hilton. "Marsden Hartley: The Return of the Native." In *The Age
of the Avant-Garde: An Art Chronicle of 1956–1972*, by Hilton Kramer, 275–
278. New York: Farrar, Straus, and Giroux, 1973.
 Review (reprinted from the *New York Times*, 21 September 1969). See entry
713.

716 Munson, Gretchen T. "Reviews and Previews: Marsden Hartley." *Art
News* 70 (January 1972) 16.
 Review of the exhibition *Marsden Hartley*, held at the Babcock Galleries,
New York, 8–29 January 1972.

717 Brown, Gordon. "Arts Reviews: Marsden Hartley." *Arts Magazine* 50
(January 1976) 26.
 Review of the exhibition *Marsden Hartley*, held at the Babcock Galleries,
New York, 1–29 October 1975.

718 Zucker, Barbara. "New York Reviews." *Art News* 74 (December 1975)
122.
 Review. See entry 717.

719 Goodman, Helen. "Marsden Hartley." *Arts Magazine* 52 (April 1978) 19.
 Review of the exhibition *Marsden Hartley 1877–1943*, held at the C.W. Post

Art Gallery, Long Island University, Greenvale, New York, 6 November–14 December 1977.

720 Sievert, Robert. "Arts Reviews: Marsden Hartley/Oscar Bluemner." *Art Magazine* 52 (May 1978) 33.
 Review of the exhibition *Marsden Hartley/Oscar Bluemner*, held at the Monique Knowlton Gallery, New York, 18 February–11 March 1978.

721 Ashbery, John. "Art: The Unquiet American." *New York* 13 (31 March 1980) 73–74. *Reported Sightings: Art Chronicles, 1957–1987*, by John Ashbery, 116–119. New York: Knopf, 1989.
 Review of the exhibition *Marsden Hartley*, held at the Whitney Museum of American Art, New York, 4 March–25 May 1980.

722 Halasz, Piri. "The Moody Work of a Lonely Painter Is Now Reassessed." *Smithsonian* 10 (March 1980) 122–128.
 Review. See entry 721.

723 Kramer, Hilton. "Marsden Hartley." In *The Revenge of the Philistines: Art and Culture, 1972–1984*, by Hilton Kramer, 113–116. New York: Free Press, 1985.
 Review (reprinted from the *New York Times*, 23 March 1980). See entry 721.

724 Paulson, Ronald. "Marsden Hartley: The Search for the Father(land)." *The Bennington Review* no. 8 (September 1980) 63–68. Reprinted, with modifications, in *Marsden Hartley in Nova Scotia* (see entry 489) and *Figure and Abstraction in Contemporary Painting*, by Ronald Paulson, 66–76. New Brunswick, N.J.: Rutgers University Press, 1990.
 Review. See entry 721.

725 Shone, Richard. "Current and Forthcoming Exhibitions: New York." *The Burlington Magazine* 122 (June 1980) 455–456.
 Review. See entry 721.

726 Welish, Marjorie. "Reviews: Fort Worth—Marsden Hartley." *Arts Canada* 37 (September–October 1980) 62–63.
 Review. See entry 721. This review pertains to the exhibition as shown at the Amon Carter Museum of Western Art, Fort Worth, Texas, 5 September–26 October 1980.

727 Whelan, Richard. "Marsden Hartley: A 'Sense of Truth and a Real Naiveté of Spirit.' " *Art News* 79 (Summer 1980) 118–120.
 Review. See entry 721.

728 Klein, Ellen Lee. "Arts Reviews: Marsden Hartley." *Arts Magazine* 59 (May 1985) 44.
Review of the exhibition *Marsden Hartley: A Major Exhibition of Paintings and Drawings*, held at the Salander-O'Reilly Galleries, New York, 6 March–27 April 1985.

729 Nadelman, Cynthia. "The Nation: Marsden Hartley." *Art News* 84 (December 1985) 99–100.
Review of the exhibition *Marsden Hartley: Soliloquy in Dogtown*, held at the Cape Ann Historical Association, Gloucester, Massachusetts, 26 July–21 September 1985.

730 Kuspit, Donald. "Reviews—New York: Marsden Hartley." *Artforum* 26 (May 1988) 142–143.
Review of the exhibition *Marsden Hartley: The Last Decade*, held at the Vanderwoude Tananbaum Gallery, New York, 13 January–27 February 1988.

731 Moorman, Margaret. "Reviews—New York: Marsden Hartley." *Art News* 87 (May 1988) 172.
Reviews of the exhibitions *Marsden Hartley: The Last Decade* (see entry 730) and *Marsden Hartley (1877–1943): Paintings and Drawings*, held at the Salander-O'Reilly Galleries, New York, 8 January–27 February 1988.

732 Pardee, Hearne. "Marsden Hartley." *Arts Magazine* 62 (May 1988) 88.
Reviews. See entries 730–731.

733 Wilkin, Karen. "Marsden Hartley: At Home and Abroad." *The New Criterion* 6 (April 1988) 23–28.
Reviews of the exhibitions *Marsden Hartley and Nova Scotia*, held at the Mount Saint Vincent Art Gallery, Halifax, Nova Scotia, 22 October–23 November 1987; *Marsden Hartley: The Last Decade* (see entry 730); and *Marsden Hartley (1877–1943): Paintings and Drawings* (see entry 731).

734 Kachur, Lewis. "World Chronicle: New York." *Art International* 13 (Winter 1990) 64.
Review of the exhibition *Marsden Hartley: The Late Figure Works*, held at the Salander-O'Reilly Galleries, New York, 4–30 June 1990.

735 Wilkin, Karen. "At the Galleries." *Partisan Review* 57 (1990) 599–600.
Review. See entry 734.

735A Silberman, Robert. "Exhibition Reviews—New York and Minneapolis: Arthur Dove and Marsden Hartley." *The Burlington Magazine* 140 (July 1998) 506–507.

Review of the exhibition *Marsden Hartley: American Modern*, held at the Frederick R. Weisman Art Museum, University of Minnesota, Minneapolis, 4 June–31 August 1997.

735B Worth, Alexi. "New York Reviews—Marsden Hartley: Babcock." *Art News* 98 (March 1999) 132.

Review of the exhibition *Marsden Hartley: The Berlin Prints*, held at the Babcock Galleries, New York, 11 February–9 April 1999.

V. REFERENCE SOURCES

736 *Allgemeines Lexikon der bildenden Künstler des XX. Jahrhunerts*, edited by Hans Vollmer. Leipzig: E.A. Seeman, 1953–1962. S.v. "Hartley, Marsden."

737 *American National Biography*, edited by John A. Garraty and Mark C. Carnes. New York: Oxford University Press, 1998. S.v. "Hartley, Marsden," by Gail Levin.

738 *Atlantic Brief Lives: A Biographical Companion to the Arts*, edited by Louis Kronenberger. Boston: Little, Brown, 1971. S.v. "Hartley, Marsden."

739 Baigell, Matthew. *Dictionary of American Art*. New York: Harper and Row, 1979. S.v. "Hartley, Marsden (1877–1943)."

740 Bénézit, E. *Dictionaire critique et documentaire des Peintres, Sculpteurs, Dessinateurs et Graveurs de tous les temps et de tous les pays*, nouvelle éd. Paris: Gründ, 1976. S.v. "Hartley (Marsden)."

741 *Chambers Biographical Dictionary*, 6th ed., edited by Melanie Parry. Edinburgh, Scotland: New York: Chambers, 1997. S.v. "Hartley, Marsden."

742 Chilvers, Ian. *A Dictionary of Twentieth-Century Art*. Oxford: Oxford University Press, 1998. S.v. "Hartley, Marsden (1877–1943)."

743 *Contemporary Artists*, edited by Colin Naylor and Genesis P-Orridge. New York: St. Martin's Press, 1977. S.v. "Hartley, Marsden," by Ralph Pomeroy.

744 *Contemporary Authors*, Vol. 123, edited by Hal May and Susan M. Trosky. Detroit: Gale Research, 1988. S.v. "Hartley, Marsden, 1877–1943."

745 Cummings, Paul. *Dictionary of Contemporary American Artists*, 6th ed. New York: St. Martin's Press, 1994. S.v. "Hartley, Marsden."

746 *Current Biography: Who's News and Why, 1943.* New York: H.W. Wilson, 1944. S.v. "Hartley, Marsden."
An obituary.

747 Dawdy, Doris Ostrander. *Artists of the American West: A Biographical Dictionary* [Vol. I]. Chicago: Sage, 1974. S.v. "Hartley, Marsden (1877–1943)."

748 *Dictionary of American Biography.* Suppl. Three, *1941–1945,* edited by Edward T. James. New York: Scribner's, 1973. S.v. "Hartley, Marsden," by Alfred V. Frankenstein.

749 *The Dictionary of Art,* edited by Jane Turner. New York: Grove's Dictionaries, 1996. S.v. "Hartley, Marsden," by Gail Levin.

750 *Dictionary of Literary Biography.* Vol. 54, pt. 1, *American Poets, 1880–1945, Third Series,* edited by Peter Quartermain. Detroit: Gale Research, 1987. S.v. "Marsden Hartley (4 January 1877–2 September 1943)," by Robert K. Martin.

751 *Dictionary of Modern Painting,* 3d ed., edited by Carlton Lake and Robert Maillard. New York: Tudor, 1964. S.v. "Hartley, Marsden," by John Ashbery.

752 *Encyclopedia of American Art.* New York: E.P. Dutton, 1981. S.v. "Hartley, Marsden (1877–1943)," by David W. Scott.

753 *Encyclopedia of Homosexuality,* edited by Wayne Dynes. New York: Garland, 1989. S.v. "Hartley, Marsden (1877–1943)," by Wayne R. Dynes.

753A *The Encyclopedia of New England,* edited by Robert O'Brien. New York: Facts on File, 1985. S.v. "Hartley, Marsden."

754 Fielding, Mantle. *Mantle Fielding's Dictionary of American Painters, Sculptors and Engravers.* New York: Apollo, 1986. S.v. "Hartley, Marsden."

755 *Gay and Lesbian Literature.* Vol. 2, edited by Tom Pendergast and Sara Pendergast. Detroit: St. James Press, 1998. S.v. "Hartley, Marsden," by Pamelyn Nance Dane.

756 Gowing, Lawrence. *A Biographical Dictionary of Artists,* rev. ed. New York: Facts on File, 1995. S.v. "Hartley, Marsden, 1877–1943."

756A Hogan, Steve and Lee Hudson. *Completely Queer: The Gay and Lesbian Encyclopedia.* New York: Henry Holt, 1998. S.v. "Hartley, Marsden (1877–1943)."

757 *McGraw-Hill Dictionary of Art*, edited by Bernard S. Myers. New York: McGraw-Hill, 1969. S.v. "Hartley, Marsden (Edmund Marsden Hartley)," by Jerome Viola.

758 "Marsden Hartley (1877–1943)." In *American Art Analog*, 779. New York: Chelsea House, in association with American Art Analog, 1986.

759 "Marsden Hartley—Painter." In *The Index of Twentieth-Century Artists, 1933–1937*, 514–516, 525. New York: Arno Press, 1970.

760 National Museum of American Art (U.S.) *Descriptive Catalogue of Painting and Sculpture in the National Museum of American Art, Washington, D.C.; Comprises All Paintings and Sculpture in the Collection of the Museum as of October 31, 1982*. Boston: G.K. Hall, 1983.
 Contains an entry for Hartley.

761 Oppenheimer, Priscilla. "Hartley, Marsden." In *A Gertrude Stein Companion: Content with the Example*, edited by Bruce Kellner, 198–199. New York: Greenwood Press, 1988.

762 *The Oxford Companion to American Literature*, 4th ed., edited by James D. Hart. New York: Oxford University Press, 1965. S.v. "Hartley, Marsden (1877–1943)."

763 *The Oxford Companion to Twentieth-Century Art*, edited by Harold Osborne. Oxford: Oxford University Press, 1981. S.v. "Hartley, Marsden (1877–1943)."

764 *The Oxford Dictionary of Art*, edited by Ian Chilvers and Harold Osborne, new ed. Oxford: Oxford University Press, 1997. S.v. "Hartley, Marsden (1877–1943)."

765 *Petit Larousse de la Peinture*, sous la direction de Michel Laclotte. Paris: Larousse, 1979. S.v. "Hartley, (Marsden)," by Eric Michaud.

766 *Phaidon Dictionary of Twentieth-Century Art*. London: Phaidon Press, 1973. S.v. "Hartley, Marsden Edmund."

767 *Praeger Encyclopedia of Art*. New York: Praeger, 1971. S.v. "Hartley, Marsden," by John Ashbery.

768 Samuels, Peggy and Harold Samuels. *The Illustrated Biographical Encyclopedia of Artists of the American West*. New York: Doubleday, 1976. S.v. "Hartley, Marsden."

769 Seuphor, Michel. *Dictionary of Abstract Painting with a History of Abstract Painting*. New York: Tudor, 1957. S.v. "Hartley, Marsden."

770 *The Thames and Hudson Dictionary of Art and Artists*, rev., expanded, and updated by Nikos Stangos; Herbert Read, consulting ed. New York: Thames and Hudson, 1994. S.v. "Hartley, Marsden (1877–1943)."

771 *Who Was Who in American Art, 1564–1975: 400 Years of Artists in America*, edited by Peter Hastings Falk. Madison, Conn.: Sound View Press, 1999. S.v. "Hartley, Marsden."

772 *Who's Who in American Art*. Vol. I, *1936–37*, edited by Alice Coe McGlauflin. Washington, D.C.: American Federation of Arts, 1935. S.v. "Hartley, Marsden."

VI. ARCHIVAL SOURCES

773 Archives of American Art. *The Archives of American Art: Collection of Exhibition Catalogs*. Boston: G.K. Hall, 1979. S.v. "Hartley, Marsden."

774 _____. *The Card Catalog of the Manuscript Collections of the Archives of American Art*. Wilmington, Del.: Scholarly Resources, 1980. S.v. "Hartley, Marsden."

775 _____. *The Card Catalog of the Manuscript Collections of the Archives of American Art, Supplement 1981–1984*. Wilmington, Del.: Scholarly Resources, 1985. S.v. "Hartley, Marsden."

This circulating microfilm collection contains extensive resources on Hartley, including the Downtown Gallery Papers; the Hudson D. Walker Papers; the Whitney Museum of American Art Papers; research materials in the Elizabeth McCausland Papers; essays and poetry from the Beinecke Rare Book and Manuscript Library, Yale University; material donated by G. Alan Chidsey, who served as trustee of Hartley's estate; exhibition catalogues and announcements; photographs of artwork; and correspondence with artists, including Andrew Dasburg and John Storrs. The catalog is searchable through SIRIS (Smithsonian Institution Research Information System) via the Internet.

776 _____. *The Card Catalog of the Oral History Collections of the Archives of American Art*, 140. Wilmington, Del.: Scholarly Resources, 1984.

The collections contain an untranscribed tape of a symposium on Hartley held on 24 August 1961 at the Portland Museum of Art, Portland, Oregon, with participants W. Joseph Fulton, Elizabeth McCausland, Hudson D. Walker, and Henry Wells, moderated by Donelson F. Hoopes.

777 Collection of American Literature. Beinecke Rare Book and Manuscript Library, Yale University, New Haven, Conn.

The Marsden Hartley Archive, organized and donated to Yale University by Hartley's niece and literary executrix, Norma Gertrude Berger, contains over 300 essays; around 600 poems; and numerous photographs, including some taken by Hartley and others of Hartley throughout his life at various locations in Europe and the United States. The archive also houses many items of correspondence between Hartley and various individuals, including Hart Crane, Adelaide Kuntz, Marianne Moore, Carl Sprinchorn, Horace Trauble, Carl van Vechten, and Hudson D. Walker. In addition, the Beinecke Library, which hosts an excellent Internet site, is the repository for other items relating to Hartley in the Alfred Stieglitz/Georgia O'Keeffe Archive, the Henry McBride Papers, the Katherine S. Dreier Papers, the Gertrude Stein/Alice B. Tolkas Papers, and other collections.

778 Gallup, Donald. "Carl Van Vechten—17 June 1880:17 June 1980—A Centenary Exhibition of Some of His Gifts to Yale." *The Yale University Library Gazette* 55 (October 1980) 71.

Catalogue of an exhibition held at the Beinecke Rare Book and Manuscript Library and the Sterling Memorial Library, Yale University, New Haven, Connecticut, 17 June–30 September 1980. The exhibition included an item of correspondence from Hartley to Van Vechten—autograph letter signed, Bangor, Maine, 12 November 1939—concerning Mt. Katahdin and the artist's receipt of a regional Legion d'honneur from the state of Maine.

779 Inventory of American Paintings. National Museum of American Art. Smithsonian Institution, Washington, D.C.

This database, which is searchable through SIRIS (see entries 773–775), contains 276 entries for Hartley's paintings from public and private collections. Each entry provides the title of the work; date of execution; medium; dimensions; subject; present owner; references; illustration (bibliographic citation to source); file; and record ID.

780 Marsden Hartley Memorial Collection. Museum of Art, Olin Arts Center, Bates College, Lewiston, Maine.

This collection, comprising gifts from Hartley's estate donated by his nieces Norma Gertrude Berger and Mary H. Libby, contains ninety-nine drawings and three small oil sketches by Hartley; around twenty works of art by artists such as Carl Sprinchorn and Mark Tobey; plus approximately 500 objects of memorabilia, including Hartley's personal photographs; personal effects (e.g., his jewelry box); mementos and souvenirs (e.g., a collection of toy Prussian soldiers); antiquarian objects (e.g., several Luristan bronzes and pre-Columbian ceramics); photographs of works by Hartley and others; the artist's painting equipment; and various items of correspondence. For further information, see

"The Marsden Hartley Collection in the Treat Gallery at Bates," *Bates College Bulletin [Alumnus Issue]* 65 (May 1968) 1–7, which includes thirteen illustrations.

781 *Native Subject: The Life and Work of Marsden Hartley; English Art and Literature, 1650–1850*. [Chapel Hill, N.C.]: National Humanities Center, 1987.
 The first part of this sound recording contains a discussion of Hartley's career with Townsend Ludington and Thomas Gittkins, moderated by Wayne Pond.

VII. DISSERTATIONS AND THESES

782 Burlingame, Robert Northcutt. "Marsden Hartley: A Study of His Life and Creative Achievement." Ph.D. diss., Brown University, 1953.

783 Colwell, James Lee. "The American Experience in Berlin during the Weimar Republic." Ph.D. diss., Yale University, 1961.
 Hartley is discussed in the chapter titled "The Creative Experience."

784 Gill, Margaret A. "Albert Pinkham Ryder, Marsden Hartley, and the Stieglitz Circle." M.A. thesis, University of Delaware, 1987.

785 Gillespie, H. Gary. "A Collateral Study of Selected Paintings and Poems from Marsden Hartley's Maine Period." Ph.D. diss., Ohio University, 1974.

785A Griffey, Randall R. "Marsden Hartley's Late Paintings: American Masculinity and National Identity in the 1930s and '40s." Ph.D. diss., University of Kansas, 1999.

786 Hokin, Jeanne. "Pinnacles and Pyramids: Marsden Hartley's 'Mountain Madness.' " Ph.D. diss., University of California, Santa Barbara, 1989.

787 McDonnell, Patricia Joan. "American Artists in Expressionist Berlin: Ideological Crosscurrents in the Early Modernism of America and Germany, 1905–1915." Ph.D. diss., Brown University, 1991.

788 Miller, Virginie Witte. "Marsden Hartley's Tribal Esthetics." M.A. thesis, University of Arizona, 1987.

789 Moore, James Collins. "Marsden Hartley: The New Mexico Period, 1918–1919." B.F.A. thesis, University of New Mexico, 1966.

790 Olds, David William. "A Study of Marsden Hartley's Mt. Katahdin Series, 1939–1942." M.A. thesis, University of Texas at Austin, 1978.

791 Weinberg, Jonathan Edman. "Speaking for Vice: Homosexuality in the Art of Charles Demuth, Marsden Hartley, and the Early American Avant-Garde." Ph.D. diss., Harvard University, 1990.

VIII. ANNOTATED REPRODUCTIONS

Abelard Ascending (A Fantasy), ca. 1941–1943. SOTHEBY/6373 (c) Pl. 163.

An Abstract Arrangement of American Indian Symbols, ca. 1920–1925. YALE/5
 (b/w) 62–63.

Abstraction, 1911. MINNESOTA/4 (b/w) 153.

Abstraction, ca. 1912–1913. HIRSCHL/9 (c) 5, 10.

Abstraction, 1913. SOTHEBY/6373 (c) Pl. 158.

Abstraction, ca. 1913. SYNCHROMISM (c) Pl. 35; p. 140.

Abstraction, ca. 1913–1914. HOUSTON/1 (b/w) 130.

————. HOUSTON/2 (c) 324–325.

————. SOTHEBY/3913 (b/w) Pl. 142.

Abstraction, ca. 1915. FUTURISM (c) 365, 488.

Abstraction, 1915–1916. CORCORAN/1 (b/w) 54–56.

Abstraction, ca. 1916. MOMA/14 (b/w) 55, 151.

Abstraction, n.d. NEW YORK/1 (c) 44–45.

*Abstraction: Blue, Yellow, and Green (Abstraction: Blue, Yellow; Abstraction
 in Red, Yellow, and Green)*, ca. 1913. ABSTRACTION/3 (b/w) 116, 118.

————. COLOR AND FORM (c) Pl. 24; p. 94.

————. LOS ANGELES/2 (b/w) 245–247.

————. SYNCHROMISM (b/w) Pl. 146; p. 140.

Abstraction (Military Symbols), 1914–1915. TOLEDO (c) 157.

Abstraction with Flowers, 1913. MINNESOTA/4 (b/w) 159–161.

Abundance, 1939–1940. CURRIER (b/w) 95.

Adelard the Drowned, Master of the "Phantom," 1938–1939. MINNESOTA/4
 (c) [front cover]; 188–189.

————. PORTRAITS/2 (b/w) 115, 137.

The Aero, ca. 1914. ABSTRACTION/2 (c) 54–56, 266–267.

————. NATIONAL/2 (c) 574.

————. NATIONAL/3 (c) 152–153, 171.

After Snow, n.d. PHILLIPS/5 (b/w) 104.

After the Hurricane, 1938. PORTLAND (c) 75.

Albert Pinkham Ryder, 1938. CROSSCURRENTS (b/w) 114.

————. LOWENTHAL (c) 10.

Alspitze, 1934. PRINTS/2 (b/w) 74–75.

Alpsitze, ca. 1934. WHITNEY/2 (b/w) 20, 28.

Alpsitze, Garmisch-Partenkirchen, 1933. PROVINCETOWN (b/w) 46, 56.

Alpsitze-Mittenwald Road, ca. 1933–1934. MORTON (b/w) 240–243, 268.

————. SANTA BARBARA/2 (b/w) Pl. 96.

Alpsitze-Mittenwald, Road from Partenkirchen, 1933. AMHERST/2 (b/w) 96.

Altar Boulder, Dogtown, 1931. SHELDON/2 (b/w) 265.

American Indian Symbols, 1914. HIRSCHL/9 (c) 7, 10–11.

Anemones, n.d. MASTERS/1 (b/w) Pl. 17.

Apple, 1923. SOTHEBY/6987 (b/w) Pl. 232.

Apples, n.d. CHRISTIE/7116 (c) Pl. 245.

Apples and Pears, 1927. FITCH (c) 35; [front cover].

Apples on a Plate, ca. 1926. CHRISTIE/6874 (c) Pl. 353A.

Apples on Table, 1923. PRINTS/13 (b/w) Pl. 47.

Aqueduct in Provence, n.d. COLBY (b/w) 62.

Artichoke and Calla Lily, n.d. CHRISTIE/8290 (c) Pl. 66.

Atlantic Window, ca. 1939. HALPERT (b/w) Pl. 16.

Autumn (1), 1908. MINNESOTA/4 (b/w) 142–143, 531.

Autumn (2), 1908. MINNESOTA/4 (b/w) 143, 531.

Autumn Cascade I, ca. 1909–1910. YORK/2 (c) Pl. 17a.

Autumn Cascade II, ca. 1909–1910. YORK/2 (c) Pl. 17b.

Autumn Lake and Hills, 1907. SHELDON/2 (b/w) 264.

Autumn Landscape: Maine, 1908–1909. HIRSCHL/9 (c) 10.

Ax Man, 1908. ARKANSAS/2 (b/w) 114–115.

Backwaters Up Millinocket Way, 1940. SAN FRANCISCO/2 (b/w) 47–48.

Banquet of Silence, 1935–1936. STILL LIFE/4 (c) 50–51, 168.

Basket and Napkin, 1923. MINNESOTA/4 (b/w) 174.

Beaver Lake, Lost River Region, 1930. CARNEGIE/1 (b/w) Pl. 5; [catalogue
 note].

————. WALKER (b/w) 539.

Berlin Abstraction, 1914–1915. CORCORAN/3 (c) 99; [color plate].

Berlin Ante-War, ca. 1914–1915. COLUMBUS (c) 80–81, 193.

————. HOWLAND (b/w) 44, 50–52.

————. STIEGLITZ/2 (c) 16–17, 78–79.

Bermuda Window, ca. 1917. HANLEY (b/w) 14, 58.

A Bermuda Window in a Semi-tropic Character, 1917. SAN FRANCISCO/1 (c)
 212–213.

Birds of the Bagaduce, 1939. BUTLER (c) 238–239, 362.

————. MAINE/2 (c) 19, 120, 125.

————. SEASCAPE (c) 74–75, 84, 107.

Black Duck, 1940–1941. BOSTON/2 (b/w) Pl. 578; p. 134.

The Blast of Winter, 1908. WHITNEY/11 (b/w) 45.

*Blessing the Melon (The Indians Bring the Harvest to Christian Mary for Her
 Blessing)*, ca. 1918. PHILADELPHIA/3 (b/w) 368.

Blue Hills, n.d. SOTHEBY/6062 (c) Pl. 187.

Blueberry Highway, Dogtown, ca. 1931. GLOUCESTER/1 (b/w) 6–7, 14, 23.

Boots, 1941. DRAWING/2 (b/w) 128–129.

————. MOMA/12 (b/w) 222, 549.

Boulders, Dogtown, n.d. CAPE ANN (c) 13–14.

Bowl of Fruit, 1923. PHILADELPHIA/1 (b/w) 77, 120.

Bowl with Fruit, n.d. STILL LIFE/3 (c) Pl. 30.
A Bowl with Silver Star, ca. 1916–1917. HIRSCHL/6 (c) 57.
The Boxer, ca. 1925. HIRSCHL/6 (b/w) 60.
———. HIRSCHL/7 (b/w) 92.
Bowl of Fruit, 1923. SPRINGFIELD/2 (b/w) 44.
Bowl of Fruit on Table, ca. 1922–1923. NEW JERSEY (c) 38–39.
Bowl with Fruit, 1919. STIEGLITZ/2 (c) 16–17, 80–81.
The Bright Breakfast of Minnie, n.d. DENVER (b/w) 122.
Brown Hat and White Decoy, 1940. SHELDON/2 (b/w) 266.
Calla Lilies, ca. 1920. SBC (c) 80.
———. HIRSCHL/8 (c) 41.
Calla Lilies, 1928. BEARDSLEY (c) 33.
Calla Lily, ca. 1916. MONTCLAIR (b/w) 152.
Camillas, n.d. PHILLIPS/2 (b/w) Pl. CC.
Cantaloupe, 1927–1929. SANTA FE (c) 48, 84.
Canuk Yankee Lumberjack at Old Orchard Beach, Maine, 1940–1941. NEW
 ENGLAND/2 (c) 189–192, 211–212.
Carnival of Autumn, 1908. BOSTON/1 (c) 136–137.
Carts by the Bay, n.d. CHRYSLER/2 (b/w) [unpaginated].
Cemetery New Mexico, 1922–1924. SOUTHWEST (c) 12, 120, 125.
Central Park No. 4, 1941. DRAWING/9 (b/w) Pl. 25.
———. HIRSCHL/8 (b/w) 57.
———. KENNEDY/3 (b/w) Pl. 20.
Chanties to the North, 1938–1939. HUNTER (b/w) 169–171.
———. SCENE/1 (b/w) Pl. 31; p. 109.
Chinese Sea Horse, 1941–1942. MINNESOTA/4 (b/w) 193.
Christ Held by Half-Naked Men, 1940–1941. HIRSHHORN/2 (c) Pl. 512;
 p. 700.
———. LUDWIG (c) 46, 445.
Church at Corea, ca. 1941. DRAWING/6 (b/w) 76.
Church on the Moors, Nova Scotia, ca. 1936–1937. HIRSCHL/6 (c) 59.
City Point, Vinalhaven, n.d. SOTHEBY/3913 (b/w) Pl. 173.
Cleophas, Master of the "Gilda Grey," 1938–1939. WALKER (c) 234–235.
The Cloisters, 1942. MET/6 (b/w) 65.
*Collection of Numbers, Designs and Letters Seen by Me at the Beginning of the
 War in Berlin—Military in Their Nature*, ca. 1915. YALE/5 (b/w) 62–
 63.
Color Analogy, ca. 1921. HOWLAND (b/w) 44, 51–52, 54.
———. STIEGLITZ/2 (c) 16–17, 84–85.
———. STILL LIFE/2 (b/w) 219–221.
Composition, 1910. HARVARD/2 (c) 42.
Composition, 1913. ABSTRACTION/3 (b/w) 116, 118.
———. COLOR AND FORM (c) Pl. 22; p. 94.
———. SYNCHROMISM (c) Pl. 34; p. 140.

Composition, 1914. COLOR AND FORM (c) Pl. 23; p. 94.
_____. HOWLAND (b/w) 44. 49, 51–52.
_____. STIEGLITZ/2 (c) 16–17, 76–77.
_____. SYNCHROMISM (b/w) Pl. 147; p. 140.
Compote of Fruits, ca. 1924–1928. SOTHEBY/5524 (c) Pl. 275.
Compote with Fruit, ca. 1916. HIRSCHL/6 (c) 56.
Cosmos (The Mountains), 1908–1909. COLUMBUS (c) 78–79, 192.
Crashing Wave, ca. 1938. MAINE/2 (c) 82, 120, 125.
Crow with Ribbons, 1941–1942. HIRSHHORN/2 (b/w) Pl. 447; p. 700.
Cynical Blue and Jovial Brown, Dogtown, ca. 1934. GLOUCESTER/1 (b/w) 6–
 7, 15, 23.
Dahlias and Crab, 1936. MINNESOTA/4 (b/w) 187, 533.
The Dark Mountain No. 1, 1909. NEW ENGLAND/2 (b/w) 189–192, 211–212.
_____. STIEGLITZ/1 (b/w) 385–386.
Desert Scene, ca. 1922. EITELJORG (c) 114.
_____. HALPERT (b/w) Pl. 129.
_____. SOUTHWEST (c) 50–51, 120, 125.
Deserted Farm, 1909. MINNESOTA/4 (b/w) 148–149.
Desertion, 1912. HOWLAND (b/w) 44, 49, 51.
_____. STIEGLITZ/2 (c) 16–17, 72–73.
Dogtown, 1934. MINNESOTA/4 (b/w) 184–185, 533.
Dogtown Common, 1936. MINNESOTA/4 (b/w) 186–187, 533.
Dogtown, the Last of the Stone Wall, 1934. MINNESOTA/4 (b/w) 184–185.
Drawing #9, ca. 1930. SBC (b/w) 290.
Dreitorspitz, 1934. PRINTS/15 (b/w) 190–191.
Duck and Robin, 1942. HIRSCHL/9 (c) 9, 11.
E, 1915. IOWA (c) 80–81.
_____. MOMA/14 (c) 51, 151.
Earth Cooling, 1932. CARTER/1 (c) 91, 93, 121.
_____. CARTER/2 (b/w) 34–35.
Earth Warming, New Mexico, ca. 1932. BLOUNT (c) 26.
_____. KENNEDY/11 (c) Pl. 32.
Eight Bells Folly: Memorial to Hart Crane, 1933. MARINE/2 (b/w) 138–139.
_____. MINNESOTA/4 (c) Pl. IV; pp. 183–184.
_____. SEASCAPE (c) 74, 83, 107.
El Santo, 1919. NEW MEXICO/1 (c) 49, 164.
_____. NEW MEXICO/2 (b/w) 64, 81.
_____. TAOS/1 (b/w) Pl. 26; p. 21.
_____. TAOS/2 (c) 93, 95.
_____. TAOS/3 (c) 305–307, 372–373.
Elsa, 1916. MINNESOTA/4 (c) Pl. XXVI; pp. 165–166.
_____. SEASCAPE (c) 74, 82, 107.
Elsa Kobenhavn, 1916. PIONEERS (b/w) [unpaginated].
_____. MINNESOTA/4 (b/w) 165–166.

End of the Hurricane, 1938. MURDOCK (b/w) 81–82.
────. WICHITA (c) 144–145.
Evening Storm, Schoodic, Maine, 1942. LANDSCAPE/2 (c) Pl. 168; p. 178.
────. MOMA/10 (b/w) 108, 176.
────. MOMA/12 (b/w) 222, 549.
────. MOMA/15 (b/w) 93, 136.
Evening Storm, Schoodic Maine No. 2, 1942. BROOKLYN/6 (b/w) 311.
────. LOWENTHAL (c) 28–29.
────. NEW ENGLAND/2 (c) 177, 189–192, 211–212.
The Faenza Jar, 1912. HIGH/2 (b/w) 97–99, 185, 194.
Fig Tree, n.d. SANTA FE (c) 49, 84.
Finnish-Yankee Sauna, 1938–1939. KOOTZ/2 (b/w) Pl. 40.
────. MINNESOTA/4 (b/w) 190.
The Fish, 1923–1933. SOTHEBY/6568 (c) Pl. 131.
Fish and Lemons, ca. 1924. SOTHEBY/3749 (b/w) Pl. 108.
────. SOTHEBY/6373 (c) Pl. 146.
Fisherman's Church, ca. 1941–1943. PENNSYLVANIA/2 (b/w) Pl. 77; p. 12.
────. SOTHEBY/4365 (c) Pl. 241.
Fishermen's Last Supper, 1938. SPIRIT (b/w) 64–66.
Fishermen's Last Supper, 1940–1941. MARTINSON (b/w) 40–41, 73.
────. MOMA/4 (b/w) 61, 221.
────. NEUBERGER (c) 261, 264, 266–268.
────. SCENE/3 (c) 30, 85–86.
Fishing Boat, No. 2, 1936. KENNEDY/5 (c) Pl. 35.
Fleurs d'Orphee, 1928. MINNESOTA/4 (b/w) 181–183.
Floral Life: Debonaire, ca. 1920. MINNESOTA/4 (b/w) 171, 532.
Flower Abstraction, 1914. FLOWER/2 (c) 152–153.
────. LOWENTHAL (c) 26.
Flower Still-Life, 1932. SOTHEBY/5524 (c) Pl. 272.
Flowers, 1910. MINNESOTA/4 (b/w) 152, 532.
Flowers, ca. 1930. SOTHEBY/4650M (b/w) Pl. 368.
Flowers, n.d. SOTHEBY/6247 (c) Pl. 100.
Flowers—Blue Background, 1941. SHELDON/2 (b/w) 267.
Flowers from Claire Spencer's Garden, 1939–1940. ELIOT (c) 184, 187–188.
────. STILL LIFE/6 (b/w) Pl. 30; [catalogue note].
Flowers in a Vase, ca. 1900. SOTHEBY/3749 (b/w) Pl. 103.
Flowers in a Vase, 1941. SOTHEBY/5463 (c) Pl. 223.
Flowers in Goblet, No. 1, n.d. PRINTS/15 (b/w) 190–191.
Flowers in Goblet #2, 1923. KENNEDY/19 (b/w) Pl. 19 [sec. III].
Forms Abstracted, 1913. HASKELL (c) 112.
────. VIEWS/2 (c) 48–49, 106.
Four Red Fish, 1924. MINNESOTA/4 (b/w) 177, 533.
Fruit Still Life, ca. 1912. GEORGIA/1 (b/w) Pl. 20.
────. HIGH/2 (b/w) 97, 99, 185, 194.

Fruit Still Life, n.d. CHRISTIE/7116 (c) Pl. 244.

Gardener's Gloves and Shears, ca. 1937. PHILLIPS/5 (b/w) 104.

———. STILL LIFE/5 (b/w) 70, 114.

Garmisch-Partenkirchen, ca. 1933–1934. BEAL (c) 38, 92.

———. CARNEGIE/2 (b/w) 228–230.

Garmisch-Partenkirchen, n.d. SOTHEBY/4038 (b/w) Pl. 169.

Garmisch-Partenkirchen (Alpspitz), 1934. SHELDON/2 (b/w) 265.

Garmisch-Partenkirchen #1, 1933–1934. HECKSCHER/1 (b/w) 36.

Georges du Loup, Provence, n.d. SOTHEBY/6568 (c) Pl. 129.

Ghosts of the Forest, n.d. KOOTZ/2 (b/w) Pl. 41.

Give Us This Day, 1938. WHITNEY/10 (b/w) 23, 29.

Gloucester Fantasy, 1936. SEASHORE (b/w) Pl. 95.

Granite by the Sea, 1937. VIEWS/1 (b/w) 27, 122.

Granite by the Sea, Seguin Light, Georgetown, 1937–1938. NEUBERGER
 (b/w) 261–262, 264.

Granite Rocks, Dogtown, 1947. DRAWING/15 (b/w) 38, 53.

Grapes, 1923. PRINTS/15 (b/w) 190–191.

Grapes, 1927. MOMA/11 (b/w) Pl. 44; p. 13.

Grapes in Bowl, 1923. SOTHEBY/6987 (b/w) Pl. 233.

Grapes, Pears at Vence, 1926. SOTHEBY/3913 (b/w) Pl. 161.

The Great Good Man, 1942. LANE (c) Pl. 8; p. 163.

———. PHOTOGRAPH (b/w) 32–33.

Green Landscape with Rocks, No. 2, 1935–1936. LOWENTHAL (b/w) 45.

Green Leaves and Rocks, 1923. MONTCLAIR (c) 98–99.

Gull, 1942–1943. LOWENTHAL (b/w) 46.

Gulls [two studies], 1940. NEWBERRY (b/w) 45.

Gymnast, ca. 1922. SOTHEBY/3749 (b/w) Pl. 120.

Handsome Drinks, ca. 1912. BROOKLYN/4 (b/w) Pl. 39.

———. LOWENTHAL (c) 27.

The Hill, ca. 1907–1908. LANE (c) Pl. 4; p. 162.

Himmel, 1915. NELSON-ATKINS/1 (c) 128–129.

———. NELSON-ATKINS/2 (b/w) 164–165.

———. NELSON-ATKINS/3 (c) 55, 245.

Hunter's Corner, 1941–1942. SHELDON/2 (b/w) 267.

Hurricane, n.d. KOOTZ/2 (b/w) Pl. 39.

Hurricane Island, Vinalhaven, Maine, 1942. PHILADELPHIA/3 (b/w) 369.

The Ice Hole, Maine, 1908. GERDTS/1 (c) 27–28.

———. HIGH/2 (c) 96–99, 185, 194.

———. NEW ORLEANS (b/w) 142.

In the Moraine, Dogtown Common, Cape Ann, 1931. GEORGIA/1 (b/w) Pl. 19.

Indian Composition, ca. 1914–1915. NINETEEN FOURTEEN (b/w) 62, 86.

———. VASSAR/2 (b/w) 61, 149.

Indian Fantasy, 1914. NORTH CAROLINA (c) 215, 267.

The Iron Cross, 1915. WASHINGTON/2 (c) 152–153, 200.

Islands, Penobscot Bay, 1939. SOTHEBY/3617 (b/w) Pl. 73.

Jetty Seen through a Window, 1936. SAN FRANCISCO/3 (b/w) 312.

Jotham's Island (now Fox), off Indian Point, Georgetown, Maine. Mouth of Kennebec River, Seguin Light at Left, 1937. ADDISON/1 (c) 140–141, 386–387.

———. ADDISON/3 (c) 100–101, 140.

———. WIGHT (c) 30, 62–63.

Kezar Lake, Autumn Evening, ca. 1910. HARVARD/2 (c) 43.

Kezar Lake, Autumn Morning, 1910. HARVARD/2 (c) 43.

A Lady in Laughter, 1919. CALIFORNIA/2 (c) 40, 43.

———. SALONS (c) 9, 18.

Landscape, ca. 1910. HARVARD/2 (c) 42.

Landscape, n.d. SOTHEBY/3644 (b/w) Pl. 70.

Landscape in New Hampshire, 1910. SOTHEBY/3823 (b/w) Pl. 126.

Landscape, Mount Katahdin, n.d. DRAWING/12 (b/w) Pl. 122; p. xiii.

Landscape, New Mexico, ca. 1918. BROOKLYN/1 (b/w) 36.

Landscape, New Mexico, ca. 1918. MOMA/10 (b/w) 118, 176.

Landscape, New Mexico, ca. 1919–1920. WHITNEY/1 (c) 72, 210, 222.

———. WHITNEY/11 (b/w) 46.

Landscape: New Mexico, 1920. ROSWELL (c) 15.

———. SOUTHWEST (c) 62, 120, 125.

———. TAOS/2 (b/w) 93–94, 96.

Landscape, New Mexico, ca. 1922. DELAWARE (b/w) 108–109.

Landscape, New Mexico, 1923. CLEVELAND/1 (b/w) 100.

———. CLEVELAND/2 (b/w) 239.

Landscape No. 1 (Trees, France), 1919. PHILADELPHIA/3 (b/w) 369.

Landscape No. 3 (Cash Entry Mines, New Mexico), 1920. SOUTHWEST (c) 63, 120, 125.

Landscape #10, 1911. MINNESOTA/4 (b/w) 154, 532.

Landscape #14, 1909. MINNESOTA/4 (b/w) 151, 532.

Landscape #18, 1908. MINNESOTA/4 (b/w) 145, 531.

Landscape #28, 1909. MINNESOTA/4 (b/w) 151, 532.

Landscape #32, ca. 1911. PARIS—NEW YORK (b/w) 219.

———. WATERCOLOR/2 (b/w) 203.

———. WATERCOLOR/3 (c) 198.

Landscape No. 35 (Beaver Lake, Lost River Region), ca. 1930. PHILADEL-PHIA/3 (b/w) 369.

Landscape #36, ca. 1908–1909. MINNESOTA/4 (b/w) 147, 531.

Landscape, Vence, 1925–1926. MINNESOTA/4 (b/w) 179–180.

Landscape with Fence Posts and Rocks (Dogtown Common), ca. 1934–1936. HILLSTROM (b/w) 15, 45.

Landscape with Single Cloud, 1923. HALPERT (c) Pl. 107.

———. HIRSCHL/6 (c) 58.

Landscape with Tree Trunks, ca. 1922–1923. HALPERT (b/w) Pl. 110.

_____. MCDONOUGH/1 (b/w) 30–31, 110.

_____. MCDONOUGH/2 (b/w) Pl. 50.

The Last Look of John Donne, 1940. LOWENTHAL (c) 28.

The Last Stone Walls, Dogtown, ca. 1936–1937. LANDSCAPE/1 (c) 29–30.

_____. YALE/5 (b/w) 63.

Late Autumn [two versions], 1908. MINNESOTA/4 (b/w) 144–145, 531.

Leaves, 1929. CHRISTIE/6972 (c) 231.

Lemons and Oranges, 1929. SOTHEBY/5524 (c) Pl. 274.

The Lifeguard, ca. 1940. HIRSCHL/9 (c) 8, 11.

The Lighthouse, ca. 1940. NEUBERGER (b/w) 261, 263–264.

The Lighthouse, 1940–1941. PHOTOGRAPH (b/w) 212–213.

Lighthouse #3, 1940. CHRISTIE/7632 (b/w) Pl. 192.

Lilies in a Vase, ca. 1920. STIEGLITZ/2 (c) 16–17, 82–83.

Lilies in Vase, 1928. SAN DIEGO (b/w) [unpaginated].

Little Canyon, Talpa, ca. 1918. HIRSCHL/7 (c) 91.

Lobster Fishermen, n.d. MET/1 (b/w) 198.

Lobster on Black Background, 1940–1941. NEW ENGLAND/2 (c) 174, 189–
 192, 211–212.

Log Jam, Penobscot Bay, 1940–1941. DETROIT (b/w) 170.

Lost Country, Petrified Sand Hills, 1932. HALPERT (b/w) Pl. 59.

The Lost Felice, ca. 1939. LOS ANGELES/2 (c) 76, 245, 247–249.

_____. MAN (b/w) Pl. 253; [catalogue note].

_____. YALE/6 (b/w) 127.

Madawacka, the Greek Boxer, 1941. NUDE (c) 172, 178–179.

Maine Coast Still Life, 1941. WALKER (b/w) 539.

Maine Coastal Still Life, 1940. MURDOCK (b/w) 83.

Maine Fisherman, ca. 1941. DRAWING/3 (b/w) 37.

Maine Islands, n.d. THOREAU (c) 36–37, 52.

Maine Landscape No. 27, 1909. PHILADELPHIA/3 (b/w) 368.

Maine Mountains, Autumn, ca. 1909. MOMA/12 (b/w) 427, 548.

Maine Seascape, n.d. CHRYSLER/2 (b/w) 192.

Maine Snowstorm, 1908. MINNESOTA/4 (b/w) 146.

Marie Ste. Esprit, ca. 1938–1939. MINNESOTA/4 (c) Pl. VII; pp. 191–192.

Masks, 1931–1932. WALKER (b/w) 539.

Military, 1913. WADSWORTH/1 (c) 180–181.

_____. WADSWORTH/3 (c) Pl. 74; pp. 441–442.

_____. WADSWORTH/4 (c) 186–197.

Military, 1914–1915. CLEVELAND/1 (b/w) 100.

Military Symbol #1, ca. 1913–1914. DRAWING/13 (b/w) 51, 117.

_____. OVER HERE (b/w) 153–154.

Military Symbol #2, ca. 1913–1914. OVER HERE (b/w) 153–154.

Mont Saint Victorie, 1927. DES MOINES (c) 132–133.

Mont St. Victorie, 1927. MINNESOTA/1 (b/w) 14, 37.

Mont St. Victorie, Afternoon, n.d. CHRISTIE/6874 (b/w) Pl. 354.

Mushrooms, 1940. BLOEDEL (b/w) 30–31.
Musical Theme, ca. 1912. HIRSCHL/5 (c) 82–83.
Musical Theme, 1912–1913. ALDRICH (b/w) Pl. 16.
Musical Theme (*Oriental Symphony*), ca. 1912–1913. OVER HERE (b/w) 151–152.
———. QUINN/1 (b/w) 23, 175.
———. QUINN/2 (b/w) 103.
———. SYMBOLIST (b/w) 121, 151–152.
———. THEMES (b/w) 243–245.
Musical Theme #1 (*Bach Preludes*), 1912. HALPERT (b/w) Pl. 40.
———. HIRSCHL/5 (c) 82–83.
———. HIRSCHL/6 (c) 54–55.
Musical Theme No. 2 (*Bach Preludes et Fugues*), 1912. THYSSEN (c) 106–109, 390–391.
New England Farm, ca. 1909–1910. HOWLAND (b/w) 44, 48, 51.
New England Fisherman, 1937. MINNESOTA/4 (b/w) 15; [back cover].
New England Landscape, ca. 1934–1935. SOTHEBY/4650M (b/w) Pl. 366.
New Hampshire Mountains, ca. 1928. PHILADELPHIA/3 (b/w) 369.
New Mexico, ca. 1918–1920. BROOKLYN/1 (b/w) 36.
New Mexico, 1923. KOOTZ/1 (b/w) Pl. 22; pp. 40–42.
New Mexico, 1925. KOOTZ/1 (b/w) Pl. 24; pp. 40–42.
———. KOOTZ/2 (b/w) Pl. 38.
New Mexico, n.d. SOTHEBY/3373 (b/w) 17.
New Mexico Landscape, 1918. CITY AND COUNTRY (c) 24, 43.
New Mexico Landscape, 1918. SOTHEBY/6568 (c) Pl. 124.
New Mexico Landscape, ca. 1918–1919. SOTHEBY/6817 (c) Pl. 148.
New Mexico Landscape, 1919. MINNESOTA/4 (b/w) 170.
New Mexico Landscape, 1919 [two versions]. PHILADELPHIA/3 (b/w) 369.
New Mexico Landscape, ca. 1923. SOTHEBY/3823 (b/w) Pl. 134.
New Mexico Landscape, n.d. SOTHEBY/4365 (b/w) Pl. 242.
New Mexico Recollection, 1922–1923. MICHENER (b/w) 149–150.
New Mexico Recollection, 1923. LANE (c) Pl. 7; p. 162.
New Mexico Recollection, 1923. LONG ISLAND/3 (b/w) 62–63.
New Mexico Recollection #6, 1922–1923. HARMSEN/1 (c) 88–89.
New Mexico Recollections, 1923. HOWLAND (b/w) 44, 51–52, 54.
———. TAOS/2 (b/w) 93–94, 97.
New Mexico Recollections, #11, 1922–1923. PRINCETON/2 (c) 295.
New Mexico Recollections, #15, 1922–1923. ANSCHUTZ (c) 94.
Night and Some Flowers, ca. 1940. CALIFORNIA/1 (c) 98.
North Atlantic Harvest, 1938–1939. MINNESOTA/4 (b/w) 192, 533.
Northern Seascape—Off the Banks, 1936–1937. MOMA/10 (b/w) 31, 176.
Northern Summer Window, 1936. MICHIGAN/1 (b/w) 99.
Nova Scotia Fishermen, 1938. IBM (c) 90–93.
Off the Banks at Night, 1942. PHILLIPS/4 (c) 100–101.

Paysage, 1924. MINNESOTA/4 (b/w) 176–177, 533.

Peaches, ca. 1927. MUNSON/2 (b/w) 108–109.

Peaches, 1927. SHELDON/1 (b/w) 53, 72.

Peaches, n.d. CHRISTIE/7020 (b/w) Pl. 274.

Peaches and Lemons, 1927–1928. FITCH (b/w) 28–29.

———. YALE/1 (b/w) 43.

Pears, 1911. MINNESOTA/4 (b/w) 155, 532.

Pears and Lemons, 1927. NORMAN/1 (b/w) 55, 75.

Pears and Lemons with Vase, 1927. KANSAS CITY (b/w) 296–297, 428.

Pears and Pomegranate, n.d. DRAWING/9 (b/w) Pl. 26.

Pears in Basket, 1923. MILLS (b/w) 21, 54.

Pears in White Compote, 1923. MINNESOTA/4 (b/w) 175, 532.

Peasant's Paradise, 1926–1927. MINNESOTA/4 (b/w) 181, 533.

Peppers, 1928–1929. SOTHEBY/6373 (c) Pl. 160.

Peppers and Seashells, 1927. DRAWING/6 (c) 87.

Pink and White Flowers in a Vase, ca. 1929. LOS ANGELES/2 (b/w) 245, 247.

Pink Flowers with Blue and Yellow Butterflies, ca. 1942–1943. SOTHEBY/4038
 (b/w) Pl. 200.

Pomegranate, Pear and Apple, 1923. PRINTS/12 (b/w) Pl. 4.

———. SOTHEBY/6987 (b/w) Pl. 232.

Popocatepetl, One Morning, 1932. SHELDON/2 (b/w) 265.

Portrait, ca. 1914–1915. MINNESOTA/2 (b/w) 30, 33.

———. MINNESOTA/4 (c) Pl. XXVII; pp. 163–164.

Portrait Arrangement, 1914. MCNAY (c) 130, [color plate].

Portrait Arrangement No. 2, 1912–1913. SYNCHROMISM (b/w) Pl. 144;
 p. 140.

Portrait of a German Officer, 1914. ELIOT (c) 184–185, 187.

———. JOACHIMIDES (c) Pl. 1; pp. 451–452.

———. MOMA/8 (b/w) Pl. 85; p. 29.

———. MOORE (b/w) 106–108.

———. SCENE/3 (c) 28, 85–86.

Portrait of Berlin, 1913. YALE/5 (b/w) 63.

Provincetown Abstraction, 1916. CARTER/1 (c) 90, 92, 121.

Pyramid and Cross, 1914. DALLAS (b/w) 118–119.

———. FORT WORTH/2 (b/w) [unpaginated]; [catalogue note].

Rain Coming—Sea Window—Cape Ann, ca. 1933–1936. SBC (c) 93.

Raptus, ca. 1913. CURRIER (b/w) 94.

Red Calla in Blue Vase, 1917. HIRSCHL/9 (c) 4, 11.

The Red Cross, ca. 1915. WHITNEY/12 (b/w) Pl. 51; p. 22.

Red Flowers on Pink Ground, 1943. LEAGUE/1 (b/w) 21, 60–61.

Rising Wave, Indian Point, Georgetown, Maine, 1937–1938. HASKELL (c) 208.

Robin, ca. 1940–1941. BEAL (b/w) 93.

Robin, 1940–1941. GOLDSTONE (b/w) 40.

Robin Hood Cove, Georgetown, Maine, 1938. ELIOT (c) 184, 186–187.

————. HASKELL (c) 208.

————. VIEWS/1 (c) 51, 122.

————. WHITNEY/11 (b/w) 46.

Rock Doxology, 1931. GLOUCESTER/2 (b/w) 32–34, 90–91.

Rocky Landscape, Dogtown (near Gloucester, Mass.), ca. 1936. FRAAD (b/w) 75.

Roofs and Woods, ca. 1931. SOTHEBY/3749 (b/w) Pl. 124.

————. SOTHEBY/6373 (c) Pl. 168.

Rope and Shells, ca. 1936. CENTURY (b/w) 106–107, 128.

Roses, 1943. WALKER (c) 236–237.

A Row of Houses, 1930. KENNEDY/19 (b/w) Pl. 3 [sec. II].

Rubber Plant, 1920. DREIER (b/w) 323–324.

————. YALE/5 (b/w) 63.

Rubber Plant, ca. 1920. MINNESOTA/4 (b/w) 171–172, 532.

Sail Boat, ca. 1919. HOWLAND (b/w) 44, 51–53.

Santos, New Mexico, ca. 1918–1919. MINNESOTA/4 (c) Pl. XIII; p. 169.

Sawing Wood, ca. 1908. WHITNEY/3 (b/w) Pl. 4; p. 108.

Sea Shell by the Window, 1941–1943. CHRISTIE/5025 (c) 143.

Sea Shells on a Violet Cloth, 1929. SOTHEBY/3749 (b/w) Pl. 114.

————. SOTHEBY/6400 (c) Pl. 141.

Sea Shells, Paris, 1929. HIRSCHL/4 (c) 23, 46.

Sea View, New England, 1934. NEW ENGLAND/2 (b/w) 175, 189–192, 211–212.

————. PHILLIPS/5 (b/w) 105.

Sea Window, New England, 1934. CHRISTIE/6972 (c) 166.

Sea Window Summer #2, ca. 1939–1940. SOTHEBY/4365 (c) Pl. 223.

Sea Window, Tinker Mackerel, 1942. SMITH (b/w) 185.

————. WINDOW (b/w) 85, 101.

Seascape at Schoodic, Maine, ca. 1942. SOTHEBY/3823 (b/w) Pl. 143.

Seated Female Nude, ca. 1923. HIRSCHL/8 (b/w) 12.

————. HIRSCHL/9 (b/w) 9, 11.

Self-Portrait, ca. 1908. DRAWING/3 (b/w) 37.

————. FLEISCHMAN/1 (b/w) 137.

————. PORTRAITS/1 (b/w) 118–119, 237.

Self-Portrait, ca. 1918. HATCH (b/w) Pl. 102; [Cat. 100].

Self-Portrait, n.d. DRAWING/11 (b/w) 139, 218.

Self-Portrait, n.d. SANTA BARBARA/1 (c) 48.

Self-Portrait, n.d. SONNENBERG (b/w) Pl. 44; p. 40.

————. VASSAR/1 (b/w) Pl. 111.

Sextant, ca. 1917. OVER HERE (b/w) 155–156.

————. PHILADELPHIA/3 (b/w) 368.

Shell, n.d. KENNEDY/19 (b/w) Pl. 4 [sec. II].

Shell and Sea Anemones, Gloucester, ca. 1934. GLOUCESTER/1 (c) 6–7, 13, 23.

_____. HALPERT (b/w) Pl. 124.

Shells, 1928. SOTHEBY/3617 (b/w) Pl. 66.

Shells by the Sea, ca. 1941–1943. BABCOCK (c) Pl. 47.

Shoshone Valley, n.d. SOTHEBY/3373 (b/w) 15.

Small Town, Maine, ca. 1940. DRAWING/6 (b/w) 81.

Smelt Brook Falls, 1937. BOHAN (b/w) 14–15.

_____. BORN (b/w) 202–203.

_____. GUSSOW (c) 40–41.

_____. LEAGUE/4 (b/w) Pl. 40.

_____. NEW ENGLAND/1 (c) 96, 124.

Sombrero and Gloves, 1936. CARTER/2 (b/w) 34–35.

Song of the Winter No. 6, ca. 1908–1909. FARNSWORTH (c) 124–125, 244–
 245.

_____. NOYCE (c) 65, 70.

Songs of Winter, ca. 1908. MINNESOTA/4 (b/w) 147, 531.

The Spent Wave, Indian Point, Georgetown, Maine, 1937–1938. COLUMBUS
 (c) 82–83, 193.

Squid, 1936. MINNESOTA/4 (b/w) 188, 533.

Starfish, 1936. LOWENTHAL (b/w) 46.

Still Life, 1912. MINNESOTA/4 (c) Pl. XI; pp. 158–159.

Still Life, 1920. WALKER (b/w) 539.

Still Life, 1923. MINNESOTA/4 (b/w) 175, 532.

Still Life, 1924. KOOTZ/1 (b/w) Pl. 23; pp. 40–42.

Still Life, 1927. HAYES (b/w) 105, 132.

Still Life, ca. 1929–1930. SANTA BARBARA/1 (c) 48–49.

Still Life, n.d. KOOTZ/1 (b/w) Pl. 25; pp. 40–42.

Still Life—Calla Lilies, n.d. NEWARK/2 (b/w) 182, 330.

Still Life: Fruit, 1911. MINNESOTA/4 (b/w) 155–156, 532.

Still Life No. 1, 1912. HIGH/2 (c) 97–99, 185, 194.

Still Life No. 1, 1913. HOWLAND (b/w) 44, 48, 51.

_____. STIEGLITZ/2 (c) 16–17, 74–75.

Still Life #7, 1920. MINNESOTA/4 (b/w) 172, 532.

Still Life #9, 1917. MINNESOTA/4 (b/w) 167–168.

Still Life #11, 1911. MINNESOTA/4 (b/w) 155–157.

Still Life #14, 1926. MINNESOTA/4 (b/w) 180, 533.

Still Life: Blue Bottle, Oranges and Lemons, 1928. SOTHEBY/6373 (c) Pl. 159.

Still Life: Painting on Glass, ca. 1917. SOTHEBY/3057 (b/w) 105.

Still Life: Three Pears, 1918. OVER HERE (b/w) 157.

_____. WILLIAMS/2 (c) 126–128, 216–217.

Still Life with Apples, ca. 1923. HIRSCHL/7 (c) 90.

Still Life with Artichoke, 1924–1925. MINNESOTA/4 (b/w) 179, 533.

Still Life with Bananas, 1913. MEYER (b/w) 71, 74.

Still Life with Blue Compote and Fruit, 1922–1923. GOLDSTONE (b/w) 39.

Still Life with Bread and Fruit, 1919. SOTHEBY/3749 (b/w) Pl. 110.

_____. SOTHEBY/6400 (c) Pl. 142.

Still Life with Calla, ca. 1928–1929. SOTHEBY/4365 (b/w) Pl. 225.

Still Life with Eel, ca. 1914. OGUNQUIT (b/w) 12, 26.

Still Life with Fan, ca. 1912. SHELDON/1 (c) 22, 66–67.

―――――. SHELDON/2 (b/w) 264–265.

Still Life with Fish, 1921. PHILADELPHIA/3 (b/w) 369.

Still Life with Flowers, ca. 1923. MINNESOTA/4 (b/w) 176, 532.

Still Life with Flowers, n.d. WALKER (b/w) 539.

Still Life with Fruit, ca. 1924. HIRSCHL/4 (c) 23, 46.

Still Life with Fruit, 1929. OWEN/1 (c) [front cover]; unpaginated.

Still Life with Grapes, 1922–1923. KENNEDY/18 (c) Pl. 12.

Still Life with Grapes and Flowers, n.d. CHRISTIE/6972 (c) 230.

Still Life with Leaves in Pitcher, 1928. MONTCLAIR (b/w) 152.

Still Life with Pink Ground, 1917. HIRSCHL/9 (c) 6, 11.

Still Life with Red Drape, 1929. BABCOCK (c) Pl. 40.

Still Life with Vase, Pears, and Lemons, 1927. KANSAS (b/w) Pl. 75.

―――――. SPENCER (b/w) 107.

Storm Clouds, Maine, 1906–1907. THEMES (b/w) 168–170.

―――――. WALKER (c) 230–231.

Storm Down Pine Point Way, Old Orchard Beach, Maine, ca. 1941–1943. MAINE (c) 83, 120, 125.

―――――. SEASHORE (b/w) Pl. 96.

Storm Wave, ca. 1937–1938. FRAAD (b/w) 76–77.

Stormy Sea No. 2, 1936. FARNSWORTH (c) 124–125, 244–245.

Summer, 1908. MINNESOTA/4 (b/w) 142, 531.

The Summer Camp, Blue Mountain, ca. 1909. ROCKEFELLER/1 (c) 287–289.

―――――. ROCKEFELLER/2 (b/w) 228–229.

―――――. SAN FRANCISCO/1 (c) 210–211.

Summer Clouds and Flowers, 1942. LOWENTHAL (b/w) 46.

Summer Outward Bound, Dogtown, 1931. GLOUCESTER/2 (c) 32–34, 88–89.

Summer—Sea Window No. 1, 1939–1940. MUNSON/1 (c) 158–159, 227.

Summer, Sea, Window, Red Curtain (Sea Window—Red Curtains), 1942. ADDISON/1 (c) 159–161, 386–387.

―――――. ADDISON/2 (c) 15, 87.

―――――. MAINE/1 (c) 47.

Sunday on the Reefs, 1935–1936. LOWENTHAL (b/w) 46.

Sundown by the Ruins, 1942. WHITNEY/11 (b/w) 46.

Sundown Kezar Lake, 1910. MAINE/2 (c) 120, 125, 128.

Surf on Reef, ca. 1937–1938. CHRISTIE/6972 (c) 250.

―――――. NOYCE (c) 31, 65.

Sustained Comedy (Portrait of an Object; The Sustained Travesty; O Big Earth), 1939. CARNEGIE/2 (c) 30, 228–231.

―――――. LUDWIG (b/w) 46, 445.

Symbol No. 4, 1914. BROOKLYN/3 (b/w) [unpaginated].

―――――. DRAWING/3 (b/w) 36–37.

Waxenstein, Garmisch-Partenkirchen, 1933. CHRISTIE/7805 (b/w) Pl. 245.

Waxenstein Peaks, Garmisch-Partenkirchen, ca. 1933–1934. YALE/2 (b/w) 47.

————. YALE/5 (b/w) 63.

Western Flame, 1920. MINNESOTA/4 (b/w) 172–173.

Whale's Jaw, Dogtown, 1931. GLOUCESTER/2 (b/w) 32–34, 92–93.

————. SOTHEBY/3417 (b/w) Pl. 41.

White Cod, 1942. LOWENTHAL (b/w) 46.

White Flower, ca. 1917. STILL LIFE/4 (b/w) 66–67, 168.

Wild Rose, 1936. SOTHEBY/3823 (b/w) Pl. 142.

Wild Roses, 1942. FLOWER/1 (c) 76–77.

————. PHILLIPS/5 (b/w) 105.

————. PHILLIPS/6 (b/w) Pl. 48; p. 187.

————. STILL LIFE/5 (c) 36, 70, 114.

The Window, 1928. STIEGLITZ/2 (c) 16–17, 88–89.

Windy Day, Maine Coast, 1941. NEW ENGLAND/1 (c) 16, 124.

Wine Bottle and Fruit, 1922. ARKANSAS/1 (b/w) 116–117.

————. SOTHEBY/4650M (b/w) Pl. 355.

Winter Chaos (Blizzard), ca. 1909–1911. PHILADELPHIA/3 (b/w) 368.

Woods, 1911. MINNESOTA/4 (b/w) 158, 532.

Yliaster (Paracelsus), 1932. NATIONAL/1 (c) 153.

Young Hunter Hearing Call to Arms, ca. 1939. CARNEGIE/2 (b/w) 228–229, 232.

Young Sea Dog with Friend Billy, 1942. HALPERT (c) Pl. 71.

Young Worshipper of the Truth (Worshipper of the Truth), 1940. PHOTO-GRAPH (b/w) 32–33.

————. SHELDON/2 (c) 80–81, 266–267.

4

John Marin

John Marin, who enjoyed the greatest popular and critical acclaim of any American artist of his generation, was born in Rutherford, New Jersey, on 23 December 1870. His earliest watercolors, executed in an Impressionist style during the summer of 1888, featured views of White Lake, Sullivan County, New York. By 1893, however, his attention had turned to the study of architecture, although he eventually abandoned this pursuit around 1897. In 1899 he enrolled at the Pennsylvania Academy of the Fine Arts in Philadelphia, where he studied under Thomas P. Anshutz and Hugh Breckenridge and formed a lifelong friendship with fellow painter Arthur B. Carles. By 1902 he had moved to New York City, where he continued his studies for a short period at the Art Students League in Manhattan before embarking on a European sojourn in September 1905.

Marin eventually settled in Paris, where he exhibited at the Salon des Indépendants in 1907 and the Salon d'Automne from 1907 to 1910. He joined the New Society of American Artists in Paris in February 1908. During this period his etchings and watercolors reflect his admiration for Whistler in style and subject matter, and he visited several cities frequented by the expatriate artist, including Amsterdam, Venice, and London. Marin was also influenced by Post-impressionism, the Nabis (principally Vuillard and Bonnard), Fauvism, and Synthetic Cubism. The Tyrolese series of 1910, which was Marin's first important group of mountain landscapes (painted in Kufstein, Austria), is particularly noteworthy. It was here that he began his mastery of capturing a specific sense of time and place through lyrical mood and dramatic atmosphere.

Stieglitz started showing Marin's work in his Photo-Secession Galleries in New York in the spring of 1909, after being sent a selection of watercolors by Edward Steichen, who formally introduced the two men in Paris later that summer. Stieglitz subsequently staged annual one-man shows for Marin at the Photo-Secession Galleries and its successors, the Intimate Gallery and An American Place. His works were also shown in several landmark exhibitions,

including the Armory Show (*International Exhibition of Modern Art*) in 1913 and *The Forum Exhibition of Modern American Painters* in 1916.

Marin returned to New York in 1910 and continued to produce etchings and watercolors, with the Brooklyn Bridge and the Woolworth Building being two of his favorite subjects. In his attempts to capture the dynamic rhythms and nervous energy in the vortex of the city, Marin appropriated some devices utilized by the Italian Futurists and the pre-Orphist work of Robert Delaunay, such as jagged distortions of architectural shapes, tilting and irregular planes, and repeating series of related motifs.

During the spring and late fall of each year Marin usually painted landscapes showing nearby locales in New York state and New Jersey, while spending the summer and early fall traveling in the country. He spent the winters focusing on scenes in the New York City area and working in his studio developing landscape ideas that he had gathered on trips outside the city. This was a general pattern that he would follow throughout his career. Among the many landscape series that he painted prior to 1920 are those featuring sites in Massachusetts (Berkshire Hills near Rowe); New York state (Adirondacks and Castorland, on the Black River in Lewis County); Pennsylvania (Echo Lake district and Delaware River region); New Hampshire (White Mountains); and Maine (Casco Bay, Deer Isle, Small Point, and Stonington). Marin also worked in oils during this period. His Weehawken Sequence is a series of more than 100 small canvases that is remarkable for its diversity of approaches to rendering urban scenes.

In 1920 Marin purchased a home in Cliffside, New Jersey, which served as his permanent residence for the rest of his life. Among the important patrons whom he gained during the 1920s were Ferdinand Howland and Duncan Phillips. His paintings continued to be shown in important exhibitions, including the Brooklyn Museum's *Exhibition of Water Color Paintings by American Artists* in 1921; *Alfred Stieglitz Presents Seven Americans* in 1925; and the *International Exhibition of Modern Art: Assembled by Société Anonyme* in 1926. His works alternated between landscapes and seascapes, with locales in Maine predominating, while others explored urban scenes in New York City.

In the early 1920s Marin energized his dynamic and expressive approach to cityscapes through using bold, black lines to dramatically define shape and movement or to impose order on structures painted with rich, dark colors enlivened by brighter highlights, as in *Lower Manhattan (Composing Derived from Top of Woolworth)* of 1922 and *The Red Sun, Brooklyn Bridge* of ca. 1922. He began to perfect a personal calligraphic style in his landscapes and seascapes, where he distilled an abstract structure from nature in a kind of geometrical schematization of mountains, clouds, rocks, trees, sun, and surf. He would suggest form and movement with a few simple, bold strokes without utilizing illusionistic modeling. Another way in which Marin often created order in his compositions was to use internal frames and enclosures of various sorts along the edges, as in *Related to Downtown New York, Movement No. 2 (The Black Sun)* and *Pertaining to Stonington Harbor, Maine, No. 1*, both of 1926. He

tended to favor an atmospheric palette, applying luminescent, transparent washes with a judicious use of unpainted white areas. His seascapes occasionally reflect more somber moods, with dark greens and blue grays predominating. It is important to note that although Marin held that the forms and colors of nature could not be captured on canvas or paper with complete accuracy, he nevertheless stated, "The sea that I paint may not be *the* sea, but it is *a* sea—not an abstraction."

At the invitation of Mabel Dodge Luhan, Marin spent the summers of 1929 and 1930 at her ranch in Taos, New Mexico. During his stays he painted approximately 100 watercolors of mountains, canyons, desert vegetation, thunderstorms, and Native American dances. In 1934 he purchased a home on Cape Split overlooking Pleasant Bay, near Addison, Maine, which would serve as his summer residence for the remainder of his life. In 1936 he was honored with a major retrospective exhibition at the Museum of Modern Art in New York.

Two significant developments took place in Marin's work during the 1930s that would continue into the next decade. The first was the emergence of the human figure, either in genre scenes, circus settings, or depictions of female nudes by the seashore. The second was his return to oil painting, which allowed him to experiment and exploit the heavy impasto qualities of the medium and produce dense and turbulent seascapes of the Maine coast, as in *Wave on Rock* of 1937. Perhaps due to his simultaneous work in oils, Marin's watercolors started to become weightier and less dependent on the fluidity of the medium. They were occasionally painted with broad, layered patches of opaque paint.

Marin's wife died in February 1945, and he suffered a heart attack shortly thereafter. Stieglitz died the following year. Despite these devastating personal losses, Marin's late work was as prolific and vigorous as ever. He moved toward an increasingly abstract and lyrical treatment of the elemental forces of nature, with highly energetic calligraphy that sometimes confounded landscape forms, as in *Movement—Sea or Mountain as You Will* of the late 1940s. He died at Cape Split on 1 October 1953, at age eighty-two, after suffering a debilitating stroke earlier that summer. Marin left a legacy of over 3,000 oils and watercolors in addition to a significant number of prints.

Marin's approach to nature was solidly in the transcendentalist tradition of Emerson and Thoreau and embodied the pantheism of Whitman as well. Due to his highly personal and idiosyncratic style, Marin did not lay the foundation for a new movement or leave any followers, yet he assumed a place alongside Winslow Homer and John Singer Sargent in the pantheon of America's greatest watercolorists.

I. MARIN'S WRITINGS, STATEMENTS, AND CORRESPONDENCE

See also entries 002, 034, 059, 087, 813, 827–828, 852–853, 932, 937, 973, and 1190–1191.

792 Marin, John. "Contributions." *Camera Work* no. 47 (July 1914) 74.
An untitled poem written in response to Stieglitz's question, "What is 291?"

793 _____. "A Few Notes." *Twice a Year* no. 2 (Spring–Summer 1939) 176–180.
Marin's stream-of-consciousness ramblings on aesthetics.

794 _____. "From: *Writings.*" *Twice a Year* nos. 14–15 (Fall-Winter 1946–1947) 235–266.
A selection of letters from Marin to Stieglitz written between 1913 and 1929 and two previously unpublished letters written during 1943 and 1944.

795 _____. "John Marin, by Himself." *Creative Art* 3 (October 1928) xxxiv–xxxix.
Marin offers comments on his aesthetic philosophy.

796 _____. *John Marin*, edited by Cleve Gray. New York: Holt, Rinehart and Winston, [1970].
An extensive compilation of Marin's writings. Although some items are reprinted from other sources, much of the book consists of previously unpublished archival material from the Alfred Stieglitz Collection, Beinecke Rare Book and Manuscript Library, Yale University; the Downtown Gallery Archives; the John Marin Archives; and other private sources. Of particular interest is the large number of drawings and watercolors illustrated for the first time (many in color) and photographs of the artist. Gray provides a foreword, notes to the text, and a list of the illustrated works.

797 _____. *Letters of John Marin*. New York: Privately printed for An American Place, 1931.
A collection of approximately eighty letters written by Marin to Stieglitz between 1911 and 1929, edited and introduced by Herbert J. Seligmann. Also included are letters from Marin to various other individuals such as Paul Strand; reprints of Marin's writings published in *Camera Work, Creative Art*, and *Manuscripts Number Two*; and Marin's tribute written for the catalogue of the *Memorial Exhibition of Ernest Haskell (1876–1925)*, held at the Macbeth Galleries, New York, 9–22 November 1926.

798 _____. "On My Friend Carles." *Art News* 52 (April 1953) 20, 67.
Marin's personal reminiscence of his friend Arthur B. Carles, written on the occasion of the *Memorial Exhibition: Arthur B. Carles, 1882–1952*, held 18 March–12 April 1953 and cosponsored by the Pennsylvania Academy of the Fine Arts and the Philadelphia Museum of Art.

799 _____. *The Selected Writings of John Marin*, edited with an introduction by Dorothy Norman. New York: Pellegrini and Cudahy, 1949.

A compilation of Marin's writings, the majority of which consists of his previously published correspondence written between 1910 and 1949 (much of it to Stieglitz); also, writings that appeared in *Manuscripts Number Two* (March 1922) and *Twice a Year* (Spring–Summer 1939); forewords to exhibition catalogues and books; various miscellaneous items; and several illustrations.

800 _____. "Some Unpublished Letters." *Twice a Year* no. 2 (Spring–Summer 1939) 181–199.

Seven letters from Marin to Stieglitz written between 1924 and 1938.

801 _____. "A Voice in the Evening." In *Paul Rosenfeld: Voyager in the Arts*, edited by Jerome Mellquist and Lucie Wiese, 263–265. New York: Creative Age Press, 1948.

A poem written as a tribute to Paul Rosenfeld.

802 _____. "The Writings of Marin—Compiled by Dorothy Norman." *Art News* 48 (October 1949) 41–43.

Four excerpts from *The Selected Writings of John Marin* are reprinted (see entry 799).

803 Norman, Dorothy. "Conversations with Marin." *Art News* 52 (December 1953) 38–39, 57–59.

An interview with Marin in which he discusses his aesthetic philosophy.

804 _____. "John Marin—Conversations and Notes." *College Art Journal* 14 (Summer 1955) 320–331.

This article contains the essential writings, interviews, and correspondence of Marin that were not included in *The Selected Writings of John Marin* (see entry 799).

805 _____. "Marin Speaks . . . and Stieglitz: Record of a Conversation." *Magazine of Art* 30 (March 1937) 151.

A transcribed conversation between Marin and Stieglitz (no context provided).

806 Photo-Secession Galleries. *Watercolors and Oils by John Marin*. New York: The Galleries, 1913.

Catalogue of an exhibition held at the Photo-Secession Galleries, New York, 20 January–15 February 1913. The catalogue contains an important statement by Marin on his New York watercolors, which is reprinted in *Camera Work* nos. 42–43 (April–July 1913) 18 and in *The Selected Writings of John Marin* (see entry 799).

II. BOOKS AND EXHIBITION CATALOGUES

807 Adams, Ansel. *An Autobiography*, 212–213. Boston: Little, Brown, 1985.
 Adams recounts a 1948 visit to Marin's home in Cliffside, New Jersey. One of Adams' photographs of the artist is reproduced. See also entry 931.

807A Albuquerque Museum. *John Marin in New Mexico*. Albuquerque, N.M.: The Museum, 1999.
 Catalogue of an exhibition held at the Albuquerque Museum, Albuquerque, New Mexico, 16 May–22 August 1999, which includes forty-seven works (all are illustrated on color plates). The catalogue contains a foreword and introduction by Ellen J. Landis; an essay by Sharyn Udall; and a chronology.

808 Allentown Art Museum. *The City in American Painting: A Selection of 19th and 20th Century Works by Artists Who Employed the Urban Scene as a Principal Theme, Either Specifically or Implied*. Allentown, Pa.: The Museum, 1973.
 Catalogue of an exhibition held at the Allentown Art Museum, Allentown, Pennsylvania, 20 January–4 March 1973, which includes three works by Marin. Essay by Richard N. Gregg.

809 Amarillo Art Center. *John Marin Watercolors*. Amarillo, Tex.: The Center, 1988.
 Catalogue of an exhibition of forty-four watercolors held at the Amarillo Art Center, Amarillo, Texas, 10 December 1988–22 January 1989. The catalogue contains an essay by Ruth E. Fine, a chronology, a selected bibliography, and a color reproduction of each work.

810 Amerika Haus. *John Marin 1870–1953: Ölbilder und Aquarelle. Ausstellung anlässlich der Berliner Festwochen 1962 im Amerika Haus, Berlin, veranstaltet vom Amerika Haus in Verbindung mit dem Senator für Volksbildun.* Berlin: Amerika Haus, 1962.
 Catalogue of an exhibition held at the Amerika Haus, Berlin, Germany, 1962.

811 Arts Council Gallery (London, England). *John Marin: Paintings, Water-Colours, Drawings, and Etchings*. London: The Gallery, 1956.
 Catalogue of an exhibition that was prepared for the U.S. Information Service by the Smithsonian Traveling Exhibition Service and held at the Arts Council Gallery, London, England, 22 September–20 October 1956. Nine works are illustrated in black and white.

812 Baltimore Museum of Art. *Contrasts in Impressionism: An Exhibition of Paintings by Alessandro Magnasco, Claude Monet, John Marin*. Baltimore: The Museum, 1942.

Catalogue of an exhibition held at the Baltimore Museum of Art, Baltimore, 13 November–27 December 1942.

813 Benson, Emanuel Mervin. *John Marin: The Man and His Work*. Washington, D.C.: American Federation of Arts, 1935.
In Part I, "Marin, the Man," Benson discusses Marin's choice of subject matter, aesthetic philosophy, and working methods. A stylistic analysis is provided in Part II, "Marin, His Works." The book contains selections from the artist's writings and correspondence; a listing of colors from Marin's palettes (oils and watercolors); a listing of public and private collections owning Marin's works; and numerous illustrations.

814 Berkshire Museum. *John Marin's Berkshire Landscapes*. Pittsfield, Mass.: The Museum, 1985.
Catalogue of an exhibition held at the Berkshire Museum, Berkshire, Massachusetts, 9 June–4 August 1985, which includes thirty-nine works featuring the Berkshire region executed between 1912 and 1925. The catalogue contains an essay by Debra Bricker Balken and a checklist of the exhibition. Fourteen works are illustrated (three in color).

815 Cape Split Place. *John Marin's Maine: A Tribute*. Addison, Maine: Cape Split Place, [1978].
Catalogue of an exhibition held at Cape Split Place, Addison, Maine, 1 August–1 October 1978, which includes fifteen watercolors, twelve drawings, and eight oils.

816 Charles H. MacNider Museum. *John Marin/Charles Burchfield*. Mason City, Iowa: The Museum, 1995.
Catalogue of an exhibition held at the Charles H. MacNider Museum, Mason City, Iowa, 17 September–12 November 1995, which includes fifteen works by Marin (six are illustrated, one in color). The catalogue contains an introduction by Richard Leet, "A Personal Note" by Lawrence A. Fleischman, and a checklist of the exhibition.

817 Cincinnati Art Museum. *Three American Masters of Watercolor: Marin, Demuth, Pascin; A Loan Exhibition from The Ferdinand Howland Collection, The Columbus Gallery of Art, Ohio*. Cincinnati, Ohio: The Museum, 1969.
Catalogue of an exhibition held at the Cincinnati Art Museum, Cincinnati, Ohio, 14 February–16 March 1969, which includes twenty-four works by Marin (six are illustrated). Foreword by Philip R. Adams and essay by Richard J. Boyle.

818 Colorado Springs Fine Arts Center. *Exhibition of Water Colors: Homer, Sargent, Marin*. Colorado Springs, Colo.: The Center, 1947.

Catalogue of an exhibition held at the Colorado Springs Fine Arts Center, Colorado Springs, Colorado, 18 April–11 June 1947.

819 Contemporary Arts Museum (Houston, Tex.) *Contemporary Calligraphers: John Marin, Mark Tobey, Morris Graves.* Houston: The Museum, 1956.

Catalogue of an exhibition held at the Contemporary Arts Museum, Houston, Texas, 12 April–13 May 1956. The exhibition was assembled in order to explore the relationship between these artists' works and Oriental calligraphy. Foreword by Frederick S. Wight.

820 Corcoran Gallery of Art. *John Marin in Retrospect.* Washington, D.C.: The Gallery, 1962.

Catalogue of an exhibition held at the Corcoran Gallery of Art, Washington, D.C., 2 March–15 April, 1962, and at the Currier Gallery of Art, Manchester, New Hampshire, 9 May–24 June 1962. Essay by Charles E. Buckley.

821 Felix Landau Gallery. *John Marin.* Los Angeles: The Gallery, 1960.

Catalogue of an exhibition held at the Felix Landau Gallery, Los Angeles, 21 June–9 July 1960.

822 Fine, Ruth E. *John Marin.* Washington, D.C.: National Gallery of Art; New York: Abbeville, 1990.

This monograph was published to accompany the retrospective exhibition *Selections and Transformations: The Art of John Marin*, held at the National Gallery of Art, Washington, D.C., 28 January–15 April 1990. Fine provides a detailed examination of all facets of Marin's career. She discusses the subject matter, compositional devices, and stylistic elements in dozens of works. There are 175 color reproductions and 125 black-and-white illustrations. The book also contains many documentary photographs, a chronology, and a selected bibliography.

823 Finch, Christopher. *American Watercolors.* New York: Abbeville Press, 1986.

In Chapter 8, "John Marin," Finch analyzes Marin's cityscapes, landscapes, and seascapes. He believes that Marin's greatest period as a watercolorist was from about 1910 to the mid-1920s and that later in his career he was more successful working in oils.

824 Fort Worth Art Center. *Marin: Paintings of John Marin.* Fort Worth, Tex.: The Center, 1961.

Catalogue of an exhibition held at the Fort Worth Art Center, Fort Worth, Texas, December 1961. Thirteen works are illustrated in black and white.

825 Gallatin, A.E. *American Water-Colourists*, 17–22. New York: E. P. Dutton, 1922.

In appraising Marin's watercolors, Gallatin writes, "John Marin is not only one of the greatest and most profound artists America has produced, but as a water-colourist he stands supreme; it is necessary to travel back to the ancient Chinese masters to find his equal."

826 Goodrich, Lloyd. *American Watercolor and Winslow Homer*. [Minneapolis]: Published by the Walker Art Center for distribution by the American Artists Group, [New York], 1945.

This book was published to accompany an exhibition held at the Walker Art Center, Minneapolis, 27 February–23 March 1945, and includes ten works by Marin. In Chapter 6, "John Marin," Goodrich points out that Marin projects his emotional responses to nature by subjective expression, not by objective representation in the manner of Homer and his generation. Goodrich also notes that although Marin is a great colorist, he is, like Homer, essentially a graphic artist.

827 Helm, MacKinley. *John Marin*. Foreword by John Marin. New York: Pellegrini and Cudahy, in association with the Institute of Contemporary Art, Boston, 1948.

Helm's biography contains extracts from Marin's correspondence (published and unpublished) and writings, as well as material drawn from the author's own extensive conversations with the artist. The book contains sixty-four works illustrated in black and white and nine reproduced on color plates.

827A Hunter, Sam. *Expression and Meaning: The Marine Paintings of John Marin*, edited by Timothy A. Eaton. West Palm Beach, Fla.: Eaton Fine Art, 1998.

Catalogue of an exhibition held at Eaton Fine Art, West Palm Beach, Florida, 8 January–6 March 1999. The exhibition featured thirty-one seascapes (oils and watercolors) from all phases of Marin's career (all are illustrated, most in color). The catalogue contains an essay by Sam Hunter, a checklist of the exhibition, and a selected bibliography.

828 Institute of Modern Art (Boston, Mass.) *John Marin: A Retrospective Exhibition*. Boston: The Institute, 1947.

Catalogue of an exhibition held at the Institute of Modern Art, Boston, 7 January–15 February 1947. The exhibition included nineteen oils, forty-five watercolors, twenty-one drawings, and twelve etchings (thirty-eight works are illustrated, two in color). The catalogue contains a foreword by James S. Plaut; essays by MacKinley Helm and Frederick S. Wight; a statement by Marin (dated 10 December 1946); a checklist of the exhibition; and a selected bibliography.

829 Jersey City Museum. *John Marin: The Weehawken Sequence*. Jersey City, N.J.: The Museum, 1985.

Catalogue of an exhibition held at the Jersey City Museum, Jersey City, New Jersey, 11 September–9 November 1985. The exhibition featured works from

the so-called Weehawken Sequence that Marin executed in oil around 1916. The
catalogue contains an essay by Robert Ferguson and seven color reproductions
but no checklist of the exhibition.

830 Kennedy Galleries. *John Marin*. New York: The Galleries, 1994.
Catalogue of an exhibition held at the Kennedy Galleries, New York, 1–22
October 1994, which includes twenty-four works, all illustrated on color plates.

831 _____. *John Marin: Between Realism and Abstraction*. New York: The
Galleries, 1997.
Catalogue of an exhibition held at the Kennedy Galleries, New York, 4 Oc-
tober–1 November 1997, which includes thirty-nine works, all illustrated on
color plates. The catalogue contains an essay, "John Marin's Originality of Vi-
sion and His 'Blessed Equilibrium,' " by William C. Agee; a chronology; and
a selected bibliography.

832 _____. *John Marin: Land and Sea*. New York: The Galleries, 1995.
Catalogue of an exhibition held at the Kennedy Galleries, New York, October
1995, which includes twenty-three works, all illustrated on color plates.

833 _____. *John Marin: New York Sketches*. New York: The Galleries, 1990.
Catalogue of an exhibition held at the Kennedy Galleries, New York, April
1990, which includes thirty-two works, all illustrated in black and white.

834 _____. *John Marin—1930s*. New York: The Galleries, 1988.
Catalogue of an exhibition held at the Kennedy Galleries, New York, 5–23
April 1988, which includes thirty-two works, all illustrated on color plates. Es-
say by John I.H. Baur.

835 _____. *John Marin: Paintings and Watercolors 1940 to 1953*. New
York: The Galleries, 1989.
Catalogue of an exhibition held at the Kennedy Galleries, New York, 4–25
November 1989, which includes thirty-five works, all illustrated on color plates.
Foreword by Sheldon Reich.

836 _____. *John Marin: Watercolors of the 1920s, Drawings from 1917 to
1931*. New York: The Galleries, 1986.
Catalogue of an exhibition held at the Kennedy Galleries, New York, 1–26
April 1986, which includes thirty-one watercolors (all illustrated on color plates)
and twenty-eight drawings (all illustrated in black and white). Essays by John
I.H. Baur.

837 _____. *John Marin and the Sea*. New York: The Galleries, 1982.
Catalogue of an exhibition held at the Kennedy Galleries, New York, 19
October–19 November 1982, which includes seventy-two works depicting sea-

scapes, beach scenes, coastal vistas, and boats, all illustrated on color plates. John I.H. Baur's essay makes this one of the more noteworthy catalogues in this series.

838 _____. *John Marin in Miniature*. New York: The Galleries, 1986.
Catalogue of an exhibition held at the Kennedy Galleries, New York, 15 November–15 December 1986, which includes thirty-four works, all illustrated on color plates. Foreword by John I.H. Baur.

839 _____. *John Marin Prints: A Retrospective* (Master Prints 10). New York: The Galleries, 1982.
Catalogue of an exhibition held at the Kennedy Galleries, New York, 19 October–30 December 1982, which includes forty-eight works, all illustrated on black-and-white plates and accompanied by descriptive annotations.

840 _____. *John Marin Watercolors, 1929–1939*. New York: The Galleries, 1987.
Catalogue of an exhibition held at the Kennedy Galleries, New York, 12 May–6 June 1987, which includes thirty works, all illustrated on color plates.

841 _____. *John Marin's Autumn*. New York: The Galleries, 1988.
Catalogue of an exhibition held at the Kennedy Galleries, New York, 8–29 October 1988, which includes twenty-four works, all illustrated on color plates. Essay by Ruth E. Fine.

842 _____. *John Marin's Mountains*. New York: The Galleries, 1983.
Catalogue of an exhibition held at the Kennedy Galleries, New York, 4–29 October 1983, which includes fifty works, all illustrated on color plates. Essay by John I.H. Baur and biographical profile by Gloria-Gilda Deak.

843 _____. *John Marin's New York*. New York: The Galleries, 1981.
Catalogue of an exhibition held at the Kennedy Galleries, New York, 13 October–6 November 1981, which includes sixty-five paintings (all illustrated on color plates) and twenty-one drawings (all illustrated in black and white). Essay by John I.H. Baur and preface by John Marin, Jr. This is an important catalogue in this series.

844 _____. *John Marin's Oils*. New York: The Galleries, 1984.
Catalogue of an exhibition held at the Kennedy Galleries, New York, 30 October–24 November 1984, which includes forty-two works, thirty-five of which are illustrated on color plates and the remainder in black and white. Essay by John I.H. Baur.

845 _____. *New York through the Eyes of John Sloan and John Marin*. New York: The Galleries, 1984.

Catalogue of an exhibition held at the Kennedy Galleries, New York, 30 October–24 November 1984, which includes nineteen of Marin's etchings and line engravings, all illustrated in black and white.

846 _____. *Paintings by John Marin.* New York: The Galleries, 1982.
Catalogue of an exhibition held at the Kennedy Galleries, New York, May 1982, which includes forty works, all illustrated on color plates. Essay by Nannette V. Maciejunes.

847 _____. *Trees as Seen through the Eyes of John Marin and Charles Burchfield.* New York: The Galleries, 1991.
Catalogue of an exhibition held at the Kennedy Galleries, New York, May 1991, which includes nineteen works by Marin, all illustrated on color plates. Essay and comments on the individual works by Nannette V. Maciejunes.

848 _____. *Watercolors by Charles Burchfield and John Marin.* New York: The Galleries, 1985.
Catalogue of an exhibition held at the Kennedy Galleries, New York, 27 March–20 April 1985, which includes twenty works by Marin, all illustrated on color plates. Essay by John I.H. Baur.

849 Knoedler Galleries. *Paintings and Watercolors by John Marin from the Phillips Collection: A Loan Exhibition for the Benefit of the Dalton School.* New York: The Galleries, 1967.
Catalogue of an exhibition held at the Knoedler Galleries, New York, 3–26 May 1967, which contains an introduction by Lloyd Goodrich and a tribute to the artist by Duncan Phillips.

850 Los Angeles County Museum of Art. *John Marin/1870–1953: A Centennial Exhibition Organized by the Los Angeles County Museum of Art.* Los Angeles: The Museum; Boston: Distributed by Boston Book and Art, 1970.
Catalogue of an exhibition held at the Los Angeles County Museum of Art, Los Angeles, 7 July–30 August 1970. The exhibition featured forty-one oils, seventy-one watercolors, thirty-five drawings, and eleven etchings, many of which are illustrated (twelve in color). The catalogue contains a foreword by Sheldon Reich; an essay by Larry Curry; a checklist of the exhibition; and a selected bibliography.

851 Marin, John. *John Marin.* New York: Raymond and Raymond, [1937].
A portfolio of six works illustrated on color plates.

852 _____. *John Marin: Drawings and Watercolors.* New York: Twin Editions, 1950.
This portfolio was designed by Marin and includes thirty drawings and eight

watercolors reproduced in facsimile collotype with eight color plates. The draw-ings were printed in France and the watercolors in New York by the Jaffe engravers. Edition I, numbered I–CXXV, was intended to be issued with an original etching; Edition II was numbered 1–300. Marin provides background on the works in an introduction. The originals were featured in an exhibition held at the Downtown Gallery, New York, 12–23 September 1950.

853 Marlborough Gallery. *John Marin, 1870–1953: Paintings 1903–1953.* New York: The Gallery, 1977.

Catalogue of an exhibition of thirty-six oils held at the Marlborough Gallery, New York, 19 March–16 April 1977. The catalogue contains selected writings of the artist and illustrations of fourteen works (two in color).

854 _____. *John Marin: Etchings, 1905–1951* [cover title]. New York: The Gallery, 1971.

Catalogue of an exhibition held at the Marlborough Gallery, New York, Feb-ruary–March 1971, which includes thirty-five works (fifteen are illustrated). The catalogue contains a photo of Marin's etching press, a checklist of the exhibition, and a list of exhibitions of Marin's etchings.

855 _____. *John Marin: Oils and Watercolors.* New York: The Gallery, 1972.

Catalogue of an exhibition held at the Marlborough Gallery, New York, 7–28 October 1972, which includes seventy-four works (thirty are illustrated, six-teen in color). The catalogue contains a chronology and an introduction by Sheldon Reich.

856 _____. *John Marin: New York Drawings.* New York: The Gallery, 1978.

Catalogue of an exhibition held at the Marlborough Gallery, New York, 6 May–17 June 1978, which includes thirty-eight drawings and three watercolors (nineteen works are illustrated in black and white).

857 _____. *John Marin's Maine 1914–1952.* New York: The Gallery, 1976.

Catalogue of an exhibition held at the Marlborough Gallery, New York, 27 March–17 April 1976, which includes thirty-three works (seven are illustrated in black and white).

858 McCauley, Lena May and H.H. Tolerton. [*John Marin: 2 Biographical Sketches.*] [S.l.]: Albert Roullier's Art Rooms, 1913.

Typescript consisting of Part I: "An Illustrated Catalogue of Painter-Etchings, John Marin of Print Collector's Bulletin Series"; and Part II: excerpt from H.H. Tolerton's "Illustrated Catalogue of Etchings by American Artists."

859 Montclair Art Museum. *John Marin: America's Modern Pioneer; A Retrospective Exhibition of the Watercolors and Oil Paintings from 1903–1953.* Montclair, N.J.: The Museum, 1964.

Catalogue of an exhibition held at the Montclair Art Museum, Montclair, New Jersey, 23 February–29 March 1964, which includes sixty-one works (seven are illustrated in black and white). Introduction by Dorothy Norman.

860 Museum of Modern Art (New York) *John Marin: Watercolors, Oil Paintings, Etchings.* New York: The Museum, 1936.

Catalogue of the first retrospective of Marin's work, held at the Museum of Modern Art, New York, 21 October–22 November 1936, which includes 160 watercolors, twenty-one oils, and forty-four etchings. The catalogue contains three essays: "John Marin" by Henry McBride; "As to John Marin, and His Ideas" by Marsden Hartley; and "John Marin—'and Pertaining Thereto' " by E.M. Benson. Also included are a preface by Alfred H. Barr, Jr.; biographical details compiled by Benson; a checklist of the exhibition; a detailed checklist of Marin's etchings, also compiled by Benson; and a selected bibliography. The extensive illustrations include numerous black-and-white reproductions, six color plates, and several photographs of the artist.

860A Owings-Dewey Fine Art. *John Marin: Etchings.* Santa Fe, N.M.: The Gallery, 1998.

Catalogue of an exhibition held at Owings-Dewey Fine Art, Santa Fe, New Mexico, 27 June–15 August 1998. The exhibition included twenty-one etchings executed between 1906 and 1951 (all illustrated). The catalogue contains an essay by James Moore and a checklist of the exhibition.

861 Parrish Art Museum. *Marin in Oil.* Southampton, N.Y.: The Museum, 1987.

Catalogue of an exhibition held at the Parrish Art Museum, Southampton, New York, 18 July–20 September 1987, which includes fifty-five oils (all are illustrated, twenty-seven in color). The catalogue contains an essay by Klaus Kertess, a chronology, a bibliography, a checklist of the exhibition.

862 Philadelphia Museum of Art. *The Complete Etchings of John Marin.* Philadelphia: The Museum, 1969.

Catalogue of Part I of the exhibition *John Marin: Etchings and Related Works,* held at the Philadelphia Museum of Art, Philadelphia, 17 January–17 March 1969. The catalogue raisonné by Carl Zigrosser consists of 180 etchings illustrated and annotated, accompanied by his introductory essay, a bibliography, and a list of exhibitions of Marin's etchings and the public collections owning them.

863 _____. *John Marin: Oils, Watercolors, and Drawings Which Relate to His Etchings*. Philadelphia: The Museum, 1969.

Catalogue of Part II of the exhibition *John Marin: Etchings and Related Works* (see entry 862), which includes fifty-two works illustrated and annotated by Sheldon Reich, preceded by his introductory essay.

864 Portland Museum of Art (Portland, Maine) *John Marin in Maine*. Portland, Maine: The Museum, 1985.

Catalogue of an exhibition held at the Portland Museum of Art, Portland, Maine, 22 May–8 September 1985. The exhibition featured ninety-three works, including three sketchbooks and Gaston Lachaise's bronze *John Marin* of 1928. The catalogue contains an essay by Megan Thorn, a checklist of the exhibition, and five reproductions (all in color).

865 Reich, Sheldon. *John Marin: A Stylistic Analysis and Catalogue Raisonné*. Tucson: University of Arizona Press, 1970.

Reich's catalogue raisonné is largely based upon his doctoral dissertation (see entry 1204). Part I consists of an extensively illustrated, stylistic analysis of Marin's works divided into six time periods. A chronology and bibliography are also included. Part II catalogs 2,978 works executed between 1888 and 1953 and provides a small black-and-white illustration for the vast majority. An exhibition list is also provided. Although it has some omissions, this is an essential resource for researchers and scholars.

866 _____. *John Marin Drawings, 1886–1951: A Retrospective Exhibition Honoring John Marin's Centennial*. [Salt Lake City]: University of Utah Press, 1969.

Catalogue of an exhibition of ninety-three drawings held at ten different venues between 13 September 1969 and 15 November 1970. The catalogue contains a foreword by E.F. Sanguinetti; an essay by Sheldon Reich; a checklist of the exhibition; and an illustration of each drawing (one in color).

866A Richard York Gallery. *John Marin: The 291 Years*. New York: The Gallery, 1998.

Catalogue of an exhibition held at the Richard York Gallery, New York, 12 November 1998–8 January 1999. The exhibition included eighty-four oils, watercolors, drawings, and etchings from 1904 to 1917. With only a few exceptions, all works are from the artist's estate; most are illustrated (the majority in color). Fifteen oils are from the Weehawken Sequence. Barbara Rose's essay provides a critical assessment of Marin's achievement, focusing on the early years. The catalogue contains introductions by Meredith E. Ward and Richard T. York; a chronology; and a checklist of the exhibition.

866B _____. *John Marin: The Painted Frame*. New York: The Gallery, 2000.

Catalogue of an exhibition held at the Richard York Gallery, New York, 12 October–9 December 2000. The thirty-five works in the exhibition are illustrated on color plates and accompanied by quotes of the artist. Essay by Hilton Kramer.

867 Rosenberg, Jakob. *On Quality in Art: Criteria of Excellence, Past and Present* (The A.W. Mellon Lectures in the Fine Arts, 1964), by Jakob Rosenberg, 220–221, 224. Princeton, N.J.: Princeton University Press, 1967.

Rosenberg compares and contrasts Marin's *Maine Islands* of 1922 with Ernst Ludwig Kirchner's *Mountain Landscape* of 1933.

868 Santa Clara University. de Saisset Museum. *The Artist and the Machine, 1910–1940*. Santa Clara, Calif.: The Museum, 1986.

Catalogue of an exhibition held at the de Saisset Museum, Santa Clara University, Santa Clara, California, 28 January–16 March 1986. The exhibition included Marin's *Downtown New York* of 1921 (not illustrated).

869 Terra Museum of American Art. *Five American Masters of Watercolor: Winslow Homer, John Singer Sargent, Maurice Prendergast, John Marin, Charles Burchfield*. Evanston, Ill.: The Museum, 1981.

Catalogue of an exhibition held at the Terra Museum of American Art, Evanston, Illinois, 5 May–12 July 1981, which includes twelve works by Marin, all illustrated (two in color). Catalogue notes by Ronald McKnight Melvin.

870 University of Arizona. Art Gallery. *John Marin, 1870–1953*. Tucson: The Gallery, 1963.

Catalogue of an exhibition held at the Art Gallery of the University of Arizona, Tucson, 9 February–10 March 1963. The catalogue contains a foreword by William E. Seaman; catalogue essays by MacKinley Helm and Sheldon Reich; and a checklist of the eighty watercolors, five drawings, and twenty-one oils in the exhibition. Twenty-one works are illustrated (seven in color).

871 University of California, Los Angeles. Art Galleries. *John Marin Memorial Exhibition*. Los Angeles: The Galleries, 1955.

Catalogue of an exhibition held at the Art Galleries of the University of California, Los Angeles (UCLA), 30 September–9 November 1955. The exhibition included four drawings, nine etchings, sixty-nine watercolors, and forty oils (forty-six works are illustrated, fifteen in color). The catalogue contains a foreword by Duncan Phillips; appreciations by William Carlos Williams and Dorothy Norman; essays by MacKinley Helm ("Conclusion to a Biography") and Frederick S. Wight ("John Marin—Frontiersman"); a checklist of the exhibition; a chronology; a list of the artist's exhibitions and works in public collections; and a selected bibliography. A hardcover edition of this catalogue

was published in 1956 by the University of California Press under the title *John Marin*. The dates of this exhibition, which have been previously uncited in the literature, have been supplied courtesy of UCLA at the Armand Hammer Museum of Art and Cultural Center.

872 University of New Mexico. Museum of Art. *Marin in New Mexico, 1929 and 1930*. Albuquerque, N.M.: The Museum, 1968.

Catalogue of an exhibition held at the Museum of Art, University of New Mexico, Albuquerque, 18 November–19 December 1968, which featured and documented (through maps and photographs) sixty-four of Marin's works executed in New Mexico during 1929 and 1930. The catalogue contains an essay by Van Deren Coke, a checklist of the exhibition, a chronology, and a bibliography. Twenty-three works are illustrated (four in color).

873 Waddington Galleries. *John Marin, 1870–1953: Retrospective Exhibition of Watercolors*. London, England: The Galleries, 1963.

Catalogue of an exhibition held at the Waddington Galleries, London, England, 3–26 October 1963. Forty-five works are illustrated, but there is no checklist of the exhibition.

874 Willard Gallery. *John Marin Paintings of the 1930's*. New York: The Gallery, 1965.

Catalogue of an exhibition held at the Willard Gallery, New York, 2 March–3 April 1965, which includes fourteen works (four are illustrated, one in color).

875 Wolanin, Barbara A. *Arthur B. Carles (1882–1952): Painting with Color*, 42–44. Philadelphia: Pennsylvania Academy of the Fine Arts, 1983.

Wolanin discusses Carles' friendship with Marin and compares the former's *Chamois* of 1908–1910 with the latter's *Tyrolean Mountains* of 1910.

876 Zayas, Marius de. *How, When and Why Modern Art Came to New York*, edited by Francis M. Naumann. Cambridge: MIT Press, 1996.

In a section devoted to Marin (pp. 87–90), de Zayas offers comments on Marin's New York watercolors. He reprints excerpts from two reviews of their first exhibition in 1913 authored by Charles H. Caffin (*New York American*) and Henry J. McBride (*New York Sun*) and Marin's statement from the exhibition catalogue (see entry 806). He also transcribes an exchange between Stieglitz and a lady visitor to a Marin exhibition at the Photo-Secession Galleries (pp. 82–83; reprinted from de Zayas' *A Study of the Modern Evolution of Plastic Expression*).

III. ARTICLES AND ESSAYS

877 "Activity—News of the Several Arts and of Federation Chapters: Marin for Fort Wayne." *Magazine of Art* 31 (July 1938) 377, 380.

Notice of the acquisition of Marin's *Three Towers of Rouen* of 1909 by the Fort Wayne Art Museum, Fort Wayne, Indiana.

878 "Activity—News of the Several Arts and of Federation Chapters: Marinara." *Magazine of Art* 31 (April 1938) 238.

A brief critique of "To My Paint Children," a letter Marin wrote in verse-prose.

879 "Art—An Ancient Mariner." *Time* 55 (9 January 1950) 35–36.

A biographical sketch centered on the publication of *The Selected Writings of John Marin* (see entry 799).

880 "The Arts—Marin's New York: A Hot Sun, a Storied Bridge." *Newsweek* 44 (11 October 1954) 58.

A brief tribute centered on *The Red Sun, Brooklyn Bridge* of ca. 1922.

881 Barker, Virgil. "John Marin." *Art and Understanding* 1 (November 1929) 106–109.

A stylistic analysis of Marin's paintings, which Barker says "convey the energy and vitality of the work in an almost intolerable degree, yet they are themselves pictorially balanced."

882 ———. "The Watercolors of John Marin." *The Arts* 5 (February 1924) 64–83.

Barker surveys Marin's watercolors and calls them "things of substance and vitality, convincing re-creations of reality."

883 Baur, John I.H. "John Marin's 'Warring, Pushing, Pulling' New York." *Art News* 80 (November 1981) 106–110.

A reprint of Baur's essay in the exhibition catalogue *John Marin's New York* (see entry 843).

884 Benson, E.M. "John Marin: The Man and His Work. Part I: Marin, The Man." *The American Magazine of Art* 28 (October 1935) 596–611, 632–633.

885 ———. "John Marin: The Man and His Work. Part II: Marin, The Work." *The American Magazine of Art* 28 (November 1935) 654–670.

A lengthy, critical analysis of Marin's earlier, lesser-known works, preceded by a detailed biography. Benson's monograph on the artist focuses on the watercolors and oils of the 1930s (see entry 813).

886 Bochner, Jay. "New York Secession." *In Modernism: Challenges and Perspectives*, edited by Monique Chefdor, Ricardo Quinones, and Albert Wachtel, 180–211. Urbana: University of Illinois Press, 1986.

In his exploration of the relationship between "straight" photography, non-representational art, and modern poetry in the New York Secession, Bochner compares and contrasts Marin's *Wall Street Stock Exchange* of 1924 and Paul Strand's photograph *Wall Street, New York* of 1915. He also offers comments on Marin's *Brooklyn Bridge* of 1910 and his cover illustration for the fourth issue of *291* (see entry 080).

887 Cassidy, Donna M. "John Marin's Dancing Nudes by the Seashore: Images of the New Eve." *Smithsonian Studies in American Art* 4 (Winter 1990) 70–91.

Cassidy analyzes Marin's works that feature female nudes by the seashore with reference to his interest in modern dance; his knowledge of works by other artists like Cézanne, Rodin, Matisse, Picasso, and Walkowitz that depict similar imagery; and his knowledge of the writings of antipuritanical authors such as Walt Whitman, D.H. Lawrence, and Waldo Frank.

888 Coe, Nancy. " 'Rocks and Sea, Small Point, Maine.' " *The Bulletin of the Cleveland Museum of Art* 44 (January 1957) 9–12.

Coe discusses the acquisition of Marin's oil *Rocks and Sea, Small Point, Maine* of 1931 by the Cleveland Museum of Art.

889 "The Collection of Dorothy Norman." *Aperture* no. 124 (Summer 1991) 50–55.

Norman discusses her collection of Marin's works (several are shown in color photographs of the interior of Norman's home).

890 Craven, Thomas Jewell. "John Marin." *Shadowland* 5 (October 1921) 11, 75.

A biographical sketch accompanied by critical comments.

891 Davidson, Abraham A. "John Marin: Dynamism Codified." *Artforum* 9 (April 1971) 37–41.

Davidson argues that of all the early American modernists, Marin most successfully appropriated Cubist idioms and devices into his work. He feels that Marin modified the Cubist aesthetic to allow the expression of hidden dynamic forces constantly in flux.

892 Deak, Gloria–Gilda. "John Marin." In *Kennedy Galleries Profiles of American Artists*, 2d ed., by Gloria–Gilda Deak, 158–159. New York: the Kennedy Galleries, 1984.

A biographical essay.

893 Dundas, Helen. "To John Marin, Art Became 'a Sort of Mad Wonder Dancing.' " *Smithsonian* 20 (February 1990) 52–63.
A lengthy, illustrated biographical essay.

894 Eglington, Guy. "John Marin, Colorist and Painter of Sea Moods." *Arts and Decoration* 21 (August 1924) 13–14, 65.
Eglington ties the emotional power of Marin's work to the artist's talents as a colorist and his sense of space.

895 Fine, Ruth. "The John Marin Archive at the National Gallery of Art." *Drawing* 9 (September–October 1987) 54–57.
An overview of the gifts from Mr. and Mrs. John Marin, Jr., which established the John Marin Archive at the National Gallery of Art, Washington, D.C. These included oils, etchings, sixteen sketchbooks containing over 400 watercolors and drawings, and 114 independent watercolor sheets.

896 Finkelstein, Louis. "Marin and De Kooning." *Magazine of Art* 43 (October 1950) 202–206.
Finkelstein compares and contrasts Marin and Willem de Kooning in terms of influences, temperament, compositional elements, treatment of space, and so forth.

897 Fisher, Dorothy Canfield. "John Marin." In *American Portraits*, by Dorothy Canfield Fisher, 106–108. New York: Henry Holt, 1946.
A brief appreciation accompanied by a sketch of the artist by Enit Kaufman.

898 Frank, Waldo. "What's Going on in the World: Art of the Month—The American Art of John Marin." *McCall's Magazine* 54 (June 1927) 27, 61–62.
Frank defends Marin's watercolors against the charge that they are fragile and timid, saying, "These physical objects are graphically there; yet they are swinging, leaping, singing like notes in a song, like children at play. What miracle is this, making the common object of a landscape tremble and glow as sunsets do, or as the broken waves of the sea?"

899 Frankfurter, Alfred M. "Editorial—Picasso; Marin; Arms." *Art News* 52 (November 1953) 13.
An obituary.

900 Freedgood, Lillian. "The Failure Who Made Good: John Marin, 1870–1953." In *Great Artists of America*, by Lillian Freedgood, 180–194. New York: Thomas Y. Crowell, 1963.
Although this biographical essay does not delve into critical analysis, it does devote attention to the influence that Marin's family life and relatives had on his career.

901 "From Their Friends." *The Art Digest* 15 (1 December 1940) 27.
Notice of a gift of Marin's *Marine, Maine* of 1932 to the Honolulu Academy of Arts.

902 Gray, Cleve. "John Marin: Graphic and Calligraphic." *Art News* 71 (September 1972) 48–53.
Gray explores the calligraphic elements in Marin's drawings, watercolors, and oils. He also discusses the relationship between Marin's writings and his art.

903 _____. "Marin and Music." *Art in America* 58 (July–August 1970) 72–81.
Nine color reproductions of Marin's oils and watercolors are captioned with selections from his writings on the theme of music.

904 Gray, Cleve and Dorothy Norman. "John Marin's Sketchbook—Summer 1951." *Art in America* 55 (September–October 1967) 44–53.
Following an introduction by Gray, Norman offers comments on a previously unpublished sketchbook that Marin made in 1951 during a brief trip to Maine and New Brunswick. Ten drawings are illustrated (six in color).

905 Halter, Peter. " 'How Shall I Be a Mirror to This Modernity?': William Carlos Williams, Alfred Stieglitz, and the Artists of the Stieglitz Circle." In *Poetry and the Fine Arts: Papers from the Poetry Sessions of the European Association for American Studies Biennial Conference, Rome 1984*, edited by Roland Hegenbuchle and Jaqueline S. Ollier, 72–101. Regensburg, Germany: Verlag Friedrich Pustet, 1989.
Halter briefly discusses Williams' poem "Young Love," published in *Spring and All*, in which he refers to Marin's "skyscraper soup" (pp. 95–96).

906 Hartley, Marsden. "The Recent Paintings of John Marin." In *Fifty New Paintings by John Marin*. New York: Intimate Gallery, 1928. Reprinted in *On Art*, by Marsden Hartley (edited by Gail R. Scott), 77–81. New York: Horizon Press, 1982.
Hartley's catalogue essay is a critical appraisal of Marin as a watercolorist.

907 Haskell, Ernest. "John Marin." *The Arts* 2 (January 1922) 201–202.
A brief reminiscence of the artist.

908 Helm, MacKinley. "John Marin: An Atlantic Portrait." *The Atlantic* 179 (February 1947) 76–81.
This biographical essay, which touches on Marin's personal life and aesthetic views, is based on Helm's conversations with the artist.

909 Hirshler, Erica E. "The 'New New York' and the Park Row Building: American Artists View an Icon of the Modern Age." *The American Art Journal* 21:4 (1989) 26–45.

In her discussion of New York's Park Row Building as an icon for early American modernist artists and photographers, Hirshler contrasts Marin's watercolor *St. Paul's, Manhattan* of 1914 with Alvin Langdon Coburn's 1905 photograph *St. Paul's Church and the Park Row Building*.

910 Hogan, C.E. "Recent Acquisitions—Additions to the Permanent Collection: *City Construction* by John Marin." *Gallery Notes* [Buffalo Fine Arts Academy, Albright Art Gallery] 19 (January 1955) 38, 71–72.

In his discussion of Marin's watercolor *City Construction* of 1932, Hogan points out that it was a key reference for the artist, and he retained it in his studio until his death in 1953.

911 "John Marin, Academician." *The Art Digest* 18 (1 April 1944) 13.

Notice of Marin's election as an associate of the National Academy.

912 "John Marin: America's Famous Master of Modern Art Is Wizard of Watercolors." *Life* 29 (10 July 1950) 62–65.

A brief profile accompanied by six illustrations.

913 "John Marin Is Dead; Water-Colorist, 80—Artist Considered by Many as 'America's No. 1 Master' Succumbs in Maine Home." *New York Times* (2 October 1953) 21.

914 "John Marin, 1870–1953." *Art Digest* 28 (15 October 1953) 25.

An obituary.

915 Johnson, Ellen H. "John Marin's Vision of Nature." In *Modern Art and the Object: A Century of Changing Attitudes*, rev. and enl. ed., by Ellen H. Johnson, 94–96. New York: HarperCollins, Icon Editions, 1995.

In a subsection of Chapter 3, "The Mountain in the Painting and the Painting in the Mountain," Johnson discusses Marin's style, compositions, and attitude toward nature.

916 Josephson, Matthew. "Profiles—Leprechaun on the Palisades." *The New Yorker* 18 (14 March 1942) 26–32.

A lengthy biographical essay.

917 Kalonyme, Louis. "John Marin: Promethean." *Creative Art* 3 (October 1928) xl–xli.

Kalonyme's analysis of Marin's watercolors emphasizes their musical aspects and uniquely American character.

918 Lane, James W. "Marin." In *Masters in Modern Art*, by James W. Lane, 65–71. Boston: Chapman and Grimes, 1936.
Lane assesses Marin's watercolors, remarking on "the austere, delicate, Chinese, and brave quality of his art."

919 Laurvik, J. Nilsen. "The Water-Colors of John Marin." *Camera Work* no. 39 (July 1912) 27, 29, 36–38.
A general analysis of Marin's watercolors, which the author describes as "eloquent with the ardour of an intense admiration of the universe."

920 Leonard, Neil. "Jazz and the Other Arts." In *American Music from Storyville to Woodstock*, edited by Charles Nanry, 152–167. New Brunswick, N.J.: Transaction Books; New York: Distributed by E.P. Dutton, 1972.
Leonard compares and contrasts the ways in which Marin and T.S. Eliot responded to jazz.

921 Lewisohn, Sam A. "Marin: American Originale." In *Painters and Personality: A Collector's View of Modern Art*, rev. ed., 150–154. New York: Harper and Brothers, 1948.
Lewisohn believes that Marin's achievement is based on both poetic spontaneity and a sincere, individual, and disciplined vision.

922 Lowe, Sue Davidson. "Marin's Maine." *Art and Antiques* 6 (April 1989) 68–75, 115.
Lowe reminisces about her 1947 visit to Marin's home in Maine.

923 "Marin, Phillips and Stieglitz." *The Art News* 25 (4 June 1927) 8.
Notice of Stieglitz's pending sale of three Marin watercolors to Duncan Phillips.

924 "Marin Water Color Breaks $6,000 Record." *The Art Digest* 3 (Mid-December 1928) 9.
Notice of Stieglitz's sale of two Marin watercolors, *Gray Sea* of 1924 (purchased by Duncan Phillips) and *The Mountain, No. 2—Franconia Notch, New Hampshire* of 1927. A paragraph from Julius Meier-Graefe's article "A Few Conclusions on American Art," which appraises Marin's watercolors, is reprinted from *Vanity Fair* 31 (November 1928) 83.

925 McBride, Henry. "Four Transoceanic Reputations." *Art News* 49 (January 1951) 26–29, 66.
A brief discussion of Marin's reputation in Europe.

926 Mellquist, Jerome. "John Marin: Painter of Specimen Days." *American Artist* 13 (September 1949) 56–59, 67– 69.

Mellquist reviews Marin's career through the mid-1940s. *Blue Sea and Boat Fantasy* of 1941 is illustrated on a color plate.

927 _____. "Obituary—John Marin: Rhapsodist of Nature (1870–1953)." *College Art Journal* 13 (Summer 1954) 311–312.

928 _____. "Pan among Our Painters." *Theatre Arts* 34 (June 1950) 35–39.
 In this general overview of Marin's career, Mellquist writes that Marin "painted as if he incarnated some living conscience about the land."

929 Miller, Henry. "Stieglitz and John Marin." *Twice a Year* nos. 8–9 (Spring–Summer/Fall–Winter 1942) 146–155. Reprinted in *The Air-Conditioned Nightmare*, by Henry Miller, 266–277. New York: New Directions, 1945.
 Miller reminisces about his encounters with Stieglitz and Marin, calling them both "wizards" and their relationship "a marriage of kindred spirits. Everything they touch becomes ennobled. There is no taint anywhere. We reach with them the realm of pure spirit."

930 Mozley, Loren. "Yankee Artist." *The Bulletin of the Museum of Modern Art* 4 (October 1936) 1–8.
 A chatty description of Marin's personal life and working methods, written in connection with the Marin retrospective at the Museum of Modern Art (see entry 860).

931 Newhall, Beaumont. "Portrait: A Day with John Marin." *Art in America* 49:2 (1961) 48–55. Reprinted in *Art in America* 51 (August 1963) 107–111.
 Newhall recounts his 1949 visit to Marin's home in Cliffside, New Jersey. Ansel Adams recorded the occasion with his camera, and several photographs of Marin are featured.

932 "Partial List of Material Acquired in 1960." *Archives of American Art Bulletin* 1 (May 1960) 3.
 The Archives of American Art acquired a set of letters that Marin wrote to his friend Charles Duncan, a retired sign painter. One letter (dated 6 October 1947) is reprinted.

933 Phillips, Duncan. "7 Americans Open in Venice—Marin." *Art News* 49 (June–July–August 1950) 20–21.
 Reprint of a short critical assessment of Marin that appeared in the catalogue to the twenty-fifth Venetian *Biennale*.

934 "A Portrait Head by Gaston Lachaise." *Bulletin of the Wadsworth Atheneum* 6 (July 1928) 20–21.

Notice of the Wadsworth Atheneum's acquisition of Gaston Lachaise's bronze *John Marin* of 1928.

935 Prasse, Leona E. "An Exhibition of the Early Etchings of John Marin." *The Bulletin of the Cleveland Museum of Art* 26 (March 1939) 33–35.
A discussion of forty-two etchings executed between 1905 and 1910, all of which depict European sites.

936 Reich, Sheldon. "Andrew Dasburg: The Late Years." *The American Art Journal* 15 (Autumn 1983) 21–44.
The early American modernist Andrew Dasburg (1887–1979) and Marin spent time together in Taos, New Mexico, during the summers of 1929 and 1930. Marin's *Taos Mountain* of 1929, which he painted in Dasburg's studio and then presented to him, is illustrated.

937 _____. "John Marin and the Piercing Light of Taos." *Art News* 73 (January 1974) 16–17.
This brief discussion of Marin's Taos landscapes is accompanied by quotes from Georgia O'Keeffe, J. Ward Lockwood, Andrew Dasburg, and the artist.

938 _____. "John Marin: Paintings of New York, 1912." *The American Art Journal* 1 (Spring 1969) 43–52.
Reich discusses Marin's series of fourteen watercolors of New York City, which he executed in 1912 and first exhibited in 1913, in the context of Futurist aesthetics and contemporary works of Robert Delaunay.

939 Ricciotti, Dominic. "Symbols and Monuments: Images of the Skyscraper in American Art." *Landscape* 25:2 (1981) 22–29.
Ricciotti focuses on Marin's passion for the "urban sublime," particularly as exemplified in the artist's treatment of New York's Woolworth Building. He notes that Marin's architectural background gave him a command of monumental form in space, which he used to render both mountains and skyscrapers. Ricciotti believes that Marin's vitality stemmed from his successful integration of nature and the human environment.

940 Rodgers, Timothy Robert. "Alfred Stieglitz, Duncan Phillips and the '$6000 Marin.' " *Oxford Art Journal* 15:1 (1992) 54–66.
Rodgers discusses Stieglitz's sale of Marin's *Back of Bear Mountain* of 1925 to Duncan Phillips. He contends that this exemplified Stieglitz's crass and commercially motivated attempt to establish Marin as a "genius" of modern American art, which enabled him to market the artist's watercolors at premium prices. Rodgers treats this topic in greater depth in his doctoral dissertation (see entry 1205).

941 Rosenfeld, Paul. "Art—An Essay on Marin." *The Nation* 134 (27 January 1932) 122–124.

Rosenfeld appraises Marin's watercolors and concludes that he had reached "matchless success" with the medium.

942 ———. "John Marin." In *Port of New York*, by Paul Rosenfeld, 153–166. New York: Harcourt, Brace, 1924.

Rosenfeld outlines the factors that he feels contributed to Marin's success, including the close connection between conception and execution in the artist's work and his concentration on relatively few motifs.

943 ———. "John Marin's Career." *The New Republic* 90 (14 April 1937) 289–292.

An assessment of Marin's achievement, which Rosenfeld believes is "a sort of absolute painting as American in feeling as Whitman's, and as simultaneously rough and exquisite."

944 ———. "The Water-Colours of John Marin." *Vanity Fair* 18 (April 1922) 48, 88, 92, 100.

A general discussion of Marin's watercolors.

945 Rub, Timothy F. "American Architectural Prints." *Print Review* 18 (1984) 6–19.

Rub briefly discusses Marin's *Ponte di Donna Onesta, Venezia* of 1907 and *Woolworth Building, No. 2* of 1913.

946 Ryerson, Margery Austen. "John Marin's Watercolors." *Art in America* 9 (February 1921) 87–88, 91.

Ryerson discusses Marin's use of color in his watercolors.

947 Saunier, Charles. "John Marin: Peintre-Graveur." *L'Art décoratif* 18 (January 1908) 17–24.

Saunier's discussion of Marin's work focuses on the etchings.

948 Seligmann, Herbert J. "For John Marin." *Saturday Review* 36 (26 December 1953) 38.

A memorial poem.

949 ———. "Frames—with Reference to Marin." *It Must Be Said* No. 3. New York: An American Place, 1934.

Introduction to the exhibition *John Marin: New Watercolors, New Oils, New Etchings*, held at An American Place, 20 December 1933–1 February 1934.

950 ———. "John Marin and the Real America." *It Must Be Said* No. 1. New York: An American Place, 1932.

This issue served as the catalogue for the exhibition *Recent Paintings and Watercolors by John Marin*, held at An American Place, 7 November–17 December 1932.

951 _____. "Marin at Cape Split: A Reminiscence of One of Maine's Greatest Painters." *Down East* 1 (Winter 1955) 23–26.

952 Soby, James Thrall. "The Paintings of John Marin." *Perspectives USA* no. 11 (Spring 1955) 48–53.
Soby sees Marin's art as falling into three categories: the Expressionist poet; the relaxed and decorative circus pictures and nudes; and the realism of direct reportage and local color. Soby believes that Marin's greatness lies in his impetuousness and visual directness.

953 _____. "Three American Watercolorists: II. John Marin." In *Contemporary Painters*, [2d ed.], by James Thrall Soby, 16–21. New York: Museum of Modern Art: Distributed by Simon and Schuster, 1948.
A general analysis of Marin's works, which Soby feels can be divided into those that are Expressionistic, lyrical, and poetic; those that are more relaxed, ornamental, and carefully controlled; and those where the Expressionist mood is tempered by an interest in direct reportage and local color.

954 Stieglitz, Alfred. "Four Marin Stories." *Twice a Year* nos. 8–9 (Spring–Summer/Fall–Winter 1942) 156–162.
Stieglitz relates the following stories: "Marin in Paris—I Buy from Him"; "Marin's Father"; "Marin Island"; and "Marin Sells a Painting."

955 Strand, Paul. "Correspondence—Marin Not an Escapist." *The New Republic* 55 (25 July 1925) 254–255.
Strand defends Marin against Waldo Frank's charge that he is an "escapist." A rejoinder by Frank follows.

956 Taylor, E.A. "The American Colony of Artists in Paris." *Studio* 53 (July 1911) 103–118.
Taylor offers some general comments on Marin's etchings and watercolors.

957 "U.S. Art: 1935—In Terms of Jones, Lee, Soyer, Lucion, Marin, Carroll, Picken." *Fortune* 12 (December 1935) 68, 73.
A brief discussion of Marin's *Old Dutch House* (*Old Dutch Farmhouse, Tappan, New York*) of 1932, which is illustrated in color.

958 Walhout, Clarence. "Ives, Crane, Marin, and 'The Mind behind the Maker.'" *Christian Scholar's Review* 16:4 (1987) 335–372.
Walhout adopts a structuralist approach in his exploration of the parallels in the lives, personalities, attitudes, and works of Marin, Charles Ives, and Stephen

Crane. He writes, "All of them join a keen interest in natural environments, specific American locales, and simple forms of life with a fascination with urban localities and the angular images of city life."

959 Weinberg, Jonathan. "Why Marin?" *BlockPoints: The Annual Journal and Report of the Mary and Leigh Block Gallery* 1 (1993) 20–33.

In his attempt to discover the reasons for Marin's popularity with the artists and critics of his own generation, Weinberg postulates that his art has a certain generalized quality; it captured the city's vitality sans its depressing and disturbing aspects; it compromised between abstraction and the recognizable motif; and it embodied a certain virile masculinity (a quality that critics found lacking in the watercolors of Marin's contemporary Charles Demuth, which Weinberg feels have equal artistic merit).

960 "Who's News." *The Art Digest* (1 August 1950) 23.

Notice of Marin's receipt of an honorary doctorate of fine arts degree from Yale University.

961 Wight, Frederick S. "John Marin." In *New Art in America: Fifty Painters of the Twentieth Century*, edited by John I.H. Baur, 42–49. Greenwich, Conn.: New York Graphic Society, in cooperation with Praeger, New York, [1957].

A biographical sketch accompanied by seven illustrations.

962 Wilder, Thornton. "John Marin, 1870–1953." In *American Characteristics and Other Essays*, by Thornton Wilder, 234–239. New York: Harper and Row, 1979.

This tribute is reprinted from the *Proceedings of the American Academy of Arts and Letters and the National Institute of Arts and Letters* (1955). Thornton believes that Marin's success was due to his "inner compulsion to present a single subject, or a single aspect of the scene before him—what the eye sees in one deep gaze, not what the eye sees as it roams about the subject in ever shifting focus," and his "joy in orienting the object toward a total universe of light and air and forms."

963 Wolanin, Barbara. "Carles and Marin: Kindred Spirits." *Archives of American Art Journal* 27:1 (1987) 2–11.

Wolanin made extensive use of the Arthur B. Carles Papers in the Archives of American Art to trace the artist's lifelong friendship with Marin.

964 Wynne, Carolyn. "Aspects of Space: John Marin and William Faulkner." *American Quarterly* 16 (Spring 1964) 59–71.

Wynne discusses Marin's expression of the dynamic, fluid quality of time; his use of interpenetrating lines and planes to depict multiple spatial viewpoints;

his use of a frame within a frame to preserve structure; and his fidelity to the recognizable object.

965 Zigrosser, Carl. "John Marin." In *The Artist in America: Twenty-four Close-ups of Contemporary Printmakers*, by Carl Zigrosser, 3–13. New York: Alfred A. Knopf, 1942.

In his discussion of Marin's printmaking, Zigrosser postulates that the artist exemplifies two theories of expression, which Zigrosser calls the "associative method" and the "aesthetic method." He also stresses the immediacy and intensity of Marin's creative reactions.

IV. EXHIBITION REVIEWS

966 "Marin's and Maurer's Works." *American Art News* 8 (10 April 1909) 6.

Review of the exhibition *Watercolors by John Marin and Sketches in Oil by Alfred Maurer*, held at the Photo-Secession Galleries, New York, 30 March–17 April 1909.

967 "The Maurers and Marins at the Photo-Secession Gallery." *Camera Work* no. 27 (July 1909) 41–44.

Reprinted reviews (see entry 966) by J. Edgar Chamberlin (*Evening Mail*), Arthur Hoeber (*Globe and Commercial Advertiser*), and Mr. Harrington (*New York Herald*). The leaflet authored by Charles H. Caffin, which appeared with the exhibition catalogue, is also reprinted.

968 MacColl, William D. "Exhibition of Water-Colors, Pastels and Etchings by John Marin." *Camera Work* no. 30 (April 1910) 41–44.

Review of the exhibition *Watercolors, etc., by John Marin* held at the Photo-Secession Galleries, New York, 7–25 February 1910. Includes reprinted reviews by B.P. Stephenson (*Evening Mail*), Elizabeth Luther Cary (*New York Times*), Israel L. White (*Newark Evening News*), J. Edgar Chamberlin (*Evening Mail*), and Mr. Harrington (*New York Herald*).

969 "Marin at Photo Secession." *American Art News* 8 (19 February 1910) 6.
Review. See entry 968.

970 "Photo-Secession Notes." *Camera Work* no. 30 (April 1910) 47.
Review. See entry 968.

971 "The Exhibitions at '291'—Marin Exhibition." *Camera Work* no. 36 (October 1911) 29–30, 47.

Review of the exhibition *John Marin*, held at the Photo-Secession Galleries, New York, 2–22 February 1911. Includes a reprinted review by James Huneker (*New York Times*).

972 "Marin Show at Photo-Secession." *American Art News* 11 (25 January 1913) 8.

Review of the exhibition *Watercolors and Oils by John Marin*, held at the Photo-Secession Galleries, New York, 20 January–15 February 1913.

973 "Notes on '291'—Water-Colors by John Marin." *Camera Work* nos. 42–43 (April–July 1913) 18, 22–26, 41–44.

Review. See entry 972. Includes reprinted reviews by Arthur Hoeber (*Globe and Commercial Advertiser*), J. Edgar Chamberlin (*New York Mail*), Samuel Swift (*New York Sun*), W.B. McCormick (*New York Press*), Mr. Boswell (*New York Herald*), Royal Cortissoz (*New York Tribune*), Forbes Watson (*New York Evening Post*), J. Nilsen Laurevik (*Boston Transcript*), Charles H. Caffin (*New York American*), and Hutchins Hapgood (*Globe and Commercial Advertiser*). Marin's statement on the exhibition is also reprinted (see entry 806).

974 "Exhibitions on Now: John Marin's Points of View." *American Art News* 13 (27 February 1915) 3.

Review of the exhibition *John Marin: Water Colors, Oils, Etchings, Drawings, Recent and Old*, held at the Photo-Secession Galleries, New York, 23 February–26 March 1915.

975 " '291' Exhibitions: 1914–1916." *Camera Work* no. 48 (October 1916) 21–22, 37–38, 45–46, 54.

Reprinted reviews of the exhibitions *John Marin: Water Colors, Oils, Etchings, Drawings, Recent and Old* and *Marin Watercolors*, held at the Photo-Secession Galleries, New York, 23 February–26 March 1915 and 18 January–12 February 1916, respectively, by Henry J. McBride (*New York Sun*), Peyton Boswell (*New York Herald*), J. Edgar Chamberlin (*Evening Mail*), Charles H. Caffin (*New York American*), Manuel Komroff (*New York Call*), Forbes Watson (*Evening Post*), and Willard Huntington Wright (*International Studio*).

976 McBride, Henry. "Marin's Watercolors." In *The Flow of Art: Essays and Criticisms of Henry McBride*, edited by Daniel Catton Rich, 99–101. New York: Atheneum, 1975.

Review of the exhibition *Marin Watercolors* (reprinted from the *New York Sun*, 16 January 1916). See entry 975.

977 Wright, W.H. "John Marin's Water-Colours." *The International Studio* 58 (March 1916) xviii.

Review of the exhibition *Marin Watercolors*. See entry 975.

978 "Exhibitions on Now: John Marin's Recent Watercolors." *American Art News* 15 (17 February 1917) 4.

Review of the *John Marin Exhibition—The Country of the Delaware, and*

Other Exercises, held at the Photo-Secession Galleries, New York, 14 February–3 March 1917.

979 Boswell, Peyton. "Current Exhibitions: Marin's Abstractions in Color." *American Art News* 19 (16 April 1921) 3.
Review of the exhibition *Watercolors Pertaining to the Sea by John Marin*, held at the Daniel Gallery, New York, March–April 1921.

980 Seligmann, Herbert J. "American Water Colours in Brooklyn." *The International Studio* 74 (December 1921) clviii–clx.
Review of the *Exhibition Water Color Paintings by American Artists*, held at the Brooklyn Museum, 7 November–18 December 1921, which included fourteen works by Marin.

981 Strand, Paul. "American Watercolors at the Brooklyn Museum." *The Arts* 2 (20 January 1922) 148–152.
Review. See entry 980.

982 _____. "John Marin." *Art Review* 1 (January 1922) 22–23.
Review. See entry 980.

983 "John Marin at Montross." *American Art News* 20 (28 January 1922) 1.
Review of the *Exhibition—Water Colors, Oil Paintings and Etchings: John Marin*, held at the Montross Gallery, New York, 24 January–11 February 1922.

984 McBride, Henry. "Modern Art." *The Dial* 72 (March 1922) 329–331.
Review. See entry 983.

985 Rosenfeld, Paul. "The Water-Colours of John Marin: A Note on the Work of the First American Painter of the Day." *Vanity Fair* 18 (April 1922) 48, 88, 92, 110.
Review. See entry 983.

986 Brook, Alexander. "The Exhibitions: John Marin." *The Arts* 3 (April 1923) 272–273.
Review of the exhibition *Recent Pictures by John Marin: 1922–23*, held at the Montross Gallery, New York, 6–24 March 1923.

987 "Marin Still Gains as Water Colorist." *The Art News* 21 (10 March 1923) 9.
Review. See entry 986.

988 Craven, Thomas. "John Marin." *The Nation* 188 (19 March 1924) 321.
Review of the exhibition *Recent Water Colors by John Marin*, held at the
Montross Gallery, New York, 16 February–8 March 1924.

989 "Exhibitions in New York: John Marin—The Intimate Gallery, through
December." *The Art News* 24 (12 December 1925) 5.
Review of the exhibition *John Marin*, held at the Intimate Gallery, New York,
7 December 1925–11 January 1926.

990 "Exhibitions in New York: John Marin." *The Art News* 26 (20 November
1926) 9.
Review of the *Marin Exhibition*, held at the Intimate Gallery, New York, 9
November 1926–9 January 1927.

991 Watson, Forbes. "New York Exhibitions: John Marin." *The Arts* 10 (De-
cember 1926) 347–348.
Review. See entry 990.

992 Mannes, Marya. "Gallery Notes." *Creative Art* 1 (December 1927) vii.
Review of the exhibition *Forty New Watercolors by John Marin*, held at the
Intimate Gallery, New York, 9 November–11 December 1927.

993 "Marin Exhibition Best Ever Held." *The Art News* 26 (12 November 1927)
1, 3.
Review. See entry 992.

994 Pemberton, Murdock. "The Art Galleries: Marin Comes to Town, via
Stieglitz, out of Leaves of Grass." *The New Yorker* 3 (19 November 1927) 94–
96.
Review. See entry 992.

995 "Loan Exhibition of Contemporary American Water Colors." *Bulletin of
the Wadsworth Atheneum* 6 (July 1928) 21–23.
Review of the *Loan Exhibition of Three Contemporary American Watercol-
orists*, held at the Wadsworth Atheneum, Hartford, Connecticut, June 1928,
which included six works by Marin.

996 "Exhibitions in New York: John Marin—Intimate Gallery." *The Art News*
27 (24 November 1928) 10.
Review of the exhibition *Fifty New Paintings by John Marin*, held at the
Intimate Gallery, New York, 14 November–29 December 1928.

997 Goodrich, Lloyd. "Exhibitions in New York." *The Arts* 14 (December 1928) 323–326.
Review. See entry 996.

998 McBride, Henry. "Modern Art." *The Dial* 86 (February 1929) 174–175.
Review. See entry 996.

999 Pemberton, Murdock. "Marin and Others." *Creative Art* 3 (December 1928) xlv.
Review. See entry 996.

1000 Flint, Ralph. "The Current American Art Season." *Art and Understanding* 1 (March 1930) 205–210.
Review of the exhibition *John Marin: Fifty New Watercolors*, which was the inaugural exhibition of An American Place, New York, December 1929–January 1930.

1001 Goodrich, Lloyd. "In the Galleries: 'An American Place.' " *The Arts* 16 (January 1930) 345.
Review. See entry 1000.

1002 "Marin Show Opens New Gallery." *The Art News* 28 (4 January 1930) 3, 7.
Review. See entry 1000.

1003 Pemberton, Murdock. "The Art Galleries: Housewarming—The Ladies of the Academy." *The New Yorker* 5 (11 January 1930) 73–74.
Review. See entry 1000.

1004 Rosenfeld, Paul. "The Marin Show." *The New Republic* 62 (26 February 1930) 48–50.
Review. See entry 1000.

1005 Flint, Ralph. "Marin Exhibits New Landscapes Done in Taos: America's Most Distinguished Watercolorist Holds Stirring Exhibition of Recent Work at 'An American Place.' " *The Art News* 29 (8 November 1930) 3, 5.
Review of the exhibition *John Marin-Recent Watercolors: New Mexico and New York*, held at An American Place, New York, November 1930.

1006 Goodrich, Lloyd. "November Exhibitions: Marin." *The Arts* 17 (November 1930) 120–121.
Review. See entry 1005.

1007 "New York Season." *The Art Digest* 5 (15 November 1930) 16.
Review. See entry 1005.

1008 Pemberton, Murdock. "The Art Galleries: The Embattled Natives—
Marin's Marvels—Still More from Europe." *The New Yorker* 6 (8 November
1930) 49–50.
Review. See entry 1005.

1009 Flint, Ralph. "Recent Work by Marin Seen at American Place: A New
Quality of Deepening Importance Seen in Recent New Mexican Work by Our
Leading Landscapist." *The Art News* 30 (17 October 1931) 3, 5.
Review of the exhibition *John Marin*, held at An American Place, New York,
11 October–27 November 1931.

1010 Pemberton, Murdock. "The Art Galleries: Oil." *The New Yorker* 7 (24
October 1931) 64.
Review. See entry 1009.

1011 Flint, Ralph. "Marin 1932 Show Has New Trend." *The Art News* 31 (12
November 1932) 10.
Review of the exhibition *Recent Paintings and Watercolors by John Marin*,
held at An American Place, New York, 7 November–17 December 1932.

1012 Mumford, Lewis. "The Art Galleries: Marin—Miro." *The New Yorker* 8
(19 November 1932) 69–70.
Review. See entry 1011.

1013 "New York Criticism: Marin the Courageous." *The Art Digest* 7 (1 De-
cember 1932) 14.
Reprinted excerpts from reviews by Henry McBride (*New York Sun*) and
Royal Cortissoz (*New York Herald Tribune*). See entry 1012.

1014 Eglington, Laurie. "Twenty-five Years of Marin Shown at An American
Place." *The Art News* 32 (28 October 1933) 11.
Review of the exhibition *Twenty-five Years of John Marin—1908–1932—
Watercolors*, held at An American Place, New York, 16 October–27 November
1933.

1015 Hopper, Inslee A. "Vollard and Stieglitz." *The American Magazine of
Art* 26 (December 1933) 544–545.
Review. See entry 1014.

1016 Mumford, Lewis. "The Art Galleries: Two Americans." *The New Yorker*
9 (11 November 1933) 60–61.
Review. See entry 1014.

1017 "New York Criticism: A Cycle of John Marin." *The Art Digest* 8 (1 November 1933) 12.
Reprinted excerpts from a review by Edward Alden Jewell (*New York Times*). See entry 1014.

1018 Eglington, Laurie. "Exhibitions in New York—Marin: An American Place." *The Art News* 32 (13 January 1934) 8.
Review of the exhibition *John Marin: New Watercolors, New Oils, New Etchings*, held at An American Place, New York, 20 December 1933–1 February 1934.

1019 Wellman, Rita. "Pioneers and Contemporaries." *Parnassus* 6 (January 1934) 13.
Review. See entry 1018.

1020 Eglington, Laurie. "Exhibitions in New York—Marin: An American Place." *The Art News* 33 (24 November 1934) 9.
Review of the exhibition *John Marin: New Oil Paintings—Water Colors—Drawings*, held at An American Place, New York, 3 November–1 December 1934.

1021 Gray, Frances. "Current Exhibitions." *Parnassus* 6 (December 1934) 25.
Review. See entry 1020.

1022 "Art: Colorful Shorthand." *Time* 27 (6 January 1936) 44.
Review of the exhibition *John Marin—Exhibition of Watercolors, Drawings, Oils (1934–1935)*, held at An American Place, New York, 27 October–15 December 1935.

1023 Dannenberg, Dorothy. "Annual Exhibit of Marin's Work Now Being Held: The Power and Individuality of the Artist's Watercolors Felt in Show of 1934–35 Work at An American Place." *The Art News* 34 (2 November 1935) 3.
Review. See entry 1022.

1024 Mumford, Lewis. "The Art Galleries." *The New Yorker* 11 (16 November 1935) 81–82.
Review. See entry 1022.

1025 "New York Criticism." *The Art Digest* 10 (15 November 1935) 14, 22.
Reprinted excerpts from reviews by Jerome Klein (*New York Post*) and Henry McBride (*New York Sun*). See entry 1022.

1026 "Arts—Marin: Boats and Towers Reel through Two Floors of Museum." *News-Week* 8 (24 October 1936) 28.

Review of the exhibition *John Marin: Watercolors, Oil Paintings, Etchings*, held at the Museum of Modern Art, New York, 21 October–22 November 1936.

1027 Breuning, Margaret. "Current Exhibitions." *Parnassus* 8 (December 1936) 27.
Review. See entry 1026.

1028 Davidson, Martha. "Marin: Master of a Minor Medium." *The Art News* 35 (24 October 1936) 10–12.
Review. See entry 1026.

1029 Du Bois, Guy Pène. "Seeing the Exhibitions—John Marin." *The American Magazine of Art* 29 (December 1936) 845–846.
Review. See entry 1026.

1030 Holme, Brian. "International Art News: America." *The Studio* 113 (February 1937) 109.
Review. See entry 1026.

1031 "John Marin—American Artist." *Design* 38 (December 1936) 30–31.
Review. See entry 1026.

1032 "John Marin, the Isolated, Honored at the Museum of Modern Art." *The Art Digest* 11 (1 November 1936) 14.
Reprinted excerpts from reviews by Edward Alden Jewell (*New York Times*) and Royal Cortissoz (*New York Herald Tribune*). See entry 1026.

1033 Lane, James W. "Notes from New York." *Apollo* 24 (December 1936) 360.
Review. See entry 1026.

1034 McBride, Henry. "A Marin Retrospective." In *The Flow of Art: Essays and Criticisms of Henry McBride*, edited by Daniel Catton Rich, 337–340. New York: Atheneum, 1975.
Review (reprinted from the *New York Sun*, 24 October 1936). See entry 1026.

1035 Mumford, Lewis. "The Art Galleries: John Marin." *The New Yorker* 12 (31 October 1936) 53–54.
Review. See entry 1026.

1036 "The Fortnight in New York: Marin's 27th Annual." *The Art Digest* 11 (1 February 1937) 18.
Reprinted excerpts from reviews of the exhibition *John Marin: New Watercolors, Oils and Drawings*, held at An American Place, New York, 5 January–3

February 1937, by Ralph Flint (*New York Sun*) and Lewis Mumford (*The New Yorker*).

1037 Lowe, Jeannette. "New Exhibitions of the Week—A Watercolorist Handles New Media: Marin." *The Art News* 35 (30 January 1937) 16–17.
 Review. See entry 1036.

1038 Mumford, Lewis. "The Art Galleries: The New Year." *The New Yorker* 12 (16 January 1937) 47.
 Review. See entry 1036.

1039 "Art: Water-Colorists." *Time* 31 (7 March 1938) 39.
 Review of the exhibition *John Marin: Recent Paintings, Water Colors and Oils*, held at An American Place, New York, 22 February–27 March 1938. (The reviewer incorrectly states that the exhibition was held at the Frick Gallery).

1040 Coates, Robert M. "The Art Galleries: Sixty Americans—And Some Frenchmen." *The New Yorker* 14 (5 March 1938) 49.
 Review. See entry 1039.

1041 Davidson, Martha. "New Exhibitions of the Week—John Marin: New York." *The Art News* 36 (19 March 1938) 16.
 Review. See entry 1039.

1042 Mellquist, Jerome. "Art: Marin and His Oils." *The Nation* 146 (5 March 1938) 308–309.
 Review. See entry 1039.

1043 Coates, Robert M. "The Art Galleries: The Romanticists—A Cubist—Two Americans." *The New Yorker* 14 (3 December 1938) 89–90.
 Review of the exhibition *John Marin: Exhibition of Oils and Water Colors*, held at An American Place, New York, 7 November–27 December 1938.

1044 Davidson, Martha. "New Exhibitions of the Week—Marin: New Oils and Watercolors." *The Art News* 37 (10 December 1938) 17.
 Review. See entry 1043.

1045 "Art throughout America—Philadelphia: Marin; Demuth . . ." *The Art News* 37 (4 March 1939) 17.
 Review of the exhibition *Marin and Demuth: Wizards of Watercolor*, held at the Philadelphia Art Alliance, Philadelphia, 14 February–5 March 1939.

1046 No entry.

1047 "Marin on Review." *The Art Digest* 14 (1 November 1939) 15.
Review of the exhibition *Beyond All "Isms"*, held at An American Place, New York, 15 October–21 November 1939. Includes reprinted excerpts from Jerome Klein (*New York Post*) and Royal Cortissoz (*New York Herald Tribune*).

1048 McCausland, Elizabeth. "Exhibitions in New York: Marin Water Colors." *Parnassus* 11 (November 1939) 23.
Review. See entry 1047.

1049 Coates, Robert M. "The Art Galleries: Eilshemius, Marin, and Others." *The New Yorker* 15 (28 October 1939) 65.
Reviews of the exhibitions *Beyond All "Isms"* (see entry 1047) and *20 Watercolors by John Marin*, held at the Downtown Gallery, New York, 19 October–4 November 1939.

1050 Lowe, Jeannette. "New Exhibitions of the Week—Marin's Subtle Vision: Two Exhibitions." *The Art News* 38 (4 November 1939) 11.
Reviews. See entry 1049.

1051 Coates, Robert M. "The Art Galleries: Allen Tucker, John Marin, and Some Others." *The New Yorker* 15 (16 December 1939) 76–77.
Review of the exhibition *New Oils/New Watercolors by John Marin*, held at An American Place, New York, 3 December 1939–17 January 1940.

1052 Lane, James W. "New Exhibitions of the Week: J. Marin's Best Paintings in Oil to Date." *The Art News* 38 (30 December 1939) 12.
Review. See entry 1051.

1053 Coates, Robert M. "The Art Galleries: John Marin—A Few First Showings." *The New Yorker* 16 (28 December 1940) 56.
Review of the exhibition *John Marin—12 New Watercolors—1940; 9 New Oils—1940; Some New Drawings/1940*, held at An American Place, New York, 11 December 1940–21 January 1941.

1054 "John Marin, Artist of Nature." *Newsweek* 16 (23 December 1940) 48.
Review. See entry 1053.

1055 Lane, James W. "New Exhibitions of the Week—Marin and Other Marines: Three Exhibitions." *The Art News* 39 (21 December 1940) 11.
Review. See entry 1053.

1056 Boswell, Helen. "Fifty-Seventh Street in Review: Marin Pro and Con."

The Art Digest 16 (1 January 1942) 23.

Reprinted review excepts of *Exhibition: John Marin (Vintage—1941)*, held at An American Place, New York, 9 December 1941–27 January 1942, by Edward Alden Jewell (*New York Times*) and Henry McBride (*New York Sun*).

1057 Coates, Robert M. "The Art Galleries." *The New Yorker* 17 (27 December 1941) 53.

Review. See entry 1056.

1058 "Fifty-Seventh Street in Review: Of Modernism and Marines." *The Art Digest* 15 (1 January 1941) 19.

Reprinted excerpts from a review by Henry McBride. See entry 1056.

1059 Lane, James W. "The Passing Shows: Marin." *Art News* 41 (1–14 April 1942) 29.

Review of the exhibition *Pertaining to New York—Circus and Pink Ladies*, held at An American Place, New York, 12 March–12 April 1942.

1060 "Art News of America: Three M's." *Art News* (1–14 December 1942) 6–7.

Review of the exhibition *Contrasts in Impressionism: An Exhibition of Paintings by Alessandro Magnasco, Claude Monet, John Marin*, held at the Baltimore Museum of Art, Baltimore, 13 November–27 December 1942.

1061 Coates, Robert M. "The Art Galleries: Situation Well in Hand." *The New Yorker* 19 (20 November 1943) 97–98.

Review of the exhibition *John Marin: Paintings—1943*, held at An American Place, New York, 5 November 1943–9 January 1944.

1062 Greenberg, Clement. "Art Note." *The Nation* 157 (25 December 1943) 769–770. Reprinted in *Clement Greenberg: The Collected Essays and Criticism*. Volume 1, *Perceptions and Judgments, 1939–1944*, edited by John O'Brian, 170. Chicago: University of Chicago Press, 1986.

Review. See entry 1061.

1063 Breuning, Margaret. "Marin Evaluated." *The Art Digest* 19 (15 December 1944) 12.

Review of the exhibition *John Marin: Paintings—1944*, held at An American Place, New York, 27 November 1944–10 January 1945.

1064 "The Passing Shows." *Art News* 43 (1–14 January 1945) 30.

Review. See entry 1063.

1065 Coates, Robert M. "The Art Galleries: A Couple of Oldsters." *The New Yorker* 21 (22 December 1945) 70.
 Review of the exhibition *John Marin: Paintings—1945*, held at An American Place, New York, 30 November 1945–17 January 1946.

1066 "The Passing Shows—John Marin: New Stature in Oils." *Art News* 44 (15–31 December 1945) 21.
 Review. See entry 1065.

1067 Wolf, Ben. "Marin in Oil." *The Art Digest* 20 (1 January 1946) 12.
 Review. See entry 1065.

1068 "Reviews and Previews." *Art News* 45 (May 1946) 58.
 Review of the exhibition *John Marin: 160 Drawings—Mostly New York, 1930–1946*, held at An American Place, New York, 7–30 April 1946.

1069 "Art: Golfer with a Brush." *Time* 49 (20 January 1947) 63–64.
 Review of the exhibition *John Marin: A Retrospective Exhibition*, held at the Institute of Modern Art, Boston, 7 January–15 February 1947.

1070 Dame, Lawrence. "Marin in Boston." *The Art Digest* 21 (1 February 1947) 6.
 Review. See entry 1069.

1071 Wight, Frederick S. "Marin: Late View of a U.S. Old Master in Boston's Retrospective." *Art News* 45 (January 1947) 40–41, 59.
 Review. See entry 1069.

1072 "Reviews and Previews." *Art News* 46 (May 1947) 43.
 Review of the *John Marin Exhibition: New Watercolors and Oils*, held at An American Place, New York, 1 April–2 May 1947.

1073 Hess, Thomas B. "Spotlight On: Marin." *Art News* 46 (January 1948) 25.
 Review of the exhibition *John Marin's New Paintings in Oil and Watercolor*, held at An American Place, 8 December 1947–31 January 1948.

1074 Reed, Judith Kaye. "Marin Goes to the Adirondacks." *The Art Digest* 22 (1 January 1948) 15.
 Review. See entry 1073.

1075 Reed, Judith Kaye. "Marin's New York." *The Art Digest* 22 (1 August 1948) 13.

Review of the exhibition *Paintings and Drawings by John Marin: New York—1910–1944*, held at the Downtown Gallery, New York, 10 August–September 8 1948.

1076 "Reviews and Previews." *Art News* 47 (September 1948) 50–51.
Review. See entry 1075.

1077 "Reviews and Previews." *Art News* 47 (November 1948) 46–48.
Review of the exhibition *John Marin: Etchings, 1906–1948*, held at An American Place, New York, 26 October–27 November 1948.

1078 Greenberg, Clement. "Art." *The Nation* 167 (25 December 1948) 732–734. Reprinted in *Clement Greenberg: The Collected Essays and Criticism*. Volume 2, *Arrogant Purpose, 1945–1949*, edited by John O'Brian, 268–270. Chicago: University of Chicago Press, 1986.
Review of the exhibition *John Marin: New Paintings in Oil and Water-Color*, held at An American Place, New York, 7 December 1948–31 January 1949.

1079 "Reviews and Previews." *Art News* 47 (December 1948) 51.
Review. See entry 1078.

1080 Breuning, Margaret. "Marin: Unfailing Improviser at 80." *The Art Digest* 24 (1 January 1950) 16.
Review of the *John Marin Exhibition: New Watercolors and Oils*, held at An American Place, New York, 19 December 1949–4 February 1950.

1081 Todd, Ruthven. "Reviews and Previews." *Art News* 48 (January 1950) 42.
Review. See entry 1080.

1082 Krasne, Belle. "Watercolorist Marin's Oil Undercurrent." *The Art Digest* 24 (15 April 1950) 14.
Review of the exhibition *John Marin: Oils—1903–1950*, held at An American Place, New York, 20 March–6 May 1950.

1083 Seckler, Dorothy. "Reviews and Previews." *Art News* 49 (April 1950) 44.
Review. See entry 1082.

1084 Seckler, Dorothy. "Reviews and Previews." *Art News* 49 (September 1950) 46.
Review of the exhibition *John Marin: Exhibition—Oils and Watercolors*, held at the Downtown Gallery, New York, 12–23 September 1950.

1085 Fitzsimmons, James. "Fifty-Seventh Street in Review: John Marin." *The Art Digest* 25 (15 January 1951) 18.

Review of the exhibition *John Marin: Exhibition—Oils and Watercolors, 1950, Being Movements in Paint*, held at the Downtown Gallery, New York, 27 December 1950–27 January 1951.

1086 "Art: Picture Writings." *Time* 58 (10 December 1951) 79.

Review of the exhibition *John Marin: Watercolors, Oils, Prints and Drawings*, held at the Munson-Williams-Proctor Institute Art Gallery, Utica, New York, 2–30 December 1951.

1087 Ashton, Dore. "New York—Avast!" *The Art Digest* 26 (15 January 1952) 15–16.

Review of the exhibition *John Marin: Exhibition—Oils and Watercolors*, held at the Downtown Gallery, New York, 2–26 January 1952.

1088 McBride, Henry. "By Henry McBride: John Marin 1951." *Art News* 50 (January 1952) 47.

Review. See entry 1087.

1089 "Art: Instinct at 82." *Time* 61 (19 January 1953) 64.

Review of the *John Marin Exhibition—1952 Paintings in Oil and Watercolor Being Composed of Movements Relating to Sea, Land, and Circus*, held at the Downtown Gallery, New York, 30 December 1952–24 January 1953.

1090 Faison, S. Lane, Jr. "Art." *The Nation* 176 (7 February 1953) 133–134.

Review. See entry 1089.

1091 McBride, Henry. "By Henry McBride: Ageless Marin." *Art News* 51 (February 1953) 58.

Review. See entry 1089.

1092 Newbill, Al. "New York: New Marin Signatures." *Art Digest* 27 (15 January 1953) 13.

Review. See entry 1089.

1093 "New York: New York Notes." *Art Digest* 28 (15 October 1953) 18, 34.

Review of the memorial exhibition *Thirteen Paintings*, held at the Museum of Modern Art, New York, October–November 1953.

1094 Feinstein, Sam. "57th Street: John Marin." *Art Digest* 28 (1 January 1954) 16.

Review of the exhibition *John Marin—Paintings of the 1950s*, held at the Downtown Gallery, New York, 29 December 1953–30 January 1954.

1095 Munro, Eleanor C. "Reviews and Previews." *Art News* 52 (January 1954) 65.
 Review. See entry 1094.

1096 Coates, Robert M. "The Art Galleries: Night and Day." *The New Yorker* 29 (30 January 1954) 65.
 Review of the memorial exhibition *John Marin: 1870–1953,* held at the American Academy of Arts and Letters and National Institute of Arts and Letters, New York, January–February 1954.

1097 Rosenblum, Robert. "New York: Marin's Dynamism." *Art Digest* 28 (1 February 1954) 13.
 Review. See entry 1096.

1098 "Art: Explosions of Sea and Sun." *Time* 65 (21 March 1955) 82–83.
 Review of the traveling *John Marin Memorial Exhibition,* as shown at the Museum of Fine Arts, Boston, February–March 1955.

1099 Mellow, James. "Memorial for John Marin." *Arts Digest* 29 (15 March 1955) 6–7, 32.
 Review. See entry 1098.

1100 Porter, Fairfield. "The Nature of John Marin." *Art News* 54 (March 1955) 24–27, 63. Reprinted in *Fairfield Porter: Art in Its Own Terms—Selected Criticism, 1935–1975,* by Fairfield Porter, 209–213. New York: Taplinger, 1979.
 Review. See entry 1099.

1101 Johnson, Ellen and C.P. Parkhurst. "Two Friends, Marin and Carles: A Memorial Exhibition." *Bulletin* [Dudley Peter Allen Memorial Art Museum] 12: 3 (1955) 98–109.
 Review and checklist of the exhibition *Two Friends, Marin and Carles: A Memorial Exhibition,* held at the Dudley Peter White Memorial Art Museum, Oberlin College, Oberlin, Ohio, May 1955.

1102 Breuning, Margaret. "Margaret Breuning Writes." *Arts* 30 (April 1956) 46.
 Review of the *Exhibition Honoring 5 Recently Deceased Painters: Feininger, Kuhn, Kuniyoshi, Marin, and B.J.O. Nordfeldt,* held at the Metropolitan Museum of Art, New York, 24 February–29 April 1956.

1103 Campbell, Lawrence. "Reviews and Previews." *Art News* 55 (April 1956) 79–80.
 Review. See entry 1102.

1104 Coates, Robert M. "The Art Galleries: Five and One." *The New Yorker* 32 (10 March 1956) 119–120.
 Review. See entry 1102.

1105 Seckler, Dorothy Gees. "Gallery Notes: Five Decades of Renewal." *Art in America* 44 (Spring 1956) 56.
 Review. See entry 1102.

1106 Friedman, B.H. "Current and Forthcoming Exhibitions: New York." *The Burlington Magazine* 98 (September 1956) 340.
 Review of the traveling *John Marin Memorial Exhibition*, as shown at the Whitney Museum of American Art, New York, 13 June–29 July 1956.

1107 "Reviews and Previews." *Art News* 55 (June 1956) 50.
 Review. See entry 1106.

1108 Alloway, Lawrence. "Art News from London: Americans in London." *Art News* 55 (November 1956) 46.
 Review of the exhibition *John Marin: Paintings, Water-Colours, Drawings and Etchings*, held at the Arts Council Gallery, London, England, 22 September–20 October 1956.

1109 Farr, D.L.A. "Current and Forthcoming Exhibitions." *The Burlington Magazine* 98 (November 1956) 420.
 Review. See entry 1108.

1110 Whittet, G.S. "London Commentary." *The Studio* 152 (December 1956) 187–189.
 Review. See entry 1108.

1111 Campbell, Lawrence. "Reviews and Previews." *Art News* 57 (February 1959) 11.
 Review of the exhibition *John Marin before 1920: Oils, Watercolors, Pastels, Drawings*, held at the Downtown Gallery, New York, 3–28 February 1959.

1112 De Mott, Helen. "In the Galleries: John Marin." *Arts* 33 (March 1959) 57.
 Review. See entry 1111.

1113 Grosser, Maurice. "Art." *The Nation* 188 (28 February 1959) 196.
 Review. See entry 1111.

1114 Getlein, Frank. "Art: The Marin Retrospective Show." *The New Republic* 146 (26 March 1962) 27–28.

Review of the exhibition *John Marin in Retrospect: An Exhibition of His Oils and Watercolors*, held at the Corcoran Gallery of Art, Washington, D.C., 2 March–15 April 1962.

1115 _____. "Current and Forthcoming Exhibitions—Washington, D.C." *The Burlington Magazine* 104 (April 1962) 178.

Review. See entry 1114.

1116 Beck, James H. "Reviews and Previews: John Marin." *Art News* 61 (February 1963) 10.

Review of the exhibition *John Marin: Paintings in Oil, 1903–1953*, held at the Downtown Gallery, New York, 8 January–2 February 1963.

1117 Raynor, Vivien. "New York Exhibitions: In the Galleries—John Marin." *Arts Magazine* 37 (March 1963) 64–65.

Review. See entry 1116.

1118 Burr, James. "Round the London Galleries: Visual Poetry in Maine and Manhattan." *Apollo* 78 (October 1963) 307.

Review of the exhibition *John Marin, 1870–1953: Retrospective Exhibition of Watercolors*, held at the Waddington Galleries, London, England, 3–26 October 1963.

1119 Campbell, Lawrence. "Reviews and Previews: John Marin." *Art News* 64 (May 1965) 11.

Review of the exhibition *John Marin Paintings of the 1930's*, held at the Willard Gallery, New York, 2 March–3 April 1965.

1120 Hoene, Anne. "In the Galleries." *Arts Magazine* 39 (May–June 1965) 62.

Review. See entry 1119.

1121 Waldman, Diane. "Reviews and Previews: John Marin." *Art News* 64 (April 1965) 15.

Review. See entry 1119.

1122 Baker, Elizabeth C. "Reviews and Previews: John Marin." *Art News* 66 (Summer 1967) 64.

Review of the exhibition *Paintings and Watercolors by John Marin from the Phillips Collection: A Loan Exhibition for the Benefit of the Dalton School*, held at M. Knoedler and Co., New York, 3–26 May 1967.

1123 Kosuth, Joseph. "Reviews: In the Galleries—John Marin." *Arts Magazine* 41 (Summer 1967) 56.
Review. See entry 1122.

1124 Young, Mahonri Sharp. "Letter from U.S.A.: Fantastics and Eccentrics." *Apollo* 85 (June 1967) 466.
Review. See entry 1122.

1125 "Art Across the U.S.A.: Outstanding Exhibitions." *Apollo* 89 (May 1969) 398.
Review of the exhibition *John Marin: Oils, Watercolors, and Drawings Which Relate to His Etchings*, held at the Philadelphia Museum of Art, Philadelphia, 17 January–17 March 1969.

1126 Butler, Joseph T. "The American Way with Art—John Marin: Etchings and Related Works." *The Connoisseur* 172 (December 1969) 308–309.
Review. See entry 1125.

1127 Gray, Cleve. "John Marin: The Etched Line." In *Artist's Proof: The Annual of Prints and Printmaking*, Vol. 9, 78–86. New York: Published by Pratt Graphics Center, in association with Barre Publishers, Barre, Massachusetts, 1969.
Review. See entry 1125.

1128 McCaughey, Patrick. "Where Paleface Meets Redskin." *Art News* 70 (May 1971) 30–33, 77–78.
Review of the exhibition *John Marin/1870–1953: A Centennial Exhibition Organized by the Los Angeles County Museum of Art*. This review pertains to the exhibition as shown at the National Collection of Fine Arts, Washington, D.C., 23 April–6 June 1971.

1129 Tarshis, Jerome. "San Francisco." *Artforum* 9 (December 1970) 83.
Review. See entry 1128. This review pertains to the exhibition as shown at the M.H. de Young Memorial Museum, San Francisco, 20 September–7 November 1970.

1130 Davis, Douglas. "Art: A New Look at Marin." *Newsweek* 76 (27 July 1970) 68–69B.
Review. See entry 1128. This review pertains to the exhibition as shown at the Los Angeles County Museum of Art, Los Angeles, 7 July–30 August 1970.

1131 Young, Joseph E. "Los Angeles." *Art International* 15 (20 May 1971) 77.
Review. See entry 1130.

1132 Glueck, Grace. "New York: Reviews and Previews." *Art in America* 60 (September–October 1972) 119–120.
Review of the exhibition *John Marin*, held at the Marlborough Gallery, New York, 7–28 October 1972.

1133 Mellow, James R. "Reviews and Previews." *Art News* 71 (November 1972) 75.
Review. See entry 1132.

1134 Schwartz, Sanford. "New York Letter." *Art International* 17 (January 1973) 69–70.
Review. See entry 1132.

1135 Josephson. Mary. "The *Art in America* Review of Exhibitions—Boston: John Marin at Alpha Gallery." *Art in America* 61 (September–October 1973) 121–122.
Review of the exhibition *John Marin*, held at the Alpha Gallery, Boston, 3–31 May 1973.

1136 Lorber, Richard. "Arts Reviews: John Marin." *Arts Magazine* 50 (June 1976) 16.
Review of the exhibition *John Marin's Maine, 1914–1952*, held at the Marlborough Gallery, New York, 27 March–17 April 1976.

1137 Ffrench-Frasier, Nina. "New York Reviews." *Art News* 76 (Summer 1977) 195.
Review of the exhibition *John Marin, 1870–1953: Paintings 1903–1953*, held at the Marlborough Gallery, New York, 19 March–16 April 1977.

1138 "Art Across North America: Outstanding Exhibitions." *Apollo* 114 (October 1981) 261–262.
Review of the exhibition *John Marin's New York*, held at the Kennedy Galleries, New York, 13 October–6 November 1981.

1139 Baro, Jean. "New York Letter: John Marin." *Art International* 25 (March–April 1982) 102.
Review. See entry 1138.

1140 Fort, Ilene Susan. "John Marin." *Arts Magazine* 56 (December 1981) 4.
Review. See entry 1138.

1141 "John Marin at the Kennedy Galleries." *The Connoisseur* 208 (October 1981) 126–127.
Review. See entry 1138.

1142 Fort, Ilene Susan. "Arts Reviews: John Marin." *Arts Magazine* 57 (January 1983) 35.

Reviews of the exhibitions *John Marin and the Sea* and *John Marin: A Print Retrospective*, held at the Kennedy Galleries, New York, 19 October–19 November 1982 and 19 October–30 December 1982, respectively.

1143 Phillips, Deborah C. "New York Reviews—John Marin: Kennedy." *Art News* 82 (January 1983) 156.

Review of the exhibition *John Marin and the Sea*. See entry 1142.

1144 Stretch, Bonnie Barrett. "Reviews—John Marin: Kennedy." *Art News* 86 (September 1987) 135, 139.

Review of the exhibition *John Marin Watercolors, 1929–1939*, held at the Kennedy Galleries, New York, 12 May–6 June 1987.

1145 Tuchman, Phyllis. "On Tour: Another Marin." *Art in America* 76 (June 1988) 56–57, 59.

Review of the exhibition *Marin in Oil*, held at the Parrish Art Museum, Southampton, New York, 18 July–20 September 1987.

1146 Kramer, Hilton. "Critic's Notebook: A Marin Miscellany." *Art and Antiques* 7 (May 1990) 147–149.

Review of the exhibition *Selections and Transformations: The Art of John Marin*, held at the National Gallery of Art, Washington, D.C., 28 January–15 April 1990.

1147 Ledes, Allison Eckardt. "Current and Coming: John Marin and the Advent of Modernism." *The Magazine Antiques* 137 (January 1990) 48, 56.

Review. See entry 1146.

1148 Loughery, John. "Early Moderns: Benton, Marin, Spencer." *The Hudson Review* 43 (Autumn 1990) 462, 464–465.

Review. See entry 1146.

1149 Pardee, Hearne. "Reviews—Washington, D.C., New York: Selections and Transformations: The Art of John Marin." *Art News* 89 (Summer 1990) 179–180.

Review. See entry 1146.

1150 "Drawings on Exhibition." *Drawing* 11 (January–February 1990) 106–107.

Reviews of the exhibitions *Selections and Transformations: The Art of John Marin* (see entry 1146), and *John Marin: New York Sketches*, held at the Kennedy Galleries, New York, April 1990.

1151 Moorman, Margaret. "Reviews—New York: John Marin." *Art News* 97 (January 1998) 130.
Review of the exhibition *John Marin: Between Realism and Abstraction*, held at the Kennedy Galleries, New York, 4 October–1 November 1997.

1151A May, Stephen. "New York Reviews—John Marin: Richard York." *Art News* 98 (March 1999) 134.
Review of the exhibition *John Marin: The 291 Years*, held at the Richard York Gallery, New York, 12 November 1998–8 January 1999.

V. REFERENCE SOURCES

1152 *Allgemeines Lexikon der bildenden Künstler des XX. Jahrhunderts*, edited by Hans Vollmer. Leipzig: E.A. Seeman, 1953–1962. S.v. "Marin, John."

1153 *American Cultural Leaders: From Colonial Times to the Present.* Santa Barbara, Calif.: ABC-Clio, 1993. S.v. "Marin, John Currey."

1154 *American National Biography*, edited by John A. Garraty and Mark C. Carnes. New York: Oxford University Press, 1998. S.v. "Marin, John," by Carol Salus.

1155 *Atlantic Brief Lives: A Biographical Companion to the Arts*, edited by Louis Kronenberger. Boston: Little, Brown, 1971. S.v. "Marin, John (Cheri)."

1156 Baigell, Matthew. *Dictionary of American Art*. New York: Harper and Row, 1979. S.v. "Marin, John (1870–1953)."

1157 Bénézit, E. *Dictionaire critique et documentaire des Peintres, Sculpteurs, Dessinateurs et Graveurs de tous les temps et de tous les pays*, nouvelle éd. Paris: Gründ, 1976. S.v. "Marin (John)," by Jacques Busse.

1158 *Chambers Biographical Dictionary*, 6th ed., edited by Melanie Parry. Edinburgh, Scotland: Chambers, 1997. S.v. "Marin, John."

1159 Chilvers, Ian. *A Dictionary of Twentieth-Century Art*. Oxford: Oxford University Press, 1998. S.v. "Marin, John (1870–1953)."

1160 *Contemporary Artists*, 2d ed. New York: St. Martin's Press, 1983. S.v. "Marin, John," by Paul J. Karlstrom.

1161 Cummings, Paul. *Dictionary of Contemporary American Artists*, 6th ed. New York: St. Martin's Press, 1994. S.v. "Marin, John."

1162 *Current Biography: Who's News and Why, 1949*. New York: H.W. Wilson, 1950. S.v. "Marin, John."

1163 *Current Biography: Who's News and Why, 1953*. New York: H.W. Wilson, 1954. S.v. "Marin, John."
 An obituary.

1164 Darmstaedter, Robert. *Kunstlerlexikon: Maler—Bildhauer—Architekten*. Bern, Switzerland: Frankcke Verlag, 1961. S.v. "Marin, John."

1165 Dawdy, Doris Ostrander. *Artists of the American West: A Biographical Dictionary*. Vol. 2. Chicago: Sage, 1974. S.v. "Marin, John (1872[sic]–1953)."

1166 *Dictionary of American Biography*. Suppl. Five, *1951–1955*, edited by John A. Garraty. New York: Scribner's, 1977. S.v. "Marin, John (Cheri)," by Sheldon Reich.

1167 *The Dictionary of Art*, edited by Jane Turner. New York: Grove's Dictionaries, 1996. S.v. "Marin, John," by Ilene Susan Fort.

1168 *Dictionary of Modern Painting*, 3d ed., edited by Carlton Lake and Robert Maillard. New York: Tudor, 1964. S.v. "Marin, John," by Jerome Mellquist.

1169 *Encyclopedia of American Biography*, 2d ed., edited by John A. Garraty and Jerome L. Sternstein. New York: HarperCollins, 1996. S.v. "Marin, John Cheri, III," by Harold E. Dickson.

1170 *Encyclopedia of American Art*. New York: E.P. Dutton, 1981. S.v. "Marin, John (1870–1953)," by David W. Scott.

1171 *Encyclopedia of World Art*. New York: McGraw-Hill, 1964. S.v. "Marin, John," by Allen S. Weller.

1172 Fielding, Mantle. *Mantle Fielding's Dictionary of American Painters, Sculptors and Engravers*. New York: Apollo, 1986. S.v. "Marin, John."

1173 Gowing, Lawrence. *A Biographical Dictionary of Artists*, rev. ed. New York: Facts on File, 1995. S.v. "Marin, John, 1870–1953."

1174 "John Marin (1870–1953)." In *American Art Analog*, 660. New York: Chelsea House, in association with American Art Analog, 1986.

1175 "John Marin—Painter." In *The Index of Twentieth Century Artists, 1933–1937*, 12–16, 19–20, 22–23. New York: Arno Press, 1970.

1176 *McGraw-Hill Dictionary of Art*, edited by Bernard S. Meyers. New York: McGraw-Hill, 1969. S.v. "Marin, John," by John C. Galloway.

1177 *The Oxford Companion to Art*, edited by Harold Osborne. London: Oxford University Press, 1970. S.v. "Marin, John (1870–1953)."

1178 *The Oxford Companion to Twentieth-Century Art*, edited by Harold Osborne. Oxford: Oxford University Press, 1981. S.v. "Marin, John (1870–1953)."

1179 *The Oxford Dictionary of Art*, edited by Ian Chilvers and Harold Osborne, new ed. London: Oxford University Press, 1997. S.v. "Marin, John (1870–1953)."

1180 *Petit Larousse de la Peinture*, sous la direction de Michel Laclotte. Paris: Larousse, 1979. S.v. "Marin, (John)," by Jean-Patrice Marandel.

1181 *Phaidon Dictionary of Twentieth-Century Art*. London: Phaidon Press, 1973. S.v. "Marin, John."

1182 *Praeger Encyclopedia of Art*. New York: Praeger, 1971. S.v. "Marin, John," by Frank Elgar.

1183 Samuels, Peggy and Harold Samuels. *The Illustrated Biographical Encyclopedia of Artists of the American West*. New York: Doubleday, 1976. S.v. "Marin, John."

1184 *The Thames and Hudson Dictionary of Art and Artists*, rev., expanded, and updated by Nikos Stangos; Herbert Read, consulting ed. New York: Thames and Hudson, 1994. S.v. "Marin, John (1870–1953)."

1185 *Who Was Who in America*. Vol. 3, *1951–1960*. Chicago: Marquis Who's Who, 1963. S.v. "Marin, John."

1186 *Who Was Who in American Art, 1564–1975: 400 Years of Artists in America*, edited by Peter Hastings Falk. Madison, Conn.: Sound View Press, 1999. S.v. "Marin, John."

1187 *Who Was Who in American History—Arts and Letters*. Chicago: Marquis Who's Who, 1975. S.v. "Marin, John."

1188 *Who's Who in American Art*, edited by Dorothy B. Gilbert. New York: R.R. Bowker, 1953. S.v. "Marin, John."

VI. ARCHIVAL SOURCES

1189 Archives of American Art. *The Archives of American Art: Collection of Exhibition Catalogs.* Boston: G.K. Hall, 1979. S.v. "Marin, John."

1190 ———. *The Card Catalog of the Manuscript Collections of the Archives of American Art.* Wilmington, Del.: Scholarly Resources, 1980. S.v. "Marin, John."

1191 ———. *The Card Catalog of the Manuscript Collections of the Archives of American Art, Supplement 1981–1984.* Wilmington, Del: Scholarly Resources, 1985. S.v. "Marin, John."

This circulating microfilm collection contains extensive resources on Marin, including the John Marin Papers (1929–1955); research materials of Cleve Gray, MacKinley Helm, and Sheldon Reich; exhibition catalogues and announcements; photographs of artwork; the Downtown Gallery Papers; the Henry McBride Papers; the Whitney Museum of American Art Papers; correspondence with various individuals including Dove, Stieglitz, and Duncan Phillips; an anecdotal reminiscence of J. Ward Lockwood; and so forth. The catalog is searchable through SIRIS (Smithsonian Institution Research Information System) via the Internet.

1192 Carl Zigrosser Papers. Van Pelt Library, University of Pennsylvania, Philadelphia.

The collection contains three folders of material gathered during Zigrosser's preparation of his catalogue raisonné of Marin's etchings (see entry 862). The papers also contain two letters from Marin (one written to Egmont Arens and the other to Lee Simonson, both dated 1928).

1193 Collection of American Literature. Beinecke Rare Book and Manuscript Library, Yale University, New Haven, Conn.

The Beinecke Library, which hosts an excellent Internet site, is the repository for many items relating to Marin in the Alfred Stieglitz/Georgia O'Keeffe Archive, the Katherine S. Dreier Papers, the Henry McBride Papers, and other collections.

1194 Inventory of American Paintings. National Museum of American Art. Smithsonian Institution, Washington, D.C.

This database, which is searchable through SIRIS (see entry 1192), contains 764 entries for Marin's paintings from public and private collections. Each entry provides the title of the work; date of execution; medium; dimensions; subject; present owner; references; illustration (bibliographic citation to source); file; and record ID.

1195 John Marin Archive. National Gallery of Art, Washington, D.C.
A collection of several hundred drawings, watercolors, and sketchbooks, a gift of John Marin, Jr. (see entry 895).

1196 Theodore Dreiser Papers. Van Pelt Library, University of Pennsylvania, Philadelphia.
The collection contains one item of correspondence from Marin to Dreiser, dated 1931.

VII. DISSERTATIONS AND THESES

1197 Buehler, Larry Andrew. "Personal Thoughts on John Marin." M.A. thesis, University of Iowa, 1988.

1198 Cass, Chrystal Effie. "John Marin." M.A. thesis, University of California, Berkeley, 1972.

1199 Guise, Alexis. "John Marin's Images of the Landscape Aesthetic: A Modernist Revisiting of Urban and Rural American Art at the Opening of the Twentieth Century." M.A. thesis, Tufts University, 1996.

1200 Jensen, Norman Kenneth. "The Iconography of John Marin." M.F.A. thesis, University of Florida, 1962.

1201 Merante, Robin. "The Art of John Marin." M.A. thesis, Hofstra University, 1980.

1202 Millican, Barbara Straiton. "The Impact of Cubism on American Watercolor Painters: Charles Demuth, John Marin, and Lyonel Feininger." M.A. thesis, Texas Women's University, 1983.

1203 Phillips, Frances George. "Aesthetics of Non-linearity: A Comparative Study of Three Works by Wallace Stevens, John Marin and Aaron Copeland." M.A. thesis, University of Texas at Dallas, 1978.

1204 Reich, Sheldon. "John Marin." Ph.D. diss., University of Iowa, 1966.

1205 Rodgers, Timothy Robert. "Making the American Artist: John Marin, Alfred Stieglitz and Their Critics, 1909–1936." Ph.D. diss., Brown University, 1994.

1206 Sanstrom, Robert Louis. "John Marin's Paintings of the Maine Seacoast: An Investigation of the Use and Appearance of the Natural Elements in the

Marine Paintings of John Marin and Their Importance to the Artist." Ed.D. diss., New York University, 1969.

1207 Schall, Ellen. "Image and Border in John Marin's Early Prints." M.A. thesis, State University of New York at Binghamton, 1983.

1208 Stevens, Walter Ellsworth. "John Marin: The New Mexico Period." M.A. thesis, University of New Mexico, 1967.

VIII. ANNOTATED REPRODUCTIONS

Abstraction, 1917. THYSSEN (c) 118–119, 394.
Abstraction, 1918. HIRSCHL/2 (b/w) 42.
———. HIRSCHL/6 (c) 76.
Abstraction, 1921. DRAWING/5 (c) 102, 134.
Adarondack [sic] Lake, 1911. ADIRONDACK/1 (c) 85, 146.
Adirondacks at Lower Ausable Lake, 1947. PHILLIPS/5 (b/w) 148.
Along the Ramapo River, 1950. GALLAGHER (b/w) 84.
Alpine District, New Jersey, 1938. KENNEDY/12 (c) Pl. 26.
American Telephone Building, New York City, 1926. KUH/1 (b/w) 32, 44.
Apple Tree at Saddle River, New Jersey, 1947. SOTHEBY/3913 (b/w) Pl. 203.
———. SOTHEBY/5524 (b/w) Pl. 293.
Approaching Thunderstorm, n.d. CHRISTIE/8051 (c) Pl. 212.
Aspen Trees in Hondo Canyon, New Mexico, 1929. FLEISCHMAN/2 (b/w) 79.
———. KENNEDY/17 (c) Pl. 29.
Autumn Coloring No. 3—Maine, 1952. NEWARK/2 (b/w) 198, 349.
———. NEWARK/3 (b/w) 45.
Autumn Landscape, 1913. ALDRICH (b/w) Pl. 30.
Autumn, New Mexico, 1930. KENNEDY/8 (c) Pl. 37.
Autumn on the Road to Deblois, Maine, No. 1, 1952. SOTHEBY/3865 (b/w) Pl. 182.
Autumn on the Road to Delbois, Maine, No. 2, 1952. BAUMFELD (b/w) 65.
Back of Bear Mountain, 1925. MOMA/13 (b/w) 57, 59.
———. PHILLIPS/2 (b/w) Pl. CXLV.
———. PHILLIPS/5 (b/w) 148.
———. PHILLIPS/6 (b/w) Pl. 131; p. 65.
———. PHILLIPS/7 (b/w) 84.
Back of Ranchos Church, 1930. NEW MEXICO/1 (c) 47, 165.
Back of the Waters, Landscape No. 2, 1942. CHRISTIE/7082 (c) Pl. 226.
———. CHRISTIE/7724 (c) Pl. 198.
———. CHRISTIE/8408 (c) Pl. 154.
———. SOTHEBY/6736 (b/w) Pl. 185.
Bal Bulliers—Paris, 1906. PRINTS/20 (b/w) [unpaginated].
Bald Head, Small Point, Maine, 1932. BOHAN (b/w) 28–29.

Barn in the Berkshire, 1925. BROOKLYN/1 (b/w) 50.

Beach, Flint Island, Maine, 1952. KENNEDY/5 (c) Pl. 40.

Before the Wind, 1939. SOTHEBY/3617 (b/w) Pl. 75.

Before the Wind, Maine, 1921. NORMAN/2 (b/w) Pl. 111.

Bennington, Vermont, ca. 1924. BEAL (b/w) 98.

Berkshire Landscape, 1925. SOTHEBY/3823 (b/w) Pl. 135.

Big Wood Island, 1914. MARINE/2 (b/w) 126–127.

A Bit of Stonington, Maine, 1926. SCENE/1 (b/w) Pl. 25; p. 112.

Black River Valley, 1913. PHILLIPS/5 (b/w) 148.

Blue Landscape, 1923. LEWISOHN (b/w) 20, 77.

Blue Mountain on Circle Drive near Taos, Red River Country II, 1929. WA-
 TERCOLOR/4 (c) 110.

Blue Sea, 1945. PHILLIPS/5 (b/w) 148.

Blue Sea, Crotch Island, 1923. ADDISON/1 (c) 126, 128.

Blue Sky, Mountain Aspen, and the Roaring Hondo, New Mexico, 1930. AN-
 SCHUTZ (c) 82–83.

Boat and Green Sea, 1938. HIRSCHL/10 (b/w) Pl. 25.

Boat and Sea, Maine, 1932. KANSAS CITY (c) 314–315, 490.

————. KENNEDY/8 (c) Pl. 38.

————. KENNEDY/14 (c) Pl. 35.

Boat before Deer Isle, 1926. LINDEMANN (c) 437–439, 470.

Boat Fantasy, Deer Island, Maine, No. 30, 1928. CHRISTIE/6610 (c) Pl. 324.

————. NOYCE (c) 11, 69.

Boat, House and Blue Sea, 1920. CUBIST/4 (b/w) 59, 93.

Boat Movement, Cape Split, 1940. WATERCOLOR/5 (c) 132, 199.

Boat off Deer Isle, 1926. CANADY (c) Pl. 112.

Boat, Sea and Land (Maine Series, No. 2), 1934. STANFORD (c) 270–271.

Boats and Bridges, 1914. PRINTS/11 (b/w) Pl. 41.

Boats and Gulls, 1940. MURDOCK (b/w) 147.

————. WICHITA (c) 196–197.

Boats and Sea, Deer Isle, Maine, No. 5, 1927. WATERCOLOR/4 (b/w) 114.

Breakers, Maine Coast, 1917. HOWLAND (b/w) 70, 74, 76.

————. STEBBINS (b/w) 304–308, 431, 449.

————. STIEGLITZ/2 (c) 12–13, 28–29.

Breaking Sea, Cape Split, Maine, 1939. SOTHEBY/5524 (b/w) Pl. 278.

Bridge across the Seine, 1919. SOTHEBY/1630 (b/w) Pl. 103.

Bridge, Amsterdam, 1906. PRINTS/15 (b/w) 289.

Broadway Night, 1929. LANDSCAPE/3 (c) 106–107, 167.

————. METROPOLIS (b/w) 445, 456, 460.

Brooklyn Bridge, 1910. BRIDGE/1 (c) 157.

————. DRAWING/4 (b/w) 214–216.

————. GRANT-MUNGER (b/w) 48, 111.

————. WATERCOLOR/3 (b/w) 200.

Brooklyn Bridge, 1911. MCNAY (b/w) 172–173.

Brooklyn Bridge, 1911. SOTHEBY/3617 (b/w) Pl. 24.

Brooklyn Bridge, ca. 1912. COLBY (b/w) 66.

Brooklyn Bridge, ca. 1912. HASKELL (c) 115.

Brooklyn Bridge, 1912. BRIDGE/1 (c) 158.

———. PARIS-NEW YORK (b/w) 250.

Brooklyn Bridge, 1913. DRAWING/1 (b/w) 100–101, 160.

Brooklyn Bridge, 1913. PHILLIPS/5 (b/w) 149.

———. SHELDON/1 (b/w) 51, 72.

Brooklyn Bridge, 1913. PRINTS/22 (b/w) Pl. 122; p. 37.

Brooklyn Bridge, ca. 1913. KENNEDY/19 (b/w) Pl. 7 [sec. II].

Brooklyn Bridge, 1917. BRIDGE/1 (b/w) 159.

———. BRIDGE/2 (b/w) Pl. [unnumbered]; pp. 133–134.

———. PRINTS/6 (b/w) 1, 16, 19.

The Brooklyn Bridge, ca. 1930. WORCESTER (c) 200–201, 227.

Brooklyn Bridge and Lower New York, 1913. CHRISTIE/7780 (b/w) Pl. 49.

Brooklyn Bridge and River Movement, 1910. CHRISTIE/6874 (c) Pl. 182.

———. YORK/3 (c) Pl. 19.

Brooklyn Bridge from Brooklyn (The Sun), 1915. CHRISTIE/7780 (b/w) Pl. 54.

———. PRINTS/19 (b/w) 68, 70, 73.

———. SOTHEBY/3061 (b/w) 109.

Brooklyn Bridge (Mosaic), 1913. BROOKLYN/4 (b/w) [4].

———. CHRISTIE/7780 (b/w) Pl. 50.

———. URBAN (b/w) 11, 41.

Brooklyn Bridge, No. 6 (Swaying), 1913. BRIDGE/1 (b/w) 159.

———. CHRISTIE/7780 (b/w) Pl. 51.

———. MANHATTAN (b/w) 16.

———. MARRON (b/w) 102–105, 155.

———. PHILADELPHIA/1 (b/w) 66, 69, 121.

———. PRINTS/17 (b/w) 116–117.

———. SOTHEBY/4370 (b/w) 124.

Brooklyn Bridge, on the Bridge, 1930. TERRA (c) 258.

———. WATERCOLOR/7 (c) 36, 70.

Brooklyn Bridge Series, 1911. KENNEDY/18 (c) Pl. 15.

Brooklyn Series, 1910. SCENE/2 (b/w) Pl. 20.

Bryant Square, 1932. PHILLIPS/5 (b/w) 149.

———. PHILLIPS/6 (b/w) Pl. 135; p. 65.

Bryant Square, New York, 1931. DRAWING/6 (b/w) 67.

Buildings, Downtown, New York, n.d. CHRISTIE/8051 (c) Pl. 175.

Buildings, Downtown, New York, 1925. HIRSCHL/3 (b/w) 58.

Buildings, New York, 1932. FLEISCHMAN/2 (b/w) 106.

Buoy, Maine, 1931. MOMA/10 (b/w) 30–31, 177.

———. MOMA/12 (b/w) 221, 565.

Ca' d'Oro, 1907. PRINTS/20 (b/w) [unpaginated].

Camden Mountain across the Bay, 1922. MOMA/10 (b/w) 114, 177.

_____. MOMA/12 (b/w) 221, 565.

Canyon of the Hondo, New Mexico, 1930. ANSCHUTZ (c) 82.

_____. TAOS/2 (b/w) 145–146.

Cape Split, 1939–1942. MURDOCK (b/w) 148–149.

_____. WATERCOLOR/5 (b/w) 161, 199.

_____. WICHITA (c) 195–196.

Cape Split and Boat. 1941. GRANT-MUNGER (b/w) 49, 111.

Cape Split, Maine, 1933. CHRISTIE/6972 (c) 164.

Cape Split, Maine, 1935. HIRSCHL/1 (b/w) 102.

_____. SOTHEBY/4038 (b/w) Pl. 197.

Cape Split, Maine, 1938. KANSAS CITY (b/w) 316–317, 454.

Cape Split, Maine, 1941. MARINE/1 (b/w) 233, 240.

_____. STERN (b/w) 86, 190.

Cape Split, Maine, 1945. HALPERT (c) Pl. 63.

Carnival #2, 1905. MILWAUKEE (b/w) [front cover]; p. 23.

Carnival #3, 1905. SOTHEBY/3617 (b/w) Pl. 34.

Casco Bay, 1914. SOTHEBY/5353 (b/w) Pl. 252.

Casco Bay, Maine, 1914. WINTERSTEEN (b/w) Pl. 18; [catalogue note].

Castorland Landscape, 1913. CHRISTIE/7508 (c) Pl. 220.

Castorland, New York, 1913. SOTHEBY/3823 (b/w) Pl. 131.

La Cathedrale . . . Rouen, 1909. PRINTS/15 (b/w) 290.

_____. PRINTS/19 (b/w) 68, 70.

Chartres Cathedral, 1910. KENNEDY/19 (b/w) Pl. 8 [sec. III].

_____. PRINTS/10 (b/w) 736–738.

_____. PRINTS/19 (b/w) 68–70.

The Circus No. 1, 1952. WHITE HOUSE (c) 250–251.

Circus Elephants, 1941. CIRCUS (b/w) [unpaginated].

City Construction, 1932. ALBRIGHT-KNOX/1 (c) 100–101.

City Hall, World and Tribune, New York City, ca. 1924. KENNEDY/7 (b/w) Pl. 23.

City Movement, Downtown Manhattan, No. 2, 1936. HUNTER (b/w) 165–167.

_____. FLEISCHMAN/1 (b/w) 103.

City Scene, 1912. KENNEDY/4 (c) Pl. 41.

Clouds and Mountains at Kufstein, 1910. STEBBINS (b/w) 304–308, 431, 449.

_____. WATERCOLOR/9 (c) 194–195.

Coal Country, Wilkes Barre, Pennsylvania, 1942. SOTHEBY/4038 (b/w) Pl. 214.

The Coast, 1914. HOWLAND (b/w) 70, 73, 75.

A Composing, Cape Split, No. 2, 1943. HIRSHHORN/2 (c) Pl. 515; pp. 718–719.

Composition, Cape Split, Maine, No. 2, 1933. CARTER/2 (b/w) 52–53.

_____. FLEISCHMAN/1 (b/w) 102.

Composition, Cape Split, Maine, No. 3, 1933. MORTON (c) 47, 247–248, 270.

Cortlandt Street, New York City, ca. 1924. CUBIST/4 (b/w) 58, 94.

The Cove, 1917. GUSSOW (c) 56–57.

Crotch Island, Maine, the Cove, 1924. WATERCOLOR/9 (c) 196–198.

Dance of the Santa Domingo Indians, 1929. SOUTHWEST (c) 86–87, 121, 126.

————. TAOS/3 (b/w) 312, 314, 377.

Deer Island, 1914. WHITNEY/8 (b/w) 13, 16.

Deer Island, Maine, 1922. KENNEDY/6 (b/w) Pl. 22; [catalogue note].

————. KENNEDY/17 (c) Pl. 28.

Deer Island, Maine (Movement No. 14), 1927. SOTHEBY/6538 (c) Pl. 140.

Deer Isle, 1914. WATERCOLOR/1 (c) 149–150.

Deer Isle, Boats, and Pertaining Thereto, 1927. WIGHT (b/w) 30, 56–57.

Deer Isle, Maine, 1919. OVER HERE (b/w) 167.

Deer Isle, Maine, 1927. LANE (c) Pl. 1, p. 162.

Deer Isle, Maine, 1928. CHRISTIE/6874 (c) Pl. 185.

Deer Isle, Maine—Boat and Sea, 1927. WHITE (b/w) Pl. 86.

Deer Isle, Maine: Sea and Boats, 1924. BOHAN (b/w) 27–28.

Deer Isle, Maine: Stonington Water Front, Two Movements, 1924. DREIER (b/w) 438–439, 441.

Deer Isle Series: Mark Island Lighthouse, 1928. MAINE/2 (c) 84, 120, 126.

Deer Isle, Stonington, No. 10, 1924. CHRISTIE/6724 (c) Pl. 329.

Della Fava, 1907. VENICE (b/w) 63, 65–66.

Delaware River Country, 1916. GRAHAM (c) 18–19, 48.

————. HOWLAND (b/w) 70, 74, 76.

————. KENNEDY/11 (c) Pl. 23.

Doorway, St. Mark's, Venice, 1907. PHILLIPS/5 (b/w) 149.

Down Town, 1925. WILLIAMS/1 (b/w) Pl. 17; p. 148.

Downtown New York, 1911. HALPERT (b/w) Pl. 97.

————. CHRISTIE/6972 (c) 162.

Downtown New York, 1921. PRINTS/7 (b/w) Pl. 66.

————. PRINTS/21 (b/w) Pl. 437; p. 491.

Downtown, New York, 1923. TATE (b/w) 486.

Downtown New York, Buildings, 1912. SOTHEBY/6026 (c) Pl. 88.

Downtown New York Series, 1910. KENNEDY/9 (b/w) Pl. 62.

Downtown New York, Street Movement, Red Sun, 1925. HALPERT (c) Pl. 37.

————. NEW JERSEY (c) 44–45.

Downtown New York: Stock Exchange, 1924. CROSSCURRENTS (b/w) 81.

Downtown, the El, 1921. LEAGUE/3 (b/w) 26, 93.

————. PHILADELPHIA/1 (b/w) 66, 71, 121.

————. PRINTS/4 (b/w) Pl. 72.

————. PRINTS/8 (b/w) 261.

————. PRINTS/12 (b/w) Pl. 14.

————. PRINTS/19 (b/w) 68, 70, 74.

————. SOTHEBY/4661M (b/w) 56–57.

————. URBAN (b/w) 17, 41.

Downtown—Vicinity of Wall Street, 1930. ANDERSON (c) 310–311, 374.

Ducks in Flight over Sea, 1943. KENNEDY/19 (c) Pl. 27 [sec. I].

East River, 1910. BALTIMORE/2 (b/w) 146–147.

———. HALPERT (b/w) Pl. 98.

Eastport, Maine, 1933. KENNEDY/2 (c) Pl. 49.

———. KENNEDY/12 (c) Pl. 28.

———. SOTHEBY/3644 (b/w) Pl. 74.

———. THYSSEN (c) 128–129, 394.

Echo Lake, Franconia Notch White Mountains, 1924. YORK/3 (c) Pl. 28.

Fantasy of the Brooklyn Bridge, 1934. GOLDSTONE (b/w) 66.

Fantasy, Small Point, Maine, 1914. SOTHEBY/6025 (c) Pl. 211.

Fifth Avenue at Forty-Second Street, 1933. PHILLIPS/1 (c) 159.

———. PHILLIPS/6 (b/w) Pl. 134; p. 65.

Figures at an Exhibition, 1932. SOTHEBY/1630 (b/w) Pl. 244A.

Figures in a New York Subway, 1931. KENNEDY/8 (c) Pl. 36.

Figures in a Waiting Room, 1931. THYSSEN (c) 126–127, 394.

Figures on Brooklyn Bridge, 1932. BEAR (b/w) Pl. 29.

Fir Tree, 1926. NEWARK/2 (b/w) 151, 349.

Fir Trees, 1914. SOTHEBY/6817 (b/w) Pl. 153.

Fir Trees, 1919. SOTHEBY/4365 (b/w) Pl. 210.

Fir Trees, 1927. PREVIN (b/w) Pl. 23.

Fishboat No. 1 at Eastport, Maine Coast, 1933. FARNSWORTH (c) 126, 128,
 245.

Fishing Smack, 1928. LANDAU (c) Pl. 26.

Fishing Smack, 1929. PHILLIPS/2 (b/w) Pl. CXLVII.

———. PHILLIPS/5 (b/w) 149.

Fishing Smacks, 1928. KENNEDY/6 (b/w) Pl. 21; [catalogue note].

Fishing Smacks—Deer Isle Maine Series, 1928. SOTHEBY/5335 (c) Pl. 224.

The Fog Lifts, 1949. MOMA/14 (b/w) 96, 153.

———. MURDOCK (b/w) 150–151.

———. WICHITA (c) 197–198.

Four-Master off the Cape—Maine Coast, No. 1, 1933. PHILLIPS/5 (b/w) 149.

———. PHILLIPS/6 (b/w) Pl. 132; p. 66.

Fourth of July, 1912–1913. SAN DIEGO (b/w) [unpaginated].

Franconia Range, White Mountains, 1924. BEARDSLEY (c) 30.

———. NOTRE DAME (b/w) 98–99.

Franconia Range, White Mountains, No. 1, 1927. PHILLIPS/5 (b/w) 149.

From Cape Split, Maine Coast, 1933. CHRISTIE/8790 (c) Pl. 89.

From Deer Island, Maine, 1924. MASTERS/1 (b/w) Pl. 62.

From Deer Isle, Maine, 1922. EBSWORTH (c) 128–129, 211.

From Deer Isle, Maine—Looking Outward, 1923. TANNAHILL (b/w) 71, 85.

From Flint Isle No. 1, 1947. CORCORAN/1 (c) 82–83.

From My Window, Cliffside, N.J., 1929. TANNAHILL (b/w) 25, 32.

From New York Hospital, 1951. SOTHEBY/6927 (c) Pl. 155.

In the Tyrol, ca. 1912. MEYER (b/w) 70–73.

Incoming Fog, 1914. HALPERT (b/w) Pl. 103.

Incoming Southwester, Cape Split, Maine, 1952. BRADLEY (b/w) 152.

Incoming Tide—Quoddy Head, Maine, 1946. SOTHEBY/3865 (b/w) Pl. 173.

Island, 1921. KOOTZ/1 (b/w) Pl. 41; pp. 45–47.

———. KOOTZ/2 (b/w) Pl. 58.

Isle au Haute from Greenhead, Maine, 1922. SOTHEBY/5335 (c) Pl. 231.

Isle off Deer Isle, 1920. KENNEDY/4 (c) Pl. 39.

Lake Champlain, No. 1, 1931. KENNEDY/15 (c) Pl. 5.

Lake Champlain, No. 2, 1931. FLORIDA (c) 62, 65.

Lake George, New York, 1928. WATERCOLOR/7 (c) 36, 71.

Land and Sky, France (Land and Sky, The Hill), 1908. DREIER (b/w) 438–
 440.

Landscape, 1913. SOTHEBY/6568 (c) Pl. 123.

Landscape, ca. 1914. HIGH/2 (c) 117–119, 186, 195.

———. SCALE (b/w) 61.

Landscape, 1915. MUNSON/1 (c) 120–121, 225.

Landscape, 1915. QUINN/1 (c) 24, 174.

Landscape, 1916. SOTHEBY/7096 (c) Pl. 125.

Landscape, 1919. CHRISTIE/7724 (c) Pl. 194.

Landscape [recto]; *Stonington Harbor* [verso], 1923. SPRINGFIELD/1 (b/w)
 66–67.

Landscape, ca. 1940. DREIER (b/w) 438–439, 442.

Landscape (Berkshires), 1912. LONG ISLAND/3 (b/w) 63.

Landscape in Maine, 1915. HORTER (c) 118.

———. WHITNEY/7 (b/w) 11, 73.

Landscape, Mountains, 1918. SHELDON/2 (c) 188–199, 300–301.

Landscape near Taos, 1929. GALLU (c) Pl. 13.

Landscape, New Mexico. 1930. SHELDON/2 (b/w) 301.

Landscape with Tree, 1915. SOTHEBY/5584 (b/w) Pl. 338.

Ledges and Sea, Cape Split, Maine, 1936. OWEN/2 (c) [unpaginated].

Little Canyon, New Mexico, 1930. SCENE/1 (b/w) Pl. 24; p. 112.

———. TAOS/2 (b/w) 145, 147.

Little Fir Tree, Deer Isle, 1921. KENNEDY/10 (c) Pl. 21 [back cover].

The Little Footbridge, Meaux, 1908. DREIER (b/w) 438–440.

The Little Maple Tree, Castorland, 1913. HIGH/2 (c) 116–119, 186, 195.

Little Rio Grande No. 1, 1930. SOTHEBY/5524 (b/w) Pl. 251.

The Little Sailboat, 1924. HOUSTON/1 (b/w) 142.

Lobster Boat, Cape Split, Maine, 1938. FLEISCHMAN/2 (b/w) 94.

———. NEW ENGLAND/1 (c) 107, 125.

London Omnibus, 1908. WATERCOLOR/4 (c) 111.

Long Island Potatoes, Spring of 1927, 1927. LONG ISLAND/2 (c) 64, 66.

Lower Manhattan, 1920. DRAWING/2 (c) 42, 51, 64.

———. GOODWIN (b/w) 10.

———. MOMA/3 (b/w) Pl. 212.

———. MOMA/4 (c) 52, 222, [color plate].

———. MOMA/5 (b/w) 88, 139.

———. MOMA/8 (b/w) Pl. 104; p. 31.

———. MOMA/12 (b/w) 221, 565.

———. WATERCOLOR/3 (b/w) 200.

Lower Manhattan, 1923. KENNEDY/3 (b/w) Pl. 32.

———. KENNEDY/13 (c) Pl. 22.

———. THYSSEN (c) 120–123, 394.

Lower Manhattan, 1925. CRANBROOK (b/w) 45.

Lower Manhattan (Composing Derived from Top of Woolworth), 1922. CUB-
 IST/5 (b/w) 216, 222–223, 322.

———. MOMA/1 (c) 144–145.

———. MOMA/7 (c) 123.

———. MOMA/9 (c) 288–289.

———. MOMA/12 (b/w) 221, 565.

———. MOMA/14 (b/w) 47, 153.

———. NEW YORK/3 (c) 49, 139.

———. ROOT (b/w) [unpaginated].

Lower Manhattan from the River, No. 1, 1921. MET/2 (c) 176.

Magnolias, 1938. STILL LIFE/3 (c) Pl. 31.

Maine Coast, n.d. SOTHEBY/5335 (c) Pl. 230.

Maine Islands, 1922. CUBIST/5 (b/w) 217, 223, 322.

———. LANDSCAPE/2 (c) Pl. 159; p. 179.

———. MARINE/3 (c) 183–184.

———. MOMA/2 (b/w) Pl. 70; p. 35.

———. MOMA/13 (b/w) 56–57.

———. PHILLIPS/1 (c) 158.

———. PHILLIPS/2 (b/w) Pl. CXLII.

———. PHILLIPS/3 (b/w) Pl. CXXII; pp. 59–60.

———. PHILLIPS/5 (b/w) 150.

———. PHILLIPS/6 (b/w) Pl. 128; p. 66.

———. PHILLIPS/7 (c) 49–50.

———. WATERCOLOR/5 (c) 129, 199.

Maine, Jordan's Delight Island, 1935. CHRISTIE/6874 (c) Pl. 184.

Maine Landscape, 1919. FARNSWORTH (c) 126–127, 245.

Maine Landscape, 1922. KANSAS CITY (b/w) 369.

Maine Series, 1925. AMHERST/2 (b/w) 136.

Manhattan, ca. 1923. MCNAY (b/w) 172–173.

Manhattan Movement, 1932. BLOUNT (c) 31.

Manhattan, St. Paul's, 1914. WHITNEY/12 (b/w) Pl. 90; p. 24.

Marin Island, Maine, 1932. KENNEDY/18 (c) Pl. 16.

The Marin's House, John's Horse Jack, Mabel Luhan's Estate, ca. 1929. KEN-
 NEDY/1 (c) Pl. 20; [biographical note].

Marin's Island, Maine, 1915. BORN (b/w) 199, 201–202.

————. GALLATIN/1 (b/w) Pl. 75; [catalogue note].

————. GALLATIN/3 (c) 10.

————. QUINN/2 (b/w) 115–116.

Market Place, Frauen Kirche, Nuremberg, 1910. KENNEDY/19 (b/w) Pl. 9
 [sec. III].

Mid-Manhattan, No. 1, 1932. NEW YORK/3 (c) 63, 139.

Mid-Manhattan II, 1932. HIRSCHL/3 (c) 56–57.

Mid Town Construction, ca. 1928. SANTA BARBARA/1 (c) 52.

Midtown Construction, 1928. SANTA BARBARA/1 (c) 52.

————. SANTA BARBARA/2 (b/w) Pl. 117.

The Modern Universe, 1937. YALE/6 (b/w) 204.

Mott Street, ca. 1920. KENNEDY/7 (b/w) Pl. 24.

Mt. Chocorua, 1926. FITCH (b/w) 37.

Mount Chocorua, 1928. HARVARD/1 (b/w) Pl. 139.

————. HARVARD/2 (c) 35.

————. WATERCOLOR/5 (c) 159, 199.

Mt. Chocorua—White Mountains, 1926. PHILLIPS/2 (b/w) Pl. CXLIX.

————. PHILLIPS/5 (b/w) 150.

Mountain Landscape, 1916. SOTHEBY/5584 (b/w) Pl. 337.

Movement: Boat and Sea in Greys, 1952. HIRSHHORN/2 (c) Pl. 714; pp. 718–
 719.

Movement: Boat off Deer Isle, Maine No. 7, 1926. HALPERT (c) Pl. 60.

Movement—Cape Split, Maine, 1936. LOS ANGELES/2 (b/w) 465–467.

Movement, Fifth Avenue, 1912. MACHINE (b/w) 215.

————. PARIS—NEW YORK (b/w) 250–251.

————. WATERCOLOR/5 (b/w) 158, 199.

Movement: Fifth Avenue, New York City, ca. 1926. DRAWING/9 (b/w) Pl. 13.

Movement—Grain Elevators, No. 1, 1916. PHILADELPHIA/1 (b/w) 66, 70,
 121.

Movement: Lower Manhattan, 1932. LONG ISLAND/3 (b/w) 62–63.

Movement, Nassau Street, n.d. SOTHEBY/5524 (b/w) Pl. 294.

Movement, Nassau Street, No. 2, 1936. LOWENTHAL (c) 34.

Movement No. 3, Downtown New York, 1926. WADSWORTH/2 (c) 38, 82.

Movement on Brooklyn Bridge, ca. 1924. KENNEDY/9 (b/w) Pl. 61.

Movement—On the Road to Addison, Maine #3, 1946. KENNEDY/16 (c) Pl.
 12.

Movement—Played with Boat Motif, 1947. KENNEDY/16 (c) Pl. 14.

————. KENNEDY/20 (b/w) Pl. 14.

Movement: Sea and Boats, Maine, 1941. KOOTZ/2 (b/w) Pl. 61.

Movement—Sea and Sky, 1946. ILLINOIS/48 (b/w) Pl. 87.

————. LANE (c) Pl. 2; p. 162.

————. WHITNEY/10 (c) 24, 35.

Movement, Sea and Sky, Cape Split, Maine, 1942. MINNESOTA/1 (b/w) 14,
 41.

Movement: Sea and Women Forms, 1941. KOOTZ/2 (b/w) Pl. 60.

Movement—Sea or Mountain as You Will, 1947. BAUR (b/w) 27, 75.
———. BOSTON/2 (c) Pl. 589; p. 193.
Movement II, 1946. KENNEDY/1 (c) Pl. 22; [biographical note].
Municipal Building, New York, 1912. WATERCOLOR/3 (c) 199.
My Hell Raising Sea, 1941. EBSWORTH (c) 130–131, 211.
———. LEVY (b/w) 31.
———. MAINE/2 (c) 86, 120, 126.
Near Great Barrington, 1925. PHILLIPS/2 (b/w) Pl. CXLVIII.
———. PHILLIPS/5 (b/w) 150.
———. PHILLIPS/6 (b/w) Pl. 130; p. 67.
Near Santa Fe, New Mexico, 1929. FLEISCHMAN/1 (b/w) 101.
Near Spring Valley, New York, 1931. FORT WORTH/1 (b/w) [unpaginated];
 [catalogue note].
Near Stonington, Maine, 1921. LEVY (b/w) 31.
Near Taos No. 5, 1930. HARMSEN/2 (c) 138–139.
———. TAOS/2 (b/w) 145, 148, 150.
———. TAOS/3 (c) 305, 312, 377.
Near Taos, No. 6, New Mexico, 1930. CARTER/1 (c) 96–97, 121.
———. CARTER/2 (b/w) 52–53.
———. TAOS/2 (c) 145, 148–149.
———. WEST/1 (c) 226–227.
Near Taos, New Mexico, 1930. FISK (b/w) 16, 37.
———. LEGACY (c) 214.
Near Taos, New Mexico, 1930. ROSWELL (c) 11.
———. SOUTHWEST (c) 19, 121, 126.
Near Taos, New Mexico, 1930. SOTHEBY/3749 (b/w) Pl. 128.
———. SOTHEBY/6373 (c) Pl. 140.
New Mexican Landscape; Near Taos, 1930. DETROIT (b/w) 202.
———. TANNAHILL (b/w) 68, 71.
New Mexico, 1930. BLANKFORT (b/w) 66–67.
———. SOTHEBY/7320 (c) Pl. 144.
New Mexico, 1930. WATERCOLOR/9 (c) 198–199.
New Mexico, near Taos, 1929. LOS ANGELES/1 (c) 210–211.
———. LOS ANGELES/2 (b/w) 465–466.
New York, 1923. CHRISTIE/6724 (c) Pl. 330.
New York, 1929. HIRSCHL/3 (c) 59.
New York at Night No. 2, 1950. SOTHEBY/6927 (c) Pl. 157.
New York at Night No. 3, 1950. NEW YORK/2 (b/w) 50, 92, 106.
New York, Downtown No. 7, 1936. WALKER (b/w) 544.
New York from the Ferry, 1914. CHRISTIE/7020 (c) Pl. 278.
New York from Weehawken, 1933. MASTERS/1 (b/w) Pl. 64.
New York Series, 1927. THYSSEN (c) 124–125, 394.
The New York Stock Exchange: A Double-Sided Drawing, n.d. CHRISTIE/7020
 (c) Pl. 277.

Notre Dame, Paris, 1908. PHILADELPHIA/1 (b/w) 66–67, 121.

Nova Scotian, 1922. TANNAHILL (b/w) 71, 83.

Off Cape Split, Maine, 1938. MAINE/1 (c) 46.

————. MET/3 (c) 89–91.

————. MOMA/3 (b/w) Pl. 107.

Off Cape Split, Maine Coast, 1933. CORNELL/2 (c) 186.

Off Cape Split, Maine, No. 1, 1934. KENNEDY/18 (c) Pl. 17.

Off Deer Isle, Maine, 1928. SBC (c) 83

Off Flint Island, Maine Coast, 1933. IOWA (c) 40–41.

Off Norton Island, Maine Coast, 1933. WATERCOLOR/7 (c) 36, 72.

Off Stonington, 1921, 1921. HOWLAND (b/w) 70, 78–79.

————. MUNSTERBERG (b/w) Pl. 42; pp. 75–78.

————. STIEGLITZ/2 (c) 12–13, 36–37.

Off the French Coast, ca. 1910. RHODE ISLAND (b/w) 40–42.

————. SOTHEBY/4650M (b/w) Pl. 348.

Off York Island, Maine, 1922. WILLIAMS/2 (c) 139–141, 218–219.

Old Church at Ranchos, New Mexico, 1930. HIRSCHL/3 (c) 60.

————. TAOS/3 (c) 312–313, 377.

————. TRANSCO (c) Pl. 59.

Old Dutch Farmhouse, Tappan, New York, 1932. CARNEGIE/1 (b/w) Pl. 64; [catalogue note].

Old House, Rue des Arpents, Rouen, I, n.d. SOTHEBY/3061 (b/w) 108.

The Old Salt, 1922. WATERCOLOR/4 (b/w) 112.

On a Ferry Boat, 1935. REALISM (c) 50, 62.

On Andrew's Island, Deer Isle, 1923. SOTHEBY/3749 (b/w) Pl. 115.

On Morse Mountain, No. 6, Maine, 1928. CROSSCURRENTS (b/w) 101.

————. SOTHEBY/6568 (c) Pl. 118.

————. WATERCOLOR/10 (c) Pl. 33.

On Morse Mountain, Small Point, Maine, 1928. KOOTZ/1 (b/w) Pl. 39; pp. 45–47.

On Morse Mountain, Small Point, Maine #5, 1928. VASSAR/1 (b/w) Pl. 110.

On the Ledges, Small Point, Maine, 1914. HORTER (c) 118.

On the Road to Addison, Maine, No. 2, 1946. FARNSWORTH (c) 126, 129, 245.

On the Road to Santa Fe, New Mexico, 1929. DALLAS (b/w) 127–129.

L'Opera, Paris, 1908. PRINTS/14 (b/w) Pl. 94; p. 143.

Out Centerville Way, Autumn, Maine, 1945. KENNEDY/15 (c) Pl. 4.

Outward from Deer Isle, Maine, 1922. TANNAHILL (b/w) 71, 84.

Palazzo Dario, Venezia, 1907. VENICE (b/w) 63–64.

Palisades, Hudson River, 1917. MOMA/10 (b/w) 162, 177.

Palisades, No. 2, 1922. HOWLAND (b/w) 70, 80, 82.

————. STIEGLITZ/2 (c) 12–13, 38–39.

Palisades on the Hudson, 1910. YORK/2 (c) Pl. 18.

Passing Schooner, Maine Coast, 1941. HIRSCHL/8 (c) 24.

Peach Trees in Blossom #3, 1948. BRADLEY (b/w) 58.

Peconic Bay, Long Island Sound, 1910. LONG ISLAND/2 (c) viii, 3–4.
Pertaining to Deer Isle, The Harbor I, 1927. WATERCOLOR/4 (b/w) 113.
Pertaining to Fifth Avenue and Forty-Second Street, 1933. PHILLIPS/5 (b/w)
 150.
Pertaining to Nassau Street, New York, 1936. BARKER (b/w) 21–27.
———. SHELDON/2 (c) 120–121, 301.
Pertaining to New Jersey, 1950. MCNAY (b/w) 172–173.
Pertaining to Stonington Harbor, 1926. TANNAHILL (b/w) 71, 85.
Pertaining to Stonington Harbor, Maine #1, 1926. NEW ENGLAND/2 (c) 172,
 218.
Pertaining to Stonington Harbor, Maine, No. 4, 1926. MET/2 (c) 12, 177.
———. WATERCOLOR/4 (c) 109.
———. WATERCOLOR/5 (b/w) 160, 199.
Pertaining to West New Jersey, 1950. SOTHEBY/6373 (c) Pl. 166.
Phillipsburg, Maine, 1932. WATERCOLOR/8 (b/w) 21, 26.
Piazetta S. Marco, Venezia, 1907. PRINTS/15 (b/w) 290–291.
Pine Tree, 1914. NINETEEN FOURTEEN (b/w) 63, 90.
———. VASSAR/2 (b/w) 71, 148.
Pine Tree, 1917. BROOKLYN/1 (b/w) 50.
———. LOWENTHAL (b/w) 50.
Pine Tree, Small Point, Maine, 1926. FLEISCHMAN (b/w) 36.
———. MOMA/8 (b/w) Pl. 105; p. 31.
Le Pont, 1907. VENICE (b/w) 63–65.
Pont Alexandre, 1909. SOTHEBY/7096 (b/w) Pl. 107.
Pont Neuf, Paris, 1909 [recto]; *Fishing on the Seine*, 1908 [verso]. PENNSYL-
 VANIA/2 (b/w) Pl. 94; p. 56.
Ponte di Donna Onesta, Venezia, 1907. PRINTS/15 (b/w) 290.
Pontoise, Paris, 1908. CHRISTIE/8051 (c) Pl. 193.
Popham Beach, Small Point, Maine (Series No. 1), 1928. BEACH (b/w) 99,
 132.
Porte San Marco, Venezia, 1907. PRINTS/15 (b/w) 290–291.
Quartier de la Maison Blanche, 1907. BAUMFELD (b/w) 64.
Quoddy Head, Maine Coast, 1933. PHILLIPS/5 (b/w) 150.
———. PHILLIPS/6 (b/w) Pl. 133; p. 67.
Ramapo Landscape, #2, 1951. SHELDON/2 (b/w) 301.
Ramapo Mountain View, 1949. SOTHEBY/7096 (c) Pl. 106.
The Ramapos, 1950. SOTHEBY/6736 (b/w) Pl. 186.
Red and Silver Landscape, 1925. BROOKLYN/1 (b/w) 50.
Red Sun, 1919. STIEGLITZ/2 (c) 12–13, 32–33.
The Red Sun—Brooklyn Bridge, 1922. STEBBINS (c) 304–308, 431, 449.
Red Sun from the Brooklyn Bridge, ca. 1932. HIRSCHL/3 (c) 56.
Region near Taos, New Mexico, 1929. MINNESOTA/2 (c) 5, 32.
Region of Brooklyn Bridge Fantasy, 1932. HASKELL (c) 209.
———. KUH/2 (b/w) 58.

_____. NEW YORK/3 (c) 19, 139.

_____. SCENE/3 (c) 25, 88.

_____. WATERCOLOR/5 (c) 131, 199.

_____. WATERCOLOR/7 (c) 36, 73.

_____. WHITNEY/3 (b/w) Pl. 27; p. 115.

_____. WHITNEY/4 (c) 64–65, 236–237.

_____. WHITNEY/5 (c) 89, 151.

Region, Trinity Church, N.Y.C., 1926–1936. MURDOCK (b/w) 145–146.

_____. WICHITA (c) 193–195.

Related to Brooklyn Bridge, 1928, 1928. BRIDGE/1 (c) 159.

_____. BRIDGE/2 (b/w) Pl. [unnumbered]; pp. 133–134.

_____. HALPERT (c) Pl. 34.

Related to Downtown, New York, Movement No. 2 (The Black Sun), 1926. MET/
 2 (c) 178–179.

Rio Grande Canyon, n.d. EITELJORG (c) 113.

River Effect—Paris, 1909. GALLATIN/2 (b/w) 43, 110.

River Movement, Paris, 1909. DRAWING/5 (c) 102, 134.

River Valley, n.d. PHILLIPS/3 (b/w) Pl. CXXI; pp. 59–60.

Road to Santa Fe, 1929. WATERCOLOR/11 (c) 22–23.

Rock and Sea, Small Point, Maine, 1931. CLEVELAND/1 (b/w) 141.

_____. CLEVELAND/2 (b/w) 238.

Rocks and Sea, 1932. KENNEDY/4 (c) Pl. 40.

Rocks, Sea and Boat, Small Point, Maine, 1932. WALKER (c) 346–347.

Rolling Land—Delaware River Country (Landscape), 1911. WHITE (b/w) Pl.
 81.

Rowe, Mass., 1918. OVER HERE (b/w) 166.

Sacco Falls, Maine, 1950. HALPERT (b/w) Pl. 217.

Sailboat, 1932. BLANKFORT (b/w) 66–67.

Sailboat, 1932. COLBY (b/w) 154.

_____. KENNEDY/9 (b/w) Pl. 93.

_____. PHILADELPHIA/1 (b/w) 66, 72, 121.

_____. PRINTS/16 (b/w) 36.

_____. SEA (b/w) Pl. 46; p. 18.

Sailboat in Harbor, ca. 1922. HOWLAND (b/w) 70, 79, 83.

_____. STIEGLITZ/2 (c) 12–13, 40–41.

St. Paul's against the El, 1930. KENNEDY/19 (b/w) Pl. 10 [sec. III].

St. Paul's, Lower Manhattan, 1912. BOHAN (b/w) 26–27.

_____. DELAWARE (b/w) 90–91.

_____. PARIS—NEW YORK (b/w) 250–251.

St. Paul's Manhattan, 1914. STIEGLITZ/1 (b/w) 389–390.

St. Paul's, New York City, 1939. KENNEDY/7 (b/w) Pl. 25.

Saint Paul's, New York, Downtown, 1912. BOHAN (b/w) 26–27.

St. Paul's, Three O'Clock, n.d. KENNEDY/7 (b/w) Pl. 22.

Sand Dunes and Sea, Small Point, Maine, 1917. SMITH (b/w) 254.

_____. PHILLIPS/5 (b/w) 150.

Ship, Sea and Sky Forms, An Impression, 1923. HOWLAND (b/w) 70, 80–81.

_____. STIEGLITZ/2 (c) 12–13, 44–45.

Ship's Stern Island (Maine Series, No. 1), 1934. PRINCETON/3 (b/w) 189.

Singer Building, 1921. KOOTZ/1 (b/w) Pl. 37; pp. 45–47.

_____. METROPOLIS (b/w) 455, 456, 460.

Sketch of Two Bison, ca. 1950. BEASTS (c) 48–49, 100.

Skyscrapers in Construction, No. 1, 1930. PRINTS/12 (b/w) Pl. 9.

_____. PRINTS/15 (b/w) 290–291.

Small Point from Road to West Point, Maine, 1928. SOTHEBY/5335 (c) Pl. 225.

Small Point Harbor, Casco Bay, Maine, 1931. BLOUNT (c) 30.

Small Point, Maine, 1932. HIRSCHL/8 (c) 25.

Small Point, Oak Tree on Marin Island, Maine, 1931. SPRINGFIELD/2 (b/w) 63.

Spring No. 1, 1953. ELIOT (c) 190–193.

_____. PHILLIPS/5 (b/w) 151.

Still Life: Vase and Flowers, Deer Isle, Maine, 1919. STILL LIFE/2 (b/w) 216, 218, 220.

The Stock Exchange, New York, 1926. GOLDSTONE (b/w) 65.

Stonington and the Harbor, Maine. 1924. FLEISCHMAN/1 (b/w) 100.

Stonington, Deer Isle, Maine, 1926. PIONEERS (b/w) [unpaginated].

Stonington Harbor, Deer Isle, Maine, 1923. HILLSTROM (c) 17, 55, [frontispiece].

Stonington, Maine, 1919. BLOEDEL (b/w) 40–41.

Stonington, Maine, 1921. SOTHEBY/3417 (c) Pl. 37.

Stonington, Maine, 1923. COLBY (c) 67, [frontispiece].

Storefronts, n.d. CHRISTIE/7414 (b/w) Pl. 228.

Storm over Taos, 1930. SOUTHWEST (c) 60, 121, 126.

_____. WATERCOLOR/5 (c) 130, 199.

Street Crossing, New York, 1928. PHILLIPS/4 (c) 138–139.

_____. PHILLIPS/5 (b/w) 151.

Street Movement, Nassau Street, No. 1, 1936. HIRSCHL/6 (b/w) 78.

Street Movement, Nassau Street, No. 2, 1936. KENNEDY/19 (c) Pl. 26 [sec. I].

Street Movement, New York City, 1932. LOWENTHAL (c) 34.

Street Movement, New York City, 1934. KENNEDY/3 (c) [frontispiece].

_____. KENNEDY/12 (c) Pl. 27.

_____. LEAGUE/2 (b/w) 162–163.

A Street Seeing, 1928. TREMAINE (c) 160, 174–175.

Study for Cover Illustration for "John Marin the Man and His Work" by E.M. Benson, n.d. SOTHEBY/4650M (b/w) Pl. 354.

Study of the Sea, 1917. MOMA/10 (b/w) 110, 177.

A Study on Sand Island, 1922. HOWLAND (b/w) 70, 79–80, 83.

_____. MARINE/2 (b/w) 132–133.

Three Master No. 2, off the Cape, Maine Coast, 1933. SOTHEBY/5524 (b/w)
 Pl. 279.
Tidal Falls, Deer Isle (Rustling Brook), 1923. CHANDLER (b/w) [unpaginated].
 _____. SOTHEBY/3823 (b/w) Pl. 130.
Tin Can Clean-Up, 1930. SOTHEBY/3373 (b/w) 53.
Top of Radio City, 1937. KENNEDY/3 (c) Pl. 33.
 _____. KENNEDY/15 (c) Pl. 3.
 _____. KENNEDY/20 (b/w) Pl. 13.
Tower of St. Germain, 1906. PRINTS/20 (b/w) [unpaginated].
Town in Maine, 1932. WATERCOLOR/6 (c) Pl. XXII; p. 114.
Tree, 1917. FISK (b/w) 16, 38.
Tree and Sea, Maine, 1919. GERDTS/1 (c) 28–29.
 _____. JANIS (b/w) 32, 38.
Tree and Sea, Stonington, Maine, 1919. BRADLEY (b/w) 152.
Tree Forms, 1915. MOMA/14 (b/w) 46, 153.
Tree Forms, 1921. SOTHEBY/3617 (b/w) Pl. 26.
Tree Forms, Maine, 1915. FUTURISM (c) 366, 511.
Tree Forms, Stonington, Maine, 1920. OWEN/2 (c) [unpaginated].
Tree, Rocks, Sea: Maine, 1923. DIAL (b/w) Pl. 58; [catalogue note].
Tree Surrounded by Flowers, n.d. SOTHEBY/1630 (b/w) Pl. 246.
Trees and Hillside, 1912. CHRISTIE/8478 (c) Pl. 225.
Trinity Church, 1916. SOTHEBY/3617 (b/w) Pl. 27.
Trinity Church, New York, 1911. HARVARD/2 (c) 34.
Trinity Church Yard, 1915. PRINTS/19 (b/w) 68, 70, 73.
Trolley Car Descending, Weehawken, New Jersey, 1918. CORRESPON-
 DENCES (c) Pl. 7b; [catalogue note].
Tunk Mountain Series No. 2, 1949. ACKLAND/1 (b/w) Pl. 148.
 _____. CINCINNATI/2 (b/w) 11–12.
Tunk Mountains, 1952. MURDOCK (b/w) 152–153.
 _____. WICHITA (c) 198–199.
Tunk Mountains, Autumn, Maine, 1945. PHILLIPS/5 (b/w) 151.
 _____. PHILLIPS/6 (b/w) Pl. 136; p. 67.
 _____. WHITNEY/6 (b/w) 22, 88.
Two-Master, Becalmed, 1923. LEAGUE/4 (b/w) Pl. 31.
 _____. MET/2 (c) 177.
 _____. STIEGLITZ/1 (b/w) 389–391.
 _____. WATERCOLOR/4 (c) 115.
Tyrolean Mountains, 1910. HOWLAND (b/w) 70, 73.
 _____. STIEGLITZ/2 (c) 12–13, 24–25.
Union Hill, New Jersey, 1929. KENNEDY/1 (c) Pl. 21; [biographical note].
Untitled, 1923. SOTHEBY/6373 (b/w) Pl. 165.
Untitled (Barges, Three Master, Grain Elevators), ca. 1898. DRAWING/3 (b/w)
 28–29.

Untitled (Circus Movement), 1942. SOTHEBY/1611 (b/w) Pl. 364.

Untitled (Construction, Vicinity Woolworth Building), ca. 1924. DRAWING/3 (b/w) 29.

Untitled (Machias, Maine), 1951. DRAWING/3 (b/w) 29.

Untitled (Maine Landscape), 1914. SOTHEBY/3644 (b/w) Pl. 66.

Untitled (Woolworth Building), ca. 1913–1915. ARKANSAS/1 (b/w) 126–127.

_____. ARKANSAS/2 (b/w) 10–11.

Up in the White Mountains, N.H., 1924. PENNSYLVANIA/2 (b/w) Pl. 96; p. 15.

Venice, n.d. CHRISTIE/8097 (c) Pl. 230.

Venice, 1916. MET/1 (c) 94–97, 237.

View from Deer Isle, Maine, 1924. FRAAD (b/w) 68.

Waterfront, Manhattan, 1936. CHRISTIE/6972 (c) 165.

Wave on Rock, 1937. HASKELL (c) 209.

_____. VIEWS/1 (c) 56, 122.

_____. WHITNEY/11 (b/w) 61.

Waves, 1914. BEACH (c) 98, 132.

Weehawken, New Jersey, 1910. BOHAN (c) 24–25.

_____. WATERCOLOR/7 (c) 37, 75.

Weehawken Railroad Yards and Grain Elevators, ca. 1910. PENNSYLVANIA/ 2 (b/w) Pl. 95; p. 14.

Weehawken Sequence, 1903–1904. SOTHEBY/5335 (c) Pl. 231A.

_____. SOTHEBY/6736 (c) Pl. 188.

Weehawken Sequence, ca. 1916. KENNEDY/10 (c) Pl. 15.

_____. SCALE (c) 30, 61.

Weehawken Sequence, #2, ca. 1916. HIGH/2 (b/w) 117, 119, 186, 195.

Weekhawken Sequence No. 20, ca. 1916. ACKLAND/2 (b/w) 22–23.

Weehawken Sequence, No. 30, ca. 1916. PHILLIPS/5 (b/w) 151.

Weehawken Sequence, #65. ca. 1915. HIGH/2 (b/w) 117, 119, 186, 195.

West Point (Casco Bay), Maine, 1914. MET/2 (c) 173.

West Street, New York, n.d. CHRISTIE/7724 (b/w) Pl. 200.

Westpoint and Vicinity, 1916. MASTERS/1 (b/w) Pl. 61.

White Horses—Sea Movement off Deer Isle, Maine, 1926. HASKELL (c) 209.

White Lake, Sullivan County, New York, 1888. SOTHEBY/6736 (b/w) Pl. 220.

White Mountain Country (Presidential Range), 1927. HARVARD/1 (b/w) Pl. 140.

_____. SACHS (b/w) 218, 253.

White Mountain Country, Summer No. 30, Dixville Notch No.2, 1927. MOUN-TAINS (c) 90.

White Mountains, Autumn, 1927. STIEGLITZ/1 (b/w) 389–391.

White Mountains, New Hampshire, ca. 1924. HIRSCHL/6 (c) 77.

White Waves on Sand, Maine, 1917. LIGHT (c) Pl. 52; [catalogue note].

_____. OVER HERE (b/w) 165.

Within Paris, 1909. SHELDON/2 (b/w) 300.

Woolworth, 1913. CINCINNATI/1 (b/w) 203.
———. WILLIAMS/1 (b/w) Pl. 3; p. 148.
Woolworth Building in Construction, 1913. WHITNEY/7 (b/w) 15, 73.
Woolworth Building, No. 1, 1913. PHILADELPHIA/1 (b/w) 66, 68, 121.
———. PHILADELPHIA/2 (c) 235.
Woolworth Building, No. 2, 1913. CHRISTIE/7780 (b/w) Pl. 52.
———. MOMA/9 (b/w) 344–345.
———. PRINTS/6 (b/w) 1, 16, 18.
———. PRINTS/13 (b/w) Pl. 57.
Woolworth Building, No. 3 (The Dance), 1913. BETHERS (b/w) 114–115.
———. BROOKLYN/2 (b/w) 432–434.
———. CHRISTIE/7780 (b/w) Pl. 53.
———. FISK (b/w) 16, 34.
———. LINDEMANN (b/w) 437, 439, 442, 470.
———. MANHATTAN (b/w) 14.
———. MARRON (b/w) 102–105, 155.
———. PRINTS/4 (b/w) Pl. 71.
———. PRINTS/6 (b/w) 1, 16–17.
———. PRINTS/10 (b/w) 736–738.
———. PRINTS/14 (b/w) Pl. 95; p. 143.
———. PRINTS/19 (b/w) 68, 70–71.
———. PRINTS/21 (b/w) Pl. 411; p. 491.
Woolworth Building, No. 4, 1913. SACHS (b/w) 219, 253.
Woolworth Building, No. 29, n.d. NATIONAL/1 (c) 686–687.
Woolworth Building, No. 31, 1912. CUBIST/1 (b/w) 176–177.
———. CUBIST/2 (c) 123.
———. CUBIST/4 (b/w) 215, 222, 322.
———. GERDTS/2 (b/w) 121–122.
———. METROPOLIS (b/w) 455–456, 460.
———. MEYER (b/w) 70–72.
Woolworth Building Series, 1912–1913. ARMORY (b/w) 24–25.
Woolworth Tower Swaying, ca. 1916 SOTHEBY/1630 (b/w) Pl. 128.

5

Max Weber

Max Weber was born into an Orthodox Jewish family in Bialystok, Russia (now Poland), on 18 April 1881. His family emigrated to the United States in 1891 and settled in the Williamsburg section of Brooklyn. His early artistic education took place at the Pratt Institute, under the tutelage of Arthur Wesley Dow, where he studied the theory and practice of design. Dow was one of the more progressive teachers of his era, and he introduced Weber to a wide range of Western and Eastern art. After graduating from Pratt on 21 June 1900, Weber continued to study under Dow for a year until he began teaching in a public high school in Lynchburg, Virginia. In 1903 he began a two-year stint as head of the Department of Drawing and Manual Training of the Minnesota State Normal School in Duluth.

On 16 September 1905 Weber set sail for Paris, where he began formal academic studies at the Académie Julian under Jean-Paul Laurens and later at the less traditional Académie Colarossi and the Académie de la Grande Chaumière. He frequented the Parisian museums and also had an opportunity to meet Picasso, Matisse, Delaunay, Metzinger, Gleizes, Denis, the French poet Guillaume Apollinaire, and the American artist Abraham Walkowitz. He joined the New Society of American Artists in Paris and traveled to Spain, Italy, Belgium, and Holland to view paintings and sculpture of the European masters. Weber was especially influenced by ten Cézanne works that he saw on 10 October 1906 in the Salon d'Automne, an event that he would later recall as the "greatest turning point in my life." He also viewed other Cézanne paintings in the collection of Gertrude Stein, as well as her collection of works by Picasso and Matisse.

In the fall of 1907, Weber helped to establish a class taught by Matisse in the deserted Couvent des Oiseaux, where the Fauve artist had recently completed his masterpiece, *Joie de Vivre*, in a rented studio. Although Weber's association with Matisse lasted only for the 1907–1908 season, it resulted in a freer approach to color and pattern in his compositions. Weber's interest in African sculpture

was kindled after viewing Matisse's collection. Weber resumed his studies at Colarossi's, where his work was generally in a Post-impressionist vein and showed excellent draftsmanship and a fresh approach to color harmony. His work was exhibited in the Salon des Artistes Indépendants in 1906 and 1907 and in the Salon d'Automne in 1907 and 1908.

Weber met Henri Rousseau while living in Paris, and they immediately became close friends. Weber acquired a small collection of Rousseau's work, which later formed the basis of a memorial exhibition staged by Stieglitz in New York after the artist's death in September 1910. By 1908 Weber was running short of funds, and he decided to return the United States. On the eve of his departure, 19 December 1908, Rousseau held a special soirée in his honor. After spending the holidays in London, Weber arrived back in New York on 9 January 1909.

Shortly after his return, Weber met with Stieglitz at the instigation of Edward Steichen. Following Stieglitz's initial refusal to exhibit Weber's work, his first one-man show was held at the Haas Gallery in New York during April–May 1909. Stieglitz eventually included Weber in his *Younger American Painters* exhibition at the Photo-Secession Galleries in March 1910, which was followed by a one-man show of more advanced works in January 1911. The latter exhibition not only elicited a hostile reaction from the New York critics but also brought to a head the clash of wills that had developed between the two men.

Weber disassociated himself from the Stieglitz Circle after the exhibition closed. He soon formed friendships with the photographers Clarence White and Alvin Langdon Coburn. Coburn's efforts in getting Weber's work better known in British art circles were rewarded when Roger Fry invited Weber to exhibit with the Grafton Club at their third London show, which was held at the Alpine Club in March 1913. Coburn also helped Weber publish his first book, *Cubist Poems*, in London the following year. In the summer of 1913, John Cotton Dana featured Weber's work at the Newark Museum, which was significant insofar as it was the first exhibition of an American modernist in an American museum.

Weber possessed a keen intellect and was one of the few American artists who were interested in exploring the fourth dimension in art. For Weber this involved the expansion of consciousness beyond perceptible reality as a result of viewing a continual succession of images of three-dimensional bodies moving through time and space. In 1910 he published an essay, "The Fourth Dimension from a Plastic Point of View," in *Camera Work*. He sought to convey this idea on canvas in *Interior of the Fourth Dimension* of 1913. Weber's paintings from 1910 to 1914 reflect his search for advanced forms of abstract expression deriving from a modified form of Analytical Cubism. He focused on New York cityscapes, figurative works (including his so-called crystal figures), interiors, and still lifes.

At the end of 1915, after a one-man exhibition at the Montross Gallery, the critical reception of Weber's work gradually became more favorable among the more enlightened New York critics. Several of his semiabstract Cubist paintings

of that year, particularly *Chinese Restaurant* and *Rush Hour, New York*, successfully incorporated dynamic lines of force derived from Italian Futurism, and they are now considered landmark American paintings of the era. In 1915 Weber created several abstract sculptures, including *Air-Light-Shadow* and *Spiral Rhythm*.

Weber's series of lectures delivered at the Clarence H. White School of Photography were published in 1916 under the title *Essays on Art*. On 27 June of that year he married Frances Abrams. Soon his paintings began to focus more on human relationships in narrative and genre scenes, frequently with Jewish themes—families in domestic settings, groups of musicians, friends engaged in conversation, and so forth. Many of his works from 1917 to 1919 show a Synthetic Cubist influence through their incorporation of solid geometrical shapes rendered in bright colors in a shallow space, accompanied by decorative elements and motifs, as in *The Two Musicians* of 1917. Between 1917 and 1920 he executed a series of small woodcuts in a primitive style that reflected his interest in the totem poles of the Pacific Coast Indians, as well as African and pre-Columbian sculpture. These were later used to illustrate his second book of poetry, *Primitives: Poems and Woodcuts*, published in 1926. Weber was also an active lithographer, often rendering scenes that had appeared earlier in his paintings.

Weber's work from the 1920s to the early 1930s tended to treat the same general subject matter—principally still lifes, classic figure studies, and idyllic landscapes—with the variation coming from his explorations in style and treatment of forms. Weber's second show at the Montross Gallery was held in 1923. J.B. Neumann became his dealer the following year, and he staged regular one-man exhibitions at his New Art Circle from 1924 to 1937. The sale of Weber's work, which in the early years had been primarily confined to private collectors like Arthur B. Davies, Mabel Dodge, Hamilton Easter Field, and Mrs. Nathan J. Miller, began to expand into museum purchases in the late 1920s for the Newark Museum, the Phillips Memorial Gallery, and the Whitney Museum of American Art. In 1929 he moved with his family to Great Neck, New York, where he resided for the rest of his life. The Museum of Modern Art gave Weber a major retrospective in 1930, its first for a living American artist.

Weber was an individual with strong political convictions. The plight of artists during the Great Depression and the growing worldwide fascist threat served as an impetus for his joining the American Artists' Congress, where he was elected its first national chairman in 1936. His paintings began to show his social concerns, with depictions of war, as in *Fighters for Freedom* of 1936, or toiling laborers, as in *At the Mill* of 1939. Weber's successful exhibition at the Associated American Artists' Galleries in 1941 was a turning point insofar as he began to see greater financial rewards from the sale of his work. Paul Rosenberg became his dealer in 1942, establishing a relationship that continued until the Downtown Gallery took over as his representative in the late 1950s.

Beginning around the mid-1930s, Weber concentrated on figurative works

(predominantly featuring the female form), Jewish themes, landscapes, and still lifes. Weber's Judaic canvases typically show small groups of solemn Jewish elders conversing or studying the Scriptures (with *The Talmudists* of 1934 considered one of the better examples of this genre), portraits of individual rabbis, or portrayals of mystical Hasidic rites, as in *Hasidic Dance* of 1940 and *Adoration of the Moon* of 1944. *A Musical Evening* of 1946 typifies his other figurative paintings, which often depict women in informal settings. He focused on female nudes in other works like *At the Lake* of 1935, a painting that is reminiscent of Cézanne's *Cinq Baigneuses* of 1885–1987.

Weber generated a feeling of humor, whimsy, and fantasy in many of his paintings of this period through appropriating Expressionistic devices like exaggeration, although he denied that his works were ever intended to be caricatures. He also painted several landscapes, which range from the bleak (e.g., *After an Ice Storm* of ca. 1943) to the dramatic (e.g., *Pacific Coast* of 1952). By the 1950s, Weber began to display more freedom and intensity in his compositions through utilizing highly energetic linear elements and complex patterns, coupled with more brilliant colors. Gouache, pastel, and charcoal increasingly became his materials of choice later in his career.

Weber's work was showcased in several major retrospective exhibitions, including those staged by the Whitney Museum of American Art in 1949, the Jewish Museum in 1956, and the Newark Museum in 1959. He died at the age of eighty in Great Neck on 4 October 1961. Although some critics feel that Weber produced little of significance after 1920, others—including Milton W. Brown, Lloyd Goodrich, and Forbes Watson—believe that his later output represented a significant contribution to American art in general and Jewish art in particular. There is no question, however, that Weber was a theoretician of the first rank and one of America's premier Cubists.

I. WEBER'S WRITINGS, STATEMENTS, AND CORRESPONDENCE

See also entries 051, 064, 087, 1258, 1260, 1263, 1269, 1272, 1276, 1293, 1296, 1302, 1318, 1322, 1326, 1333, 1336, 1341, and 1521–1527.

1209 *Max Weber* (Monograph No. 4). New York: American Artists Group, 1945.

Weber outlines his aesthetic philosophy in a series of brief statements. The book includes a chronology and illustrations of fifty-three works.

1210 Modern School. *Exhibition of Paintings and Watercolors at The Modern School*. Introduction by Max Weber. New York: The School, 1913.

1211 Montross Gallery. *Cézanne*. Introduction by Max Weber. New York: The Gallery, 1916.

Weber's introduction, "Cézanne Water Colors," is excerpted in *Cézanne and America: Dealers, Collectors, Artists and Critics, 1891–1921*, by John Rewald, 290. Princeton, N.J.: Princeton University Press, 1989.

1212 Photo-Secession Galleries. *A Loaned Collection of Some Lithographs by Manet, Cézanne, Renoir and Toulouse-Lautrec; a Few Drawings by Rodin; and Smaller Paintings and Drawings by Henri Rousseau.* Introduction by Max Weber. New York: The Galleries, 1910.

Catalogue of an exhibition held at the Photo-Secession Galleries, New York, 18 November–8 December 1910, which included Weber's collection of Rousseau's paintings and drawings. His catalogue introduction is reprinted, along with selected reviews of the exhibition, in *Camera Work* no. 33 (January 1911) 46.

1213 Weber, Max. "The Artist, His Audience, and Outlook." In *Artists Against War and Fascism: Papers of the First American Artists' Congress*, 121–129. Introduction by Matthew Baigell and Julia Williams. New Brunswick, N.J.: Rutgers University Press, 1986.

Weber's speech was delivered in New York on 16 February 1936 to the first closed session of the first American Artists' Congress. He laments the fact that contemporary artists find themselves faced with a limited audience, chiefly due to economic factors, in his view. He recommends that artists cast off bourgeois predilections, as well as academic theories and manifestos, and instead pursue art that reflects proletarian concerns and conveys social import. Weber is listed as a signer of the call for the American Artists' Congress (p. 52). His *At the Mill* of 1939 is illustrated (pp. 248–249). The speech was published under the title "The Artist and His Audience" in *Art Front* 2 (May 1936) 8–9.

1214 _____. "An Artist Must Be a Practical Dreamer." *Friday* (2 May 1941) 18–20.

This photo-essay on Weber and his family is accompanied by the artist's caption comments.

1215 _____. "Chinese Dolls and Modern Colorists." *Camera Work* no. 31 (July 1910) 51.

Weber criticizes the use of formless color by modern artists.

1216 _____. *Cubist Poems.* Foreword by Alvin Langdon Coburn. London: Elkin Mathews, 1914.

Weber's first published poetry collection.

1217 _____. "Culture and the Future—Max Weber." *New Masses* 54 (6 February 1945) 13–14.

This speech was delivered to the New Masses Cultural Awards Dinner. In

light of the Nazi attempts to destroy European culture, Weber exhorts artists to "abandon the Ivory Tower," reacquaint themselves with ancient and primitive art, and unite throughout the democratic countries to promulgate and protect their spiritual and cultural legacies.

1218 ———. "Distortion in Modern Art." *The League* [Art Students' League of New York] 6:2 (1934) [1].

Weber traces the notion of distortion back to archaic and primitive art and writes, "Distortion is born of a poetic impulse, it is the very quintessence of the finest and most subtle discernment and preference." He admonishes, however, that distortion, "if practiced by the incompetent and ungifted is indeed very repulsive and should by all means be severely criticized and discouraged."

1219 ———. *Essays on Art*. New York: William Edwin Rudge, 1916.

A collection of essays, written in the autumn of 1914, as a series of talks on art appreciation delivered at the Clarence H. White School of Photography. The essays are as follows: "Quality"; "Spiritual Tactility"; "Tradition and Now"; "Means"; "Things"; "Preparing to See"; "The Urge in Art"; "Revelation"; "Art Consciousness"; "Purity in Art"; "The Equilibrium of the Inanimate"; "Art Purpose."

1219A ———. "Fads and Academies." *Reality: A Journal of Artists' Opinions* no. 2 (Spring 1954) 1.

In this brief statement, Weber says that modern art has become subservient to passing fads and thereby has lost its connection with the infinite, the universal, and the eternal. He counsels artists to infuse their work with "human passion, pathos, elequence [*sic*], spiritual aspiration and vision."

1220 ———. "The Filling of Space." *Platinum Print: A Journal of Personal Expression* 1 (December 1913) 6.

Weber offers his thoughts on the process of composition in photography and writes, "The photographer's art lies supremely in his choice or disposition of visible objects, as prompted and guided by his intellect and taste. His mind is his screen. He may shift objects, he may choose his position, he may vary the proportion and size of the rectangle bounding the picture or print."

1221 ———. "The Fourth Dimension from a Plastic Point of View." *Camera Work* no. 31 (July 1910) 25.

Weber asserts his belief in a fourth dimension, which he describes as "the consciousness of a great and overwhelming sense of space-magnitude in all directions at one time, and is brought into existence through the three known measurements."

1222 _____. "The Hidden Beauty." *Flair* 1 (March 1950) 106–107.
Weber discusses several of his woodblock prints, which are illustrated.

1223 _____. "Kultur-Gothic: Reflections on the Ruins of Rheims in the Centuries to Come." *New York Tribune* (14 December 1917) 10.
A letter to the editor (dated 11 December 1917), in which Weber ridicules German denials that they are not responsible for the damaged condition of the Rheims Cathedral.

1224 _____. "A Letter from Weber." *Walker Art Center Activities* 2 (November 1946) i–iii.
Weber's lengthy response to an invitation from the director of the Walker Art Center, Minneapolis, to comment on his painting *Motherhood*.

1225 _____. [Letter to Franklin D. Roosevelt.] *Art Front* 3 (October 1937) 6–7.
This letter, dated 11 August 1937, was written by Weber in his capacity as national chairman of the American Artists' Congress. He asks President Roosevelt "to please advise those at the head of the W.P.A. [Works Progress Administration] Art project not to dismiss either native or alien artists from the Art Project, and to replace artists who have already been discharged several weeks since." He also asks the president to establish a permanent Federal Art Project.

1226 _____. "The Matisse Class." New York: Forum Gallery, 1992.
In conjunction with its exhibition *Max Weber: An American in Paris*, 9 December 1992–23 January 1993, the Forum Gallery published the address that Weber delivered on 19 November 1951 at a symposium accompanying the Matisse retrospective exhibition held at the Museum of Modern Art, New York, 13 November 1951–13 January 1952. Weber recounts his experiences in Paris from 1905 to 1908, including his tutelage under Matisse in the Couvent des Oiseaux, his viewing French art in Parisian galleries, museums, and private collections; and his encounters with various individuals at the Friday evening salons hosted by Gertrude and Leo Stein. (The title comes from Weber's handwritten manuscript of the lecture that resides in the Archives of American Art, although no title was provided by the Forum Gallery.)

1227 _____. "The New Humanity in Modern Art." *The New York Call Magazine* (25 May 1919) sec. 2, pp. 2–3.
Weber sees modern art as universal, all-embracing, and rightfully serving its own ends, namely, "beauty, revelation, and prophecy."

1228 _____. "Painting: A Note on 'Talmudists.'" *The Menorah Journal* 23 (April–June 1935) 100.
Weber notes that his *The Talmudists* of 1934 was painted after a pilgrimage

that year to one of the oldest synagogues on the East Side of New York City and observing a discussion of the Talmud. He writes, "To witness a group of such elders bent down and intent upon nothing but the eternal quest and interpretation of the ethical and spiritual significance of the great Jewish legacy— the Torah—is for me an experience never to be forgotten."

1229 _____. *Primitives: Poems and Woodcuts*. New York: Spiral Press, 1926.

Weber's second published poetry collection. Sixteen poems are accompanied by eleven sepia woodcuts printed by Joseph Blumenthal and A. George Hoffman. Edition of 350 copies, signed by the artist and printed from hand-set type on English handmade paper. Introduction by Benjamin de Casseres.

1230 _____. *The Reminiscences of Max Weber*. New York: Oral History Research Office, Columbia University, 1958.

Transcribed tape-recorded interviews with Weber, totaling 520 pages, conducted by Carol S. Gruber between January and March 1958 in the artist's studio, 11 Hartley Road, Great Neck, New York. Weber discusses his career as a painter; his studies with Arthur Dow, Jean Laurens, and Henri Matisse; his travels in Europe; his relationship with Stieglitz; his opinions of art critics, juries, and galleries in the United States; and his views on art and artists, past and present.

1231 _____. "Rousseau as I Knew Him: Reminiscences upon a Retrospective." *Art News* 41 (15–28 February 1942) 17, 35.

Weber's reminiscence and assessment of Henri Rousseau were delivered as a lecture on 4 February 1942 at the Art Institute of Chicago on the occasion of the Henri Rousseau exhibition, 22 January–23 February. A copy of the complete thirty-six-page typescript resides in the files of the Whitney Museum of American Art, New York.

1232 _____. "These Hun Geniuses: What Reward Is Possible for Their Pretty Ways?" *New York Tribune* (12 January 1918) 8.

A letter to the editor (dated 2 January 1918), in which Weber questions the merits of German art, architecture, and sculpture.

1233 _____. *Things: An Essay and Woodblock Print*. Brooklyn, N.Y.: Pratt Adlib Press, 1960.

This book contains a reprint of Weber's essay "Things," from *Essays on Art* (see entry 1219), and a woodblock print. Edition of 300.

1234 _____. "To Xochipilli, Lord of Flowers." *Camera Work* no. 33 (January 1911) 34.

A poem concerning a primitive Mexican sculpture.

1235 ———. "Why Blame the Jews? They Are Doing Their Part to Uphold This Government." *New York Tribune* (27 October 1917) 10.

A letter to the editor (dated 24 October 1917), which Weber wrote in response to L.T. Heatley's anti-Semitic letter "Fighting Law and Order," *New York Tribune* (24 October 1917) 10.

1236 ———. *Woodcuts and Linoleum Blocks*. New York: E. Weyhe, 1956.

A book of thirty-one woodcut and linoleum block prints that were printed from the original blocks at the Spiral Press. In his introduction, Weber notes, "Most of the small abstract woodcuts were made in 1918. . . . The large figurative woodcuts were made more recently." Edition of 225, with twenty-five copies issued with an additional portfolio of prints signed by the artist.

II. BOOKS AND EXHIBITION CATALOGUES

1237 Alpine Club Gallery. *Grafton Group Exhibition*. [London: The Gallery, 1913.]

Catalogue of an exhibition held at the Alpine Club Gallery, London, England, 15–31 March 1913. Weber exhibited eleven works at the invitation of Roger Fry.

1238 American Academy of Arts and Letters. Art Gallery. *Max Weber, 1881–1961—Memorial Exhibition: Paintings, Drawings, Sculpture*. New York: The Academy, 1962.

Catalogue of an exhibition held at the Art Gallery of the American Academy of Arts and Letters, New York, 19 January–18 February 1962. Essay by Leon Kroll.

1239 Amishai-Maisels, Ziva. *Depiction and Interpretation: The Influence of the Holocaust on the Visual Arts*, 306–308. Oxford: Pergamon Press, 1993.

In Chapter 6, "Jewish Identity," Amishai-Maisels discusses a number of Weber's works on Jewish themes. The author's detailed and extensively documented footnotes are especially noteworthy.

1240 Associated American Artists. *Max Weber—Lithographs*. New York: Associated American Artists, 1970.

Catalogue of an exhibition held at Associated American Artists, New York, 2–28 November 1970. The catalogue contains a foreword by Una E. Johnson; an introduction by Sylvan Cole, Jr.; illustrations of fifty-two lithographs; a biographical sketch of the artist; and a chronology.

1241 Associated American Artists' Galleries. *Max Weber*. New York: The Galleries, 1941.

Catalogue of an exhibition of forty-five oils and five gouaches held at the

Associated American Artists' Galleries, New York, 11 February–3 March 1941. Introduction by Donald J. Bear.

1242 Baigell, Matthew. *Jewish-American Artists and the Holocaust*, 9–10. New Brunswick, N.J.: Rutgers University Press, 1997.

 A brief discussion of Weber's *Whither Now?* of 1938, accompanied by an excerpt from "The Reminiscences of Max Weber" (see entry 1230).

1243 Bernard Danenberg Galleries. *Exhibition and Sale of Max Weber Drawings*. New York: The Gallery, 1972.

 Catalogue of an exhibition and sale held at the Bernard Danenberg Galleries, New York, 9–27 May 1972. The catalogue contains illustrations of nineteen works (one in color), a chronology, a list of one-man exhibitions, and a list of Weber's works in public collections.

1244 _____. *Fifty Years of Painting by Max Weber*. New York: The Galleries, 1969.

 Catalogue of an exhibition held at the Bernard Danenberg Galleries, New York, 15 April–10 May 1969, which includes thirty-one oils, eleven pastels, six gouaches, and eleven watercolors (fifty-one are illustrated, two in color). The catalogue contains a chronology and a list of one-man exhibitions. Lloyd Goodrich's essay is reprinted from *New Art in America* (see entry 1306).

1245 _____. *Max Weber: Early Works on Paper*. New York: The Galleries, [1971].

 Catalogue of an exhibition held at the Bernard Danenberg Galleries, New York, 27 April–15 May 1971, which includes forty-eight drawings, gouaches, pastels, and watercolors executed between 1909 and 1917 (all are illustrated, eight in color). The exhibition was also shown at the Adelson Galleries, Boston, 24 May–19 June 1971, and that catalogue bears a different imprint on the title page. The catalogue contains a chronology; lists of one-man exhibitions and works in public collections; and a checklist of the exhibition. Foreword by Alfred Werner.

1246 Boston University. School of Fine and Applied Arts. Art Gallery. *Max Weber, 1881–1961; Memorial Exhibition: Paintings, Drawings, Sculpture*. Boston: The Gallery, [1962].

 Catalogue of an exhibition held at the Boston University Art Gallery, Boston, 10–31 March 1962. The exhibition included 104 oils, watercolors, gouaches, drawings, lithographs, woodcuts, and sculptures (four works are illustrated in black and white). The catalogue contains an essay by Lillian Fortess and a checklist of the exhibition.

1247 Cahill, Holger. *Max Weber*. New York: Downtown Gallery, 1930.

Cahill provides a forty-five-page overview of Weber's early career, including an analysis of his influences and stylistic development, emphasizing the personal expressiveness, harmony, and equilibrium in the artist's work. Thirty-two paintings, drawings, prints, and sculptures are reproduced on black-and-white plates. The book concludes with a checklist of thirty-eight lithographs executed between 1918 and 1930.

1248 Carnegie Institute. Department of Fine Arts. *Exhibition of Paintings by Max Weber*. Pittsburgh: The Institute, 1943.

Catalogue of an exhibition of fifty-three works held in Galleries E and F, Department of Fine Arts, Carnegie Institute, Pittsburgh, 9 March–18 April 1943. The catalogue contains a biographical note and seven illustrations.

1249 College of William and Mary. Joseph and Margaret Muscarelle Museum of Art. *Into the Melting Pot: The Immigration of American Modernism (1909–1929)*. Williamsburg, Va.: The Museum, 1984.

Catalogue of an exhibition held at the Joseph and Margaret Muscarelle Museum of Art, College of William and Mary, Williamsburg, Virginia, 8 October 1984–10 January 1985, which includes six works by Weber (all illustrated in black and white). The catalogue contains an essay by Percy North and a biographical note.

1250 Downtown Gallery. *Max Weber: The Figure in Retrospect, 1906–1958*. New York: The Gallery, [1958].

Catalogue of an exhibition held at the Downtown Gallery, New York, 11 November–6 December 1958. The exhibition included thirty-three oils and gouaches (eight are illustrated in black and white) and an unspecified number of drawings from 1906 (one is illustrated on the front cover). The catalogue contains an essay by Jerome Klein on Weber's figurative work, a list of public collections owning the artist's paintings, and a checklist of the exhibition.

1251 *Exposition Max Weber*. Paris: Bernheim-Jeune, 1924.

Catalogue of an exhibition of sixty-four works (four illustrated), held at the Galerie Bernheim-Jeune, Paris, France, 26 January–13 February 1924.

1252 Forum Gallery. *Max Weber*. New York: The Gallery, 1975.

Catalogue of an exhibition held at the Forum Gallery, New York, 25 October–14 November 1975. The exhibition included ninety-three works (nine are illustrated, two in color).

1253 _____. *Max Weber: Cubist Visions, Early and Late*. New York: The Gallery, 1986.

Catalogue of an exhibition held at the Forum Gallery, New York, November

1986. The catalogue contains seven illustrations (five in color); essays by Percy North and Joy S. Weber; and a chronology.

1253A _____. *Max Weber: Discoveries*. New York: The Gallery, 1999.
Catalogue of an exhibition held at the Forum Gallery, New York, 14 January–20 February 1999. The exhibition featured thirteen figurative works and still lifes executed between 1907 and 1955 (all are illustrated on color plates). Essay by Percy North.

1254 _____. *Max Weber: Max Weber's Women*. New York: The Gallery, 1996.
Catalogue of an exhibition held at the Forum Gallery, New York, 6 February–9 March 1996. Although no checklist of the exhibition is provided, there are eighteen color illustrations of works featuring the female figure executed between 1906 and 1956. Essay by Percy North.

1255 _____. *Max Weber: Sculpture, Drawings and Prints*. New York: The Gallery, 1979.
Catalogue of an exhibition held at the Forum Gallery, New York, 27 October–24 November 1979. The exhibition featured 115 works, including sixty-eight sculptures (sixteen works are illustrated, one in color). Essay by Ellen Schwartz.

1256 _____. *Max Weber: Works on Paper*. New York: The Gallery, 1975.
Catalogue of an exhibition held at the Forum Gallery, New York, 15 February–7 March 1975, which includes twenty-seven works executed in gouache, pastel, or a combination of the two. Seven works are illustrated (one in color). The catalogue contains a chronology, a list of one-man exhibitions, a list of public collections owning the artist's work, and a checklist of the exhibition. Preface by Bella Fishko.

1257 Genauer, Emily. *Best of Art*, 141–143. Garden City, N.Y.: Doubleday, 1948.
Genauer discusses Weber's *Guitar Player*, which is illustrated on a color plate.

1257A Gerald Peters Gallery. *Max Weber*. Santa Fe, N.M.: The Gallery, 2000.
Catalogue of an exhibition held at the Gerald Peters Gallery, Santa Fe, New Mexico, 4 May–10 June 2000. The exhibition included over fifty works from the Weber estate executed between 1906 and 1956, all illustrated in color. The catalogue contains a foreword by Joy S. Weber, an essay by Percy North, and a chronology.

1258 Harbor Gallery. *Max Weber: The Collected Woodcuts*. Cold Spring Harbor, N.Y.: The Gallery, [1973].

Catalogue of an exhibition held at the Harbor Gallery, Cold Spring Harbor, New York, 27 May–23 June 1973. The catalogue contains a foreword by Joy S. Weber and a statement by the artist.

1259 Henderson, Linda Dalrymple. *The Fourth Dimension and Non-Euclidian Geometry in Modern Art*, 167–182. Princeton, N.J.: Princeton University Press, 1983.

Henderson devotes a subsection of Chapter 4, "The Fourth Dimension and Non-Euclidian Geometry in America," to the intellectual background of Weber's theory of the fourth dimension, including a comparison of his theory with that of Guillaume Apollinaire. She also examines the ways in which this idea was reflected in Weber's art and the influence that it had on the Stieglitz Circle.

1260 High Museum of Art. *Max Weber: The Cubist Decade, 1910–1920*. Atlanta, Ga.: The Museum, 1991.

Catalogue of an exhibition held at the High Museum of Art, Atlanta, Georgia, 10 December 1991–9 February 1992. The exhibition included seventy-five works executed between 1910 and 1919 (the majority are illustrated, twenty-one in color). Percy North's essay provides a detailed examination of Weber's artistic activities from the time of his return to America from Europe in 1909 until the end of his Cubist period in 1919. The catalogue contains an introduction by Susan Kranc; a chronology; a selection of Weber's writings; a selected bibliography; numerous documentary photographs and illustrations; and a checklist of the exhibition.

1261 Jewish Museum of the Jewish Theological Seminary of America. *An Exhibition of Oil and Tempera Paintings, Gouaches, Pastels, Woodcuts, Lithographs and Drawings by Max Weber, Celebrating the Artist's 75th Birthday*. New York: The Museum, 1956.

Catalogue of an exhibition held at the Jewish Museum of the Jewish Theological Seminary of America, New York, 2 March–31 May 1956. The exhibition featured forty-five oils, four temperas, two pastels, eighteen gouaches, eight drawings, sixteen woodcuts, and eight lithographs (ten works are illustrated in black and white). The catalogue contains an introduction by Stephen S. Kayser, biographical notes, and a checklist of the exhibition.

1262 Kampf, Avram. *Jewish Experience in the Art of the Twentieth Century*. South Hadley, Mass.: Bergin and Garvey, 1984.

In Chapter 6, "The Evocation of the Religious Tradition," Kampf discusses the Jewish themes in Weber's work, focusing on *Invocation* of 1919, *The Talmudists* of 1934, and *Adoration of the Moon* of 1944.

1263 Leonard, Sandra E. *Henri Rousseau and Max Weber*. New York: Richard L. Feigan, 1970.

Leonard's scholarly study of the friendship between Rousseau and Weber was published to accompany the exhibition of Weber's collection of Rousseau paintings and drawings held at Richard L. Feigan and Co., New York, 15 April–31 May 1969. The book contains a selection of correspondence between the two artists, seventeen black-and-white illustrations, and a bibliography.

1264 Marter, Joan, Roberta K. Tarbell, and Jeffrey Wechsler. *Vanguard American Sculpture, 1913–1939*. [New Brunswick, N.J.]: Rutgers University Art Gallery, Rutgers, the State University of New Jersey, with support from the National Endowment for the Arts, Washington, D.C., 1979.

Catalogue of an exhibition held at the Rutgers University Art Gallery, New Brunswick, New Jersey, 16 September–4 November 1979. The exhibition included three sculptures by Weber and one assemblage by Dove. In her catalogue essays, Tarbell discusses Weber's Cubist and nonobjective sculptures as experiments in three dimensions of ideas that he was exploring concurrently in his paintings (pp. 21–23) and his interest in African, Mayan, and Aztec sculpture (pp. 5–6, 33).

1265 *Max Weber: Retrospective Exhibition*. [New York]: Whitney Museum of American Art; [Minneapolis]: Walker Art Center, 1949.

Catalogue of an exhibition held at the Whitney Museum of American Art, New York, 5 February–27 March 1949, and the Walker Art Center, Minneapolis, 17 April–29 May 1949. The exhibition featured eighty oils; twenty-nine watercolors, gouaches, and pastels; eleven drawings; nineteen woodcuts; seven lithographs; and fourteen sculptures (thirty-seven works are illustrated, one in color). Lloyd Goodrich's essay provides a succinct analysis of Weber's career. The catalogue contains a biographical note and a selected bibliography.

1266 *Max Weber: The Years 1906–1916*. [S.l.: s.n., 1970]. (Philadelphia: Quality Lithographing).

Catalogue of an exhibition held at the Bernard Danenberg Galleries, New York, 12–30 May 1970, which traveled to twelve venues during 1970–1972. The exhibition included fifty-eight oils, watercolors, gouaches, and pastels (nine are illustrated in color). The catalogue contains a foreword by Bernard Danenberg; a checklist of the exhibition; a chronology; lists of one-man exhibitions and works in public collections; and a photograph of an exhibition at the Murray Hill Gallery, New York, which included three works by Weber.

1267 Meredith Long and Company. *Max Weber: Selected Works: 1908–1932*. Houston, Tex.: The Company, 1989.

Catalogue of an exhibition of nineteen works held at Meredith Long and Company, Houston, Texas, 31 January–3 March 1989. The catalogue contains brief information on exhibitions and museum collections owning Weber's work, illustrations of six works (two in color), and a checklist of the exhibition.

1268 Milwaukee Art Museum. *The Jewish Contribution in Twentieth-Century Art: Selections from the Permanent Collection.* Milwaukee: The Museum, 1993.

Catalogue of an exhibition held at the Milwaukee Art Museum, Milwaukee, 19 November 1993–9 January 1994. The exhibition included Weber's *Decoration with Red Table* of 1914 (not illustrated).

1269 Museum of Modern Art (New York). *Max Weber: Retrospective Exhibition, 1907–1930.* New York: The Museum, 1930.

Catalogue of an exhibition held at the Museum of Modern Art, New York, 13 March–2 April 1930, which includes ninety-eight works (eighteen are illustrated). The catalogue contains an introduction by Alfred H. Barr, Jr.; a chronology; six brief excerpts from exhibition reviews (1911–1912); and a checklist of the exhibition accompanied by Weber's notes on fourteen works.

1270 Newark Museum. *Max Weber: Retrospective Exhibition.* Newark, N.J.: The Museum, 1959.

Catalogue of an exhibition held at the Newark Museum, Newark, New Jersey, 1 October–15 November 1959, which includes sixty-three oils; twenty-seven sculptures; and forty-four drawings, gouaches, and lithographs (twenty-seven works are illustrated in black and white). The catalogue contains an essay by William H. Gerdts, Jr.; a checklist of the exhibition; and photographs of two installations at the Newark Museum that Weber coordinated in 1911 and 1913.

1271 North, Percy. *Max Weber: American Modern.* New York: Jewish Museum, 1982.

Catalogue of an exhibition held at the Jewish Museum, New York, 5 October 1982–16 January 1983, which includes eighty-five paintings; thirty-one drawings and watercolors; twenty-two graphic works; and twelve sculptures. In her lengthy essay, North discusses Weber's still lifes and interiors, figurative works, landscapes, views of New York, and sculpture. The catalogue contains a checklist of the exhibition; a list of one-man exhibitions; a selected bibliography; a title index; and eighty-seven illustrations (six in color).

1272 North Shore Child Guidance Association. *Arts Festival 1957.* Manhasset, N.Y.: The Association, 1957.

Catalogue of an exhibition sponsored by the North Shore Child Guidance Association, Manhasset, New York, 2–5 May 1957. Weber was presented with an honorary scroll by Lloyd Goodrich following introductory remarks by Stephen Kayser, which are reprinted. The catalogue contains a statement by the artist and a biographical profile.

1273 *Painting a Place in America: Jewish Artists in New York, 1900–1945—A Tribute to the Educational Alliance Art School,* edited by Norman L. Kleeblatt

and Susan Chevlowe. New York: Jewish Museum; Bloomington: Indiana University Press, 1991.

Catalogue of an exhibition held at the Jewish Museum at the New York Historical Society, 16 May–29 September 1991, which includes nine works by Weber. Matthew Baigell's essay "From Hester Street to Fifty-Seventh Street: Jewish-American Artists in New York" contains a subsection ("Max Weber and His Critics") in which he discusses the conflicting and confusing interpretations of the artist's work by leading art critics of the era. The catalogue also contains a brief biography of Weber accompanied by a selected exhibition history and bibliography (pp. 199–201).

1274 Phillips Memorial Gallery. *Cross Section Number One of a Series of Specially Invited American Paintings and Water Colors, with Rooms of Recent Work by Max Weber, Karl Knaths, Morris Graves.* Washington, D.C.: The Gallery, 1942.

Catalogue of an exhibition held at the Phillips Memorial Gallery, Washington, D.C., 15–31 March 1942. Weber had eleven works shown in Gallery A, one in the Main Gallery, and five in Print Room No. 1 (one is illustrated). The exhibition also included three works by Dove and two each by Hartley and Marin.

1275 Pratt Institute. Manhattan Center. *Max Weber, 1881–1961: A 10th Year Commemorative.* New York: The Center, 1971.

Catalogue of an exhibition held at the Pratt Institute Manhattan Center, New York, 13 October–2 November 1971. The catalogue contains a chronology and three black-and-white illustrations.

1276 Print Gallery. *Catalogue of an Exhibition of Paintings and Drawings by Max Weber.* New York: The Gallery, 1915.

Catalogue of an exhibition of eighteen works held at the Print Gallery, New York, 1–13 February 1915. The catalogue contains a statement by Weber.

1277 Riva Yares Gallery. *Milton Avery, Raphael Soyer, Max Weber.* Scottsdale, Ariz.: The Gallery, 1990.

Catalogue of an exhibition held at the Riva Yares Gallery, Scottsdale, Arizona, 15 March–14 April 1990. The exhibition featured thirteen works by Weber (six are illustrated in color). The catalogue contains a biographical sketch and a checklist of the exhibition.

1278 Rubenstein, Daryl R. *Max Weber: A Catalogue Raisonné of His Graphic Work.* Chicago: University of Chicago Press, 1980.

Rubenstein's catalogue raisonné contains 110 detailed entries on Weber's relief prints, lithographs, intaglio prints, monotypes, and silk-screen prints. His essay provides a thorough technical and stylistic analysis of these works. The book also includes a list of the artist's exhibitions that contained graphic art; a chronology; a list of prints in public collections; and a bibliography.

1279 _____. *Max Weber: Prints and Color Variations*. Washington, D.C.: National Collection of Fine Arts, Smithsonian Institution, 1980.

Catalogue of an exhibition held at the National Collection of Fine Arts, Smithsonian Institution, Washington, D.C., 11 July–5 October 1980, which includes fifty-one monotypes, relief prints, lithographs, lithotints, and related works. The catalogue contains an essay by Rubenstein, a checklist of the exhibition, and several illustrations (one in color).

1280 Santa Fe East. *Max Weber: An Exhibition of Works*. Santa Fe, N.M.: Santa Fe East, 1982.

Catalogue of an exhibition held at Santa Fe East, Santa Fe, New Mexico, 13 August–20 September 1982. The exhibition included six sculptures and thirty-nine oils, watercolors, gouaches, and pastels. The catalogue contains a foreword by Alma S. King; twenty-one black-and-white illustrations; a checklist of the exhibition; a chronology; a list of the artist's posthumous exhibitions; and a selected bibliography.

1281 School of the Museum of Fine Arts. School Galleries. *Max Weber: Exhibition of Paintings*. Boston: The School, 1945.

Catalogue of an exhibition of eleven works held at the Galleries of the School of the Museum of Fine Arts, Boston, 10–31 May 1945. Introduction by Russell T. Smith.

1282 University of California, Santa Barbara. Art Galleries. *First Comprehensive Exhibition in the West of Oils, Gouaches, Pastels, Drawings, and Graphic Works by Max Weber (1881–1961)*. Santa Barbara: The Galleries, 1968.

Catalogue of an exhibition held at the Art Galleries of the University of California, Santa Barbara, 6 February–3 March 1968. The exhibition included fifty-five oils, gouaches, and pastels; eighteen drawings; and fourteen lithographs (sixty-five works are illustrated). The catalogue contains an essay by Ala Story; a chronology; lists of one-man exhibitions and works in public collections; a selected bibliography; and a checklist of the exhibition.

1283 University of Minnesota, Duluth Branch. Department of Art. Tweed Gallery. *An Exhibition Commemorating the Dedication of Tweed Gallery, A Memorial to George Peter Tweed*. Duluth: The Gallery, 1958.

Catalogue of an exhibition of held at the Tweed Gallery, Department of Art, University of Minnesota, Duluth Branch, 19 October–23 November 1958, which includes six works by Weber (all illustrated).

1284 _____. *A Retrospective Exhibition of the Works of Max Weber*. Duluth: The Gallery, 1951.

Catalogue of an exhibition of seventy-seven works held at the Tweed Gallery, Department of Art, University of Minnesota, Duluth Branch, 2–25 May 1951. The catalogue contains a biographical profile and a checklist of the exhibition.

1285 Werner, Alfred. *Max Weber*. New York: H.N. Abrams, 1975.

Werner's monograph, which contains separate sections devoted to Weber's printmaking and Judaic themes, is accompanied by 160 plates (forty-nine in color). Werner, however, provides scant analysis of individual works, mentions Weber's relationship with Stieglitz only in passing, and has little to say about the artist's political activism or his theory of the fourth dimension. A chronology and bibliography are provided.

1286 Weyhe Gallery. *Max Weber: Woodcuts and Related Paintings*. New York: The Gallery, 1956.

Catalogue of an exhibition of nine paintings and an unspecified number of woodcuts, held at the Weyhe Gallery, New York, 26 November–22 December 1956.

1287 Wichita Art Museum. *Max Weber: Pioneer of American Modernism*. Wichita, Kans.: The Museum, 1983.

Catalogue of an exhibition held at the Wichita Art Museum, Wichita, Kansas, 6 March–10 April 1983. The exhibition included three sculptures and forty-six oils, watercolors, gouaches, pastels, and drawings (fourteen works are illustrated in black and white). Preface and essay by Howard E. Wooden.

III. ARTICLES AND ESSAYS

1288 "Art News International—Obituary: Max Weber." *Art News* 60 (November 1961) 8.

1289 "Art—Patriarch's Prizes." *Time* 39 (2 March 1942) 47–48.

A brief review of Weber's career, mentioning his receipt of three prizes in 1941: the Pennsylvania Academy's Temple Gold Medal; the Corcoran Biennial's $1,000 W.A. Clark Prize; and the Art Institute of Chicago's Ada S. Garrett Prize.

1290 *Artlover* 2:5 (1927).

This issue of *Artlover*, a periodical published by J.B. Neumann, is devoted to a catalogue of the exhibition *Max Weber: Recent Paintings*, held at Neumann's New Art Circle, New York, 12 March–9 April 1927.

1291 *Artlover* 3:3 (1935) 33–48.

Illustrations of fifteen works from the exhibition *Max Weber: New Paintings*, held at the New Art Circle, New York, November–December 1935, accompanied by J.B. Neumann's comments.

1292 *Artlover* 3:5 (1936) 65–80.

Illustrations of eight new works shown at J.B. Neumann's New Art Circle, New York, during 1935–1936.

1293 Bird, Paul. "A Weber Profile." *The Art Digest* 25 (1 July 1951) 6.
This biographical profile contains quotes of the artist.

1294 Bohn, Willard. "In Pursuit of the Fourth Dimension: Guillaume Apollinaire and Max Weber." *Arts Magazine* 54 (June 1980) 166–169.
Bohn traces the influence of Weber's article "The Fourth Dimension from a Plastic Point of View" (see entry 1221) on Apollinaire's theory of the fourth dimension as set forth in *Les Peintres Cubistes* (1913). He notes that for both men the fourth dimension essentially embodies the illusion of infinite space and the subjective perspective of the artist, which results in a personal and arbitrary reality arising from the creative imagination.

1295 Brian, Doris. "E Pluribus Weber—Out of Many Sources and Influences This Russian-born American Has Built His Own Style (Contemporary Contours No. 1)." *Art News* 40 (15–28 February 1941) 14–15, 38.
In tracing Weber's career, Brian notes the influence of Arthur Wesley Dow's beliefs that every part of a canvas must serve a function and that drawing must be done to the most strictly conservative standards. She also argues against the notion that Weber is an eclectic.

1296 Bridgman, Edward C. "Max Weber—Modernist." *Touchstone* 8 (January 1921) 319–320.
Bridgman's notes on his interview with Weber contain quotes of the artist.

1297 Brown, Milton W. "Max Weber, 'Jewish Artist'? The Painting of this Pioneer of Modern Art and Its Supposed 'Jewish' Nature." *The Jewish Survey* 1 (May 1941) 18–19.
Brown argues that the roots of Weber's art should be sought in modern French painting, African sculpture, and the art of Native Americans, India, Persia, and the Near East, rather than in any biblical sources. He does, however, readily acknowledge Weber's high ranking among contemporary Jewish artists.

1298 Burck, Jacob. "Max Weber—Reborn Artist: One of America's Great Painters Finds a New Contact with Life and Envisions a Greater Art." *Sunday Worker* [Magazine Section] (30 May 1937) 8.
Burck focuses on Weber's social concerns.

1299 Cahill, Holger. "Max Weber: A Reappraisal in Maturity." *Magazine of Art* 42 (April 1949) 128–133.
Cahill authored a monograph on Weber in 1930 (see entry 1247). In this reappraisal, he discusses Weber's religious themes, social concerns, artistic influences, and critical reception.

1300 Chanin, A.L. "American Pioneer." *The New York Times Magazine* (26 February 1956) 74–75.

This brief assessment of Weber's career includes the artist's comments on his work.

1301 DiFrederico, Frank. "Alvin Langdon Coburn and the Genesis of Vorto-graphs." *History of Photography* 11 (October–December 1987) 265–296.

In the subsection "Coburn and Weber," DiFrederico discusses Weber's relationship with the photographer Alvin Langdon Coburn in the context of the Stieglitz Circle. He compares Weber's oil *Woolworth Building* with Coburn's photograph *The House of a Thousand Windows*, both dating from 1912 (pp. 276–283).

1302 Edwards, Hugh. "Max Weber's Woodcuts." *Bulletin of the Art Institute of Chicago* 36 (December 1942) 98–99.

Edwards reprints passages from Weber's correspondence with the Art Institute of Chicago regarding the techniques that he used to produce his color woodblock prints.

1303 Farber, Manny. "Weber Answers Questions: Walking through His Retrospective at the Whitney, This Famous American Painter Talks about His Many Adventures in the Avant-Garde." *Art News* 48 (March 1949) 22–24, 56.

Farber's interview with Weber centers on his retrospective exhibition staged at the Whitney Museum of American Art (see entry 1265).

1304 "The Forty-First American Exhibition." *Bulletin of the Art Institute of Chicago* 22 (December 1928) 117.

Notice of Weber's winning the Potter Palmer Gold Medal and a $1,000 prize for his *Still Life* in the Art Institute of Chicago's 41st *Annual Exhibition of American Painting and Sculpture*, 25 October–16 December 1928.

1305 Gilliam, Florence. "Max Weber: Humanist." *The Menorah Journal* 11 (December 1925) 580–582.

This overview of Weber's aesthetic philosophy contains extensive quotes of the artist.

1306 Goodrich, Lloyd. "Max Weber." In *New Art in America*, edited by John I.H. Baur, 67–72. Greenwich, Conn.: New York Graphic Society, in cooperation with Praeger, New York, [1957].

A biographical sketch of Weber accompanied by six illustrations.

1307 Gregg, Frederick James. "Max Weber: A Leader in the New Art." *Vanity Fair* (September 1915) 36.

A short overview of Weber's career.

1308 Gutman, Walter. "American Lithography." *Creative Art* 5 (November 1929) 800–804.

Gutman appraises the work of seven American lithographers, including Weber. He remarks, "The deep black typical of lithography is given a soft bloom by Max Weber."

1309 Henderson, Linda Dalrymple. "Mabel Dodge, Gertrude Stein, and Max Weber: A Four-Dimensional Trio." *Arts Magazine* 57 (September 1982) 106–111.

Henderson discusses Weber's introduction of the fourth dimension to the Stieglitz Circle and the impact that this concept had on Mabel Dodge and Gertrude Stein.

1310 Holley, Horace. "The Seven Arts Chronicle for May—Max Weber's Book." *The Seven Arts* 2 (May 1917) 127–129.

A discussion of Weber's *Essays on Art* (see entry 1219).

1311 Johnson, Una E. "The Woodcuts and Lithographs of Max Weber." *Brooklyn Museum Bulletin* 9 (Summer 1948) 7–12.

Johnson's discussion of Weber's printmaking includes quotes of the artist on his working methods (six prints are illustrated).

1312 Kayser, Stephen S. "The Art of Max Weber." *The Reconstructionist* 22 (29 June 1956) 16–22.

Reprint of Kayser's introduction to the catalogue for Weber's retrospective exhibition held at the Jewish Museum (see entry 1261).

1313 Kenner, Hugh. "Brooklyn's Braque: How Max Weber Brought Cubism to America." *Art and Antiques* 9 (March 1992) 120.

Kenner provides a synopsis of Weber's Cubist work.

1314 Klein, Jerome. "Some Artists of the Past Season." *The Menorah Journal* 15 (August 1928) 143.

Klein offers some general comments on Weber's still lifes.

1315 Lane, John R. "The Sources of Max Weber's Cubism." *Art Journal* 35 (Spring 1976) 231–236.

In tracing the sources of Weber's work during 1909–1913 to the influence of Cézanne, Matisse, Picasso, and Braque, Lane focuses in particular on *Bathers* of 1909; *Surprise, Composition with Four Figures*, and *Composition with Three Figures*, all of 1910; and *Composition—Three Figures* of ca. 1911–1913. Lane believes that Weber did not follow Analytical Cubism to its most extreme formal complexity because he felt that it detracted from the immediate expressive im-

pact of his compositions. He turned instead to the vocabulary of Synthetic Cubism coupled with Futurist devices.

1316 Lawrence, Jacob. "Tribute to Max Weber—Delivered on His 75th Birthday at the N.Y. Equity Party at the Hotel Westover." *Artists Equity Association National Newsletter* (June 1956) 1, 6.
 In his tribute, Lawrence notes that Weber is "possessed with a profound empathy for his fellow men" and in whose life's work are "expressed with great poignancy the aspirations, sufferings, and joys of mankind."

1317 "Max Weber." *Baltimore Museum of Art News* 4 (February 1942) 14–15.
 Notice of an exhibition of Weber's work in the Members' Room for Modern Art, Baltimore Museum of Art, Baltimore, 13 February–14 March 1942. Weber was serving at the time as a member of the 10th Annual All-Maryland Exhibition Jury.

1318 "Max Weber." In *100 Contemporary American Jewish Painters and Sculptors*, 192–193. New York: YKUF Art Section, 1947.
 A brief biographical sketch accompanied by a statement by Weber.

1319 "Max Weber Dies; Painter, Was 80—A Pioneer of Modern Art in U.S. Was Noted for Hebraic Themes and Abstractions." *New York Times* (5 October 1961) 37.

1320 "Max Weber 1881–1961." *The Art Journal* 21 (Spring 1962) 176.
 An obituary.

1321 "Max Weber's Year." *The Art Digest* 19 (1 April 1941) 13.
 Notice of Weber's receipt of the $1,000 Clark Prize at the Corcoran Biennial and the Temple Gold Medal at the Pennsylvania Academy Annual. The article also notes that Weber's *Music* was acquired by the Brooklyn Museum (a related article appears on the preceding page of the same issue).

1322 Meixner, Mary. "Max Weber as Teacher." *College Art Journal* 56 (Spring 1957) 235–238.
 Meixner reminisces about her tutelage in 1956 under Weber during the second summer session at the University of Minnesota, Duluth Branch, where Weber was a guest instructor in the Department of Art. The article contains several quotes of the artist.

1323 Norman, Dorothy. "From the Writings and Conversations of Alfred Stieglitz." *Twice a Year* no. 1 (Fall–Winter 1938) 77–110.

In excerpt No. 8 (from his notes of 1938), Stieglitz wrote, "Weber had a knowledge of art only equalled in America by Arthur B. Davies."

1323A North, Percy. "Bringing Cubism to America—Max Weber and Pablo Picasso." *American Art* 14:3 (Fall 2000) 58–77.
North traces the influence of Picasso on Weber's Cubist work, which he argues is not derivative but unique in its focus on American subjects rather than the traditional imagery preferred by the French Cubists.

1324 _____. "Turmoil at 291." *Archives of American Art Journal* 24:1 (1984) 12–20.
North recounts the relationship between Stieglitz and Weber, which he describes as initially stimulating and challenging but eventually degenerating into a power struggle. The article is followed by a reprint of a lengthy letter from Stieglitz to Edith Gregor Halpert, dated 20 December 1930, in which Stieglitz responds to what he feels are "distortions and misrepresentations of historical facts" in Holger Cahill's *Max Weber* (see entry 1247). This letter contains excerpts from a twenty-four-page manuscript that Stieglitz wrote on 22 February 1923, known as "The Story of Weber" (see entry 164).

1325 O'Connor, John, Jr. " 'The Quartet' by Max Weber Purchased for the Permanent Collection through Patrons Art Fund." *Carnegie Magazine* 17 (February 1944) 273–275.
Notice of the purchase of Weber's *The Quartet* of 1939 by the Carnegie Museum of Art, Pittsburgh.

1326 Pagano, Grace. "Max Weber." In *Contemporary American Painting: The Encyclopaedia Britannica Collection*, Pl. 115. New York: Duell, Sloan and Pearce, 1945.
Pagano provides a brief sketch of Weber's career, accompanied by a statement by the artist on his *Discourse* of 1940, which is illustrated in color.

1327 Pearson, Ralph M. "The Artist's Point of View—Max Weber: Leading American Artist." *Forum and Century* 103 (March 1940) 96.
Pearson defends Weber's status as an American artist in light of his omission from two books on American art authored by Thomas Craven and Peyton Boswell, both published in 1939.

1328 Ricciotti, Dominic. "The Revolution in Urban Transport: Max Weber and Italian Futurism." *The American Art Journal* 16 (Winter 1984) 46–64.
Ricciotti explores the influence of Italian Futurism on Weber's New York cityscapes, including *Blue New York* of 1912; *New York* of 1913; *Chinese Restaurant, Grand Central Terminal*, and *Rush Hour, New York*, all of 1915; and the pastel *The City* of 1918.

1329 Riegner, Heinrich. "The amerikanische Maler Max Weber." *Werk* 37 (February 1950) 55–61.

An overview of Weber's career accompanied by five illustrations. Text in German with an abstract in English.

1330 Royer, Ed. "Max Weber: Godfather of Modern American Art." *Design* 49 (May 1948) 18, 21.

Royer's summary of Weber's career is interspersed with excerpts from the artist's writings.

1331 Salpeter, Harry. "The Human Touch—Max Weber." *The American Hebrew* (9 May 1941) 6.

For a fuller assessment of Weber's achievement, see Salpeter's earlier article in *Esquire* (entry 1332).

1332 ———. "Max Weber: Artist-Scholar." *Esquire* 10 (November 1938) 62–65, 163–167.

In his overview of Weber's career, Salpeter writes that the artist "combines in himself the qualities of poet and builder, of dreamer and workman. . . . Max Weber is simple and complex, subtle and profound, a conservor of the abiding values in art."

1333 Sargeant, Winthrop. "Max Weber: A Great Neck Poet and Philosopher Is the Pioneer of Modern Art in America." *Life* 19 (20 August 1945) 84–87.

This personal profile is accompanied by illustrations of eight paintings and sculptures (five in color); two photographs of Weber (one in his studio and the other with his family at home); and quotes of the artist.

1334 Schwartz, Sanford. "Indignant Max Weber." In *The Art Presence*, by Sanford Schwartz, 76–85. New York: Horizon Press, 1982.

Schwartz provides an overview of Weber's career, including discussions of his influences and critical reception.

1335 Scott, Temple. "Fifth Avenue and the Boulevard Saint-Michel." *The Forum* 44 (December 1910) 665–685. Reprinted in *The Silver Age*, by Temple Scott, 143–174. New York: Scott and Seltzer, 1919.

A short story based on the Stieglitz Circle's regular lunches at Holland House. The character named Weaver (who represents Weber) is presented as the group's only adherent to the idea of the fourth dimension. The other characters are generally presumed to represent Stieglitz, Marin, Benjamin de Casseres, J. Nilson Laurvik, and Charles H. Caffin.

1336 Silverstein, Adolph J. "Max Weber Harkens to Voice of Time." *The American Hebrew* 127 (19 September 1930) 474, 525, 529.

This discussion of the Judaic influences on Weber's work contains extensive quotes of the artist.

1337 Soby, James Thrall. "Max Weber and Edward Hopper." In *Contemporary Painters*, [2d ed.], by James Thrall Soby, 28–34. New York: Museum of Modern Art: Distributed by Simon and Schuster, 1948.
Soby's survey of Weber's achievement focuses on his European influences.

1338 "Studio War Art." *Life* 16 (12 June 1944) 76, 78.
A selection of works produced by painters who were not on the front lines. It includes Weber's painting of the Spanish civil war, *Fighters for Freedom* of 1936, which is reproduced in color and accompanied by caption comments.

1339 Strawn, Arthur. "Rebel Triumphant." *Outlook and Independent* 156 (29 October 1930) 351.
This brief appreciation of Weber includes an anecdote about the artist defending a Pissarro painting to a student at the Metropolitan Museum of Art in New York.

1340 Sweeney, James Johnson. "Art Chronicle." *Partisan Review* 11 (Spring 1944) 175–176.
Sweeney's analysis of Weber's work notes its Cubist and Futurist influences and its "curious affinity" with the works of Marc Chagall.

1341 Thurlow, Fearn C. "The Dana Influence: The Newark Museum Collections—Painting and Sculpture." *The Newark Museum Quarterly* 30 (Fall 1979) 15–20.
In this article on John Cotton Dana, the founder and first director of the Newark Museum, Thurlow briefly discusses Weber's role in planning several early exhibitions at the museum. Two excerpts from his correspondence with Dana are reprinted.

1342 "U.S. Art—Max Weber." *Time* 39 (4 May 1942) 66.
Three color illustrations (*Gaillardias, Straggly Pines*, and *The Builders*), accompanied by brief comments.

1343 Watson, Forbes. "Max Weber—1941." *Magazine of Art* 34 (February 1941) 78–83.
Watson draws upon his conversations with Weber for this article, which was published to coincide with the artist's exhibition at the Associated American Artists' Galleries (see entry 1241). In contrast to other critics, Watson does not feel that Weber's post-Cubist output represented a decline. He believes instead that "[i]t was when the Hebraic quality came into Weber's work that his destiny as a great modern religious painter began to show fulfillment."

1344 Werner, Alfred. "The Eternal Youth of Max Weber." *Painter and Sculptor* 4 (Winter 1960–61) 5–12.

Werner reviews Weber's European influences. He also comments on the varied subject matter that Weber treated between 1920 and 1960, which included industrial scenes, flower still lifes, and Judaic themes.

1345 _____. "Ghetto Graduates." *The American Art Journal* 5 (November 1973) 71–82.

Werner's survey of Jewish immigrant artists of the twentieth century includes a brief discussion of Weber's early religious experiences in Bialystok and Brooklyn (p. 73). He also discusses the critical reaction to Weber's depiction of the Jewish community on the Lower East Side (pp. 81–82).

1346 _____. "Max Weber at Seventy-Seven: The Veteran Modernist Painter Looks Back on an Historic Career Which Began at the Turn of the Century." *Arts* 32 (September 1958) 26–29, 64.

Weber's reminiscences about his career, as recorded by Werner, are interspersed with comments about other artists, including Arthur Wesley Dow, Henri Rousseau, Henri Matisse, Alfred Maurer, and Joseph Brummer.

1347 _____. "Max Weber: Great and Humble." *The Chicago Jewish Forum* 14 (Winter 1955–1956) 94–99.

Werner discusses Weber's artistic development, aesthetic philosophy, Jewish themes, and critical reception.

1348 _____. "Max Weber: Hasidic Painter." *Judaism* 9 (Summer 1960) 260–268.

Werner emphasizes Weber's spirituality and his uncompromising adherence to his conscience and artistic principles, even in the face of the hostile reception that his work was given by many art critics early in his career.

1349 _____. "Max Weber's Triumph." *The Jewish Chronicle* (26 August 1955) 15.

A biographical sketch.

1350 _____. "The Quiet Genius of Max Weber." *Jewish Heritage* 7 (Fall 1964) 22–29.

This covers much the same ground as Werner's earlier article in *Judaism* (see entry 1348).

1351 _____. "Who Is Max Weber?" *Art and Artists* 6 (April 1971) 20–23.

This biographical sketch was written with the aim of making Weber's achievement better known in Europe.

1352 Williams, Dave and Reba Williams. "The Influence of Picasso on American Printmakers." *Print Quarterly* 13 (September 1996) 259–286.

This article includes a brief look at Picasso's influence on Weber's lithograph *Repose* of 1928, which is illustrated.

IV. EXHIBITION REVIEWS

1353 "Exhibitions Now On: Weber at Haas Gallery." *American Art News* 7 (1 May 1909) 6.

Review of the *Exhibition of Paintings and Drawings by Max Weber*, held at the Haas Gallery, New York, 22 April–8 May 1909, which was Weber's first one-man show.

1354 "The Exhibitions at '291'—Max Weber Exhibition." *Camera Work* no. 36 (October 1911) 29, 31–34, 45–47.

Review of *An Exhibition of Paintings and Drawings by Mr. Max Weber, of New York*, held at the Photo-Secession Galleries, New York, 11–31 January 1911, and reprinted reviews by Arthur Hoeber (*New York Globe*), J. Edgar Chamberlin (*Evening Mail*), Henry Tyrrell (*Evening World*), B.P. Stephenson (*Evening Post*), James B. Townsend (*American Art News*), Israel White (*Newark Evening News*), Elizabeth Luther Cary (*New York Times*), Mr. Harrington (*New York Herald*), Royal Cortissoz (*New York Tribune*), and James Huneker (*New York Sun*).

1355 "Exhibitions Now On: Weber's Weird Work." *American Art News* 9 (21 January 1911) 6.

Review. See entry 1354.

1356 "Photo-Secession Notes." *Camera Work* no. 38 (April 1912), 43–44.

Reprinted review by Hutchins Hapgood (*New York Globe*) of the *Exhibition of Paintings and Drawings by Max Weber*, held at the Murray Hill Gallery, New York, 12–24 February 1912.

1357 Dana, John Cotton. "Paintings by Max Weber." *The Newark Museum Bulletin* 3 (July 1913) 1–6.

Review of the exhibition *Paintings by Max Weber*, held at the Newark Museum, Newark, New Jersey, June–July 1913. The review is followed by a checklist of the exhibition.

1358 "Exhibitions in the Galleries: Max Weber, Conscious Modern." *Arts and Decoration* 6 (February 1916) 185.

Review of the *Exhibition of Paintings and Sculpture by Max Weber*, held at the Montross Gallery, New York, 14–30 December 1915.

1359 McBride, Henry. "Max Weber at Montross." In *The Flow of Art: Essays and Criticisms of Henry McBride*, edited by Daniel Catton Rich, 92–96. New York: Atheneum, 1975.
Review (reprinted from *New York Sun*, 19 December 1915). See entry 1358.

1360 "Modern Expressions in Painting and Sculpture." *Vanity Fair* 5 (February 1916) 65.
Review. See entry 1358.

1361 Brook, Alexander. "March Exhibitions—Max Weber." *The Arts* 3 (March 1923) 212.
Review of the *Exhibition—Max Weber*, held at the Montross Gallery, New York, 12 February–3 March 1923.

1362 McBride, Henry. "Modern Art." *The Dial* 74 (April 1923) 424–425. *The Flow of Art: Essays and Criticisms of Henry McBride*, edited by Daniel Catton Rich, 172–175. New York: Atheneum, 1975.
Review. See entry 1361.

1363 "Weber Show Strong, Varied." *American Art News* 22 (17 February 1923) 5.
Review. See entry 1361.

1364 Barker, Virgil. "Notes on the Exhibitions." *The Arts* 5 (June 1924) 342.
Review of the exhibition *Max Weber: Small Paintings*, held at J.B. Neumann's Print Room, New York, 13 May–21 June 1924.

1365 Lozowick, Louis. "Jewish Artists of Season." *The Menorah Journal* 10 (June 1924) 282–285.
Review. See entry 1364.

1366 McBride, Henry. "Modern Art." *The Dial* 78 (April 1925) 346–348.
Review of the exhibition *Max Weber: Recent Paintings*, held at J.B. Neumann's Print Room, New York, 7 February–7 March 1925.

1367 Schnackenberg, Henry. "New York Exhibitions—Max Weber." *The Arts* 7 (March 1925) 164.
Review. See entry 1366.

1368 "Exhibitions in New York—Max Weber." *The Art News* 25 (19 March 1927) 9.
Review of the exhibition *Max Weber: Recent Paintings*, held at J.B. Neumann's New Art Circle, New York, 12 March–9 April 1927.

1369 Goodrich, Lloyd. "In the New York Galleries." *The Arts* 11 (April 1927) 210.
Review. See entry 1368.

1370 McBride, Henry. "Modern Art." *The Dial* 83 (July 1927) 86.
Review. See entry 1368.

1371 "New York Season." *The Art Digest* 1 (1 April 1927) 16.
Review (plus reprinted review excerpts from the *New York Sun, New York World*, and *New York Times*). See entry 1368.

1372 Pemberton, Murdock. "The Art Galleries: Geniuses—Hot, Cold, and Nine Days Old." *The New Yorker* (26 March 1927) 90–91.
Review. See entry 1368.

1373 "Exhibitions in New York—Max Weber: Neumann Gallery." *The Art News* 26 (18 February 1928) 11.
Review of the exhibition *Max Weber: Gouaches and Watercolors*, held at J.B. Neumann's New Art Circle, New York, 9–29 February 1928.

1374 Pemberton, Murdock. "The Art Galleries: Late Rewards, Newcomers, and a Little Dash of French." *The New Yorker* 4 (10 November 1928) 102.
Review of the exhibition *Max Weber Lithographs*, held at the Downtown Gallery, New York, 29 October–17 November 1928.

1375 "In the Galleries." *The Arts* 16 (March 1930) 514.
Review of the *Max Weber: Retrospective Exhibition, 1907–1930*, held at the Museum of Modern Art, New York, 13 March–2 April 1930.

1376 Mannes, Marya. "Exhibitions." *International Studio* 95 (April 1930) 76.
Review. See entry 1375.

1377 "Modern Museum Shows Weber, Klee, Maillol, Lehmbruck." *The Art News* 28 (15 March 1930) 3, 11.
Review. See entry 1375.

1378 Pemberton, Murdock. "The Art Galleries—One German and a Lot of Americans." *The New Yorker* 6 (29 March 1930) 81–82.
Review. See entry 1375.

1379 Watson, Forbes. "In the Galleries—Max Weber." *The Arts* 16 (March 1930) 514.
Review. See entry 1375.

1380 ———. "In the Galleries—The Museum of Modern Art." *The Arts* 16 (April 1930) 567–568.
　　Review. See entry 1375.

1381 "Current Exhibitions of Interest." *Parnassus* 2 (April 1930) 7.
　　Review of the exhibition *Paintings and Gouaches by Max Weber*, held at J.B. Neumann's New Art Circle, New York, 10–29 March 1930.

1382 "Exhibitions in New York Galleries: Max Weber—New Art Circle." *The Art News* 28 (22 March 1930) 20.
　　Review. See entry 1381.

1383 Flint, Ralph. "Around the Galleries." *Creative Art* 6 (April 1930) suppl.-88.
　　Reviews. See entries 1375 and 1381.

1384 McMahon, Audrey. "A Perspective of the New York Season." *Parnassus* 2 (May 1930) 4–5.
　　Reviews. See entries 1375 and 1381.

1385 "Exhibitions in New York: Max Weber, Wassily Kandinsky, Paul Klee—New Art Circle." *The Art News* 34 (9 November 1935) 8.
　　Review of the exhibition *Paintings and Watercolors by Wassily Kandinsky, Paul Klee, and Max Weber*, held at J.B. Neumann's New Art Circle, New York, 4–16 November 1935.

1386 Benson, E.M. "Exhibition Reviews—New Paintings by Weber at the New Art Circle." *The American Magazine of Art* 29 (January 1936) 41–42.
　　Review of the exhibition *New Work by Max Weber*, held at J.B. Neumann's New Art Circle, New York, 25 November–21 December 1935.

1387 "Exhibitions in New York: Max Weber—New Art Circle." *The Art News* 34 (30 November 1935) 18–19.
　　Review. See entry 1386.

1388 Mumford, Lewis. "The Art Galleries: Leaves from a Notebook." *The New Yorker* 11 (14 December 1935) 96.
　　Review. See entry 1386.

1389 "Weber Develops a 'More Individual Quality.'" *The Art Digest* 10 (15 December 1935) 13.
　　Review. See entry 1386.

1390 Davidson, Martha. "New Exhibitions of the Week—A Retrospective of Max Weber." *The Art News* 36 (13 November 1937) 19.

Review of the *Max Weber Retrospective Exhibition: Still Lives 1907–1930*, held at J.B. Neumann's New Art Circle, New York, 1–27 November 1937.

1391 "Arts—Can They Draw? Yes." *Newsweek* 12 (12 December 1938) 21–22.

Review of the exhibition *Can We Draw?*, held at the A.C.A. Gallery, New York, which featured the works of twelve artists who had failed the New York Board of Art Examiners drawing test early in their careers. Weber's *The River* of 1926, which received its first public showing, is illustrated.

1392 Coates, Robert M. "The Art Galleries: From Rodin On—And Up." *The New Yorker* 17 (1 March 1941) 37–38.

Review of the exhibition *Max Weber*, held at the Associated American Artists' Galleries, New York, 11 February–3 March 1941.

1393 Devree, Howard. "New York Letter." *Magazine of Art* 34 (March 1941) 142–143.

Review. See entry 1392.

1394 "Max Weber, at 60, Holds Exciting Show." *The Art Digest* 15 (15 February 1941) 7, 30.

Review. See entry 1392.

1395 Brian, Doris. "The Passing Shows—Max Weber's Most Fruitful Year." *Art News* 41 (15–31 March 1942) 25.

Review of the exhibition *Recent Works by Max Weber*, held at Paul Rosenberg and Co., New York, 10 March–4 April 1942.

1396 Coates, Robert M. "The Art Galleries: The Douanier Rousseau—Two Americans." *The New Yorker* 18 (28 March 1942) 60–61.

Review. See entry 1395.

1397 Farber, Manny. "Max Weber and Paul Cézanne." *Magazine of Art* 35 (December 1942) 294–295.

Review. See entry 1395.

1398 "Max Weber Again." *The Art Digest* 16 (15 March 1942) 15.

Review. See entry 1395.

1399 "The Passing Shows." *Art News* 42 (15–31 March 1943) 23.

Review of the exhibition *Recent Paintings by Max Weber*, held at Paul Rosenberg and Co., New York, 2 March–3 April 1943.

1400 Riley, Maude. "Max Weber Presents His Latest Canvases." *The Art Digest* 17 (15 March 1943) 11.
Review. See entry 1399.

1401 O'Connor, John, Jr. "Max Weber: Exhibition of His Paintings at the Carnegie Institute from March 9 to April 18." *Carnegie Magazine* 16 (March 1943) 302–306.
Review of the *Exhibition of Paintings by Max Weber*, held in Galleries E and F, Department of Fine Arts, Carnegie Institute, Pittsburgh, 9 March–18 April 1943.

1402 Brian, Doris. "Last Word on Weber—A Long-Awaited Full-Length of America's No. 1 Experimentalist." *Art News* 42 (1–14 February 1944) 18–19, 28.
Review of the *Retrospective Exhibition of Paintings by Max Weber*, held at Paul Rosenberg and Co., New York, 11 January–12 February 1944. *Interior with Still-Life* of 1932 is illustrated on a color plate.

1403 Riley, Maude. "Max Weber in Retrospective Exhibition." *The Art Digest* 18 (15 January 1944) 6.
Review. See entry 1402.

1404 Breuning, Margaret. "Weber on Review." *The Art Digest* 19 (15 February 1945) 8.
Review of the exhibition *Recent Paintings by Max Weber*, held at Paul Rosenberg and Co., New York, 5 February–3 March 1945.

1405 Louchheim, Aline B. "Max Weber: Late Edition." *Art News* (15–28 February 1945) 18–19.
Review. See entry 1404.

1406 "The Passing Shows: Max Weber—Early Power, Late Works." *Art News* 45 (March 1946) 52.
Review of the exhibition *Recent Paintings by Max Weber*, held at Paul Rosenberg and Co., New York, 4–30 March 1946.

1407 Wolf, Ben. " 'Blue Period' Max Webers in Exciting Show." *The Art Digest* 20 (1 March 1946) 11.
Review. See entry 1406.

1408 Bartsch, Walter Frederick. "Review: Max Weber." *Critique* 1 (October 1946) 30–31.
Review of the exhibition *Gouaches and Pastels by Max Weber*, held at Paul Rosenberg and Co., New York, 14 October–9 November 1946.

1409 "Reviews and Previews." *Art News* 45 (October 1946) 62.
Review. See entry 1408.

1410 Wolf, Ben. "Tracing Weber." *The Art Digest* 21 (15 October 1946) 14.
Review. See entry 1408.

1411 Lansford, Alonzo. "Four Americans." *The Art Digest* 21 (15 April 1947)
21.
Review of the exhibition *Paintings by Avery—Knaths—Rattner—Weber*, held
at the Rosenberg Galleries, New York, 31 March–19 April 1947.

1412 Louchheim, Aline B. "Spotlight On: Weber." *Art News* 46 (November
1947) 36.
Review of the exhibition *Recent Paintings by Max Weber*, held at the Rosen-
berg Galleries, New York, 27 October–15 November 1947.

1413 Reed, Judith Kaye. "New Webers Distinguished by Lyric Color." *The
Art Digest* 22 (1 November 1947) 15.
Review. See entry 1412.

1414 Burger, William Thor. "Art: Max Weber." *Masses and Mainstream* 2
(April 1949) 82–87.
Review of the *Max Weber Retrospective Exhibition*, held at the Whitney Mu-
seum of American Art, New York, 5 February–27 March 1949.

1415 Coates, Robert M. "The Art Galleries: A Max Weber Retrospective."
The New Yorker 24 (19 February 1949) 72, 75.
Review. See entry 1414.

1416 Fremantle, Christopher E. "New York Commentary." *The Studio* 138
(July 1949) 29–30.
Review. See entry 1414.

1417 Gibbs, Jo. "Whitney Museum Honors Career of Max Weber, Pioneering
Modern." *The Art Digest* 23 (15 February 1949) 13.
Review. See entry 1414.

1418 Lewison, Florence. "Going Around in Art Circles—Weber at Whitney
Museum." *Design* 50 (April 1949) 19.
Review. See entry 1414.

1419 "The Story of an Exhibition." *Notes and Comments from the Walker Art
Center* (May 1949) [unpaginated].

Review of the *Max Weber Retrospective Exhibition*, as staged at the Walker Art Center, Minneapolis, 17 April–29 May 1949.

1420 Breuning, Margaret. "Lots in Little Webers." *The Art Digest* 24 (1 December 1949) 13.
Review of the exhibition *Recent Gouaches by Max Weber*, held at the Rosenberg Galleries, New York, 14 November–10 December 1949.

1421 Seckler, Dorothy. "Reviews and Previews." *Art News* (December 1949) 41.
Review. See entry 1420.

1422 Breuning, Margaret. "Three Veterans of the American League." *The Art Digest* 24 (15 February 1950) 14.
Review of the exhibition *Knaths, Rattner, Weber*, held at the Rosenberg Galleries, New York, February 1950.

1423 Breuning, Margaret. "New York—Tinged with Melancholy." *Art Digest* 26 (1 March 1952) 17.
Review of the exhibition *Max Weber: Recent Paintings (1948–1952)*, held at the Rosenberg Galleries, New York, 11 February–8 March 1952.

1424 Seckler, Dorothy. "Reviews and Previews." *Art News* (February 1952) 42.
Review. See entry 1423.

1425 Breuning, Margaret. "Margaret Breuning Writes." *Arts* 30 (April 1956) 46–47.
Review of *An Exhibition of Oil and Tempera Paintings, Gouaches, Pastels, Woodcuts, Lithographs and Drawings by Max Weber, Celebrating the Artist's 75th Birthday*, held at the Jewish Museum of the Jewish Theological Seminary of America, New York, 2 March–31 May 1956.

1426 Buchwald, Stella. "Art Review: The Painting of Max Weber." *Jewish Life: A Progressive Monthly* (May 1956) 38–39.
Review. See entry 1425.

1427 Campbell, Lawrence. "Reviews and Previews." *Art News* 55 (April 1956) 80.
Review. See entry 1425.

1428 Coates, Robert M. "The Art Galleries: Morris Graves and Max Weber." *The New Yorker* 32 (17 March 1956) 132.
Review. See entry 1425.

1429 George, LaVerne. "In the Galleries: Max Weber." *Arts* 31 (January 1957) 58–59.
Review of the exhibition *Max Weber: Woodcuts and Related Paintings*, held at the Weyhe Gallery, New York, 26 November–22 December 1956.

1430 Porter, Fairfield. "Reviews and Previews." *Art News* 55 (December 1956) 8.
Review. See entry 1429.

1431 Coates, Robert M. "The Art Galleries: Accent on Age." *The New Yorker* 32 (19 January 1957) 88.
Review of the exhibition *Max Weber, Paintings in Gouache 1955 and 1956*, held at the Downtown Gallery, New York, 8 January–2 February 1957.

1432 Mellow, James R. "In the Galleries: Max Weber." *Arts* 31 (January 1957) 52.
Review. See entry 1431.

1433 Breuning, Margaret. "Margaret Breuning: . . . Figure Pieces by Max Weber . . ." *Arts* 33 (November 1958) 52.
Review of the exhibition *Max Weber: The Figure in Retrospect, 1906–1958*, held at the Downtown Gallery, New York, 11 November–6 December 1958.

1434 Coates, Robert M. "The Art Galleries: Artists' Progress." *The New Yorker* 34 (22 November 1958) 175–176.
Review. See entry 1433.

1435 Porter, Fairfield. "Reviews and Previews." *Art News* 57 (November 1958) 12.
Review. See entry 1433.

1436 Kayser, Stephen S. "Max Weber: A Patriarch Returns to Newark." *Art News* 58 (October 1959) 44–45, 55–56.
Review of the *Max Weber: Retrospective Exhibition*, held at the Newark Museum, Newark, New Jersey, 1 October–15 November 1959.

1437 Mellow, James R. "Month in Review." *Arts* 34 (November 1959) 50–51.
Review. See entry 1436.

1438 Beck, James H. "Reviews and Previews." *Art News* 60 (February 1962) 14.
Review of the exhibition *Max Weber, 1881–1961—Memorial Exhibition:*

Paintings, Drawings, Sculpture, held at the Art Gallery of the American Academy of Arts and Letters, 19 January–18 February 1962.

1439 Preston, Stuart. "Current and Forthcoming Exhibitions: New York." *The Burlington Magazine* 104 (March 1962) 133.
 Review. See entry 1438.

1440 Raynor, Vivien. "New York Exhibitions: In the Galleries—Max Weber." *Arts Magazine* 36 (March 1962) 47.
 Review. See entry 1438.

1441 "Art: Weber's Search." *Time* (14 June 1963) 74–75, 77.
 Review of the exhibition *Max Weber: Pastels and Gouaches, 1909–1956*, held at the Downtown Gallery, New York, 7 May–1 June 1963.

1442 DeMott, Helen. "Reviews and Previews." *Art News* 62 (Summer 1963) 12.
 Review. See entry 1441.

1443 Raoul, Rosine. "Letter from New York—Weber and Wyeth: A Study in Opposites." *Apollo* 78 (September 1963) 222–223.
 Review. See entry 1441.

1444 Lanes, Jerrold. "Current and Forthcoming Exhibitions: New York." *The Burlington Magazine* 111 (May 1969) 324.
 Review of the exhibition *Fifty Years of Painting by Max Weber*, held at the Bernard Danenberg Galleries, New York, 15 April–10 May 1969.

1445 Levin, Kim. "Reviews and Previews: Max Weber." *Art News* 68 (May 1969) 73.
 Review. See entry 1444.

1446 Nemser, Cindy. "In the Galleries: Max Weber." *Arts Magazine* 43 (April 1969) 59.
 Review. See entry 1444.

1447 Pincus-Witten, Robert. "New York: Max Weber, Danenberg Gallery." *Artforum* 7 (Summer 1969) 60–61.
 Review. See entry 1444.

1448 "Art across the U.S.A.: Outstanding Exhibitions—Americans Abroad and at Home." *Apollo* 92 (September 1970) 231.
 Review of the exhibition *Max Weber: The Years 1906–1916*, held at the Bernard Danenberg Galleries, New York, 12–30 May 1970.

1449 Gollin, Jane. "Reviews and Previews: Max Weber." *Art News* 69 (May 1970) 74–75.
Review. See entry 1448.

1450 Hobhouse, Janet K. "In the Galleries: Max Weber at Danenberg." *Arts Magazine* 44 (May 1970) 63.
Review. See entry 1448.

1451 Lanes, Jerrold. "New York." *Artforum* 9 (September 1970) 78–79.
Review. See entry 1448.

1452 Young, Joseph E. "Los Angeles." *Art International* 15 (20 May 1971) 77.
Review (as shown at the Long Beach Museum of Art, 8–29 November 1970). See entry 1448.

1453 Brown, Gordon. "Reviews: Galleries." *Arts Magazine* 45 (November 1970) 67.
Review of the exhibition *Max Weber—Lithographs*, held at Associated American Artists, New York, 2–28 November 1970.

1454 Downes, Rackstraw. "Reviews and Previews: Max Weber." *Art News* 69 (November 1970) 70.
Review. See entry 1453.

1455 Gollin, Jane. "Reviews and Previews: Max Weber." *Art News* 69 (December 1970) 63–64.
Review of the exhibition *Max Weber: Monotype Woodcuts*, held at the Graham Gallery, New York, 8 December 1970–9 January 1971.

1456 Hancock, Marianne. "Reviews: New York Galleries." *Arts Magazine* 45 (April 1971) 88–89.
Review of the exhibition *Max Weber: Early Works on Paper*, held at the Bernard Danenberg Galleries, New York, 27 April–15 May 1971.

1457 Wolmer, Bruce. "Reviews and Previews: Max Weber." *Art News* 70 (Summer 1971) 62.
Review. See entry 1456.

1458 Anderson, Laurie. "Reviews and Previews: Max Weber." *Art News* 70 (November 1971) 83.
Review of the exhibition *Max Weber, 1881–1961: A 10th Year Commemorative*, held at the Pratt Institute Manhattan Center, New York, 13 October–2 November 1971.

1459 Henry, Gerrit. "Reviews and Previews: Max Weber." *Art News* 71 (Summer 1972) 60.

Review of the *Exhibition and Sale of Max Weber Drawings*, held at the Bernard Danenberg Galleries, New York, 9–27 May 1972.

1460 Derfner, Phyllis. "New York Letter." *Art International* 19 (20 April 1975) 58.

Review of the exhibition *Max Weber: Works on Paper*, held at the Forum Gallery, New York, 15 February–7 March 1975.

1461 Weissman, Julian. "New York Reviews: Max Weber." *Art News* 74 (April 1975) 94.

Review. See entry 1460.

1462 Wooster, Ann-Sargent. "New York Reviews." *Art News* 75 (January 1976) 119.

Review of the exhibition *Max Weber*, held at the Forum Gallery, New York, 25 October–14 November 1975. For comments on this review by Joy S. Weber, daughter of the artist, and a rejoinder by Wooster, see *Art News* 75 (May 1976) 28–29.

1463 Nadelman, Cynthia. "New York Reviews: Max Weber." *Art News* 79 (February 1980) 200–201.

Review of the exhibition *Max Weber: Sculpture, Drawings and Prints*, held at the Forum Gallery, New York, 27 October–24 November 1979.

1464 Robbins, Diane Tepfer. "Max Weber." *Arts Magazine* 54 (February 1980) 27.

Review. See entry 1463.

1465 North, Percy. "Max Weber." *Arts Magazine* 55 (February 1981) 17.

Review of the exhibition *Max Weber: Early Works on Paper, 1910–1918*, held at the Forum Gallery, New York, 2–31 January 1981.

1466 Bass, Ruth. "New York Reviews: Max Weber." *Art News* 80 (May 1981) 200.

Review. See entry 1465.

1467 Kuspit, Donald. "Reviews: New York." *Artforum* 21 (January 1983) 74–75.

Review of the exhibition *Max Weber: American Modern*, held at the Jewish Museum, New York, 5 October 1982–16 January 1983.

1468 North, Percy. "Album: Max Weber." *Art Magazine* 57 (November 1982) 40–41.
Reviews of the exhibitions *Max Weber: American Modern* (see entry 1467) and *Max Weber: Work in All Media*, held at the Forum Gallery, New York, 6 October–4 November 1982.

1469 Phillips, Deborah C. "New York Reviews: Max Weber." *Art News* 82 (January 1983) 144.
Reviews. See entry 1468.

1470 Rub, Timothy. "Art Reviews: Max Weber." *Arts Magazine* 57 (December 1982) 35.
Review (Forum Gallery). See entry 1468.

1471 Yellin, Deborah. "Reviews: New York—Max Weber." *Art News* 90 (Summer 1991) 155.
Review of the exhibition *Max Weber (1881–1961): The Figure, 1907–1957*, held at the Forum Gallery, New York, 7 March–6 April 1991.

1472 "Drawings on Exhibition." *Drawing* 13 (January–February 1992) 106.
Review of the exhibition *Max Weber: The Cubist Decade, 1910–1920*, held at the High Museum of Art, Atlanta, Georgia, 10 December 1991–9 February 1992.

1473 Kramer, Hilton. "Critic's Notebook: A Misalliance with Modernism." *Art and Antiques* 9 (September 1992) 78–79.
Review. See entry 1472.

1474 Loughery, John. "Bearing Witness." *The Hudson Review* 45 (Autumn 1992) 449–450.
Review of the exhibition *Max Weber: The Cubist Decade, 1910–1920*, as staged at the Corcoran Gallery of Art, Washington, D.C., 31 May–9 August 1992.

1475 Tarbell, Roberta. "Max Weber: The Cubist Decade, 1910–1920." *American Art Review* 5 (Winter 1993) 132–139.
Review of the exhibition *Max Weber: The Cubist Decade, 1910–1920*, as staged at the Brooklyn Museum, Brooklyn, New York, 13 November 1992–10 January 1993.

1476 MacAdam, Barbara. "Reviews: New York—Max Weber." *Art News* 92 (March 1993) 110.
Reviews of the exhibitions *Max Weber: An American in Paris*, held at the Forum Gallery, New York, 9 December 1992–23 January 1993 and *Max Weber:*

The Cubist Decade, 1910–1920, as staged at the Brooklyn Museum (see entry 1475).

V. REFERENCE SOURCES

1477 *Allgemeines Lexikon der bildenden Künstler des XX. Jahrhunderts*, edited by Hans Vollmer. Leipzig: E.A. Seemann, 1953–1962. S.v. "Weber, Max."

1478 *American National Biography*, edited by John A. Garraty and Mark C. Carnes. New York: Oxford University Press, 1998. S.v. "Weber, Max," by Percy North.

1479 Baigell, Matthew. *Dictionary of American Art*. New York: Harper and Row, 1979. S.v. "Weber, Max (1881–1961)."

1480 *Biographical Encyclopedia of American Jews*, edited by Leo M. Glassman. New York: M. Jacobs and L.M. Glassman, 1935. S.v. "Weber, Max."

1481 *Chambers Biographical Dictionary*, 6th ed., edited by Melanie Parry. Edinburgh, Scotland: Chambers, 1997. S.v. "Weber, Max."

1482 Chilvers, Ian. *A Dictionary of Twentieth-Century Art*. Oxford: Oxford University Press, 1998. S.v. "Weber, Max (1881–1961)."

1483 *The Concise Dictionary of American Jewish Biography*, edited by Jacob Rader Marcus. Brooklyn, N.Y.: Carlson, 1994. S.v. "Weber, Max."

1484 *Contemporary Artists*, 2d ed. New York: St. Martin's Press, 1983. S.v., "Weber, Max," by Willard Bohn.

1485 *Current Biography: Who's News and Why, 1941*. New York: H.W. Wilson, 1941. S.v. "Weber, Max."

1486 *Current Biography Yearbook, 1961*. New York: H.W. Wilson, 1962. S.v. "Weber, Max."
 An obituary.

1487 Bénézit, E. *Dictionaire critique et documentaire des Peintres, Sculpteurs, Dessinateurs et Graveurs de tous les temps et de tous les pays*, nouvelle éd. Paris: Gründ, 1976. S.v. "Weber (Max)," by Jacques Busse.

1488 *The Blackwell Companion to Jewish Culture: From the Eighteenth Century to the Present*, edited by Glenda Abramson. Oxford, England: Blackwell Reference, 1989. S.v. "Weber, Max," by Kristie A. Jayne.

1489 Cummings, Paul. *Dictionary of Contemporary American Artists*, 6th ed. New York: St. Martin's Press, 1994. S.v. "Weber, Max."

1490 Darmstaedter, Robert. *Kunstlerlexikon: Maler—Bildhauser—Architekten*. Bern, Switzerland: Francke Verlag, 1961. S.v. "Weber, Max."

1491 *The Dictionary of Art*, edited by Jane Turner. New York: Grove's Dictionaries, 1996. S.v. "Weber, Max," by Ruth L. Bohan.

1492 *Dictionary of American Biography*. Suppl. Seven, *1961–1965*, edited by John A. Garraty. New York: Scribner's, 1981. S.v. "Weber, Max," by Ernest Scheyer.

1493 *Dictionary of Modern Painting*, 3d ed., edited by Carlton Lake and Robert Maillard. New York: Tudor, 1964. S.v. "Weber, Max," by John Ashbery.

1494 *Encyclopaedia Judaica*. Jerusalem: Encyclopedia Judaica, 1972. S.v. "Weber, Max (1881–1961)."

1495 *Encyclopedia of American Art*. New York: E.P. Dutton, 1981. S.v. "Weber, Max (1881–1961)," by David W. Scott.

1496 *The Encyclopedia of New York City*, edited by Kenneth T. Jackson. New Haven, Conn.: Yale University Press; New York: New York Historical Society, 1995. S.v. "Weber, Max," by Judith Zilczer.

1497 *Encyclopedia of World Art*. New York: McGraw-Hill, 1967. S.v. "Weber, Max," by Lloyd Goodrich.

1498 Fielding, Mantle. *Mantle Fielding's Dictionary of American Painters, Sculptors and Engravers*. New York: Apollo, 1986. S.v. "Weber, Max."

1499 Gowing, Lawrence. *A Biographical Dictionary of Artists*, rev. ed. New York: Facts on File, 1995. S.v. "Weber, Max, 1881–1961."

1500 Marcus, Jacob Rader, ed. *The Concise Dictionary of American Jewish Biography*. Brooklyn, N.Y.: Carlson, 1994. S.v. "Weber, Max."

1501 Marks, Claude. *World Artists, 1950–1990*. New York: H.W. Wilson, 1984. S.v. "Weber, Max."

1502 "Max Weber." In *American Art Analog*, 820. New York: Chelsea House, in association with American Art Analog, 1986.

1503 "Max Weber—Painter." In *The Index of Twentieth Century Artists, 1933–1937*, 646–649. New York: Arno Press, 1970.

1504 *McGraw-Hill Dictionary of Art*, edited by Bernard S. Myers. New York: McGraw-Hill, 1969. S.v. "Weber, Max," by Jerome Viola.

1505 *The New Standard Jewish Encyclopedia*, 7th ed., edited by Geoffrey Wigoder. New York: Facts on File, 1992. S.v. "Weber, Max (1881–1961)."

1506 Opitz, Glenn B. *Dictionary of American Sculptors: "18th Century to the Present."* Poughkeepsie, N.Y.: Apollo, 1984. S.v. "Weber, Max."

1507 *The Oxford Companion to Art*, edited by Harold Osborne. London: Oxford University Press, 1970. S.v. "Weber, Max (1881–1961)."

1508 *The Oxford Companion to Twentieth-Century Art*, edited by Harold Osborne. Oxford: Oxford University Press, 1981. S.v. "Weber, Max (1881–1961)."

1509 *The Oxford Dictionary of Art*, edited by Ian Chilvers and Harold Osborne, new ed. Oxford: Oxford University Press, 1997. S.v. "Weber, Max (1881–1961)."

1510 *Petit Larousse de la Peinture*, sous la direction de Michel Laclotte. Paris: Larousse, 1979. S.v. "Weber, (Max)," by Daniel Robbins.

1511 *Phaidon Dictionary of Twentieth-Century Art*. London: Phaidon Press, 1973. S.v. "Weber, Max."

1512 Seuphor, Michel. *Dictionary of Abstract Painting with a History of Abstract Painting*. New York: Tudor, 1957. S.v. "Weber, Max."

1513 Simons, John, ed. *Who's Who in American Jewry: A Biographical Dictionary of Living Jews of the United States and Canada*. Vol. 3, *1938–1939*. New York: National News Association, [1939]. S.v. "Weber, Max."

1514 *The Thames and Hudson Dictionary of Art and Artists*, rev., expanded, and updated by Nikos Stangos; Herbert Read, consulting ed. New York: Thames and Hudson, 1994. S.v. "Weber, Max (1881–1961)."

1515 *The Universal Jewish Encyclopedia . . . An Authoritative and Popular Presentation of Jews and Judaism since the Earliest Times*, edited by Isaac Landman. New York: Universal Jewish Encyclopedia, 1943. S.v. "Weber, Max," by George S. Hellman.

1516 *Who Was Who in America.* Vol. 4, *1961–1968.* Chicago: Marquis Who's Who, 1968. S.v. "Weber, Max."

1517 *Who Was Who in American Art, 1564–1975: 400 Years of Artists in America,* edited by Peter Hastings Falk. Madison, Conn.: Sound View Press, 1999. S.v. "Weber, Max."

1518 *Who Was Who in American History—Arts and Letters.* Chicago: Marquis Who's Who, 1975. S.v. "Weber, Max."

1519 *Who's Who in American Art,* edited by Dorothy B. Gilbert. New York: R.R. Bowker, 1959. S.v. "Weber, Max."

VI. ARCHIVAL SOURCES

1520 Archives of American Art. *The Archives of American Art: Collection of Exhibition Catalogs.* Boston: G.K. Hall, 1979. S.v. "Weber, Max."

1521 ———. *The Card Catalog of the Manuscript Collections of the Archives of American Art.* Wilmington, Del.: Scholarly Resources, 1980. S.v. "Weber, Max."

1522 ———. *The Card Catalog of the Manuscript Collections of the Archives of American Art, Supplement 1981–1984.* Wilmington, Del.: Scholarly Resources, 1985. S.v. "Weber, Max."

This circulating microfilm collection contains extensive resources on Weber, including the Max Weber Papers (1907–1961); scrapbooks of articles and clippings; exhibition catalogues and announcements; photographs of artwork; unpublished addresses, lectures, and essays; the Whitney Museum of American Art Papers (which contain Lloyd Goodrich's 1948–1949 research material and interviews with the artist); the Downtown Gallery Papers; material relating to the American Artists' Congress; and correspondence with various individuals, including Stieglitz, Arthur B. Davies, Robert Delaunay, Juliana Force, Gaston Lachaise, Louis Lozowick, Jules Pascin, Joseph Stella, and Abraham Walkowitz. The catalogue is searchable through SIRIS (Smithsonian Institution Research Information System) via the Internet.

1523 Inventory of American Paintings. National Museum of American Art. Smithsonian Institution, Washington, D.C.

This database, which is searchable through SIRIS (see entries 1520–1522), contains 197 entries for Weber's paintings from public and private collections. Each entry provides the title of the work; date of execution; medium; dimensions; subject; present owner; references; illustration (bibliographic citation to source); file; and record ID.

1524 Inventory of American Sculpture. National Museum of American Art. Smithsonian Institution, Washington, D.C.

Contains three entries for Weber's sculpture (see entry 1523).

1525 Carl Zigrosser Papers. Van Pelt Library, University of Pennsylvania, Philadelphia.

These papers contain nine items of correspondence between Zigrosser and Weber concerning the progress of Weber's work, purchases from Zigrosser's Weyhe Gallery, and a failed attempt at printmaking during 1936 with a proof of Weber's unsuccessful woodcut.

1526 Oral History Research Office, Butler Library, Columbia University, New York.

The office is the repository for the *Reminiscences of Max Weber* (see entry 1230).

1527 Rare Book and Manuscript Library, Butler Library, Columbia University, New York.

The library holds several items of Weber's correspondence in the Marius de Zayas Papers and in the Spanish Refugee Relief Organization Files.

VII. DISSERTATIONS AND THESES

1528 Braufman, Sheila B. "Max Weber's Judaic Themes." M.A. thesis, San Jose State University, 1981.

1529 Kent, Richard John, Jr. "Alfred Stieglitz and the Maturation of American Culture." Ph.D. diss., Johns Hopkins University, 1974.

Contains a discussion of Weber's influence on Stieglitz's view of photography (pp. 379–380, 386–390).

1530 North, Phylis Burkely. "Max Weber: The Early Paintings (1905–1920)." Ph.D. diss., University of Delaware, 1975.

1531 Tarbell, Roberta Lucille Kuperian. "John Storrs and Max Weber: Early Life and Work." M.A. thesis, University of Delaware, 1968.

1532 Terry, James Strother. "Alfred Stieglitz: The Photographic Antecedents of Modernism." Ph.D. diss., State University of New York at Stony Brook, 1979.

Contains a discussion of Weber's influence on Stieglitz's aesthetic philosophy, with the latter's photograph *The Steerage* of ca. 1907–1908 singled out for analysis (pp. 265–267).

VIII. ANNOTATED REPRODUCTIONS

Abstract, 1914. CUBIST/4 (b/w) 48, 95.
Abstract Geometric, 1915. CUBIST/4 (b/w) 49, 95.
Abstract Head, 1946. DELAWARE (b/w) 134–135.
Abstract Study, ca. 1915. SOTHEBY/4038 (b/w) Pl. 164.
Abstraction, 1913. NEW BRITAIN (c) 166–167, 187.
————. OVER HERE (b/w) 197–198.
————. STEBBINS (b/w) 302, 431, 452.
Acrobats, 1946. CIRCUS (b/w) [unpaginated].
————. WHITNEY/9 (b/w) 40–41, 49.
African Sculpture (Congo Statuette), 1910. SCULPTURE/2 (b/w) 112–114.
After an Ice Storm, ca. 1943. PHILLIPS/6 (b/w) Pl. 194b; p. 106.
After Bathing, n.d. SOTHEBY/5335 (c) Pl. 234.
Afternoon Repast, 1924. MICHIGAN/3 (b/w) Pl. 62; [catalogue note].
Air—Light—Shadow [sculpture], 1915. ABSTRACTION/2 (c) 56–57.
————. MOMA/12 (b/w) 218, 597.
————. SCULPTURE/1 (b/w) 62, 171.
————. SCULPTURE/3 (b/w) 33.
Alone, 1927. MOMA/13 (b/w) 84–85.
Alone, 1929. KOOTZ/1 (b/w) Pl. 58; pp. 55–59.
————. MOMA/13 (b/w) 84–85.
Among the Trees, 1911. CHRISTIE/6429 (c) Pl. 102.
————. CHRISTIE/6610 (c) Pl. 312.
Anemones in Pot, ca. 1917. HALPERT (b/w) Pl. 111.
The Antique, 1930. DREIER (b/w) 733–735.
The Apollo in Matisse's Studio, 1908. HIGH/2 (c) 174–177, 190, 198.
————. MONTPARNASSE (c) Pl. IV; pp. 115–116.
The Apollo in Matisse's Studio, 1915. MET/6 (c) 64.
Apples, ca. 1928–1930. MCNAY (b/w) 258–259.
At the Mill, 1939. NEWARK/2 (b/w) 178, 393.
————. NEWARK/3 (b/w) 43.
————. REALISM (b/w) 32, 64.
————. SCENE/1 (b/w) Pl. 61; p. 117.
Athletic Contest, 1915. CUBIST/1 (c) 178, 312.
————. FUTURISM (c) 370, 601.
————. MET/4 (b/w) 205.
The Balcony, 1939. SCHULMAN (b/w) 34–35.
The Balcony, 1958. LONG ISLAND/3 (b/w) 65.
Bather, 1913. GOLDEN DOOR (b/w) 108–110, 430.
————. HIRSHHORN/2 (c) Pl. 223; p. 757.
Bathers, 1907. CHRISTIE/6772 (b/w) 160.
The Bathers, 1909. PARIS-NEW YORK (b/w) 211.

Contemplation, 1946–1947. DRAWING/5 (c) 100–101, 139.
Conversation, 1919. MCNAY (b/w) 258–259.
Conversation, 1948. PREVIN (b/w) Pl. 36.
Conversation, 1949. SOTHEBY/4650M (b/w) Pl. 361.
Conversation, 1955. SOTHEBY/5353 (b/w) Pl. 255.
Conversation, n.d. PHILLIPS/5 (b/w) 241.
Cosmos, n.d. SOTHEBY/3617 (b/w) Pl. 42.
Crystal Figure, 1917. LEIN (b/w) 60, 71.
_____. MINNESOTA/2 (b/w) 30–31.
_____. MINNESOTA/3 (b/w) Pl. 253; [catalogue note].
Cubist Head, 1919–1920 (1928 edition). CUBIST/7 (b/w) 184, 216.
Cubist Head, 1943. CHRISTIE/7871 (c) Pl. 218.
Cubist Woman, 1912. HIRSHHORN/3 (b/w) 107–108.
The Dancers, 1948. REYNOLDA (c) 118–119.
Dauntless Bird, n.d. ILLINOIS/49 (b/w) Pl. 35; [biographical note].
Deserted Farm, 1943. CLEVELAND/1 (b/w) 256.
_____. CLEVELAND/2 (b/w) 240.
Discourse, 1950. SCHULMAN (c) 34, 36.
_____. SOTHEBY/6026 (c) Pl. 111.
Discussing the Torah, 1939. SHELDON/2 (b/w) 359.
Discussion, n.d. NOTRE DAME (b/w) 112–113.
Draped Female Nude and Sleeping Child, 1911. BLOEDEL (b/w) 61–64.
_____. WILLIAMS/2 (c) 114–117, 214.
Draped Head, 1925. PHILLIPS/2 (b/w) Pl. CLXXVII.
_____. PHILLIPS/3 (b/w) Pl. CXIX; pp. 61–62.
_____. PHILLIPS/5 (b/w) 241.
_____. PHILLIPS/6 (b/w) Pl. 172b; p. 106.
Equilibrium (The Gliding Sphere) [sculpture], 1915 (cast 1948). SCULPTURE/3
 (c) viii, 159.
Exotic Dance, 1940. WHITNEY/6 (b/w) 15, 91.
Facing East, Figure of a Woman, 1956. CHRISTIE/8051 (c) Pl. 238.
The Family, 1911. CHRISTIE/8408 (c) Pl. 163.
A Family Reunion, 1944. ILLINOIS/51 (b/w) Pl. 68; p. 223.
Farmhouse, Summer, 1947. SOTHEBY/7320 (c) Pl. 154.
Figure, 1912. DRAWING/5 (b/w) 24, 137.
Figure, 1912. HALPERT (b/w) Pl. 177.
Figure, 1918. SACHS (b/w) 217, 258.
Figure in Rotation, [sculpture], 1915. SCULPTURE/3 (b/w) 33.
_____. SCULPTURE/6 (b/w) 161.
Figure Study, 1908. PARIS-NEW YORK (b/w) 216–217.
Figure Study, 1911. ALBRIGHT/KNOX/2 (c) 80–81.
_____. NUDE (b/w) 164, 166–168.
Figures, ca. 1914. GEORGIA/2 (b/w) 148–149.
Five Heads, ca. 1910. SOTHEBY/5463 (b/w) Pl. 240.
Fleeing Mother and Child, 1913. HIGH/2 (b/w) 175–177, 190, 198.

_____. LOWENTHAL (b/w) 53.

Interior with Five Women, 1941. CHRISTIE/8051 (c) Pl. 219.

Interior with Men, 1919. SOTHEBY/6373 (c) Pl. 132.

Invocation, 1919. JEWISH/1 (c) 302–303.

_____. JEWISH/2 (c) 142–143.

_____. JEWISH/3 (b/w) 337–338.

_____. MOMA/3 (b/w) Pl. 124.

Invocation, 1919–1920. PHILADELPHIA/1 (c) 46, 48, 121.

Laborer's Huts, ca. 1927. CHRISTIE/7116 (c) Pl. 295.

_____. KENNEDY/4 (c) Pl. 33.

The Lake, ca. 1911. SOTHEBY/1343 (b/w) Pl. 260.

Landscape, 1911. FITCH (b/w) 41.

Landscape, ca. 1920–1928. LOS ANGELES/2 (b/w) 458.

Landscape, 1925. MINNESOTA/4 (b/w) 472–474.

Landscape and Country Barn, n.d. SPRINGFIELD/3 (b/w) 22, 43.

Last Snow, n.d. PHILLIPS/5 (b/w) 242.

Latest News, 1940. ELIOT (c) 182–183.

_____. REALISM (b/w) 32, 64.

Leaning Figure, n.d. HALPERT (c) Pl. 72.

Lecture at the Metropolitan Museum, 1916. MET/1 (c) 126–129, 237.

_____. SOTHEBY/3417 (b/w) Pl. 34.

Maine, 1914. MOMA/12 (b/w) 218, 597.

Man Reading, 1918. SACHS (b/w) 217, 258.

Mandolin Player, 1951. CHRISTIE/6144 (c) Pl. 100.

_____. CHRISTIE/7020 (c) Pl. 311.

Meditation, 1910. GREENVILLE (c) 132–133, 284.

Mexican Jugs, 1914. SOTHEBY/1343 (b/w) Pl. 414.

_____. SOTHEBY/5353 (b/w) Pl. 257.

Mirror, 1928. PRINTS/2 (b/w) 54–55.

The Mirror, ca. 1940. JEWISH/5 (b/w) Pl. 62.

The Mirror, 1950. SOTHEBY/6062 (b/w) Pl. 214.

The Mirror, 1957. UNIVERSAL (b/w) 283–284, 527.

Mother and Child, ca. 1918. PRINTS/9 (b/w) Pl. 46; pp. 62–63.

_____. PRINTS/21 (b/w) Pl. 86; p. 498.

_____. PRINTS/22 (b/w) Pl. 121; p. 37.

Mother and Child, 1919–1920. DOW (c) 58.

_____. PRINTS/10 (c) 482, 737.

_____. PRINTS/19 (b/w) 70, 73–75.

Mother Love (Madonna and Child), 1919–1920. PHILADELPHIA/1 (b/w) 46–
 47, 121.

Mothers and Children, n.d. LEWISOHN/1 (b/w) 284, 287.

Multiple Portrait, 1956. ILLINOIS/61 (b/w) 60–61.

Music, 1912. COLOR AND FORM (c) Pl. 79; p. 96.

_____. SYNCHROMISM (c) Pl. 49; p. 144.

Music, 1947. MUNSTERBERG (b/w) Pl. 51; pp. 93–94.

Music of the Orient, n.d. ILLINOIS/55 (b/w) Pl. 60; pp. 255–256.

A Musical Evening, n.d. SOTHEBY/217 (b/w) Pl. 489.

My Studio in Paris, 1907. HIGH/2 (b/w) 175, 177, 190, 198.

————. HIRSCHL/4 (c) 2, 48.

Near the Sea, 1944. CRANBROOK (b/w) 60.

New York, 1912. HIRSCHL/3 (b/w) 90.

New York, 1912. MOMA/14 (b/w) 37, 156.

New York, 1912. HIRSCHL/3 (c) 91.

————. SBC (c) 79.

————. YORK/4 (c) Pl. 22.

New York, 1913. THYSSEN (c) 154–157, 399.

New York, 1914. NINETEEN FOURTEEN (b/w) 72, 95.

————. OVER HERE (b/w) 199–200.

New York, 1928. URBAN (b/w) 12, 41.

New York at Night, 1915. GOLDEN DOOR (b/w) 108, 110–111, 430.

————. MOMA/14 (b/w) 41, 156.

New York Department Store (An Idea of a Modern Department Store), 1915.
 HERITAGE (b/w) Pl. 40.

————. NEW YORK/3 (c) 48, 142.

Night, 1915. SHELDON/1 (c) 20, 66.

————. SHELDON/2 (c) 190–191, 358–359.

The Night Class, 1939. KOOTZ/2 (b/w) Pl. 87.

Nude, ca. 1925–1927. BROOKLYN/1 (b/w) 83.

Nude Figure, 1910. MONTCLAIR (b/w) 184.

Nude Figures, 1911. OWEN/1 (c) [unpaginated].

On the Shore, 1928–1930. PENNEY (b/w) 53.

On the Shore (On the Seashore), 1957. UNIVERSAL (b/w) 283, 527.

Orchestra, 1954. CHRISTIE/7020 (c) Pl. 312.

Oriental Scene, 1918. KOOTZ/1 (b/w) Pl. 56; pp. 55–59.

Pacific Coast, 1952. LANE (c) Pl. 38; p. 166.

Pacific Coast, 1952. MET/3 (c) 32–33.

————. MET/5 (b/w) 60.

La Parisienne, 1907. HIGH/2 (b/w) 175, 177, 190, 198.

————. NEUBERGER (b/w) 448–449.

Pensioned, n.d. PRINTS/3 (b/w) Pl. 30; p. 12.

The Picture Admirers, 1952. SYRACUSE/1 (b/w) 70–71.

————. SYRACUSE/2 (c) 60, 122.

The Pleasures of Summer, 1934. CHRISTIE/7082 (c) Pl. 249.

Portrait, 1919–1920 (1928 edition). CUBIST/7 (b/w) 184, 216.

Portrait, ca. 1919. PRINTS/19 (b/w) 70, 73–76.

Portrait, ca. 1922. HALPERT (b/w) Pl. 147.

Prayer, 1920. PHILADELPHIA/1 (b/w) 46–47, 121.

Primitive, 1918. PRINTS/6 (b/w) 2, 24, 28.

Primitive Head, n.d. CHRISTIE/8362 (b/w) Pl. 136.

Primitive Man, 1918. PRINTS/6 (b/w) 1, 24–25.

Primitive Model [sculpture], 1917 (cast 1959). SCULPTURE/3 (b/w) 5.

Primitives: Poems and Woodcuts [illustrated book], 1926. ARTIST AND BOOK
 (b/w) 218–219.

_____. CUBIST/6 (b/w) 63–88.

The Quartet, ca. 1939. CARNEGIE/2 (b/w) 473–474.

Rabbi, 1940. PHILLIPS/5 (b/w) 242.

Rabbi, 1957. SCHULMAN (b/w) 34, 36.

The Rabbi, 1958. UNIVERSAL (b/w) 283, 528.

Rabbi, n.d. JEWISH/6 (b/w) Pl. 330; p. 306.

Rabbi Reading, 1919–1920. PHILADELPHIA/1 (c) 46, 48, 121.

Reclining Figure, ca. 1915. SOTHEBY/3823 (b/w) Pl. 145.

Reclining Figure, 1956. UNIVERSAL (b/w) 283, 527.

Reclining Nude, 1918. PRINTS/5 (b/w) Pl. 59; pp. 32–33.

The Red Carnation, ca. 1944. CARNEGIE/2 (b/w) 473–474.

Red Poppies, 1953. LANE (c) Pl. 39; pp. 166–167.

Refreshments, 1947. LEAGUE/4 (b/w) Pl. 45.

_____. MCNAY (b/w) 258–259.

Refugees, 1939. MURDOCK (b/w) 204–205.

Repose, 1910. CHRISTIE/6972 (c) 163.

Repose, 1928. WILLIAMS/1 (b/w) Pl. 23; p. 153.

Resting Figure, 1956. CHRISTIE/8151 (c) Pl. 213.

Resting Women, 1912. SOTHEBY/6400 (b/w) Pl. 145.

Rush Hour, New York, 1915. ABSTRACT/2 (b/w) 84–85.

_____. CUBIST/1 (c) 178, 180, 312.

_____. CUBIST/2 (c) 122, 124.

_____. CUBIST/5 (b/w) 212, 221–222, 322.

_____. FUTURISM (c) 370, 601.

_____. GOLDEN DOOR (c) 108, 110, 112, 430.

_____. MOMA/14 (b/w) 38, 156.

_____. NATIONAL/2 (c) 574.

_____. NATIONAL 3 (c) 150–151, 175.

_____. PARIS—NEW YORK (b/w) 333, 341.

_____. WASHINGTON/1 (c) 130–131.

Russian Ballet, 1916. LOWENTHAL (c) 38–39.

Sabbath, 1941. HALPERT (c) Pl. 150.

Sculptured Figure, 1911. CORNELL/1 (c) 59, 187.

Seated Figure, 1912. BAKER/PISANO (b/w) 55.

_____. HALPERT (b/w) Pl. 157.

Seated Figure, 1917. DRAWING/7 (c) 85, 139, 142.

Seated Figure, 1956. GRANT-MUNGER (b/w) 79, 118.

Seated Figure, ca. 1957–1958. UNIVERSAL (b/w) 283, 528.

Seated Musician, 1917. CORRESPONDENCES (b/w) Pl. 6b; [catalogue note].

Still Life with Black Cup, 1916. GOLDSTONE (b/w) 104.
Still Life with Chinese Teapot, 1925. MOMA/12 (b/w) 218, 597.
Still Life with Daisy, Bottle and Peach, 1911. WATERCOLOR/7 (c) 40, 94.
Still Life with Flowers, n.d. SOTHEBY/1586 (b/w) Pl. 349.
Still Life with Palette, 1947. HIRSHHORN/2 (b/w) Pl. 576; p. 757.
Still Life with Red Bananas, 1909. CHRISTIE/7020 (c) Pl. 276.
Still Life with Two Tables, ca. 1934. LOS ANGELES/2 (b/w) 349–350.
———. WHITNEY/13 (b/w) 13, 31.
Still Life with Woman, ca. 1945. SOTHEBY/6538 (c) Pl. 168.
Straggly Pines, 1933. KOOTZ/2 (c) Pl. 84.
———. LEAGUE/1 (b/w) 24, 112–113.
———. LONG ISLAND/2 (c) 28–29.
String Music, 1944. NEUBERGER (b/w) 448, 450–451.
Students of the Torah, 1939. PHILLIPS/5 (b/w) 242.
Study for Russian Ballet, 1914. LOWENTHAL (b/w) 53.
———. WATERCOLOR/1 (c) 154–155.
———. WATERCOLOR/7 (c) 40, 95.
Study of a Young Woman, 1912. SOTHEBY/6884 (c) Pl. 158.
Summer, 1909. NATIONAL/1 (c) 178.
Summer, 1911. WATERCOLOR/5 (b/w) 168, 202.
Surprise, 1910. MCNAY (b/w) 258–259.
Table with Still Life, 1929. KOOTZ/1 (b/w) Pl. 59; pp. 55–59.
Talmudic Student, 1947. SOTHEBY/3913 (b/w) Pl. 231A.
The Talmudists, 1934. HALPERT (c) Pl. 142.
———. JEWISH/2 (b/w) 144.
———. JEWISH/4 (c) 108.
———. JEWISH/7 (b/w) Pl. 26; pp. 220–222.
———. MOMA/8 (b/w) Pl. 152; p. 34.
Tea, n.d. MASTERS/1 (b/w) Pl. 94.
Things, 1960. PRINTS/8 (b/w) 128.
Three Figures, 1910. WADSWORTH/2 (c) 45, 89.
Three Figures at a Table, 1910. CHRISTIE/7103 (b/w) Pl. 366.
Three Jugs, n.d. PHILLIPS/2 (b/w) Pl.CLXXVI.
Three Literary Gentlemen, 1945. ILLINOIS/48 (b/w) Pl. 134.
———. LANE (c) Pl. 37; p. 166.
Three Women, n.d. HALPERT (c) Pl. 88.
Three Women in the Garden, 1913. CHRISTIE/7270 (c) Pl. 288.
The Toiler, 1940. KOOTZ/2 (c) Pl. 85.
The Toilers, 1942. REALISM (b/w) 32, 64.
The Trio, 1949. HALPERT (c) Pl. 79.
Trio, 1953. ROBY/1 (b/w) 142.
———. ROBY/2 (b/w) 12, 25.
Two Figures Embracing, 1910. ARKANSAS/1 (b/w) 142–143.
Two Geometric Figures, 1912. CUBIST/4 (b/w) 47, 95.

Keyword Index to Source Volumes

ADIRONDACK/2: Welsh, Caroline M. "Masterworks of the Adirondacks." *American Art Review* 9 (July–August 1997).

AGEE: Agee, William C. *Modern American Painting 1910–1940: Toward a New Perspective.* Houston, Tex.: Museum of Fine Arts, Houston, 1977.

ALBRIGHT-KNOX/1: Albright-Knox Art Gallery. *Masterworks on Paper from the Albright-Knox Art Gallery.* New York: Hudson Hills Press, in association with the Gallery, Buffalo, New York, 1987.

ALBRIGHT-KNOX/2: Spaulding, Karen Lee, ed. *Masterworks at the Albright-Knox Art Gallery.* New York: Hudson Hills Press, in association with the Gallery, Buffalo, New York, 1999.

ALDRICH: Virginia Museum of Fine Arts. *Paintings and Sculpture Collected by Mr. and Mrs. Larry Aldrich.* Richmond: The Museum, 1958.

AMHERST/1: Amherst College. *American Drawings and Watercolors from Amherst College.* San Francisco: Art Museum Association of America, 1985.

AMHERST/2: Amherst College. Mead Art Building. *A Summary Catalogue of the Collection at Mead Art Gallery.* [Cover title: *American Art at Amherst.*] Middletown, Conn.: Distributed by Wesleyan University Press, 1978.

ANDERSON: *Celebrating Modern Art: The Anderson Collection.* San Francisco: San Francisco Museum of Modern Art, in association with University of California Press, Berkeley, 2000.

ANSCHUTZ: Anschutz Collection. *West, West, West: Major Paintings from the Anschutz Collection.* Denver, Colo.: The Collection, in association with University of Nebraska Press, Lincoln, 1991.

ARKANSAS/1: Arkansas Arts Center. *Selections from the Permanent Collection of the Arkansas Arts Center Foundation.* Little Rock: The Center, 1983.

ARKANSAS/2: Arkansas Arts Center Foundation Collection. *Twentieth Century American Drawings: From the Arkansas Arts Center Foundation Collection.* Miami Beach, Fla.: Grassfield Press, in association with the Collection, Little Rock, Arkansas, 1998.

ARMORY: Amherst College. Mead Art Building. *The 1913 Armory Show in Retrospect.* [Amherst, Mass.]: Amherst College, 1958.

ARTIST AND BOOK: Museum of Fine Arts, Boston. *The Artist and the Book, 1860–1960, in Western Europe and the United States.* Boston: The Museum; Cambridge: Harvard College Library, Department of Printing and Graphic Arts, 1961.

ASSEMBLAGE: Seitz, William C. *The Art of Assemblage.* New York: Museum of Modern Art: Distributed by Doubleday, Garden City, New York, 1961.

BABCOCK: Babcock Galleries. *Traditions: Babcock Galleries and American Art.* New York: The Galleries, 1989.

BAKER/PISANO: Heckscher Museum. *Late Nineteenth and Early Modernist*

American Art: Selections from the Baker/Pisano Collection. Huntington, N.Y.: The Museum, 1983.

BALTIMORE/1: Baltimore Museum of Art. *Master Drawings and Watercolors of the Nineteenth and Twentieth Centuries.* New York: American Federation of Arts, 1979.

BALTIMORE/2: Rosenthal, Gertrude, ed. *From El Greco to Pollock: Early and Late Works by European and American Artists.* Baltimore: Baltimore Museum of Art; Distributed by New York Graphic Society, New York, 1968.

BARKER: Barker, Virgil. *From Realism to Reality in Recent American Painting.* Lincoln: University of Nebraska Press, 1959.

BAUMFELD: University of California, Los Angeles. Grunwald Center for the Graphic Arts. *The Rudolf L. Baumfeld Collection of Landscape Drawings and Prints.* Los Angeles: The Center, 1989.

BAUR: Baur, John I.H. *Nature in Abstraction: The Relation of Abstract Painting and Sculpture to Nature in Twentieth-Century American Art.* New York: Published for the Whitney Museum of American Art by Macmillan, 1958.

BEACH: Tampa Museum of Art. *At the Water's Edge: 19th and 20th Century American Beach Scenes.* Tampa, Fla.: The Museum, 1989.

BEAL: Carnegie Museum of Art. *The Beal Collection of American Art.* Pittsburgh: The Museum, 1994.

BEAR: Santa Barbara Museum of Art. *Donald Bear Memorial Collection.* Santa Barbara, Calif.: The Museum, [1964].

BEARDSLEY: University of Notre Dame. Snite Museum of Art. *Twentieth Century Art: Walter R. Beardsley Gallery.* [Notre Dame, Ind.]: The Museum, 1980.

BEASTS: National Gallery of Art (U.S.) *Noble Beasts: Animals in Art.* Boston; New York: Bulfinch Press, Little, Brown, 1994.

BECK: Leeds, Valerie Ann. *An American Palette: Works from the Collection of John and Dolores Beck.* St. Petersburg, Fla.: Museum of Fine Arts, 2000.

BESTIARY: Haverstock, Mary Sayre. *An American Bestiary.* New York: H.N. Abrams, 1979.

BETHERS: Bethers, Ray. *How Paintings Happen.* New York: W.W. Norton, 1951.

BLANKFORT: Los Angeles County Museum of Art. *The Michael and Dorothy Blankfort Collection.* Los Angeles: The Museum, 1982.

BLOEDEL: *The Lawrence H. Bloedel Collection: A Loan Exhibition from the Whitney Museum of American Art and the Williams College Museum of Art.* Washington, D.C.: International Exhibitions Foundation, 1980.

BLOUNT: Montgomery Museum of Fine Arts. *Blount Collection of American Art.* Montgomery, Ala.: The Museum, 1993.

BLUES: Powell, Richard. *The Blues Aesthetic: Black Culture and Modernism.* Washington, D.C.: Washington Project for the Arts, 1989.

BOHAN: Bohan, Ruth L. "American Drawings and Watercolors, 1900–1945." *Bulletin of the Saint Louis Art Museum* n.s. 19 (Summer 1989).

BORN: Born, Wolfgang. *American Landscape Painting: An Interpretation.* New Haven, Conn.: Yale University Press, 1948.

BOSTON/1: "Centennial Acquisitions: Art Treasures for Tomorrow." *Bulletin of the Museum of Fine Arts, Boston* 68, nos. 351/352 (1970).

BOSTON/2: Museum of Fine Arts, Boston. *American Paintings in the Museum of Fine Arts, Boston.* Boston: Distributed for the Museum by New York Graphic Society, Greenwich, Conn., 1969.

BOSTON/3: Museum of Fine Arts, Boston. *Illustrated Handbook.* Boston: The Museum, 1976, c. 1975.

BOSWELL: Boswell, Peyton. *Modern American Painting.* New York: Dodd, Mead, 1948.

BRADLEY: Milwaukee Art Center. *The Collection of Mrs. Harry Lynde Bradley.* Milwaukee, Wis.: The Museum, 1968.

BRIDGE/1: Brooklyn Museum. *The Great East River Bridge, 1883–1983.* New York: Distributed for the Museum by H.N. Abrams, 1983.

BRIDGE/2: Trachtenberg, Alan. *Brooklyn Bridge: Fact and Symbol.* New York: Oxford University Press, 1965.

BROOKLYN/1: Brooklyn Museum. *American Watercolors, Pastels, Collages: A Complete Illustrated Listing of Works in the Museum's Collection.* New York: The Museum, 1984.

BROOKLYN/2: Brooklyn Museum. *Brooklyn Museum Handbook.* Brooklyn, N.Y.: The Museum, 1967.

BROOKLYN/3: Brooklyn Museum. *Golden Years of American Drawings, 1905–1956.* Brooklyn, N.Y.: The Museum, 1957.

BROOKLYN/4: Brooklyn Museum. *Masterpieces in the Brooklyn Museum.* New York: The Museum, in association with H.N. Abrams, 1988.

BROOKLYN/5: Brooklyn Museum. *Masterpieces of American Painting from the Brooklyn Museum.* Brooklyn, N.Y.: The Museum, 1976.

BROOKLYN/6: Faunce, Sarah. "Recent Acquisitions at the Brooklyn Museum." *The Burlington Magazine* 135 (April 1993).

BUTLER: Butler Institute of American Art. *Master Paintings from the Butler Institute of American Art.* New York: H.N. Abrams, in association with the Institute, Youngstown, Ohio, 1994.

CALIFORNIA/1: Fort, Ilene Susan. *American Paintings in Southern California Collections: From Gilbert Stuart to Georgia O'Keeffe.* Los Angeles: Los Angeles County Museum of Art, 1996.

CALIFORNIA/2: Richard York Gallery. *California: One Hundred Forty Years of Art Produced in the State.* New York: The Gallery, 1996.

CANADA: Boggs, Jean Sutherland. *The National Gallery of Canada.* Toronto: Oxford University Press, 1971.

CANADY: Canady, John. *Metropolitan Seminars in Art.* Portfolio 10, *Tech-*

niques. [Cover title: *Water Color, Pastel, and Prints.*] New York: Metropolitan Museum of Art, 1959.

CAPE ANN: Spanierman Gallery. *Painters of Cape Ann, 1840–1940: One Hundred Years in Gloucester and Rockport.* New York: The Gallery, 1996.

CARNEGIE/1: Carnegie Institute. Department of Art. *Retrospective Exhibition of Paintings from Previous Internationals, 1896–1955.* Pittsburgh: The Institute [1955].

CARNEGIE/2: Starzdes, Diana. *American Paintings and Sculpture to 1945 in the Carnegie Museum of Art.* New York: Hudson Hills Press, in association with the Carnegie Museum of Art, Pittsburgh, 1993.

CARTER/1: Amon Carter Museum of Western Art. *American Paintings: Selections from the Amon Carter Museum.* Birmingham, Ala.: Oxmoor House, 1986.

CARTER/2: Amon Carter Museum of Western Art. *Catalogue of the Collection.* Fort Worth, Tex.: The Museum, 1972.

CENTURY: Mayor, A. Hyatt and Mark Davis. *American Art at the Century.* [New York]: Century Association, 1977.

CHANDLER: Kilgore, Karen and Pam Andich. *The Gallery Guild and the University Gallery Present American Paintings from the First Half of the 20th Century: From the Eloise and William Chandler Collection.* Gainesville: University Gallery, College of Fine Arts, University of Florida, 1985.

CHICAGO/1: Art Institute of Chicago. *The Art Institute of Chicago: The Essential Guide.* Chicago: The Institute, 1993.

CHICAGO/2: Art Institute of Chicago. *Paintings in the Art Institute of Chicago: A Catalogue of the Picture Collection.* [Chicago]: The Institute, 1961.

CHICAGO/3: Wood, James N. and Teri J. Edelstein. *The Art Institute of Chicago: Twentieth-Century Painting and Sculpture.* Chicago: The Institute; New York: Distributed by Hudson Hills Press, 1996.

CHICAGO/4: Wood, James N. and Katherine C. Lee. *Master Paintings in the Art Institute of Chicago.* Chicago: The Institute; New York: Distributed by Hudson Hills Press, 1988.

CHRISTIE/5025: *American Paintings, Drawings and Sculpture of the 19th and 20th Centuries* (Public Sale 5025). New York: Christie, Manson and Woods, 1980.

CHRISTIE/6552: *American Watercolors, Drawings, Paintings and Sculpture of the 19th and 20th Centuries* (Public Sale 6552). New York: Christie's, 1988.

CHRISTIE/6610: *Important American Paintings, Drawings and Sculpture of the 19th and 20th Centuries* (Public Sale 6610). New York: Christie's, 1988.

CHRISTIE/6724: *Important American Paintings, Drawings and Sculpture of the 18th, 19th and 20th Centuries* (Public Sale 6724). New York: Christie's, 1988.

CHRISTIE/6772: *American Watercolors, Drawings, Paintings and Sculpture of*

the 19th and 20th Centuries (Public Sale 6772). New York: Christie's, 1989.

CHRISTIE/6874: *Important American Paintings, Drawings and Sculpture of the 18th, 19th and 20th Centuries* (Public Sale 6874). New York: Christie's, 1989.

CHRISTIE/6890: *American Watercolors, Drawings, Paintings and Sculpture of the 19th and 20th Centuries* (Public Sale 6890). New York: Christie's 1989.

CHRISTIE/6972: *Important American Paintings, Drawings and Sculpture of the 18th, 19th, and 20th Centuries* (Public Sale 6972). New York: Christie's, 1989.

CHRISTIE/7020: *American Watercolors, Drawings, Paintings and Sculpture of the 19th and 20th Centuries* (Public Sale 7020). New York: Christie's, 1990.

CHRISTIE/7023: *19th and 20th Century American Paintings, Drawings, Watercolors and Sculpture* (Public Sale 7023). New York: Christie's East, 1990.

CHRISTIE/7082: *Important American Paintings, Drawings and Sculpture of the 18th, 19th and 20th Centuries* (Public Sale 7082). New York: Christie's, 1990.

CHRISTIE/7103: *19th and 20th Century American Paintings, Drawings, Watercolors and Sculpture* (Public Sale 7103). New York: Christie's East, 1990.

CHRISTIE/7116: *American Watercolors, Drawings, Paintings and Sculpture of the 19th and 20th Centuries* (Public Sale 7116). New York: Christie's, 1990.

CHRISTIE/7230: *American Watercolors, Drawings, Paintings and Sculpture of the 18th, 19th and 20th Centuries* (Public Sale 7230). New York: Christie's 1991.

CHRISTIE/7270: *Important American Paintings, Drawings and Sculpture of the 18th, 19th and 20th Centuries, including Paintings from the Collection of Mrs. George Arden, Part I* (Public Sale 7270). New York: Christie's, 1991.

CHRISTIE/7414: *American Watercolors, Drawings, Paintings, and Sculpture of the 19th and 20th Centuries* (Public Sale 7414). New York: Christie's, 1992.

CHRISTIE/7415: *American Paintings, Drawings, Watercolors and Sculpture* (Public Sale 7415). New York: Christie's East, 1993.

CHRISTIE/7493: *American Paintings, Drawings and Watercolors* (Public Sale 7493). New York: Christie's East, 1993.

CHRISTIE/7508: *American Paintings, Watercolors and Drawings of the 18th, 19th and 20th Centuries* (Public Sale 7508). New York: Christie's, 1992.

CHRISTIE/7629: *American Paintings, Drawings and Sculpture* (Public Sale 7629). New York: Christie's East, 1994.

CHRISTIE/7632: *American Paintings, Watercolors, Drawings and Sculpture of*

the 19th and 20th Centuries (Public Sale 7632). New York: Christie's, 1993.

CHRISTIE/7724: *American Paintings, Drawings and Sculpture* (Public Sale 7724). New York: Christie's, 1993.

CHRISTIE/7780: *American and Modern Prints and Illustrated Books* (Public Sale 7780). New York: Christie's, 1993.

CHRISTIE/7805: *American Paintings* (Public Sale 7805). New York: Christie's East, 1995.

CHRISTIE/7871: *American Paintings* (Public Sale 7871). New York: Christie's East, 1996.

CHRISTIE/8051: *American Paintings and Sculpture* (Public Sale 8051). New York: Christie's East, 1997.

CHRISTIE/8097: *American Paintings and Sculpture* (Public Sale 8097). New York; Christie's East, 1998.

CHRISTIE/8151: *American Paintings and Sculpture* (Public Sale 8151). New York: Christie's East, 1998.

CHRISTIE/8260: *American Paintings, Drawings and Sculpture* (Public Sale 8260). New York: Christie's, 1995.

CHRISTIE/8290: *Important American Paintings, Drawings and Sculpture* (Public Sale 8290). New York: Christie's, 1995.

CHRISTIE/8362: *American Paintings, Drawings and Sculpture* (Public Sale 8362). New York: Christie's, 1996.

CHRISTIE/8408: *Important American Paintings, Drawings and Sculpture* (Public Sale 8408). New York: Christie's, 1996.

CHRISTIE/8478: *American Paintings, Drawings and Sculpture* (Public Sale 8478). New York: Christie's, 1996.

CHRISTIE/8790: *Important American Paintings, Drawings and Sculpture* (Public Sale 8790). New York: Christie's, 1997.

CHRYSLER/1: Anderson, Dennis R. *Three Hundred Years of American Art in the Chrysler Museum*. Norfolk, Va.: Chrysler Museum at Norfolk, 1975.

CHRYSLER/2: Chrysler Museum. *The Controversial Century, 1850–1950: Paintings from the Collection of Walter P. Chrysler, Jr*. [S.l.: s.n., 1962.]

CINCINNATI/1: Cincinnati Art Museum. *Cincinnati Art Museum Handbook*. Cincinnati, Ohio: The Museum, 1975.

CINCINNATI/2: "Paintings of the Later Nineteenth and Earlier Twentieth Centuries." *The Cincinnati Art Museum Bulletin* 8 (October 1968).

CINQUANTE: *Cinquante ans de dessins américains, 1930–1980*. Paris: Ecole nationale supérieure des Beaux-Arts; Houston, Tex.: Menil Collection, 1985.

CIRCUS: John and Mable Ringling Museum of Art. *The Circus in Art*. Sarasota, Fla.: The Museum, 1977.

CITY AND COUNTRY: Terra Museum of American Art. *The City and the Country: American Perspectives, 1870–1920*. Chicago: Terra Foundation for the Arts, 1999.

New York ; Greenwich, Conn.: Distributed by New York Graphic Society, [1966].

CUBIST/1: Cooper, Douglas. *The Cubist Epoch*. New York: Phaidon, 1971.

CUBIST/2: Daix, Pierre. *Cubists and Cubism*. Geneva, Switzerland: Skira; New York: Rizzoli International, 1982.

CUBIST/3: Eddy, Arthur Jerome. *Cubists and Post-Impressionism*, new and rev. ed. Chicago: A.C. McClurg, 1919.

CUBIST/4: Janie C. Lee Gallery. *Cubist Drawings, 1907–1929*. Houston, Tex.: The Gallery, [1982].

CUBIST/5: Rosenblum, Robert. *Cubism and Twentieth-Century Art*. New York: H.N. Abrams, 1960.

CUBIST/6: Stein, Donna. *Cubist Prints, Cubist Books*. [*Flue* 4, nos. 1 and 2 (Fall 1983).] New York: Franklin Furnace, 1983.

CUBIST/7: Wallen, Burr and Donna Stein. *The Cubist Print*. Santa Barbara: University Art Museum, University of California, Santa Barbara, 1981.

CURRIER: Currier Gallery of Art. *The Currier Gallery of Art: Handbook of the Collection*. Manchester, N.H.: The Gallery, 1979.

DADA: Naumann, Francis M. *Making Mischief: Dada Invades New York*. New York: Whitney Museum of American Art : Distributed by H.N. Abrams, 1996.

DALLAS: Nash, Steven A. *Dallas Collects American Paintings: Colonial to Early Modern. An Exhibition of Paintings from Private Collections in Dallas*. Dallas, Tex.: Dallas Museum of Fine Arts, 1982.

DELAWARE: Delaware Art Museum. *American Painting and Sculpture: Delaware Art Museum*. Wilmington: The Museum, 1975.

DELGADO: Isaac Delgado Museum of Art. *Early Masters of Modern Art: A Local Collection Exhibited Anonymously*. New Orleans: The Museum, 1959.

DENVER: Denver Art Museum. *The Denver Art Museum: Guide to the Collection*. Denver: The Museum, 1971.

DES MOINES: Des Moines Art Center. *An Uncommon Vision: The Des Moines Art Center*. Des Moines, Iowa: The Center; New York: Distributed by Hudson Hills Press, 1998.

DETROIT: Detroit Institute of Arts. *The Detroit Institute of Art Illustrated Handbook*. Detroit: Published for the Institute by Wayne State University Press, 1971.

DIAL: Worcester Art Museum. *The Dial and the Dial Collection*. Worcester, Mass.: The Museum, 1959.

DOW: Cornell University. Herbert F. Johnson Museum of Art. *Arthur Wesley Dow and His Influence*. Ithaca, N.Y.: The Museum, 1990.

DRAWING/1: Bowen, Ron. *Drawing Masterclass*. Boston: Bulfinch Press, 1992.

DRAWING/2: Chaet, Bernard. *The Art of Drawing*, 2d ed. New York: Holt, Rinehart, and Winston, 1978.

DRAWING/3: Cummings, Paul. *American Drawings: The 20th Century*. New York: Viking, 1976.

DRAWING/4: Davidson, Marshall B. *The Drawing of America: Eyewitnesses to History*. New York: H.N. Abrams, 1983.

DRAWING/5: Hayes, Bartlett H., Jr. *American Drawings* (Drawings of the Masters). Boston: Little, Brown, 1975.

DRAWING/6: Hirschl and Adler Galleries. *Realism and Abstraction: Counterpoints in American Drawing, 1900–1940*. New York: The Galleries, 1983.

DRAWING/7: Johnson, Una E. *20th Century Drawings*. Part I, *1900–1940* (Drawings of the Masters). Boston: Little, Brown, 1976.

DRAWING/8: Johnson, Una E. *20th Century Drawings*. Part II, *1940 to the Present* (Drawings of the Masters). Boston: Little, Brown, 1976.

DRAWING/9: Kennedy Galleries. *The Spontaneous Eye: American Drawings of the Twentieth Century*. New York: The Galleries, 1985.

DRAWING/10: Mendelowitz, Daniel M. *Drawing*. New York: Holt, Rinehart, and Winston, 1967.

DRAWING/11: Mendelowitz, Daniel M. *A Guide to Drawing*. New York: Holt, Rinehart and Winston, 1976.

DRAWING/12: Slatkin, Charles E. and Regina Shoolman. *Treasury of American Drawings*. New York: Oxford University Press, 1947.

DRAWING/13: Solomon R. Guggenheim Museum. *Twentieth-Century American Drawing: Three Avant-Garde Generations*. New York: Solomon R. Guggenheim Foundation, 1976.

DRAWING/14: Spanierman/Drawings. *American Works on Paper III* (Winter 1989). New York: Spanierman/Drawings, 1989.

DRAWING/15: University of Georgia. Georgia Museum of Art. *Intimate Expressions: Two Centuries of American Drawing*. Athens: The Museum, 1998.

DREIER: Yale University. Art Gallery. *The Société Anonyme and the Dreier Bequest at Yale University: A Catalogue Raisonné*. New Haven, Conn.: Published for the Gallery by Yale University Press, 1984.

EBSWORTH: Buckley, Charles. *The Ebsworth Collection: American Modernism, 1911–1947*. [Saint Louis, Mo.]: Saint Louis Art Museum, 1987.

EITELJORG: Eiteljorg, Harrison. *Treasures of the American West: Selections from the Collection of Harrison Eiteljorg*. New York: Balance House, 1981.

ELIOT: Eliot, Alexander. *Three Hundred Years of American Painting*. New York: Time, 1957.

ENCOUNTERS: Katonah Gallery. *New England—New Mexico: Artistic Encounters, 1910–1940*. Katonah, N.Y.: The Gallery, 1989.

FARNSWORTH: Belanger, Pamela J. *Maine in America: American Art at the Farnsworth Art Museum.* Rockland, Maine: The Museum; Hanover, N.H.: Distributed by University Press of New England, 2000.

FISK: Fisk University. Carl van Vechten Gallery of Fine Arts. *The Alfred Stieglitz Collection for Fisk University.* [Nashville, Tenn.: Fisk University, 1984.]

FITCH:"American Watercolors from the Collection of George Hopper Fitch." *Yale University Art Gallery Bulletin* 37 (Spring 1980).

FLEISCHMAN/1: Milwaukee Art Center. *American Painting, 1760–1960: A Selection of 125 Paintings from the Collection Mr. and Mrs. Lawrence A. Fleischman, Detroit.* Milwaukee, Wis.: The Center, 1960.

FLEISCHMAN/2: University of Arizona. Art Gallery. *Selections from the Lawrence A. and Barbara Fleischman Collection of American Art.* [Cover title: *American Painting, 1765–1963.*] Tucson: The Gallery, 1964.

FLORIDA: Leeds, Valerie Ann. *Hidden Treasures: American Paintings from Florida Private Collections.* Orlando, Fla.: Orlando Museum of Art, 1992.

FLOWER/1: Anderson, Dennis R. *American Flower Painting.* New York: Watson-Guptill, 1980.

FLOWER/2: Foshay, Ella M. *Reflections of Nature: Flowers in American Art.* New York: Alfred A. Knopf, in association with the Whitney Museum of American Art, 1988.

FOREIGN: Milwaukee Art Center. *From Foreign Shores: Three Centuries of Art by Foreign Born American Masters.* Milwaukee, Wis.: The Center, 1976.

FORT WORTH/1: Fort Worth Art Museum. *Painting and Sculpture: Selections from the Collection of the Fort Worth Art Museum, A Museum of Twentieth Century Art.* [S.l.: s.n., 1974?].

FORT WORTH/2: Fort Worth Art Museum. *Twentieth Century Art from Fort Worth/Dallas Collections.* Fort Worth, Tex.: The Museum, 1974.

FRAAD: Brooklyn Museum. *American Painting: Selections from the Collection of Daniel and Rita Fraad.* Brooklyn, N.Y.: The Museum, 1964.

FUTURISM: Hulten, Pontus. *Futurism and Futurisms.* New York: Abbeville Press, 1986.

GALLAGHER: University of Arizona. Museum of Art. *The Gallagher Memorial Collection: Paintings, Watercolors, Drawings and Sculptures Collected by Mr. Edward Joseph Gallagher, Jr.* Tucson: The Museum, [1968?].

GALLATIN/1: Gallery of Living Art. *Gallery of Living Art: A.E. Gallatin Collection.* New York: The Gallery, 1933.

GALLATIN/2: Philadelphia Museum of Art. *A.E. Gallatin Collection: "Museum of Living Art."* Philadelphia: The Museum, 1954.

GALLATIN/3: Stavistsky, Gail. "The A. E. Gallatin Collection: An Early Ad-

venture in Modern Art." *Bulletin. Philadelphia Museum of Art* 89 (Winter/Spring 1994).

GALLU: Porter, Jean Chenault. *Selected Works from the Collection of Samuel Gallu*. University Park: Museum of Art, Pennsylvania State University, 1981.

GEORGIA/1: Georgia Museum of Art. *A University Collects: Georgia Museum of Art, the University of Georgia*. [Athens]: The Museum, 1969.

GEORGIA/2:Morrin, Peter and Eric Zafran. *Drawings from Georgia Collections: 19th and 20th Centuries*. Atlanta, Ga.: High Museum of Art, 1981.

GEORGIA/3: University of Georgia. Museum of Art. *Before 1948: American Paintings in Georgia Collections*. [Athens]: The Museum, 1998.

GERDTS/1: Gerdts, William H. *Art across America: Regional Painting in America, 1710–1920*. Vol. 1, *New England, New York, Mid-Atlantic*. New York: Abbeville Press, 1990.

GERDTS/2: Gerdts, William H. *Impressionist New York*. New York: Abbeville Press, 1994.

GLOUCESTER/1: Grace Borgenicht Gallery. *The Gloucester Years*. New York: The Gallery, 1982.

GLOUCESTER/2: *Portrait of a Place: Some American Landscape Painters in Gloucester*. [Gloucester, Mass.]: Gloucester 350th Anniversary Celebration, [1973].

GOLDEN DOOR: McCabe, Cynthia Jaffee. *The Golden Door: Artist-Immigrants of America, 1876–1976*. Washington, D.C.: Published for the Hirshhorn Museum and Sculpture Garden, Smithsonian Institution, by the Smithsonian Institution Press, 1976.

GOLDSTONE: Goldstone, Herbert A. *The Herbert A. Goldstone Collection of American Art*. Brooklyn, N.Y.: Brooklyn Museum, 1965.

GOODWIN: "Works of Art: Given or Promised. The Philip L. Goodwin Collection: Two Exhibitions." *The Museum of Modern Art Bulletin* 26 (Fall 1958).

GRAHAM: Denver Art Museum. *Early American Modernism: The Lucile and Donald Graham Collection*. Denver: The Museum, 1988.

GRANT-MUNGER: Fine Arts Gallery of San Diego. *The Grant-Munger Collection: American and European 19th and 20th Century Art and Asiatic Art*. San Diego: The Gallery, 1970.

GREENVILLE: Greenville County Museum of Art. *Greenville County Museum of Art: The Southern Collection*. New York: Hudson Hills Press, in association with the Museum, Greenville, South Carolina, 1995.

GUSSOW: Gussow, Alan. *A Sense of Place: The Artist and the American Land*. San Francisco: Friends of the Earth, [1972].

HALPERT: *Highly Important 19th and 20th Century American Paintings, Watercolors and Sculpture from the Estate of the Late Edith Gregor Halpert (The Downtown Gallery)*. New York: Sotheby Parke Bernet, 1973.

HANLEY: Gallery of Modern Art (New York) *Selections from the Collection of Dr. and Mrs. T. Edward Hanley, Bradford, Pennsylvania.* New York: The Gallery, including the Huntington Hartford Collection, Foundation for Modern Art, 1967.

HARMSEN/1: Harmsen, Dorothy. *American Western Art: A Collection of One Hundred Twenty-Five Western Paintings and Sculpture with Biographies of the Artists.* [Denver: Harmsen Western], 1977.

HARMSEN/2: Harmsen, Dorothy. *Harmsen's Western Americana: A Collection of One Hundred Western Paintings with Biographical Profiles of the Artists.* Flagstaff, Ariz.: Northland Press, 1971.

HARVARD/1: Harvard University. Fogg Art Museum. *American Art at Harvard.* Cambridge, Mass.: The Museum, 1972.

HARVARD/2: Jones, Caroline A. *Modern Art at Harvard: The Formation of the Nineteenth- and Twentieth-Century Collections of the Harvard Art Museums.* Cambridge: Harvard University Art Museums; New York: Abbeville Press, 1985.

HASKELL: Haskell, Barbara. *The American Century: Art and Culture, 1900–1950.* New York: Whitney Museum of American Art, in association with W.W. Norton, 1999.

HATCH: Heim Gallery. *100 American Drawings: Loan Exhibition from the Collection of John Davis Hatch.* London: The Gallery, 1976.

HEALTH: Kuspit, Donald B. and Lynn Gamwell. *Health and Happiness in 20th-Century Avant-Garde Art.* Ithaca, N.Y.: Cornell University Press; Binghampton, N.Y.: Binghampton University Art Museum, State University of New York, 1996.

HECKSCHER/1: Heckscher Museum. *Catalogue of the Collection: Paintings and Sculpture.* Huntington, N.Y.: The Museum, 1979.

HECKSCHER/2: Heckscher Museum. *Collections in Context: Works on Paper from the Permanent Collection.* Huntington, N.Y.: The Museum, 1986.

HERITAGE: Toledo Museum of Art. *Heritage and Horizon: American Painting 1776–1976.* [Toledo, Ohio]: The Museum, 1976.

HIGH/1: Chambers, Bruce W. *American Paintings in the High Museum of Art: A Bicentennial Catalogue.* Atlanta, Ga.: The Museum, 1975.

HIGH/2: High Museum of Art. *The Advent of Modernism: Post-Impressionism and North American Art, 1900–1918.* Atlanta, Ga.: The Museum, 1986.

HILLSTROM: Jon, Dennis Michael. *American Masters: Selections from the Richard Lewis Hillstrom Collection.* Minneapolis: Minneapolis Institute of Arts, 1993.

HIRSCHL/1: Hirschl and Adler Galleries. *American Art from the Gallery's Collection.* New York: The Galleries, 1980.

HIRSCHL/2: Hirschl and Adler Galleries. *American Masterworks on Paper: Drawings, Watercolors, and Prints.* New York: The Galleries, 1985.

HIRSCHL/3: Hirschl and Adler Galleries. *Buildings: Architecture in American Modernism.* New York: The Galleries, 1980.

IBM: *American Paintings, Drawings and Watercolors from the IBM International Foundation* (Public Sale 6713, Vol. II). New York: Sotheby's, 1995.

ILLINOIS/48: University of Illinois—Urbana. College of Fine and Applied Arts. *University of Illinois Competitive Exhibition of Contemporary American Painting*. Urbana: University of Illinois, College of Fine and Applied Arts, 1948.

ILLINOIS/49: University of Illinois—Urbana. College of Fine and Applied Arts. *University of Illinois Exhibition of Contemporary American Painting*. Urbana: University of Illinois, College of Fine and Applied Arts, 1949.

ILLINOIS/51: University of Illinois—Urbana. College of Fine and Applied Arts. *University of Illinois Exhibition of Contemporary American Painting*. Urbana: University of Illinois Press, 1951.

ILLINOIS/57: University of Illinois—Urbana. College of Fine and Applied Arts. *Contemporary American Painting and Sculpture*. Urbana: University of Illinois Press, 1957.

ILLINOIS/61: University of Illinois—Urbana. College of Fine and Applied Arts. *Contemporary American Painting and Sculpture*. Urbana: University of Illinois Press, 1961.

ILLUSIONISM: *Illusionism and Trompe L'Oeil*. San Francisco: California Palace of the Legion of Honor, 1949.

ILLUSTRATION: Larson, Judy L. *American Illustration, 1890–1925: Romance, Adventure, Suspense*. Calgary, Canada: Glenbow Museum, 1986.

INDIANA: Indiana University Art Museum. *Guide to the Collections: Highlights from the Indiana University Art Museum*. Bloomington: The Museum, 1980.

IOWA: University of Iowa. Museum of Art. *The University of Iowa Museum of Art: 101 Masterworks, with Introduction and Essays by Robert Hobbs*. Iowa City: The Museum, 1986.

JACKSON: *The Private Collection of Martha Jackson*. [S.l.: s.n., 1973.] (Mount Vernon, N.Y.: The Press of A. Colish; New York: Distributed by Wittenborn Art Books.)

JANIS: Janis, Sidney. *Abstract and Surrealist Art in America*. New York: Reynal and Hitchcock, 1944.

JEWISH/1: Grossman, Grace Cohen. *Jewish Art*. Southport, Conn.: Hugh Lauter Levin Associates, 1995.

JEWISH/2: Kampf, Avram. *Chagall to Kitaj: Jewish Experience in 20th Century Art*. New York: Praeger, in association with Barbican Art Gallery, London, England, 1990.

JEWISH/3: Landsberger, Franz. *A History of Jewish Art*. Cincinnati, Ohio: Union of American Hebrew Congregations, 1946.

JEWISH/4: Mann, Vivian B. and Emily B. Biliski. *The Jewish Museum New York*. New York: Scala, in association with the Museum, 1993.

JEWISH/5: Maurice Spertus Museum of Judaica. *Jewish Artists of the Twentieth Century*. Chicago: Spertus College of Judaica Press, 1975.

JEWISH/6: Roth, Cecil. *Jewish Art: An Illustrated History*, rev. ed. Greenwich, Conn.: New York Graphic Society, 1971.

JEWISH/7: Schwarz, Karl. *Jewish Artists of the 19th and 20th Centuries*. New York: Philosophical Library, 1949.

JEWISH/8: Yochim, Louise Dunn. *The Harvest of Freedom: Jewish Artists in America 1930–1980s*, edited by Michael Weinberg. Chicago: American References, 1989.

JOACHIMIDES: Joachimides, Christos M. and Norman Rosenthal, eds. *American Art in the 20th Century: Painting and Sculpture, 1913–1993*. Munich: Prestel; New York: Distributed in the United States and Canada on behalf of Prestel by the Neues Publishing Company, 1993.

KANSAS: University of Kansas. Museum of Art. *American Drawings and Watercolors from the Collection of the University of Kansas Museum of Art*. [Lawrence]: The Museum, 1973.

KANSAS CITY: Adams, Henry. *American Drawings and Watercolors from the Kansas City Region*. Kansas City, Mo.: Nelson-Atkins Museum of Art, 1992.

KENNEDY/1: Kennedy Galleries. *The American Tradition of Realism, Part II: Paintings and Sculpture of the Twentieth Century*. New York: The Galleries, 1983.

KENNEDY/2: Kennedy Galleries. *The American View: Art from 1770 to 1978*. New York: The Galleries, 1978.

KENNEDY/3: Kennedy Galleries. *The City as a Source*. New York: The Galleries, 1977.

KENNEDY/4: Kennedy Galleries. *Continuity and Diversity in American Art in the Nineteenth and Twentieth Centuries*. New York: The Galleries, 1984.

KENNEDY/5: Kennedy Galleries. *The Eyes of America from 1792–1979*. New York: The Galleries, 1979.

KENNEDY/6: Kennedy Galleries. *Important American Art, 1903–1972*. New York: The Galleries, 1972.

KENNEDY/7: Kennedy Galleries. *Insights and Outlooks: A Selection of American Twentieth Century Watercolors and Drawings*. New York: The Galleries, 1986.

KENNEDY/8: Kennedy Galleries. *A Kennedy Galleries Selection of American Art for Public and Private Collectors*. New York: The Galleries, 1981.

KENNEDY/9: Kennedy Galleries. *One Hundred Years of American Drawings and Watercolors; The Empire State: American Paintings, Watercolors, Drawings and Prints; Selected American Prints*. New York: The Galleries, 1986.

KENNEDY/10: Kennedy Galleries. *People, Places, and Things: American Master Paintings, 1760–1966*. New York: The Galleries, 1994.

KENNEDY/11: Kennedy Galleries. *People, Places and Things: American Paintings 1750–1980*. New York: The Galleries, 1980.

KENNEDY/12: Kennedy Galleries. *Rare American Masterpieces of the 18th, 19th, and 20th Centuries, Vol. II*. New York: The Galleries, 1974.

KENNEDY/13: Kennedy Galleries. *Recently Acquired American Masterpieces of the 19th and 20th Centuries*. New York: The Galleries, 1974.

KENNEDY/14: Kennedy Galleries. *Selected American Masterworks: John Singleton Copley to Jack Levine, 1770–1979*. New York: The Galleries, 1979.

KENNEDY/15: Kennedy Galleries. *Selected Highlights of American Art*. New York: The Galleries, 1993.

KENNEDY/16: Kennedy Galleries. *A Selection of 20th Century American Masterpieces*. New York: The Galleries, 1973.

KENNEDY/17: Kennedy Galleries. *Sixty American Paintings, 1840–1980*. New York: The Galleries, 1980.

KENNEDY/18: Kennedy Galleries. *Summits: Outstanding American Paintings 1763–1985*. New York: The Galleries, 1985.

KENNEDY/19: Kennedy Galleries. *Summits III: American Master Paintings, Watercolors, Drawings and Prints*. New York: The Galleries, 1987.

KENNEDY/20: Kennedy Galleries. *Twentieth Century American Masters*. New York: The Galleries, 1971.

KOOTZ/1: Kootz, Samuel M. *Modern American Painters*. [New York]: Brewer and Warren, 1930.

KOOTZ/2: Kootz, Samuel. *New Frontiers in American Painting*. New York: Hastings House, 1943.

KUH/1: Kuh, Katharine. *American Artists Paint the City (xxviith Biennale, Venice)*. [S.l.: s.n.], 1956. (Chicago: R.R. Donnelley and Sons, Lakeside Press.)

KUH/2: Kuh, Katharine. *Break-Up: The Core of Modern Art*. Greenwich, Conn: New York Graphic Society, 1965.

LANDAU: Felix Landau Gallery. *American and European Paintings and Watercolors*. Los Angeles: The Gallery, 1969.

LANDSCAPE/1: Arthur, John. *Spirit of Place: Contemporary Landscape Painting and the American Tradition*. Boston: Bulfinch Press, Little, Brown, 1989.

LANDSCAPE/2: Czestochowski, Joseph S. *The American Landscape Tradition: A Study and Gallery of Paintings*. New York: E.P. Dutton, 1982.

LANDSCAPE/3: Robinson, Malcolm. *The American Vision: Landscape Paintings of the United States*. London: Octopus, 1988.

LANE: Stebbins, Theodore and Carol Troyen. *The Lane Collection: 20th-*

LOS ANGELES/2: Los Angeles Museum of Art. *American Art: A Catalogue of the Los Angeles Museum of Art Collection*. Los Angeles, Calif.: The Museum, 1991.

LOWENTHAL: Messinger, Lisa Mintz. "American Art: The Edith and Milton Lowenthal Collection." *The Metropolitan Museum of Art Bulletin* 54 (Summer 1996).

LUDWIG: Museum Ludwig. *Europa/Amerika: Die Geschichte einer Kunstlerischen Faszination seit 1940*. Koln: The Museum, 1986.

MACHINE: Wilson, Richard Guy, Dianne H. Pilgrim, and Dickran Tashjian. *The Machine Age in America, 1918–1941*. New York: Brooklyn Museum, in association with H.N. Abrams, 1986.

MAINE/1: Little, Carl. *Art of the Maine Islands*. Camden, Maine: Down East Books, 1997.

MAINE/2: Skolnick, Arnold, ed. *Paintings of Maine*. New York: Clarkson Potter, 1991.

MAN: M.H. de Young Memorial Museum. *Man: Glory, Jest, and Riddle: A Survey of the Human Form through the Ages*. San Francisco: The Museum, 1965.

MANHATTAN: Museum of Modern Art (New York). *Manhattan Observed: Selections of Drawings and Prints*. New York: The Museum; Greenwich, Conn.: Distributed by New York Graphic Society, 1968.

MARINE/1: Gaunt, William. *Marine Painting: An Historical Survey*. London: Secker and Warburg, 1975.

MARINE/2: Virginia Museum. *American Marine Painting*. Richmond, Va.: The Museum, 1976.

MARINE/3: Wilmerding, John. *American Marine Painting*, 2d ed. New York: H.N. Abrams, 1987.

MARONEY: *The Odd Picture: Distinctive Yet Not Necessarily Predictable Efforts by Recognized Masters, All Modern in Their Several Ways*. New York: James Maroney, 1984.

MARRON: Santa Barbara Museum of Art. *The Gloria and Donald B. Marron Collection of American Prints*. Santa Barbara, Calif.: The Museum, 1981.

MARTINSON: *What Is American in American Art? An Exhibition in Memory of Joseph B. Martinson for the Benefit of the Museum of American Folk Art*. New York: M. Knoedler and Co., 1971.

MASTERS/1: Bernard Danenberg Galleries. *American Masters: Gallery Collection of Important Paintings and Sculpture*. New York: The Galleries, 1970.

MASTERS/2: Maurice Sternberg Galleries. *Nineteenth and Twentieth Century Masters*. Chicago: The Galleries, 1976.

MAY/1: Huntsville Museum of Art. *The May Family Collection of American Paintings*. Huntsville, Ala.: The Museum, 1988.

MAY/2: Texas A&M University. Memorial Student Center Gallery. *The American Vision: Paintings from the C. Thomas May, Jr. Family Collection*. College Station, Tex.: The Gallery, 1982.

MCDONOUGH/1: Bullard, E. John. *A Panorama of American Painting: The John J. McDonough Collection.* [New Orleans]: New Orleans Museum of Art, 1975.

MCDONOUGH/2: *Fine American Paintings: The Property of Dr. John D. McDonough, Youngstown, Ohio* (Public Sale 4098). New York: Sotheby, Parke, Bernet, 1978.

MCNAY: Marion Kooger McNay Art Institute. *The Marion Kooger McNay Art Institute Selective Catalogue.* San Antonio, Tex.: Published for the Institute by Trinity University Press, 1980.

MET/1: Metropolitan Museum of Art (New York). *American Pastels in the Metropolitan Museum of Art.* New York: The Museum, in association with H.N. Abrams, 1989.

MET/2: Metropolitan Museum of Art (New York). *American Watercolors from the Metropolitan Museum of Art.* New York: American Federation of Arts, in association with H.N. Abrams, 1991.

MET/3: Metropolitan Museum of Art (New York). *The Landscape in Twentieth-Century American Art: Selections from the Metropolitan Museum of Art.* New York: American Federation of Arts, 1991.

MET/4: Metropolitan Museum of Art (New York). *Notable Acquisitions, 1965–1975.* New York: The Museum, 1975.

MET/5: Metropolitan Museum of Art (New York). *Recent Acquisitions, 1985–1986.* New York: The Museum, 1986.

MET/6: "Recent Acquisitions: A Selection, 1988–1989." *The Metropolitan Museum of Art Bulletin* 47 (Fall 1989).

MET/7: "Recent Acquisitions: A Selection, 1991–1992." *The Metropolitan Museum of Art Bulletin* 50 (Fall 1992).

MET/8: "Recent Acquisitions: A Selection, 1994–1995." *The Metropolitan Museum of Art Bulletin* 53 (Fall 1995).

MET/9: Sims, Lowery Stokes. *The Figure in 20th Century American Art: Selections from the Metropolitan Museum of Art.* New York: Metropolitan Museum of Art: American Federation of Arts, 1984.

METROPOLIS: Montreal Museum of Fine Arts. *The 1920s: Age of the Metropolis.* Montreal, Canada: The Museum, 1991.

MEYER: Hyland, Douglas K.S. "Agnes Ernst Meyer: Patron of American Modernism." *The American Art Journal* 12 (Winter 1980).

MICHENER: University of Texas at Austin. University Art Museum. *The James A. Michener Collection: Twentieth-Century American Painting.* Austin: The Museum, 1977.

MICHIGAN/1: University of Michigan. Museum of Art. *Illustrated Catalogue of European and American Painting and Sculpture.* Ann Arbor: The Museum, 1988.

MICHIGAN/2: University of Michigan. Museum of Art. *Modern Master Drawings: Forty Years of Collecting at the University of Michigan Museum of Art.* Ann Arbor: The Museum, 1986.

MICHIGAN/3: University of Michigan. Museum of Art. *Works of Art Selected*

ing in America 1800–1950. New York: The Museum; Boston: Distributed by New York Graphic Society, 1976.

MOMA/11: Museum of Modern Art (New York). *Painting and Sculpture by Living Americans: Ninth Loan Exhibition*. New York: The Museum, [1930].

MOMA/12: Museum of Modern Art (New York). *Painting and Sculpture in the Museum of Modern Art, 1929–1967*. New York: The Museum, 1977.

MOMA/13: Museum of Modern Art (New York). *Paintings by Nineteen Living Americans*. New York: The Museum, 1930.

MOMA/14: Ritchie, Andrew Carnduff. *Abstract Painting and Sculpture in America*. New York: Museum of Modern Art, 1951.

MOMA/15: Soby, James Thrall and Dorothy C. Miller. *Romantic Painting in America*. New York: Museum of Modern Art, 1943.

MONTCLAIR: Montclair Art Museum. *Three Hundred Years of American Paintings: The Montclair Art Museum Collection*. New York: Hudson Hills Press, in association with the Museum, Montclair, N.J., 1987.

MONTPARNASSE: Silver, Kenneth E. and Romy Golan. *The Circle of Montparnasse: Jewish Artists in Paris, 1905–1945*. New York: Jewish Museum; Universe Books, 1985.

MOORE: Leavell, Linda. *Marianne Moore and the Visual Arts: Prismatic Color*. Baton Rouge: Louisiana State University Press, 1995.

MORTON: Santa Barbara Museum of Art. *The Preston Morton Collection of American Art*. Santa Barbara, Calif.: The Museum, 1981.

MOUNTAINS: McGrath, Robert L. and Barbara J. MacAdam. *"A Sweet Taste of Heaven:" Artists in the White Mountains 1830–1930.*" Hanover, N.H.: Dartmouth College, Hood Museum of Art; Distributed by University Press of New England, 1988.

MUNSON/1: Munson-Williams-Proctor Institute. *Masterworks of American Art from the Munson-Williams-Proctor Institute*. New York: H.N. Abrams, 1989.

MUNSON/2: Murray, Mary E. and Paul D. Schweizer. *Life Lines: American Master Drawings from the Munson-Williams-Proctor Institute*. Utica, N.Y.: The Institute, 1994.

MUNSTERBERG: Munsterberg, Hugo. *Twentieth Century Painting*. New York: Philosophical Library, 1951.

MURDOCK: Wichita Art Museum. *Catalogue of the Roland P. Murdock Collection*. Wichita, Kans.: The Museum, 1972.

NATIONAL/1: Smithsonian Institution. National Museum of American Art. *National Museum of American Art*. Washington, D.C.: The Museum; Boston: In association with Bulfinch Press, Little, Brown, 1995.

NATIONAL/2: Walker, John. *National Gallery of Art, Washington*, new and rev. ed. New York: H.N. Abrams, 1984.

NATIONAL/3: Wilmerding, John. *American Masterpieces from the National Gallery of Art*. New York: Hudson Hills Press, 1980.

NELSON-ATKINS/1: Nelson-Atkins Museum of Art. *The Collections of the Nelson-Atkins Museum of Art*. New York: H.N. Abrams, in association with the Museum, Kansas City, Mo., 1988.

NELSON-ATKINS/2: Nelson-Atkins Museum of Art. *Handbook of American Paintings*. Kansas City, Mo.: The Museum, 1991.

NELSON-ATKINS/3: Nelson-Atkins Museum of Art. *The Nelson-Atkins Museum of Art: A Handbook of the Collection*. New York: Hudson Hills Press, in association with the Museum, Kansas City, Mo., 1993.

NEUBERGER: Rhode Island School of Design. Museum of Art. *The Neuberger Collection: An American Collection; Paintings, Drawings, and Sculpture*. [Providence, R.I.: The Museum, 1968.]

NEW BRITAIN: New Britain Museum of American Art. *New Britain Museum of American Art: Highlights of the Collection, Vol. I*. New Britain, Conn.: The Museum, in association with Prestel, Munich, New York, 1999.

NEW ENGLAND/1: Little, Carl. *Paintings of New England*. Camden, Maine: Down East Books, 1996.

NEW ENGLAND/2: Truettner, William H. and Roger B. Stein, eds. *Picturing Old New England: Image and Memory*. Washington, D.C.: National Museum of American Art, Smithsonian Institution; New Haven, Conn.: Yale University Press, 1999.

NEW JERSEY: New Jersey State Museum. *Selections from the American Art Collection of the New Jersey State Museum and Catalogue of the American Paintings and Sculpture through 1950*. Trenton: The Museum, [1982].

NEW MEXICO/1: Museum of Fine Arts (Museum of New Mexico). *Artists of Twentieth-Century New Mexico: The Museum of Fine Arts Collection*. Santa Fe: Museum of New Mexico Press, 1992.

NEW MEXICO/2: Museum of Fine Arts (Museum of New Mexico). *Handbook of the Collections, 1917–1974: Museum of Fine Arts*. [Santa Fe]: The Museum, 1974.

NEW MEXICO/3: Whitney Museum of American Art at Champion. *Modernists in (New) Mexico*. Stamford, Conn.: The Museum, 1996.

NEW ORLEANS: New Orleans Museum of Art. *Handbook of the Collection*. New Orleans: The Museum, 1980.

NEW YORK/1: ACA Galleries. *19th and 20th Century Masterpieces in New York Private Collections*. New York: The Galleries, 1978.

NEW YORK/2: New York University. Art Collection. *A Century of Teaching: Morse to Hofmann*. New York: Distributed by New York University Press, 1967.

NEW YORK/3: Whitney Museum of American Art. *City of Ambition: Artists and New York*. New York: The Museum, in association with Flammarion, 1996.

and Sculpture Garden, Smithsonian Institution, by the Smithsonian Institution Press, 1978.

RANDOLPH-MACON/1: Maier Museum of Art. *American Art, American Vision: Paintings from a Century of Collecting.* Lynchburg, Va.: The Museum, Randolph-Macon Women's College, in conjunction with Art Services International, Alexandria, Va., 1990.

RANDOLPH-MACON/2: Williams, Mary Frances. *Catalogue of the Collection of American Art at Randolph-Macon Women's College; A Selection of Paintings, Drawings, and Prints*, 2d ed. Charlottesville: University Press of Virginia, 1977.

REALISM: Nassau County Museum of Art. *American Realism between the Wars: 1919–1941.* Roslyn Harbor, N.Y.: The Museum, 1994.

REYNOLDA: Reynolda House. *American Originals: Selections from Reynolda House, Museum of American Art.* New York: Abbeville Press; American Federation of Arts, 1990.

RHODE ISLAND: "Selection I: American Watercolors and Drawings from the Museum's Collection." *Bulletin of Rhode Island School of Design, Museum Notes* 58 (January 1972).

RINGLING: Janson, Anthony F. *Great Paintings from the John and Mabel Ringling Museum of Art.* [Sarasota, Fla.]: The Museum, in association with H.N. Abrams, New York, 1986.

ROBY: Mecklenburg, Virginia M. *Modern American Realism: The Sara Roby Foundation Collection.* Washington, D.C.: Published for the National Museum of American Art by the Smithsonian Institution Press, 1987.

ROCHESTER: University of Rochester. *Memorial Art Gallery. Memorial Art Gallery: An Introduction to the Collection.* Rochester, N.Y.: The Gallery, in association with Hudson Hills Press, 1988.

ROCKEFELLER/1: Fine Arts Museums of San Francisco. *The Rockefeller Collection of American Art at the Fine Arts Museums of San Francisco.* [San Francisco]: The Museums; New York: H.N. Abrams, 1994.

ROCKEFELLER/2: Richardson, Edgar Preston. *American Art: A Narrative and Critical Catalogue.* [Cover title: *An Exhibition from the Collection of Mr. and Mrs. John D. Rockefeller, 3rd.*] [San Francisco]: Fine Arts Museums of San Francisco, 1976.

ROOT: Munson-Williams-Proctor Institute. *Edward Wales Root, 1884–1956: An American Collector.* Utica, N.Y.: The Institute, [1957].

ROSWELL: Roswell Museum and Art Center. *Roswell Museum and Art Center: Guide to the Collections* [cover title]. Roswell, N.M.: The Museum, 1983.

SACHS: Sachs, Paul. *Modern Prints and Drawings.* New York: Alfred A. Knopf, 1954.

SOTHEBY/3061: *Modern and Old Master Prints: Various Objects including the Estate of the Late Harris B. Steinberg, New York* (Public Sale 3061). New York: Parke-Bernet Galleries, 1970.

SOTHEBY/3373: *20th Century American Paintings, Sculpture, Watercolors and Drawings* (Public Sale 3373). New York: Sotheby, Parke-Bernet, 1972.

SOTHEBY/3417: *Highly Important 19th and 20th Century American Paintings, Watercolors and Drawings: The Collection of Dr. and Mrs. Irving F. Burton, Huntington Woods, Michigan* (Public Sale 3417). New York: Sotheby Parke Bernet, 1972.

SOTHEBY/3617: *Twentieth Century American Paintings, Drawings and Sculpture* (Public Sale 3617). New York: Sotheby Parke Bernet, 1974.

SOTHEBY/3644: *Important Eighteenth, Nineteenth, and Twentieth Century American Paintings, Watercolors and Drawings* (Public Sale 3644). New York: Sotheby Parke Bernet, 1974.

SOTHEBY/3749: *American 18th, 19th and 20th Century Paintings, Drawings, Watercolors and Sculpture* (Public Sale 3749). New York: Sotheby Parke Bernet, 1975.

SOTHEBY/3823: *American 18th, 19th and 20th Century Paintings, Drawings, Watercolors and Sculpture* (Public Sale 3823). New York: Sotheby Parke Bernet, 1975.

SOTHEBY/3865: *American 18th, 19th and Twentieth Century Paintings, Drawings, Watercolors and Sculpture* (Public Sale 3865). New York: Sotheby Parke Bernet, 1976.

SOTHEBY/3913: *A Collection of Watercolors and Drawings by Charles Demuth; American 19th and 20th Century Paintings, Drawings, Watercolors and Sculpture* (Public Sale 3913). New York: Sotheby Parke Bernet, 1976.

SOTHEBY/4038: *American 19th and 20th Century Paintings, Drawings, Watercolors and Sculpture* (Public Sale 4038). New York: Sotheby Parke Bernet, 1977.

SOTHEBY/4365: *American 19th and 20th Century Paintings, Drawings, Watercolors and Sculpture* (Public Sale 4365). New York: Sotheby Parke Bernet, 1980.

SOTHEBY/4370: *Nineteenth and Twentieth Century Prints* (Public Sale 4370). New York: Sotheby Parke Bernet, 1980.

SOTHEBY/4650M: *American 19th and 20th Century Paintings, Drawings, and Sculpture* (Public Sale 4650M). New York: Sotheby Parke Bernet, 1981.

SOTHEBY/4661M: *Old Master Prints, Nineteenth and Twentieth Century Prints, Posters* (Public Sale 4661M). New York: Sotheby Parke Bernet, 1981.

SOTHEBY/5335: *Important American 18th, 19th and 20th Century Paintings, Drawings and Sculpture* (Public Sale 5335). New York: Sotheby's, 1985.

SOTHEBY/5353: *American 19th and 20th Century Paintings, Drawings and Sculpture.* (Public Sale 5353). New York: Sotheby's, 1985.

SYNCHROMISM: Levin, Gail. *Synchromism and American Color Abstraction, 1910–1925*. New York: George Braziller, in association with the Whitney Museum of American Art, 1978.

SYRACUSE/1: Schmeckebier, Laurence. *The Syracuse University Collection— 1964: Painting, Drawing, Sculpture*, edited by Alexandra K. Schmeckebier. Syracuse, N.Y.: School of Art, Syracuse University, [1964].

SYRACUSE/2: Syracuse University. School of Art. *The Syracuse University Centennial Collection of Art*. Syracuse, N.Y.: The School, 1970.

TANNAHILL: Detroit Institute of Arts. *The Robert Hudson Tannahill Bequest to the Detroit Institute of Arts*. Detroit: The Institute, 1970.

TAOS/1: Luhan, Mabel Dodge. *Taos and Its Artists*. New York: Duell, Sloan and Pearce, 1947.

TAOS/2: *Picturesque Images from Taos and Santa Fe: An Exhibition Sponsored by the First National Bank of Denver and the Denver Art Museum*. [Denver: The Museum, 1974.]

TAOS/3: Porter, Dean A., Teresa Hayes Ebie, and Suzan Campbell. *Taos Artists and Their Patrons, 1898–1950*. [Notre Dame, Ind.]: Snite Museum of Art, University of Notre Dame; Albuquerque: Distributed by the University of New Mexico Press, 1999.

TATE: Tate Gallery. *Catalogue of the Tate Gallery's Collection of Modern Art, Other than Works by British Artists*. London: The Gallery, in association with Sotheby Parke Bernet, 1981.

TERRA: *A Proud Heritage: Two Centuries of American Art. Selections from the Collections of the Pennsylvania Academy of the Fine Arts, Philadelphia, and the Terra Museum of America Art, Chicago*. Chicago: Terra Museum of American Art, 1987.

THEMES: Henkes, Robert. *Themes in American Painting: A Reference Guide to Common Styles and Genres*. Jefferson, N.C.: McFarland, 1993.

THOREAU: Koslow, Francine Amy. *Henry David Thoreau: As a Source for Artistic Inspiration*. Lincoln, Mass.: DeCordova and Dana Museum and Park, 1984.

THYSSEN: Levin, Gail. *Twentieth-Century American Painting: The Thyssen-Bornemisza Collection*. London: Sotheby's Publications, 1987.

TOLEDO: Toledo Museum of Art. *Toledo Treasures: Selections from the Toledo Museum of Art*. New York: Hudson Hills Press; Toledo, Ohio: The Museum, 1995.

TRANSCO: *The Transco Energy Company Collection of American Watercolors* (Public Sale 6374). New York: Sotheby's, 1992.

TREMAINE: Wadsworth Atheneum. *The Tremaine Collection: 20th Century Masters, The Spirit of Modernism*. Hartford, Conn.: Wadsworth Atheneum, 1984.

UNIVERSAL: Sparks, Esther. *Universal Limited Art Editions. A History and Catalogue: The First Twenty-Five Years*. Chicago: Art Institute of Chicago; New York: H.N. Abrams, 1989.

URBAN: Farmer, Jane. *The Image of Urban Optimism*. Washington, D.C.: Smithsonian Institution Traveling Exhibition Service, 1977.

VASSAR/1: Vassar College. *Centennial Loan Exhibition: Drawings and Watercolors from Alumnae and their Families*. Pougkeepsie, N.Y.: Vassar College, 1961.

VASSAR/2: Vassar College. Art Gallery. *Vassar College Art Gallery: Selections from the Permanent Collection*. Poughkeepsie, N.Y.: The Gallery, 1967.

VENICE: Lovell, Margaretta M. *Venice: The American View, 1860–1920*. San Francisco: Fine Arts Museums of San Francisco; Seattle: Distributed by University of Washington Press, 1984.

VIEWS/1: Fuchs, Rudi and Adam D. Weinberg. *Views from Abroad: European Perspectives on American Art 1*. New York: Whitney Museum of American Art: Distributed by H.N. Abrams, 1995.

VIEWS/2: Serota, Nicholas, Sandy Nairne, and Adam D. Weinberg. *Views from Abroad: European Perspectives on American Art 3; American Realities*. New York: Whitney Museum of American Art: Distributed by H.N. Abrams, 1997.

WADSWORTH/1: Silk, Gerald. *Museums Discovered: The Wadsworth Atheneum*. Ft. Lauderdale, Fla.: Penhurst Books; New York: Shorewood Fine Arts Books, 1982.

WADSWORTH/2: Wadsworth Atheneum. *American Drawings and Watercolors from the Wadsworth Atheneum*. New York: Hudson Hills Press, in association with American Federation of Arts, 1987.

WADSWORTH/3: Wadsworth Atheneum. *American Paintings before 1945 in the Wadsworth Atheneum*. Hartford, Conn.: Wadsworth Atheneum; New Haven, Conn.: Yale University Press, 1996.

WADSWORTH/4: Wadsworth Atheneum. *"The Spirit of Genius:" Art at the Wadsworth Atheneum*. New York: Hudson Hills Press, in association with the Wadsworth Atheneum, Hartford, Conn., 1992.

WALKER: Walker Art Center. *Walker Art Center: Painting and Sculpture from the Collection*. Minneapolis: The Center; New York: Rizzoli International, 1990.

WASHINGTON/1: Brown, Milton. *One Hundred Masterpieces of American Art from Public Collections in Washington, D.C.* Washington, D.C.: Smithsonian Institution Press, 1983.

WASHINGTON/2: Washington University. Gallery of Art. *A Gallery of Modern Art at Washington University in St. Louis*. Saint Louis, Mo.: The Gallery, 1994.

WATERCOLOR/1: Ferber, Linda S. and Barbara Dayer Gallati. *Masters of Color and Light: Homer, Sargent, and the American Watercolor Movement*. Brooklyn, N.Y.: Brooklyn Museum, in association with Smithsonian Institution Press, Washington, D.C., 1998.

WATERCOLOR/2: Finch, Christopher. *American Watercolors*. New York: Abbeville Press, 1986.

WATERCOLOR/3:Finch, Christopher. *Twentieth-Century Watercolors*. New York: Abbeville Press, 1988.

WATERCOLOR/4: Gardner, Albert Ten Eyck. *History of Watercolor Painting in America*. New York: Reinhold, 1966.

WATERCOLOR/5: Hoopes, Donelson F. *American Watercolor Painting*. New York: Watson-Guptill, 1977.

WATERCOLOR/6: Koschatzky, Walter. *Watercolor: History and Technique*. New York: McGraw-Hill, 1970.

WATERCOLOR/7: Kushner, Marilyn. *The Modernist Tradition in American Watercolors, 1911–1939*. Evanston, Ill.: Mary and Leigh Block Gallery, Northwestern University, 1991.

WATERCOLOR/8: Metropolitan Museum of Art (New York). *200 Years of Watercolor Painting in America: An Exhibition Commemorating the Centennial of the American Watercolor Society*. New York: The Museum, 1967.

WATERCOLOR/9: Reed, Sue Welsh and Carolyn Troyen. *Awash in Color: Homer, Sargent, and the Great American Watercolor*. Boston: Museum of Fine Arts, Boston, in association with Bulfinch Press, Little, Brown, 1993.

WATERCOLOR/10: Spanierman Gallery. *One Hundred Years Twenty-five Years of American Watercolor Painting*. New York: The Gallery, 1998.

WATERCOLOR/11: Tomko, George P. *Masters of American Watercolor*. [S.l.]: Mid-America Arts Alliance, [1980?].

WEST/1: Hassrick, Peter. *The Way West: Art of Frontier America*. New York: H.N. Abrams, 1977.

WEST/2: Kennedy Galleries. *Selected Paintings and Sculpture of the American West*. New York: The Galleries, 1982.

WEST/3: Palm Springs Desert Museum. *The West as Art: Changing Perceptions of Western Art in California Collections*. Palm Springs, Calif.: The Museum, 1982.

WHITE:"The Samuel S. White, 3rd, and Vera White Collection." *Bulletin. Philadelphia Museum of Art* 63 (January-June 1968).

WHITE HOUSE: *Art in the White House: A Nations' Pride*. Washington, D.C.: White House Historical Association, in cooperation with the National Geographic Society, 1992.

WHITNEY/1: Armstrong, Tom and Susan C. Larsen. *Art in Place: Fifteen Years of Acquisitions*. New York: Whitney Museum of American Art, 1989.

WHITNEY/2: Cummings, Paul. *Drawing Acquisitions, 1981–1985*. New York: Whitney Museum of American Art, 1985.

WHITNEY/3: Cummings, Paul. *Twentieth-Century Drawings: Selections from the Whitney Museum of American Art*. New York: Dover, 1981.

WHITNEY/4: Sims, Patterson. *Whitney Museum of American Art: Selected*

Works from the Permanent Collection. New York: Whitney Museum of American Art, in association with W.W. Norton, 1985.

WHITNEY/5: Whitney Museum of American Art. *Art of the United States, 1670–1966.* New York: The Museum, 1966.

WHITNEY/6: Whitney Museum of American Art. *Between the Fairs: 25 Years of American Art, 1939–1964.* New York: Published for the Museum by Praeger, 1964.

WHITNEY/7: Whitney Museum of American Art. *The Decade of the Armory Show: New Directions in American Art, 1910–1920. Sixth Loan Exhibition of the Friends of the Whitney Museum of American Art.* New York: The Museum, 1963.

WHITNEY/8: Whitney Museum of American Art. *The Friends Collect: Recent Acquisitions by Members of the Friends of the Whitney Museum of American Art, 7th Friends Loan Exhibition.* New York: The Museum, 1964.

WHITNEY/9: Whitney Museum of American Art. *The Museum and Its Friends: Eighteen Living American Artists Selected by the Friends of the Whitney Museum [Second Loan Exhibition].* New York: The Museum, 1959.

WHITNEY/10: Whitney Museum of American Art. *The Museum and Its Friends: Twentieth-Century American Art from Collections of Friends of the Whitney Museum [First Loan Exhibition].* New York: The Museum, 1958.

WHITNEY/11: Whitney Museum of American Art. *Painting and Sculpture Acquisitions, 1973–1986.* New York: The Museum, 1986.

WHITNEY/12: Whitney Museum of American Art. *Pioneers of Modern Art in America.* New York: The Museum, 1946.

WHITNEY/13: Whitney Museum of American Art. *The Theatre Collects American Art: Fourth Loan Exhibition by the Friends of the Whitney Museum of American Art.* New York: The Museum, 1961.

WICHITA: Ross, Novelene. *Toward an American Identity: Selections from the Wichita Art Museum Collection of American Art.* Wichita, Kans.: The Museum, 1997.

WIGHT: Wight, Frederick S. *Milestones of American Painting in Our Century.* Boston: Institute of Contemporary Art; New York: Chanticleer Press, 1949.

WILLIAMS/1: Beall, Karen F. and David W. Kiehl. *Graphic Excursions: American Prints in Black and White. Selections from the Collection of Reba and Dave Williams.* Boston: David R. Godine, in association with American Federation of Arts, New York, 1991.

WILLIAMS/2: Mathews, Nancy Mowll, ed. American Dreams: *American Art to 1950 in the Williams College Museum of Art.* New York: Hudson Hills Press, in association with the Williams College Museum of Art, Williamstown, Mass., 2001.

WINDOW: Delehanty, Suzanne. *The Window in Twentieth-Century Art*. Purchase: Neuberger Museum, State University of New York at Purchase, 1986.

WINTER: Hood Museum of Art. *Winter*. Hanover, N.H.: The Museum, Dartmouth College; Distributed by University Press of New England, 1986.

WINTERSTEEN: *The Collection of Mrs. John Wintersteen: An Exhibition of Paintings, Drawings and Sculpture*. San Francisco: California Palace of the Legion of Honor; Santa Barbara, Calif.: Santa Barbara Museum of Art, 1966.

WORCESTER: Acton, David. *Master Drawings from the Worcester Art Museum*. New York: Hudson Hills Press, in association with the Worcester Art Museum, Worcester, Mass., 1998.

YALE/1: "Acquisitions 1972." *Yale University Art Gallery Bulletin* 34 (June 1973).

YALE/2: "Acquisitions 1977." *Yale University Art Gallery Bulletin* 37 (Fall 1978).

YALE/3: "Acquisitions 1980." *Yale University Art Gallery Bulletin* 38 (Winter 1982).

YALE/4: "Acquisitions 1981." *Yale University Art Gallery Bulletin* 38 (Winter 1983).

YALE/5: Yale University. Art Gallery. *A Checklist of American Paintings at Yale University*. New Haven, Conn: The Gallery, 1982.

YALE/6: Yale University. Art Gallery. *Paintings, Drawings and Sculpture Collected by Yale Alumni*. New Haven, Conn.: The Gallery, 1960.

YALE/7: Yale University. Art Gallery. *Selected Paintings and Sculpture from the Yale University Art Gallery*. New Haven, Conn.: Published for the Gallery by Yale University Press, 1972.

YORK/1: Richard York Gallery. *An American Gallery* [Spring 1987]. New York: The Gallery, 1987.

YORK/2: Richard York Gallery. *An American Gallery*, Vol. 5. New York: The Gallery, 1989.

YORK/3: Richard York Gallery. *An American Gallery*, Vol. 6. New York: The Gallery, 1990.

YORK/4: Richard York Gallery. *An American Gallery*, Vol. 8. New York: The Gallery, 1997.

Author Index

Short-Title Index to Exhibition Catalogues

Subject Index

About the Author

R. SCOTT HARNSBERGER is an Associate Professor in the Newton Gresham Library at Sam Houston State University in Huntsville, Texas. He is the author of *Ten Precisionist Artists*: *Annotated Bibliographies* (Greenwood, 1992).

DATE DUE

GAYLORD		PRINTED IN U.S.A.